Practical Sculpture

TUCK LANGLAND

Indiana University at South Bend

PRENTICE HALL, Englewood Cliffs, New Jersey 07632

Library of Congress Cataloging-in-Publication Data

Langland. Tuck.
 Practical sculpture.

 Bibliography: p. 237
 Includes index.
 1. Sculpture—Technique. I. Title.
NB1170.L36 1988 731.4 87-12581
ISBN 0-13-692179-5

Editorial/production supervision and
 interior design: Serena Hoffman
Manufacturing buyer: Ray Keating
Page layout: Peggy Finnerty, Lorraine Mullaney
Illustrations: Tuck Langland
Illustrations assistant: Frances M. Kasturas
Photo research: Kay Dellosa
Cover design: Diane Saxe
Cover art: *Odyssey* by Dennis Westwood

© **1988 by Prentice Hall**
A Division of Simon & Schuster
Englewood Cliffs, New Jersey 07632

Printed in the United States of America

10 9 8 7 6 5 4 3 2

ISBN 0-13-692179-5 01

PRENTICE-HALL INTERNATIONAL (UK) LIMITED, *London*
PRENTICE-HALL OF AUSTRALIA PTY. LIMITED, *Sydney*
PRENTICE-HALL CANADA INC., *Toronto*
PRENTICE-HALL HISPANOAMERICANA, S.A., *Mexico*
PRENTICE-HALL OF INDIA PRIVATE LIMITED, *New Delhi*
PRENTICE-HALL OF JAPAN, INC., *Tokyo*
SIMON & SCHUSTER ASIA PTE. LTD., *Singapore*
EDITORA PRENTICE-HALL DO BRASIL, LTDA., *Rio de Janeiro*

Contents

FIVE

Modeling from Life 44

SIX

Abstract Modeled Sculpture 68

SEVEN

Making Clay Sculpture Permanent 77

EIGHT

Mold Making 85

NINE

Filling Molds 107

TEN

Metal Casting 122

ELEVEN

Direct Building 150

TWELVE

Wood 159

Preface

It's true that no book can make a novice into a sculptor, and it's also true that many great sculptors learned their art without books. But with a subject as complicated as sculpture, involving both ideas and technique, it is certainly a help to have a handbook full of practical information, step-by-step demonstrations, and suggestions for creating.

Practical Sculpture is meant to help the beginning or intermediate sculptor pursue two different paths toward art. First, it helps sculptors search out their own sculptural ideas and run those ideas through variations and changes, bringing out all the complexity or simplicity an idea can offer. The first three chapters deal with form, variations on form, and how materials affect form. These chapters are to be read first, then referred to again and again to keep stirring the creative process.

Second, *Practical Sculpture* takes the reader through most of the processes of sculpture, from traditional clay modeling and simple casting through more complex casting methods, including bronze casting, and then into the areas of wood, stone, metal, and other materials.

In these technical chapters the emphasis is on actually doing the job, rather than watching someone else do it. The text and photos enable the reader to get through a complex job with a high chance of success, avoiding all the glitches and problems that can occur, and also beginning to invent individual solutions to difficult problems. These chapters are full of tricks of the trade picked up or invented during my twenty-five years of work in the studio. The emphasis is less on ''Do it this way'' than on ''This way works, but try your own way, if you can make it work better.''

Another aspect of this book is that it doesn't try to be all books, but refers the reader to more detailed sources when available. For example, there are dozens of books on ceramic technique, so *Practical Sculpture* doesn't spend a lot of time on that subject when dealing with ceramic sculpture. Rather, it details some techniques not gener-ally used by ceramicists, ones more useful to sculptors, then refers the reader to other books for information on clay bodies, glazes, firing, etc. The same is true for wood joinery and finishing, or welding.

The bibliography at the end of this text lists books which may be useful for further reading, and of course each of those books includes a bibliography of still other books. The appendix lists sources of supplies and tools, and there is also a glossary of terms.

Though this book contains a lot of photos of other sculptors' works, it is not intended as a browsing gallery of contemporary sculpture. Each piece is included to show a particular idea, and the book does not try to show all the latest work being done. In fact, many standard works are illustrated, though there are several pieces which may be new and interesting to the reader.

Sculpture can be dangerous, and safety is important. Discussions of procedures to follow and dangers to avoid are integrated throughout the book, as part of each operation, rather than in a separate chapter at the end.

The best way to use this book is to read through the introductory chapters, the ones dealing with ideas, then to use the technical chapters as needed. The book can continue to be a good studio reference guide for years to come, as well as an initial explanation of complex processes. It is structured so that ideas and creativity are discussed continually, even in the technical chapters, since a sculptor never completely separates creativity from technique.

Practical Sculpture is easy to read, easy to understand, and easy to learn from. It does away with highly formal or technical language, and it says what it means. I hope the book will provide good armchair reading, and then become a valuable addition to the studio. If it gets all dirty and spattered with plaster, then it is doing its job!

Tuck Langland

Introduction

We have to begin with a discussion about what sculpture is and what it is not. Any such attempt at a definition is not meant to limit the artist making sculpture, but only to give us some common ground about the meaning of a word. Words gain meaning as they become focused, so talk can move from vague generalities to specifics.

By *sculpture* I mean any form of the visual arts that is predominantly three dimensional and objectlike in nature, with the general exception of functional objects like pottery or furniture. This in no way means that sculpture is limited, only that the word *sculpture* becomes more useful through refining. When an artist chooses particular means to express certain ideas or feelings, the artist should feel free to draw upon any means—sculptural, pictorial, or whatever—to express those ideas in the best way. The fact that we can later talk about parts of a work, or certain works, as being ''sculptural'' has no bearing on the choices the artist made while creating the work. I grow very tired of hearing some artists talk about ''breaking down the barriers between painting and sculpture.'' What barriers? Artists should feel free to establish the guidelines that best serve the needs of the particular work. If that means that the work roams across traditional ''barriers,'' then so be it.

The main thing to remember is that *communication is probably the most important function of art.* Most communication between people takes the form of speech, accompanied in face-to-face situations by facial expressions, bodily gestures, and those all-important vocal inflections, but there are many other things to communicate that don't fit neatly into words, for which other modes of expression are best. Each of us has feelings, ideas, or moods which can only be expressed in certain ways. For example, if a child has had a disappointment, a hug can be more important than words. For communicating the design for a house, a drawing may be the most obvious and natural vehicle. I can imagine Beethoven, the most gifted pianist of his day, and especially noted for his improvisations, being asked how he felt about his growing deafness. The loss of his hearing left him isolated, embittered, and frightened, but he retained the inner belief in his genius and had thoughts about the ultimate goal of humanity. I can imagine him beginning to answer the question, then stopping, going to his piano, and answering with an improvisation of far more eloquence, subtlety, and profundity than any words he could utter.

This is the nature of art, whether music, literature, dance, theater, crafts, painting and sculpture, or any other form, even those not yet invented. We must always remember, as artists, that we are trying to communicate something to someone—sometimes just to ourselves. We must always be careful that the means we choose fit the kinds of ideas we wish to communicate. If an idea fits more easily into words, then use words. If, for example, someone thought about the current world political situation and wished to express certain thoughts on the subject, words would probably convey those thoughts more directly and clearly than any other means. I don't doubt, however, that Beethoven *thought in sound*, so that music became his most natural ''voice.'' Similarly, the sculptor often *thinks in form*, so that creating forms for others to see becomes a natural mode of expression. Rigidly limiting art to various materials or rules becomes irrelevant.

Freedom in the creation of art, though, is not as simple as it might seem. In the first place, I don't believe artistic freedom actually exists. Each of us is subjected to so many influences every day that we cannot think or act without feeling those influences. Our path is like the path of a pool ball, being profoundly affected by the other balls and cushions on the table. I'm sure we all realize that if we were born in ancient Egypt, we would find it quite natural to produce sculpture in the style of

that culture and would probably think ourselves "free" within its limits. So it is today. We know a great deal about the history of sculpture—certainly more than any sculptors of the past have known. We know less, however, than sculptors yet to come will know; so in that sense we retain a certain amount of ignorance. Further, for all our supposed "freedom" as artists in this age, most of the art of the past is forbidden to us as a medium for expression. No one could seriously work in the ancient Egyptian style today: they would be producing copies of museum pieces. Even though our knowledge of past styles allows us to draw upon a rich source of imagery and ideas, we are still really limited to a fairly narrow slice of current styles and directions.

But that is not a bad thing, because I'm not at all sure that "freedom" is particularly desirable. This may seem like a contradiction of what I have just written, but if you follow the argument, you will see that it is not.

Virtually all the art of the past was produced under restrictive conditions of one sort or another, yet it didn't turn out too badly. I believe that artists are like gunpowder. With complete freedom they dissipate their power in a generalized burning, but with confinement they gain force and direction. In the past these confinements or limitations often came from outside the artist, such as from the church or other social requirements. Yet artists were still able to create works of great power and meaning. Today, with little or no outside societal limitation, artists must supply their own.

Instead of calling this "limitation," we might call it "self-discipline" or "direction." Art in any form gains focus and strength when elements extraneous to the main idea are pared away, allowing the essential elements to gain prominence. Just as when writing, speaking, or carrying on a brief business discussion one tries to "get to the point" and not ramble, so a work of art should express the essential ideas and avoid aimless wandering.

There are many things in life that gain interest and complexity when limited. The game of tennis, with its net, court lines, and rules, is far more interesting than just batting a tennis ball around a field, and it can test the extreme limits of the greatest athletes. Music has long concerned itself with *form*, from the fugue or the sonata allegro to other more complex but no less limiting forms. It is through finding the possibilities in restrictions, through realizing the force and focus coming from confinement, that art can emerge vastly more powerful and complex. Allen Tate, my poetry writing teacher, used to insist that his students use strict meter and rhyme. His reason was that if students wrote free verse they might set down the first word that came to mind, but if they were forced to consider meter and rhyme, that word would often be unacceptable. The students would be forced to cast through many more words, uncovering in the process layers of meaning that they would otherwise have missed. Thus restrictions, rather than limiting expression, enhanced it.

These ideas lie behind what follows. First, sculpture is an art form that is primarily three dimensional, but the sculptor need not feel restricted by this definition. Second, art in any form is communication, on levels that range from the slick and superficial to the deep and profound. Finally, the artist ought to discipline thought and expression through some sort of form or framework to eliminate irrelevancies and enhance essentials.

This book will concentrate on these ideas more than on the mechanical processes used to manipulate materials. Less time will be spent explaining how to handle a stone chisel than on considering stone as a vehicle for expression. Another very important aspect of the book is a discussion of how we generate ideas. The old adage is true: "How do I know what I think until I hear what I've said?" For the artist, the act of creation is often simply working with materials, sometimes without obvious direction, and looking back to see what has happened. Then, by a careful observation of "what has been said," the artist can clarify thoughts and move on to greater levels of eloquence and profundity.

All ideas come from something, and it is wonderful to see your own brain generate ideas from other ideas, sometimes leap-frogging about in a seemingly random pattern, other times moving in a straight line progression. This book will talk continually about letting one idea generate ten more, and those generate a hundred more. But it will also talk about developing the ability to choose among those ideas ruthlessly, discarding the shallow and reinforcing the profound. So the twin poles of freedom and discipline—which are not, after all, mutually contradictory, but interdependent—define the arena in which the artist works.

One more caution is needed. The ideas about art expressed in this book are my ideas. They are certainly not the only valid ideas, nor are they infallible. Your teacher may have equally strong ideas, some of which agree with mine, and some of which don't. This is not only inevitable, but actually a good thing. As a student you will be faced with various opinions, all of which are worth consideration, and you must think about them, evaluate them, and arrive at your own conclusions. You shouldn't accept one person's word as final, whether it is your teacher's or printed in a book. Always weigh what you hear against your own beliefs, and be ready to find your own way. Further, be ready to modify and change your beliefs as time goes on, as you learn more, see more, and experience more. Art can never be pinned down with a single set of ideas or rules. It will always change with the times and with artists. Be willing to change with it!

ONE

Form

SOME DEFINITIONS

Sculptures are things, and things have form, so we have to begin by talking about form. And we must begin our discussion of form by getting some words straight, so it's clear what is meant as we go along.

The word *form* has several meanings. The most common meaning is that of three-dimensional volume, such as the ovoid *form* of an egg, or the cube-like *form* of a building. It has another meaning appropriate to a discussion of art, and that is the arrangement or order of things, such as the *form* of a piece of music or poetry —for example, a fugue or a sonnet.

By *shape* I mean a two-dimensional thing. The *shape* of a phonograph record is round, while the *form* of a bowling ball is round, yet the record is two dimensional and circular, while the ball is three dimensional and spherical. A *shape* can be cut from paper with scissors, but the paper must be bent or folded to give it *form*.

A *surface* is the outer skin of a form, such as the shell of the egg, the cardboard of the box. It is the surface which contains shape and which creates form. There is another meaning to *surface*, and that is to describe the texture or the character of the material of the form, such as polished, rough, or lumpy.

A *plane* is a flat surface. Many forms have planes, most obviously forms such as boxes, but there are also planes on more complex forms, though they are more subtle and harder to see. Seeing planes often helps in understanding a complex form, so we will speak of them often.

KINDS OF FORMS

Surfaces of Forms

The world seems to be filled with a limitless variety of forms, from simple geometric ones like balls and boxes, to complex ones like the human body, and on to even more complex collections of forms like a forest. But even the most complex forms can be broken down into a very few elements to better understand them. Just as only four colors of ink, plus the white of the page, can print full-color pictures with amazing variation and complexity, so just four kinds of surfaces can create virtually all the forms in existence.

The four possible kinds of surfaces, as shown in Figure 1-1, are:

1. *The flat plane.* This is fairly obvious.
2. *The simple curved plane.* A piece of paper can be bent into a cylinder or cone. That is a simple curve. But it cannot be bent into a ball without bending and crumpling.
3. *The complex curve,* with both curves in the same direction. This is a ball. Using a material like chickenwire, which can crush on itself, one can bend it first one way, then in the same direction along the other axis to create a ball or bowl form.
4. *The complex curve,* with the curves in opposite directions. This is the saddle form, made by bending the second bend in the opposite direction from the first.

These four kinds of planes account for virtually every object you see. They can be combined in infinite ways and can constantly change. A simple curve can change radius continually, can even change between tube and cone, and can change direction, from ridge to valley. It can change to a complex curve of either kind, and can include planes as well.

Study your hand for a few moments, and note the various kinds of surfaces that make it up. You won't find any part that is not one of the four kinds mentioned, and you will find several examples of rather pure instances of those forms. Fingernails are simple curves. Fingers, taken as a whole, are tubes, or simple curves, while the heel of the hand is ball-like, or a complex curve. You can find saddle forms between the fingers and between the knuckles. And there is even the odd tiny flat plane here and there.

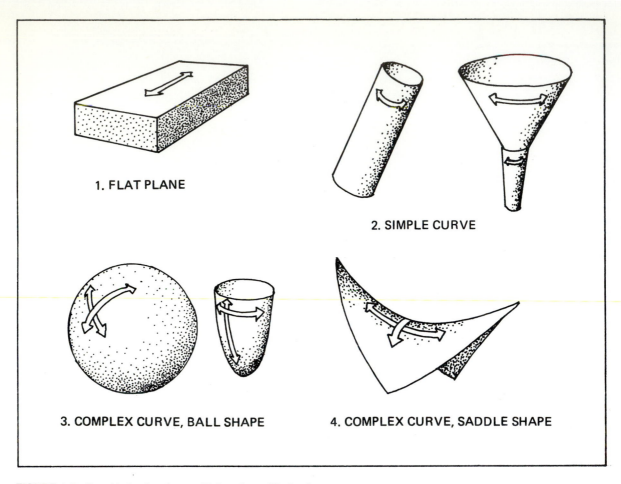

FIGURE 1-1 Four kinds of surfaces: (1) flat plane; (2) simple curve;
(3) complex curve, ball shape; (4) complex curve, saddle shape.

Open Form versus Closed Form

So far we have been describing *closed forms*, such as eggs or boxes. But there are also *open forms*, such as cages or strainers. A ring, like a basketball hoop, is really a complex curve—a thin cylinder that is bent into a circle. But it also implies a flat plane with a circular shape. It contains space within the circle, and charges that space, making it different from the space around the outside of the hoop. A brick and a cage can be the same shape, but one is solid and closed, and the other is open and filled with space.

Implied Form

A great many of the shapes we see and interact with every day are implied spaces. The space within a drinking glass is a cylinder, within a drawer a rectangle. The planes that surround these spaces are curved or flat and relate to each other in particular ways that determine the implied shape. As the drinking glass is filled, the open space remaining—the implied cylinder—becomes

shorter and changes its proportion. The cylindrical space inside the glass is defined by a simple curve around it, with a flat plane (of circular shape) on the bottom and an implied, similar flat plane at the top.

In many cases, the space within or between forms is as important as the forms themselves, just as the silence between notes in music can be as important as the sound. Spaces between forms are what relate forms to each other. When two people stand and talk, they establish a space between themselves that is very important, and that may differ greatly, depending on whether, for example, the two people are angry at each other or are in love. If you hold your hands with palms pressed together as though in prayer and then move them slowly apart, you can sense the changing character of the space between them, from a tightly charged and compressed space at a distance of about an inch, to a much more relaxed space at about a foot, to a completely uncharged space as your hands get very far apart.

Similarly, a hole through an object changes it fundamentally, and not just in practical terms, as a hole in

a drinking glass would change the glass. A window is a hole through one of the flat planes defining a room, and it changes the character of the room completely. A fist is a solid mass, but slightly opened it contains a tunnel with intricate interior spaces. Sculptures can contain such interior spaces, which often become more important than the exterior forms. *Reclining Mother and Child* by Henry Moore (Figure 1-2) shows this perfectly. Many works by Moore explore the idea of an outer protecting form encasing an inner form. This is, of course, a principle commonly found in nature, and Moore can express, with abstract forms, the protective, even tender, quality involved.

SOME CONCEPTS

Form as Communication

Appropriately, it was Henry Moore who held that sculpture really is a "language of form." What he meant was that the shapes and forms that we see constantly in our lives communicate to us various kinds of meanings, and that every shape is a word in a language. Often a word and a form will go very well together, like the word *spiky* and a cactus, or the word *smooth* and a bowling ball. In these cases the words describe what we see but do not indicate what we feel. That occurs on another level, a nonverbal level. We are repelled from the cactus, at least in physical terms, and do not want to touch it,

but we are drawn to the bowling ball and want to run our hand across its smooth and inviting surface. Just watch people in a cactus garden drawing back involuntarily from the more vicious-looking ones, and watch people in a sporting goods store almost unconsciously caressing the bowling balls. Or consider the task of the museum guard trying to keep visitors from rubbing their hands all over particularly smooth and shiny bronze or marble sculptures.

If we consider those two kinds of objects—spiky ones and shiny ones—as but two "words" in the language of form, it takes little thought to realize that virtually every object we see operates on us in some manner and thus becomes, in effect, another "word." Sculptors are like writers, who put words together to communicate: sculptors communicate nonverbally, but they communicate nonetheless.

Any writer knows that words can change their effect depending on their context and how they are used. A sculptor can utilize the forms of sculpture so that the implications of the forms change with their context as well.

Form and Material

But forms do not exist independently of their material. A granite egg and a foam-rubber egg have the same form, but will affect us quite differently. Complicating the issue, as far as sculpture is concerned, is the wide range of materials now available. For centuries

FIGURE 1-2 **Henry Moore, Reclining Mother and Child.** 1960–61, cast bronze. Collection of Walker Art Center, Minneapolis; gift of the T. B. Walker Foundation.

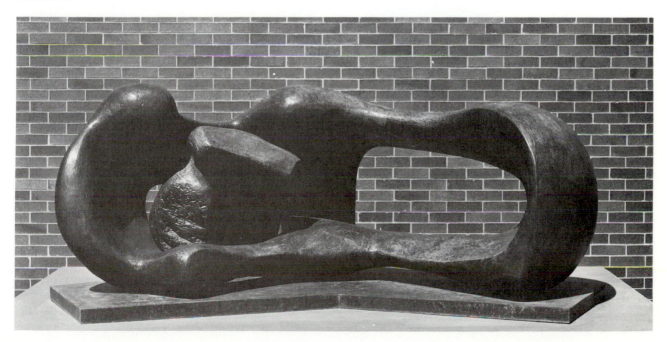

sculptors used only stone, bronze, or fired clay, with occasional minor excursions into materials like wood, ivory, or metals other than bronze. If, as in the case of the majority of existing Greek sculpture, the material is the same white marble from piece to piece, then material ceases to become a differentiating factor in this language of form. Every Greek marble sculpture has more or less the same color, crystalline surface, and sense of weight. Greek bronzes, however, suddenly add quite a new element (Figures 1-3 and 1-4). While the forms of the sculptures may be very similar, their overall effect is different. There is a clean, crystalline quality to the marble, while the bronze has a slightly rougher surface, appearing more crusted and natural. When the sculptures were new, however, the difference was even more striking. It is generally believed that the marble sculptures were painted bright colors, but the bronzes were polished to gleam in the sun.

There is a lot of variation in the sculpture of the past, even though the bulk of it is stone or metal. The Egyptians used granite and other hard, dense stones (Figure 1-5), while the Gothic sculptors used limestone (Figure 1-6), which is much more open and grainy on the surface and allows much more intricate cutting. During

FIGURE 1-3 The Kritios Boy. Classical Greek, marble. Acropolis Museum, Athens.

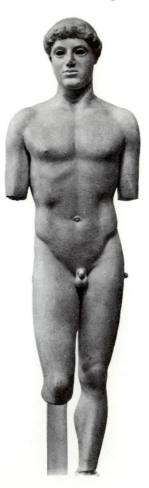

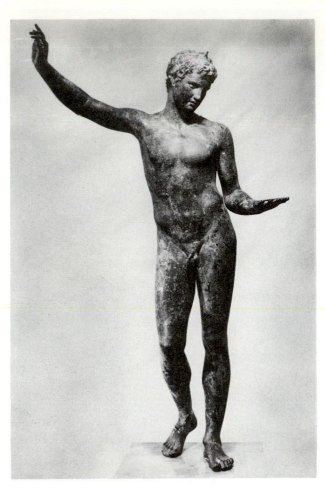

FIGURE 1-4 Hermes. Greek, bronze. National Archaeological Museum, Athens.

the Renaissance and Baroque periods, Bernini and his workshop developed incredible virtuosity at carving marble (Figure 1-7). Thus even a single material, like stone, can lend a wide variety of character to a sculpture.

Adding other materials, like wood and cast metal, further complicates the language, but in the twentieth century sculptors threw the issue wide open by accepting into sculpture first forged iron and cut tin, then virtually every material.

Truth to Materials and Beyond

Materials affect form. Something made from clay is fundamentally different from something made from wire. One of the sculptor's most important tasks is to select a material that relates to the intended form. Further, it is important to select forms that bear some relationship to the selected material. I am not preaching here an idea that arose in the 1930s called "truth to materials," in which the qualities of the form must be in harmony with the inherent qualities of the material. It was this idea that prompted Henry Moore to carve his *Recumbent Figure*

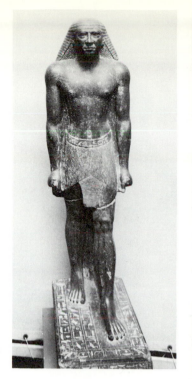

**FIGURE 1-5 Mentemhet the
Governor.** Egyptian Dynasty XXV, 7th
Century B.C. Egyptian Museum, Cairo.

FIGURE 1-6 South Porch of Notre Dame, Louviers, France.
15th Century.

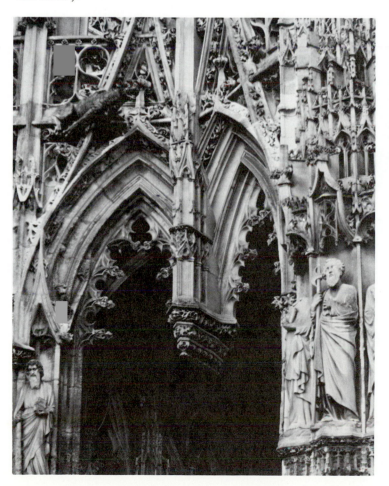

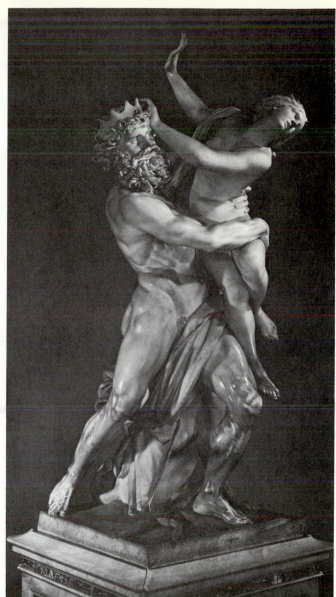

FIGURE 1-7 Bernini, The Rape of Proserpina.
Italian, 17th Century, marble. Borghese Gallery,
Rome.

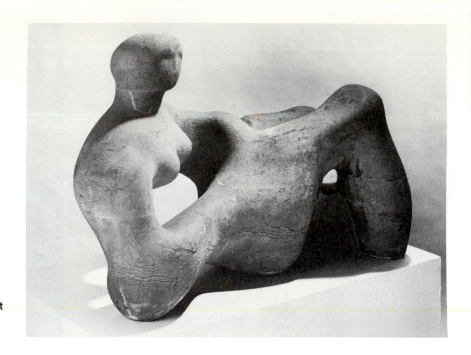

FIGURE 1-8 Henry Moore, Recumbent
Figure. 1938, Hornton stone. Tate
Gallery, London.

FIGURE 1-9 **Mark Di Suvero, Keepers of the Fire.** 1980,
steel. South Bend, Indiana.

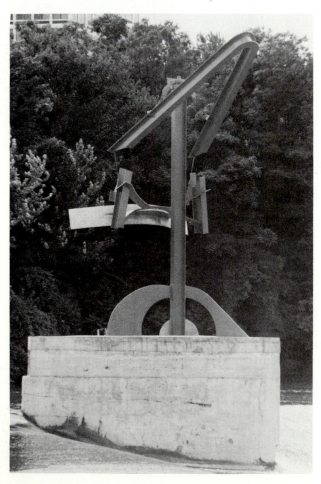

FIGURE 1-10 **Marcel Duchamp, Fountain.** 1917, urinal.
Courtesy Sidney Janis Gallery, New York.

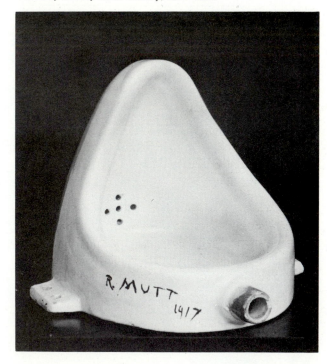

(Figure 1-8) with forms more like those of a natural boulder than a woman. Moore believed that if the reality of the sculpture was stone, then the forms should reflect that reality. Many sculptors, however, can express power through forcing the material to take on very different qualities, such as Bernini did in the work shown in Figure 1-7. Mark Di Suvero gains sculptural expression through denying the ponderous weight of heavy steel I-beams, by making them seem to float and hover as though almost weightless (Figure 1-9).

Without creating any sort of dogma here, I am merely urging sculptors to consider carefully the best material to express a given idea, or, working from the other direction, to utilize a material so that the forms created take advantage of the inherent characteristics of that material, whether by reinforcing them, denying them, or using some other aspect of the material.

Preformed Materials

When Marcel Duchamp signed a urinal in 1917 and attempted to display it as a work of art (Figure 1-10), he was not really creating an aesthetic experience so much as making a conceptual statement. What he was saying was that any material, whether already used or not, was properly within the grasp of the artist, and that there was no minimum amount of change the artist had to make to that material. According to Duchamp, simply by choosing something, the artist could elevate it to the status of art. Very little art produced today is that extreme—simple selection and exhibition—but his ideas have fundamentally altered sculpture. The use and incorporation of found objects (things already manufactured) has become a central fact in contemporary sculpture.

This throws yet another level of complexity into the materials-as-communication issue, since objects affect us not only by their form and their shape, but also by their associations through use and by their present condition. A toilet remains a toilet, with all that implies. Likewise a knife, or machine gun, or doll cannot be stripped of the multiple associations that adhere to it. And a new doll affects us very differently from a discarded, dirty, or broken one. The condition of the object adds yet another level of nonverbal communication.

Montage

In movie making, *montage* refers to cutting one scene against another for artistic effect. A typical horror film does not simply show a mad killer sneaking into a house, but intercuts shots of the sneaking killer with shots of the innocent sleeping girl, peacefully unaware of his approach. Putting two or more images and ideas together creates stronger and more complex levels of meaning than the images would convey by themselves.

Sculpture can utilize montage in exactly the same way. Some obvious and hopelessly corny examples drawn from two paragraphs above could be: the doll is one thing, the knife another, but the knife stuck in the doll is a third thing. Likewise, adding either of them to the toilet creates another meaning. Unfortunately, these are literary examples, which suggest literary meanings, such as murdering babies. What we are more concerned with here are purely sculptural ideas. Placing together spiky forms and smooth forms or softly undulating forms and crystalline angular ones is more purely sculptural, and it begins to communicate better in the nonverbal world of art.

DISCOVERING THE LANGUAGE OF FORM

Any artist draws, and many artists keep a small drawing book with them to make notes of things they see that interest them. Keep a drawing pad with you, and begin to notice forms in your world. Take particular notice of what sort of effect those forms have on you. Try, if you can, to note the nonverbal effects. Try to move beyond quick and shallow responses to things you see (such as "yucky," "gross," or "really pretty"), and dig for the deeper feelings you encounter. Try to classify different forms with their feelings, to get some ideas about what kinds of forms create what kinds of effects. A good way to pursue this is to think of the various things you saw during the day when you go to sleep at night. Your mind will have stripped off the inessential things, and you can sense the more important aspects of forms more clearly. Most of all, take careful note of the kinds of forms that stick in your memory, that keep coming back, that give you pleasure to remember.

As you do this, you will be *thinking in form*. These will be your thoughts, and no one else's. You may have vague or hard-to-define form ideas, or you may see things clearly. You may think abstractly, or you may remember specific things, like the powerful flank of a horse or the way water glides over stones. Make notes, make drawings, and remember.

It's not enough to have a head full of shapes, however, any more than a writer can have a head full of ideas. Shapes or ideas must be organized so they can be communicated with the fullest effect. A writer may have an entire story in mind, but must decide how to tell it —whether to start at the beginning and go right through, or at the end and use flashbacks, what character will tell the story, and so on. And the sculptor must think about selecting forms, how to focus on the essentials, and how to organize the thoughts, to put them in a logical format so they make sense.

The next chapter will deal with organizing visual ideas, running through variations on them, expanding them, enriching them, and giving them order.

TWO

Organizing Form

In the previous chapter we talked about form, thinking of it as a single object, like a box or cylinder. Such forms are really only the building blocks of sculpture, and they must be considered in combination to move towards any kind of complexity.

CATEGORIES OF FORM

Monolithic Form

First let us consider the single form as a complete sculpture. It is rare for a sculptor to make just a single form without combining it with any other forms, but it is done occasionally. The idea of a single form is given a name—*monolithic*—which is *single* (mono) *stone* (lithic). Prehistoric people in northern France and southern England erected a number of monoliths, such as the group of three massive stones at Stonehenge (Figure 2-1). Though this trilithon is part of a complex group, many single stones were also placed at important places in the landscape, most likely as markers, and not as sculpture in any aesthetic sense.

Several contemporary sculptors have used monolithic forms for completed sculptures. Brancusi perhaps went farther than any others when he made *The Beginning of the World* (Figure 2-2), a single egg. This piece actually followed logically in a long series of sculptures that explored the head as object, and it has profound philosophical implications: thus it is not as simple as it seems. Nothing Brancusi did is as simple as it seems; that is his great power as an artist. But even here, he did not present the egg shape as the complete sculpture, but combined it with a massive stone base (not shown in the photo), which was nevertheless clearly part of the total work.

The late English sculptor Barbara Hepworth created a piece called *Single Form* (Figure 2-3), which was a model for a much larger version she placed at the United Nations headquarters in New York as a memorial to Dag Hammerskjold. She used a single, blade shape, but "added" to the form by piercing it with a carefully placed hole. Barbara Hepworth lived on the western tip of Cornwall, in southern England, where one can see many prehistoric monoliths on the lonely hills.

The monolithic form can indeed be used as sculpture, but it is rarely found without some sort of embellishment, such as a base integral to the piece, cuts in the form, or lines engraved on the surface. As you look through books of sculpture, keep your eye out for the rare, pure monolith. You will find a few, and you may be surprised at the amount of variety that can occur with this seemingly limited idea.

Open Form and Solid Form

Often a complex series of forms, like a tree or a person, is a combination of solid forms and *open*, or *implied*, forms. When a person stands hand on hip, a space is created between arm and body, and that space itself has a shape. These open spaces operate like forms in that they have shape and volume, and thus are part of the totality of combined form. Almost everything observed in nature shows similar combinations of solid form and open form, or real shapes and implied shapes.

Linear Form

A third kind of form involves form implied by line. Open forms, cages, rings, or hoops are implied forms. Lines can cut across space and connect two solid forms.

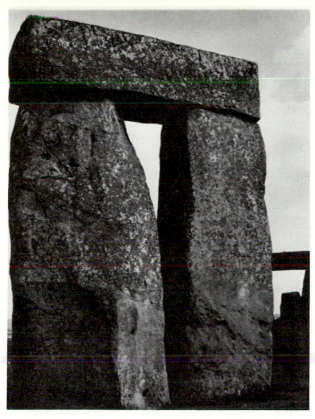

FIGURE 2-1 Monoliths at Stonehenge. Prehistoric. Salisbury Plain, England.

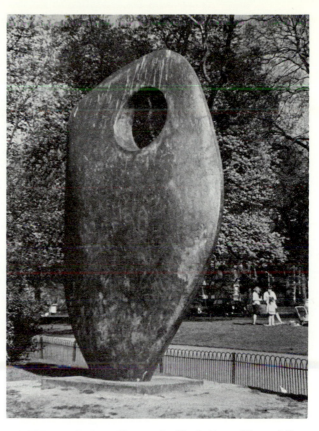

FIGURE 2-3 Barbara Hepworth, Single Form (Memorial). 1961–62, bronze. Battersea Park, London.

FIGURE 2-2 Constantin Brancusi, The Beginning of the World (Sculpture for the Blind). 1916, marble. The Philadelphia Museum of Art; the Louise and Walter Arensberg Collection.

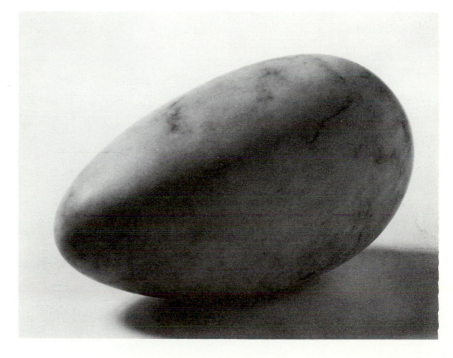

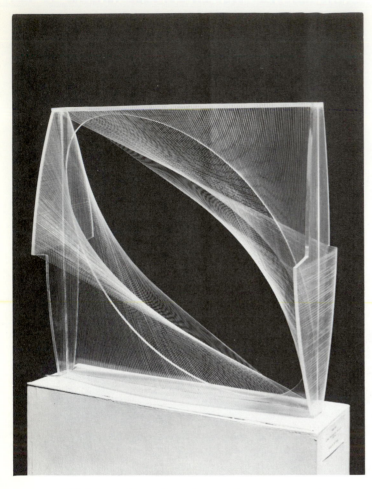

FIGURE 2-4 Naum Gabo, Linear Construction in Space No. 1, Variation. 1943–48, lucite with nylon thread. The Phillips Collection, Washington, D.C.

Lines can indicate implied forces between various shapes, as in the sculpture by Naum Gabo (Figure 2-4), where thin nylon fishing line, drawn tightly between many points on the edges of curved forms, creates new shapes.

Combinations of Simple Forms

A natural tendency is to combine forms, often very simple ones, to create greater interest and complexity. This can be done in a simple and pure manner, such as in the piece by Barbara Hepworth (Figure 2-5), or more subtly. Even a piece as seemingly simple as Brancusi's *Bird in Space* (Figure 2-6) is a combination of forms: the main shaft of the bird, and two more cylindrical forms to imply feet and tail. Like *The Beginning of the World*, the various "Bird" sculptures are all mounted on carefully designed bases, each composed of multiple elements.

Perhaps the most obvious monolithic group of forms is the human figure. Standing up, arms at the sides, the figure approaches a monolith, but is composed (on the simplest level) of a series of cylinders and spheres. These can press together to form a single form, or spread out from the main body to form a never ending series of variations. As you examine the figure in greater detail, you find more forms adding to the complexity.

As Cézanne noted, everything in nature seems to contain within it the ideas of geometry and can be mentally reduced to cones, cubes, cylinders, or spheres. These can then be mentally separated from each other and seen as a grouping of monolithic shapes to form whatever the complex totality might be. Looking at natural forms this way is a simple way of mentally organizing them, of understanding their fundamentals a little better.

FIGURE 2-5 Barbara Hepworth, Discs in Echelon. 1935, wood. The Museum of Modern Art; gift of W. B. Bennet.

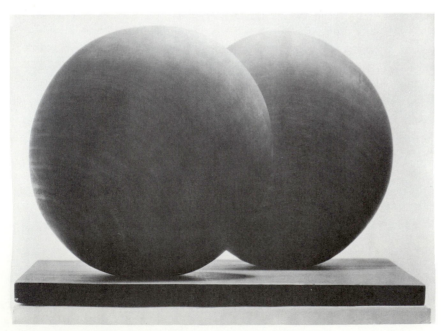

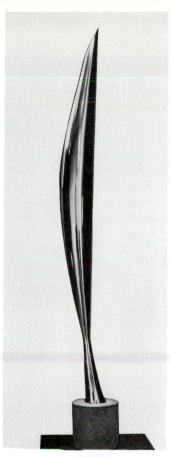

FIGURE 2-6 Constantin Brancusi, Bird in Space. 1928, bronze. The Museum of Modern Art.

Combinations of Solid Forms

When simple forms are grouped together to make more complex forms, various factors come into play. As you look around at the many complex groupings of forms you see in nature—human figures, animals, trees, the landscape itself—notice how these factors apply in each case.

First, there is the idea of what kinds of forms are grouped. A portrait head, for example, is usually expressible as a sphere mounted on a cylinder. Two rounded forms, one a complex curve, the other a simple curve, are combined. Continuing through the body, we notice many groups of cylinders, such as arms, legs, trunk, or fingers. There are few flat surfaces in the body, few "corners" such as on a cube.

Look around for things which show combinations of form involving forms other than those of the figure—forms like pyramids, cubes, or discs. Note how the various forms are combined. In the figure, just about all the cylinders are joined end-to-end, like sections of pipe. Think of other ways cylinders may be combined: they can be laid side by side like fingers in your flat hand, or crossed at the middles like logs in a fire. Think of as many other kinds of forms as you can, and for each kind try to run through some variations of how they can be paired or joined.

Other Combinations of Forms

Next, begin to think about larger groups of forms; several different kinds of forms may be combined, and in different ways. Add to this complexity the idea of spaces between forms, so they are not just joined, but exist *in relation* to each other.

And now add one more element, the element of size. Begin mentally to vary the sizes of the many forms; as in the body, some are large, like the chest, some small, like a finger. There are other levels of complexity you can add, such as variations in texture, like rough and smooth; changes in color; or changes in feel or material, such as balsa wood next to granite.

By mentally conceiving a form and then adding to it, changing relations, changing feel and material—all inside your head—you can run through scores of variations and possibilities without getting out of your chair. This is *thinking in form*.

ENRICHING FORM

Variations

Another way to enrich form and move towards sculptures of interest and complexity is to work variations on a simple theme. For centuries, musical composers have been fascinated by the idea of *themes and variations*. Mozart, for example, wrote a work in which the theme is a children's song that we know as "Twinkle, Twinkle, Little Star." This little tune is so simple that virtually anyone can pick it out on a piano (its sculptural equivalent might be a single cylinder), yet as the variations progress, it gains so much complexity and requires so much sheer pianistic wizardry that it becomes a dazzling showpiece.

Something similar can happen with sculpture. Often the simplest variation can change a piece profoundly, turning it into something quite different. Here are a few variations to apply to forms or pieces you may have created (even if only in your mind or in a sketchbook). You will see how these ideas can be turned and twisted and reworked a thousand ways to enrich your ideas.

Doubling

Sometimes very interesting things happen when a piece is created twice and set beside itself. I made a little figure of an *Apsara*, a celestial being from the mythology

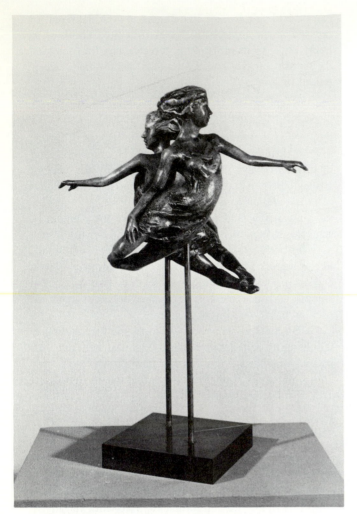

FIGURE 2-7 **Tuck Langland, Stella Maris.** 1985, bronze.
Private collection.

of India. When I cast a second plaster and held it near the first, I began to see a completely new idea, which resulted in the piece *Stella Maris* (Figure 2-7).

Later, I was asked to make a small sculpture as an award for cooperation in business. I again created a single form and doubled it (Figure 2-8).

The principle of doubling also occurs in music. Telemann wrote several ''Canon Sonatas'' for two flutes in which there is a single line of music, but one flute plays the notes two measures after the other, creating a lovely duet.

Sculptures can even be tripled. In the famous *Gates of Hell* by Rodin, the three Shades on the very top (Figure 2-9) are actually the same figure turned in three different directions.

In the piece *Lowdo* by Janet Dean, a single, horn-shaped form is repeated eight times with no variation except rotation to create a flowerlike sculpture of great beauty (Figure 2-10).

Stretching and Compressing

Take a form and mentally stretch or compress it. Stretch one part and compress another. Enlarge one section, leaving the rest the same. All of these activities can alter a single form to create a new concept. In a sculpture by Fernando Botero, every form is fattened as though inflated (Figure 2-11). The works of Giacometti (Figure 2-12), while not exactly in the same spirit, nevertheless are figures which have undergone extreme stretching and elongation. Much of what happened during the period of sixteenth century Italian art called *Mannerism* was a similar deformation for the effect of elegance.

Emphasizing

A single part of a work can be extracted and emphasized. Marisol made a number of portraits where the body is represented as a box, but the face, hands, or other details get special, fully modeled treatment, and are thus emphasized, becoming different from the rest (Figure 2-13). As you look through books of sculpture, notice how often this sort of variation is used.

FIGURE 2-8 **Tuck Langland, Award.** 1986, bronze.
Corporate collection.

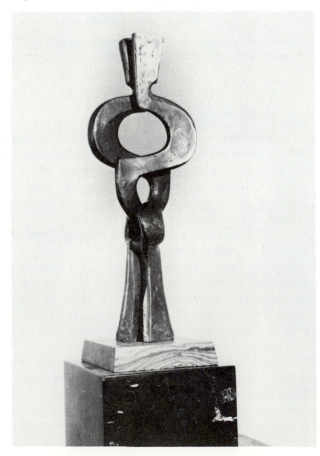

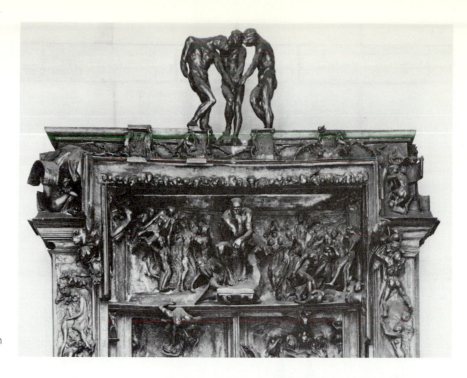

FIGURE 2-9 August Rodin, Three Shades, from The Gates of Hell. 1880–81, bronze. Philadelphia Museum of Art.

FIGURE 2-10 Janet Dean, Lowdo. 1984, bronze. Collection of the artist.

FIGURE 2-11 Fernando Botero, The Lovers. Bronze. Joachim-Jean Aberbach.

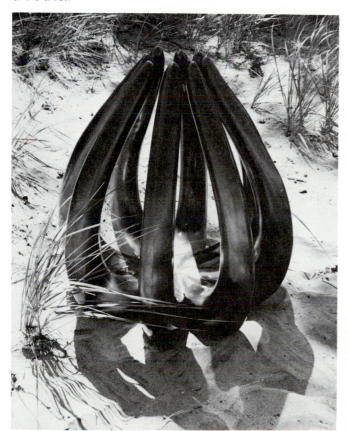

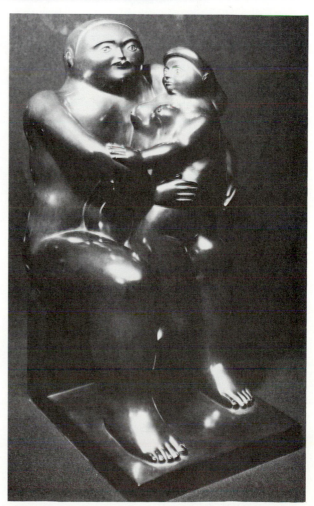

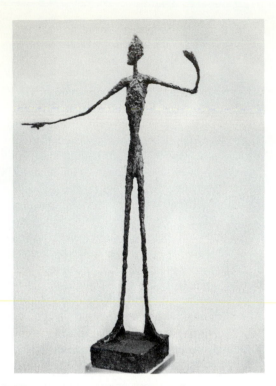

FIGURE 2-12 Alberto Giacometti, Man Pointing. 1947, bronze. The Museum of Modern Art; gift of Mrs. John D. Rockefeller 3rd.

FIGURE 2-13 Marisol, Women and Dog. 1964, wood, leather, fur, etc. Collection of the Whitney Museum of American Art, New York.

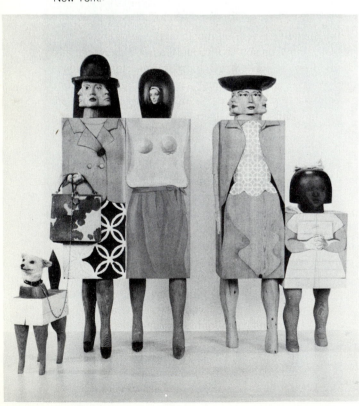

Isolating

By extracting a part of a larger form and treating it in isolation, a completely new sculpture can be created. A torso or head is such a treatment of a figure. More radical is this arm and hand by Ipousteguy (Figure 2-14), and more radical still is the single thumb by Cesar (Figure 2-15). Still, these are parts of a recognizable whole. What if the starting point was a particularly interesting rock or bone, part of which was extracted and isolated, or a sculpture you had created, a small part of which was isolated?

More Complex Variations

Now think about combining some of these ideas. Create a form, then isolate and enlarge a part of it and place that part in close relation to the original. Imagine an elongated form or a compressed form doubled, tripled, or arranged like flower petals. You can quickly see the countless possibilities of beginning with one form and running it through some variations. It can explode into thousands of quite different sculptures. Again, much of this can happen in your head. The principle I am talking about here is the idea of taking a simple thing and moving it through a series of simple changes until a great deal of complexity has been accumulated.

USE OF MUSICAL AND POETIC FORMS

Composers and poets have developed a number of formal devices to give order and interest to their works. While most of these devices are best suited to linear works—that is, works consisting of elements that follow each other in time, such as music or poetry—some of these ideas can be applied to nonlinear, nontemporal works, such as works in the visual arts.

We have already talked about theme and variation, which is a musical form (I am using the word *form* in this section in the musical and poetic sense, meaning a pattern or organization, such as the fugue form, or sonnet form). A sculpture may also be run through variations, as discussed above. Those variations may then stand on their own or be grouped. Composers and poets use other forms that may supply ideas for sculpture.

The Fugue

This is one of the more perfectly structured musical forms. A melody is played, then the same melody is played by another instrument or voice while the original instrument continues into new material. Three, four, or even more voices can take up the tune at staggered intervals. The logic and clarity of the fugue make it particularly appealing. When a composer like Bach combines

this clarity and logic with thundering passion, the result is especially moving. The piece of mine called *Stella Maris* (Figure 2-16) is fuguelike in some positions (compare it with Figure 2-7) in that the forms, though the same, are offset enough to repeat or echo each other. This kind of stepped offsetting is usually called placing *in echelon*. There are numerous other ways the concept of the fugue may be applied to sculpture.

Sonata Allegro

Much of the music of the *Classical period*, namely the time of Haydn and Mozart, is in *sonata allegro* form. Two themes alternate and are then varied. Sculptures composed of two parts, or two ideas, operate something like music in the sonata allegro form. The two themes contrast in such a way that each brings out something in the other. In figurative sculpture, there are a great many possibilities, such as male-female, mother-child, or

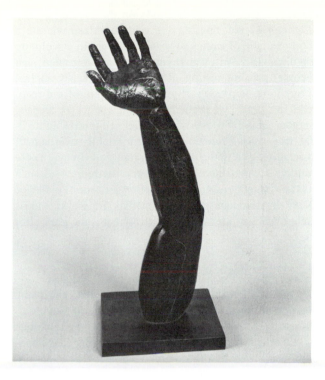

FIGURE 2-14 Jean Ipousteguy, The Arm. 1965, bronze. Courtesy of the Art Institute of Chicago.

FIGURE 2-15 Cesar, The Thumb (in progress). 1980, marble. Photo by Todd Villeneuve.

FIGURE 2-16 Tuck Langland, Stella Maris.

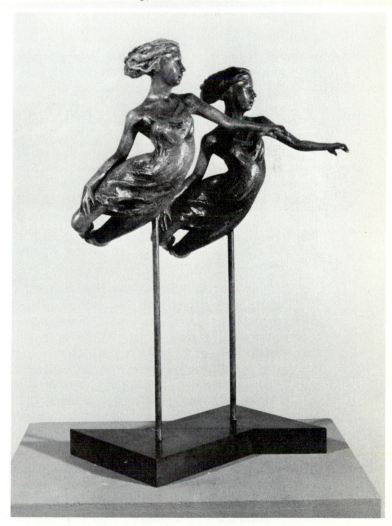

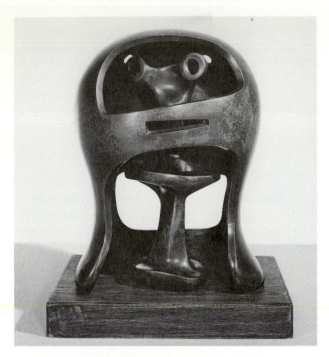

FIGURE 2-17 Henry Moore, Helmet Head No. 2. 1950, bronze.

standing-reclining. But these same ideas can be applied to abstract forms as well. The *Helmet Head* series by Henry Moore uses this idea particularly effectively (Figure 2-17). In this case the two themes are the outer protecting form and the inner protected one. Notice how this piece differs in character from a somewhat similar theme in his *Reclining Mother and Child* (Figure 1-2). In both sculptures the outer form seems to protect the inner, but in the *Helmet Head*, it is the inner form that seems to possess consciousness, just as the head inside a helmet does the thinking. The themes of strength and weakness are offset by counterthemes of awareness and blindness.

Rondo

In a *rondo* a tune is followed by a variation on it. Then the original is played again, followed by another variation, and so on. The original theme always returns between variations. A rondo is not too different from a song with different verses and a repeated chorus sung between verses. Imagine a sculpture composed of several parts, in which a repetition of one part occurs between each of the others. These repetitions serve as landmarks, anchoring the multiple parts to an easily understood logic and giving order to the work.

Meter and Rhyme

Much poetry depends on *meter* (rhythm) and *rhyme* for effect. These two elements are effective in sculpture as well. Rhythm can be implied by regular spacing of

elements. The lines of the folds on the carving of *The Madonna* by the Yugoslavian sculptor Mestrovic are a good example of even and regular rhythm in a sculpture (Figure 2-18). An even rhythm, when interrupted, can become more interesting. Rhyme, of course, is implied in any kind of pairing or grouping. When a form reappears in a work, we immediately connect it with its pair. Another work by Mestrovic, a relief sculpture (Figure 2-19), uses similar figures that appear slightly overlapped, in echelon, giving the effect of a repeated rhyme. These multiple rhymes also become very rhythmic. All such mental connections are a form of organization, evidence of the intelligence and order behind the work, and as such reveal the mind of the artist, which is the idea, after all.

Other Poetic Forms

The villanelle, the sestina, the sonnet, and many other poetic forms are simply ways to organize material. Humans respond to logic and regularity. In fact, one aspect of art is that it applies a kind of order to the random visual world. Any time you can bring an underpinning of logic and order to your work you strengthen it. Logic and order can stand on their own or can gain

FIGURE 2-18 Ivan Mestrovic, The Ashbaugh Madonna. 1917, French walnut. Collection of the Snite Museum of Art, Notre Dame, Indiana.

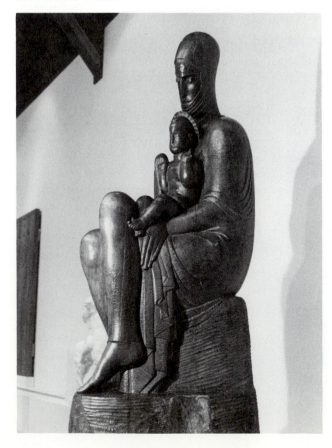

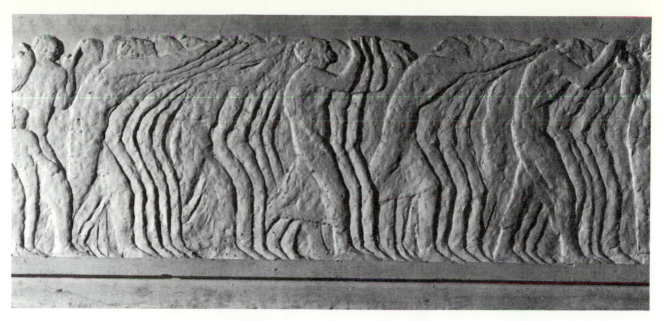

FIGURE 2-19 Ivan Mestrovic, Study for the Jewish Memorial. Plaster.
Collection of the Snite Museum of Art, Notre Dame, Indiana.

additional interest and meaning through being violated and broken.

An artist gains ideas from many sources. I suggest you look at the various forms used by poets to see if they suggest some ideas you can use in your sculpture. And go beyond poetry and music. Try to sense order and logic behind all things, from architecture to flowers, from the grouping of people at a cocktail party to the way water flows over rocks. Make notes of what you see so you can select and apply these ideas when you have need of them.

Narrative, Logical Form

One of the most obvious ways to apply order to a complex series of events or images is to use them as *narrative*. By narrative, I mean storytelling. There has been a strong reaction against narrative as a part of art in the twentieth century, primarily because it became such an important part of art in much of the nineteenth century. The Pre-Raphaelite painters, for example, seemed to begin their artistic concepts not by looking at the world around them, but in the library, finding a suitable passage from the Bible, literature, or mythology to illustrate. It was the Impressionists who first rejected this idea and painted something completely visual, without any literary qualities at all, namely, the effects of light on nature.

Much of the art of this century has preached against any intrusion of literature or storytelling into what is believed to be a purely visual arena, but I argue against that position. I maintain that art is big enough to include much more than a single visual point of view. Further-

more, if we were to remove from our museums all works with a literary basis, we would have nearly empty museums. If a literary basis was good enough for Michelangelo (the whole Sistine Ceiling, for example) it's good enough for me!

We find narrative elements sneaking into some of the most unexpected corners of twentieth century art. Narrative can provide a structure to seemingly scattered elements, much as a musical or poetic form can. For example, the abstract sculptor David Smith used narrative in his piece *Hudson River Landscape* (Figure 2-20), which he described as a record of the sights he saw on his weekly train journey along the Hudson from New York to his upriver home. The visual ideas are arranged in sequence (we assume in the order in which he passed them on the train, though not necessarily) like beads on a string, and this sequence organizes the piece.

This same concept can be applied in many other ways. We may view life as a series of stories that can be told with beginning, middle, and end. Each day is a small story (not always very interesting, I'll admit), and such things as vacations and trips, difficulties with a car, or getting or losing a job all become stories in the longer and more complex story of our lives. We also hear countless stories about other people, about relatives, friends, a guy your cousin once knew, the sister of someone at work, celebrities, and on and on.

Though most of the stories we tell and hear may be mundane or trivial, some stories are of deep importance, for example, Bible stories, stories of the history of this country, myths, fables, or heroic tales. These are almost invariably stories we only hear, never live, but

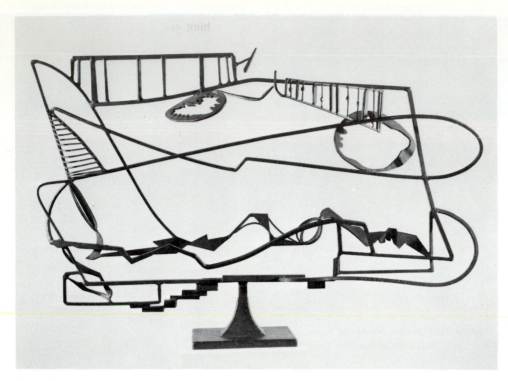

FIGURE 2-20 David Smith, Hudson River Landscape. 1951, steel.
Collection of the Whitney Museum of American Art, New York.

FIGURE 2-21 Tuck Langland, The Shower. 1981, bronze. Collection of the
artist.

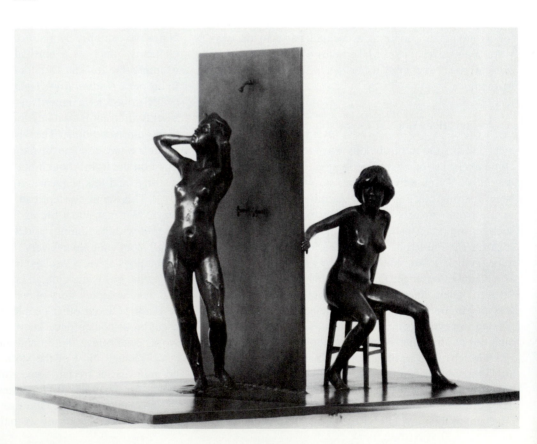

they are a common property of our society. We all know, for example, the story of George Washington and the cherry tree; we understand its significance as part of our American heritage. Other stories, such as Bible stories, the Trojan War stories, and many others are common to most societies in Europe and this country. The reason many of these stories have been told for centuries is because they have deeper meanings which reveal truths about humanity. These truths are possible material for artists, if we can get past superficial illustration of actions and grapple with the message behind events.

Some more recent stories are becoming mythic in our society. We are even collecting a certain number of relics, similar to the ancient relics of the Christian Church. The assassination of President Kennedy (where *is* the bullet that killed him?) or the adventure of exploring space are becoming the epics of our day. Many of the relics of these tales are enshrined in reliquaries such as the Smithsonian Museum. Believing as I do that nothing is outside consideration as material for an artist, there may well be material in these modern-day tales for the sculptor.

A narrative has a beginning, middle, climax, and conclusion. This pattern can be applied to sculpture, but with care. Difficult artistic decisions about what to include and what to leave out can often be made on the basis of narrative. The sense of a story behind the work can determine a thousand decisions, lending unity to the piece. My sculpture *The Shower* (Figure 2-21) is an example of narrative sculpture. In this case, I'm not sure of what the story is or what is happening. It is as though I dreamed a story, rather than made it up, and the sculpture is a way to let others look at the story I dreamed. But the common thread between the figures on either side of the wall and the added element of the towel in the process of falling are all tied together by the feeling of anxiety on the face of the seated figure, and her secret look at the figure showering.

Think about stories you know, or sense, or just make up, and see if there isn't a way they can be told, implied, or hinted at with sculpture.

Intuitive Form

By *intuitive form* I mean form, order, organization, or arrangement that just "feels right" to you. If you are setting the table for a special dinner, you will arrange things a certain way—usually not from a given set of rules, but just because some arrangements feel right. It is this kind of intuition that is probably the major impetus behind most works of art, and it is in this area that the fundamental idea of art as communication comes most alive.

But, like anything else, intuitive form is not as simple as it seems. Each of us operates with a different kind of intuition. Each of us, given a blank paper and several colored paper shapes to arrange in a pleasing way, will arrange them differently. And each of us, given many such opportunities for free arrangement, will begin to arrange things in characteristic patterns. Such concepts as bold and dramatic, symmetrical, loosely scattered, or unbalanced and unsettled will emerge for each of us. It is this consistency of intuition that reveals something about us. There is no right and wrong here, any more than one person's fingerprints are more right or wrong than another's. We are individuals, and one way to tap our individuality is through the free play of intuitive arrangement of forms.

As you create art over a period of years, you will slowly assemble a large number of pieces in the puzzle that is you. One of the most exciting aspects of making art is the chance to look back at your collected works and see someone emerge—someone you might not have realized was in there. Whoever is deep inside you has a chance to peep out through the medium of art—if you create art honestly, letting your own mind direct you, and don't get suckered into cranking out the current page of the book of fashion in art.

Intuition is probably the most important structural device of all, and also the most elusive. It takes a long time and, paradoxically, lots of discipline before you can liberate your own intuitions, just as pianists have to practice boring scales and runs and chords for years to gain the freedom to improvise the personal music inside their heads. But it is expressing those personal ideas and letting the world see them that is at the root of art.

FROM THEORY TO REALITY

So far we have been talking ideas, but sculpture is things. The next chapter will discuss a variety of materials, some of their characteristics and qualities, and a little about how to select materials. After that, this book will get specific about each material and deal with actually making things.

My suggestion is that as you progress into actually making sculptures, you browse through these early chapters occasionally to refresh your mind about the mental part of the process. Try not to let yourself get too bogged down in purely mechanical processes, but keep the mental flexibility there by thinking about what you're making, and running through some of these variations and manipulations in your own head. After all, inside your brain is where the bulk of the important work really takes place.

THREE

The Materials of Sculpture

This chapter is a general look at the many materials available to the sculptor, as an introduction to the remainder of this book, which deals specifically with each type of material.

TRADITIONAL MATERIALS

As mentioned previously, sculpture of the past generally was made of one of two materials—stone or bronze. These two materials represent the two essential ways of making sculpture: that of *carving* (subtraction) in the case of stone, and of *modeling* (addition) in the case of bronze. At least this has been the prevailing view of sculpture history. It is not quite true, however, and the many materials the present-day sculptor can use, as well as the many ways of approaching those materials, are not as foreign to sculptors of the past as we might think.

Stone and Wood

First, let us deal with the oldest, and thus most obvious, materials. Without venturing too much into speculative quasi-historical daydreams, it does seem likely that early humans noticed rocks and stones that resembled animals or humans and altered them a little to increase the resemblance. With greater resemblance, the rocks probably had greater magic in the minds of their owners. Since early humans were used to working stone to make tools, this would occur very naturally. When dealt with this way, stone becomes the perfect *subtractive* medium. The unwanted matter is carved or rubbed or fractured away. This process limits the final sculpture. The final sculpture must fit within the existing piece of stone. If you could order a quarry to free any size block from a mountain, this restriction would not apply, but in many cases the sculptor begins with an existing block and proceeds from there.

A good example is Michelangelo's *David* (Figure 3-1). This huge piece of stone already had a name—''Il Gigante,'' the giant. It took over a year to wrestle the massive, nearly fourteen-foot-high block of Carrara marble down from the mountains. (I imagine the workers had one or two other names for it by the time they were finished!) Another sculptor had begun to carve a figure from the block but abandoned the job, leaving the block standing idle in Florence with great chunks removed from it. The young Michelangelo, only twenty-five at that time, examined the stone and declared he could carve a ''David'' from it, but the city fathers objected since much of the stone was missing. They said he would have to make his figure considerably smaller than the full stone. But Michelangelo insisted he could fit his figure into the entire block, and it is said that he left a small circle of stone the size of a quarter on the very top of the head, untouched and still bearing the outer surface of the quarried marble, to prove he had kept his promise.

Henry Moore liked to create growing, swelling forms that look as if they are pressing out from within. He was fond of saying that he liked to carve sculptures that looked bigger than the original stone.

But regardless of Moore's statement, carved sculpture cannot be bigger than the block from which it is carved. Or can it? Actually, a great many carved sculptures end up bigger than the original block by the addition of parts. This Greek *Kore* (Figure 3-2) shows broken sockets at the elbows where additional pieces of stone had been added to form arms holding offerings. Other stone sculptures have been carved with various extensions added on, to eliminate the need for great big stones with massive amounts carved away.

Much architecture can be viewed as stone sculpture, but conceived as a series of small carvings joined into a larger conception. The great Gothic cathedrals (Figure 3-3) used stone in the most daring ways, launched

20

FIGURE 3-1 **Michelangelo, David.** 1501–04, marble. Academia di Belli Arti, Florence; Alinari, Art Resource.

FIGURE 3-2 **Kore of the Dorian Peplos.** Archaic Greek, 6th Century B.C. Acropolis Museum, Athens; courtesy of the Metropolitan Musuem of Art.

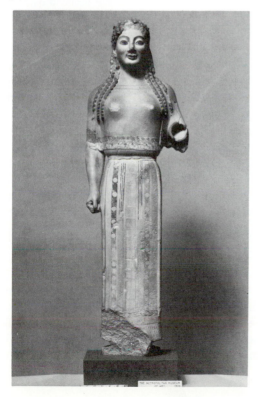

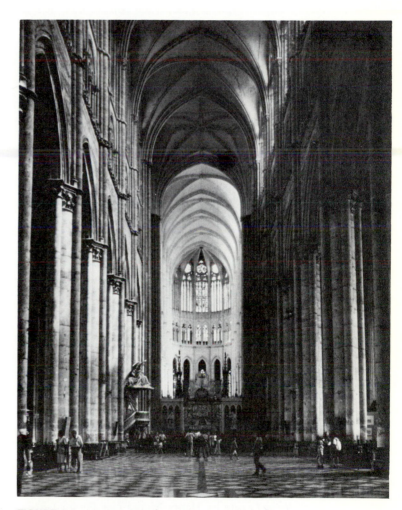

FIGURE 3-3 Interior of the Nave of Amiens Cathedral, France. Begun 1220. Photo by the author.

high on slender columns, supported by lacelike webs of buttressing, all staying in place over the centuries by careful alignment to resist the forces of wind and gravity. These works of hollow abstract sculpture use stone quite differently from the usual subtractive process, and the principles and practices of the Gothic builders might float around in the back of your head when you consider stone as a material.

Wood is another subtractive material; most wood sculptures are carved from a large piece. The final form of the sculpture must reside within the piece chosen and be freed from it by removing excess, but again, there is the possibility of adding, and thus constructing a sculpture. Furniture is, of course, wood construction, as is a house, so wood, like stone, is a material of both subtraction and construction.

Another important aspect of wood as a material is that we usually buy it as lumber, which is a form already "carved" from the natural state, a form which is geometric, usually a solid rectangle such as a beam, a two-by-four, or even a sheet of plywood. As such it has already undergone a profound change from its natural tree-state, and has become a man-made (or artificially shaped) material. Wood as a carving medium, however, is usually in its natural state; for example, a section of a tree trunk in which the cylinder becomes the dominant form.

Truth to Materials

With these natural materials (called "natural" since they come directly from nature, whatever that is) we can raise the question of *truth to materials*. This phrase was a great rallying cry in England during the 1930s on through much of the 1960s, and was actually a reaction against many of the sculptural practices in Europe from the Baroque through the nineteenth century, and urged a closer look at "primitive" sculpture.

What was meant by "truth to materials" was that the final sculpture should have a quality consistent with the material from which it was made. Thus, stone sculpture should have the dense, solid compactness of stone, with a feeling of weight; wood sculpture should reflect the strength, fibrousness, and cylindrical quality of a tree. *Recumbent Figure* by Henry Moore (see Figure 1-8) in the Tate Gallery, London, not only looks like stone, but even looks like it has been carved the way nature carves, by erosion, as though it was lying in the bed of a fast-flowing stream. In contrast, the famous piece by Bernini, *The Ecstasy of St. Theresa* (Figure 3-4), though carved of marble, which is a heavy, dense stone, is made to resemble only soft, fluttery, light materials such as flesh, hair, feathers, cloth, fire, and even clouds!

The way these two sculptures were made differs completely. Bernini began by modeling the work. Then, a stone was cut specially from the quarry to fit his conception, and workers began the laborious task of transferring the model to the stone by means of *pointing*—establishing a vast number of points in the stone through a three-dimensional, graphlike machine—and carving away the material between the points.

Moore, on the other hand, began with a stone he found or bought. He wrestled with the stone himself, levering it up onto a carving stand, feeling its weight and mass, running his hands all over its contours. He let the stone begin to tell him what it would be. Then, by carving directly into the stone with little or no previous model, he let the sculpture evolve as a fusion of his will and that of the material.

I make no judgment here. I am only stating that these are two poles of thought about dealing with stone—or any material, for that matter. The idea of truth to materials raises the issue of ethics and honesty, implying that Moore's method is more "honest" in its dealing with the stone than Bernini's. We can now understand, from our late-twentieth-century vantage point, that this is, in fact, a late-nineteenth-century idea, which arose with the Gothic Revival and the Arts and Crafts Movement. Like so many ideas we imagine to be eternally true, it has a definite origin at a particular place and time and is subject to change by later generations.

I believe one should react to such ideas and their opposites much as one selects tools. Pick up those that suit what you are doing and leave alone those that do not. Dogmatism in art is deadly, and the attempt to apply a particular set of ideas to all cases is doomed to narrowness, followed by revolt. Unfortunately, the history of art is full of cases where people believed that a particular set of ideas was to be universally applied. Inevitably, the ideas were rejected and replaced by a different set. Though I know this process will never end, I at least urge those who read this book and ponder it to try to avoid dogmatic statements, to avoid believing that their ideas can and should be applied to all cases, and to remain open to seeing another person's work for what it is—a communication from another mind and intelligence, however different that mind may be from their own.

Clay

Since we have found that stone and wood can be both subtractive and constructive materials, let us examine clay, traditionally thought of only as an additive material. Clay is perhaps the most primary of all modeling materials (see Chapter 4), and it is most often used

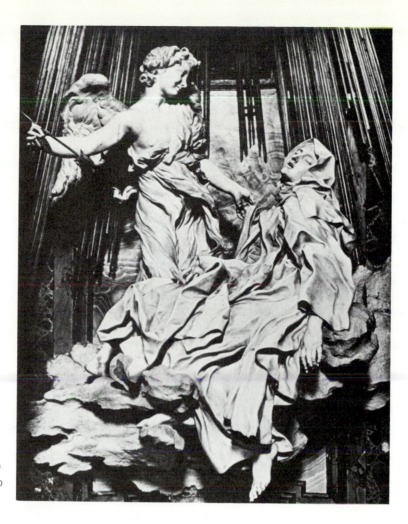

FIGURE 3-4 Bernini, The Ecstasy of St. Theresa. 1645–52, marble. Cornaro Chapel, Sta. Maria della Vittoria, Rome.

soft, added lump by lump and pressed together, usually over some kind of support or armature. Then it is usually either fired to make it hard, or cast with a mold into some other permanent material. We will look in some detail at this process later, since it is central to sculpture as we know it, but first I want to insist that clay be viewed more broadly.

Years ago I made several sculptures by allowing rectangular blocks of clay to dry completely and then carving them. The clay sculptures were primarily studies for carved works, but clay carves quite well. Carving is a way of making form with clay that is well suited to the qualities of the medium.

When my oldest daughter was about five years old, she came into my studio while I worked and, naturally, asked for a lump of clay to play with. I noticed that she rolled out long snakes of clay, then curved two of these into rings. With two uprights of clay snakes, she positioned one ring horizontally above the other. I asked her what she was making (most kids make mud pies), and she replied, ''Orange juice.'' She had made a transparent

drinking glass of heavy, wet clay, something I would never have thought to do. She used clay as a material of construction. Sure, it fell apart—but she had an unfettered approach to the material, and needed only a slightly more sophisticated technique to be successful.

Clay is well suited for monolithic sculpture that emphasizes a constantly shifting, modulated surface. The human figure is such a form, and clay is the ideal material for sculpturing it. Clay is also very adaptable for abstract sculpture, but it is usually best in a monolithic or nearly monolithic form. While it is possible to make ''orange juice'' out of clay, the use of wire, wood, or even wax makes the job a lot easier.

Clay has another quality that most other materials do not have, and that is the ability to record the slightest movements of the hand. Just as Japanese and Chinese brush painting is, on one level, a method of recording the most subtle movements of the painter's arm and hand, so clay can record the softest touch, the most rapid gouge. Neither stone, nor wood, nor metal, nor plastic can record the personal touch of the artist like clay, and so clay is

probably the most personal of all materials. It lends itself well to rapid, dexterous work, preserving the fingerprints of the artist. It can be made to behave like machined steel, but only with difficulty, and never as perfectly as actual machined steel. So clay is the material of choice for those whose expression needs that intimate personal record of touch.

Transforming Clay

Clay can be fired, which gives it certain qualities, usually changing its color and surface feel. It stops looking wet and becomes very hard. Often glazes are applied to make it shiny or crackled, or to create any of a thousand other surfaces. Also, the color can be changed from a close neighbor of the original clay to any pattern or hue. We will deal with color later on, but to understand its power, imagine a simple portrait head made of plaster, gleaming white. Now imagine the same thing painted bright red, and again, painted zebra stripes. Color or pattern can dominate form with alarming ease and must be carefully considered.

The other thing that can be done with soft clay is to cast it into another material. This enables you to combine the characteristics of two materials in one object. Clay can be mushed and smeared, then cast faithfully into bronze; the result is hard, unyielding bronze that appears to have surrendered before the feverish fingers of the artist. The material into which clay is cast can change the feel of the sculpture completely. Imagine how different a clay form would look if it were cast into polished bronze, or matte white plaster, or gray grainy cement, or metal-flake painted fiberglass. When working with clay, in general you are working with only half the problem. The final outcome of the sculpture, the visual and emotional effect it will have on the viewer, has yet to be fully determined, depending on the material with which it is made permanent.

Other Modeling Materials

There are other materials that can be modeled. Wax works very much like clay, but has quite a different surface feel. It can also be cut into sheets or rods and constructed. These sheets, strips, and rods can be formed and pressed together with the fingers into a sculpture, and since bronze casting is usually *lost wax* casting, it is very easy to turn these direct wax sculptures into bronze.

Another modeling material that combines modeling and carving is *direct plaster*. When plaster is mixed correctly, it has the consistency of butter and can be applied like soft clay with tools to a form. It can be pushed, slid, and modeled for a while before it turns hard, and then it can be carved, almost like stone or wood. Many contemporary sculptors have made their sculptures in plaster, which was then cast into bronze (see Chapter 11).

There are other modeling materials as well, such as various plastic compounds or cement. Body putty, used to repair the rusted-out parts of cars, can be applied when soft, then carved, filed, and sanded when hard. Numerous other products, some specifically designed for sculpture, also work this way.

MODERN MATERIALS

And then there are the modern materials. In the early years of the century Picasso began working with cut-out tin, wire, and even found objects. These works opened up virtually any material to the sculptor, so that today we do not feel anything is excluded. A case can be made for using ephemeral, or nonpermanent, materials such as ice or food.

Metal and wood are most often used as construction materials. Metal usually comes as a manufactured product—such as rod, bar, sheet, or angle iron—or post-manufactured products, such as junk. We don't think of steel as great lumps, but as something already manufactured of steel. There are really only three things you can do with such metal: cut it, bend it, or join it. (You can also melt it, but that turns it into something else.) These three processes are without limit, however, in terms of the variety of form and expression possible. The same is true of wood, plastic, glass, or any of the other materials which can be adapted to sculptural purposes.

In general, the traditional materials of carved stone or wood and modeled clay or plaster are best suited to solid, closed forms. More recently adopted materials, such as steel, lumber, wire, and the like seem more suited to open, cagelike forms. A great and profound change in sculpture occurred in this century with the opening of form into space. It coincides exactly with the adoption by sculptors of modern materials.

When we add the concept of *found objects*—materials that already have a high level of identity—we have an unending palette from which to choose. Found objects can parade their former identity or conceal it. They may provide the sculptor with shapes that are extremely difficult to make or that come from outside the sculptor's own range of form ideas. Found objects are often the byproducts of industry, and they may contain such qualities as many identical forms, or forms with extremely even and precise parts, such as gears. The materials, colors, and textures of these cast-offs of modern society vary widely. And of course, found objects can be altered further, as well as joined with ''raw'' or more traditional, sculptural materials. To many sculptors, a scrapyard is a wonderful place, and a walk through a rich one is a pleasurable experience filled with discovery and potential.

EFFECTS OF CHOICE OF MATERIAL

The purpose of this chapter is to look at how materials affect the sculpture made from them. A form made of clay has a different feeling or mood from the same form made of chickenwire. Also, building a sculpture of a tree-like form with many branching forms would be easier and have a higher chance of success if it was made of a strong material like metal rather than of a malleable material like clay. Conversely, it is much easier to make a portrait head out of clay than out of welded steel. The appropriate material ''gets out of the way'' more readily, allowing the ideas to come through. So, selection of material depends on two factors—the intended feeling or idea, and the material best suited physically to the final form.

To explore how the material affects the feeling of a piece, look at this work by Claes Oldenburg in Figure 3-5. His intent is to recreate a familiar object, a toilet, in a material that is very different from the original. The vinyl Oldenburg uses is soft and floppy; it denies the rigid hardness of the toilet and lends a sense of play and wonder to the sculpture.

Similarly, look at these two portraits by Gaston Lachaise. The head of Edgard Varèse (Figure 3-6), modeled in clay, is spontaneous, rich, and energetic. The marble head of Antoinette Kraushaar (Figure 3-7), in

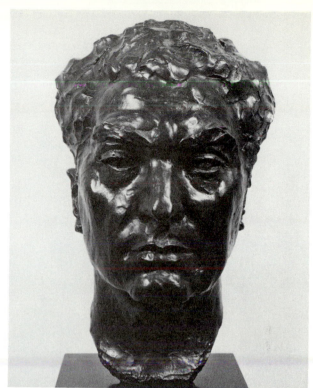

FIGURE 3-6 Gaston Lachaise, Edgard Varèse. 1928, bronze. Collection of the Lachaise Foundation.

FIGURE 3-5 Claes Oldenburg, Soft Toilet. 1966, vinyl, kapok, etc. Whitney Museum of American Art, New York.

FIGURE 3-7 Gaston Lachaise, Antoinette Kraushaar. 1923, marble. Collection of Antoinette Kraushaar.

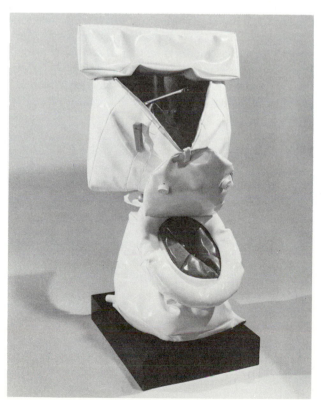

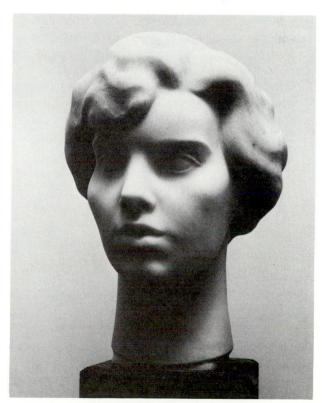

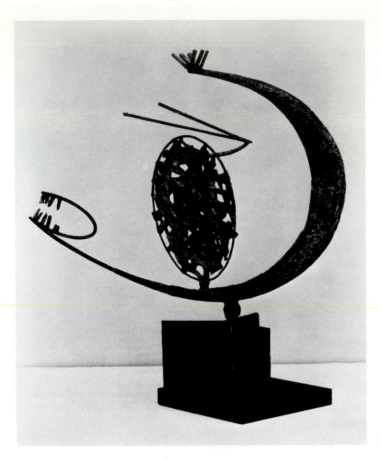

FIGURE 3-8 Julio Gonzalez, Head.
1935?, wrought iron. The Museum of
Modern Art.

contrast, is formal and still. Again, I make no value judgment here, but only wish to point out that similar endeavors end up with different results when different materials are used. And to see how profoundly the use of modern materials by sculptors of this century has changed things, study this ''head'' by the Spanish sculptor Julio Gonzales (Figure 3-8), who was a pioneer in working with steel construction.

From now on we will stop talking in generalities, and get specific. The next four chapters will deal with clay and making clay permanent. It takes four chapters because clay and casting is perhaps the most complex, yet also the most varied and free, of all sculptural media. Following that, we will look at stone and wood, in both traditional and nontraditional ways, then metal, plastics, and other delights.

FOUR

Clay

Deep in the cave at Tuc d'Audubert in the Pyrenees of southern France, is a sculpture (Figure 4-1) of two bison, made from the natural clay found on the spot. Dating from prehistoric times, perhaps contemporary with the paintings at Lascaux and other great caves, this is one of the earliest sculptures known, and one of the very rare surviving prehistoric sculptures made of clay. Since clay must be fired to become permanent, we suspect that many sculptures like this one had been made, but were left to the elements and quickly washed away. This one, deep in the cave, survived because it was undisturbed.

One of the fascinating things about this sculpture is the way the material has been handled, with bare hands kneading, patting, and smearing the soft material. It seems such an obvious thing to do, to find soft clay, and push it about until it begins to resemble something important to the maker. Clay, then, is among the very earliest materials people used to make sculpture, and it remains the material which gives the greatest flexibility of form.

This chapter will deal with clay as a material, and how to use it to make sculptural forms. Later chapters will deal with how to make it permanent after the modeling is done.

Kinds of Clay

Clay comes in a bewildering variety, and yet all clay has some common qualities. Clay is a natural material, of course, and is found on every part of the earth.

FIGURE 4-1 Two Bison. Prehistoric, unfired clay. Cave of Tuc d'Audubert, France.

Geologically, clay results from the slow breaking down of granite, one of the major items of which the earth itself is made. When granite is broken down, it forms several substances, and clay usually becomes separated from the others by the action of wind and water, resulting in deposits which can be mined.

Clay is usually of two sorts: *primary clay*, which is relatively pure, and thus white; and *secondary clay*, which has become mixed through the action of nature and time with other minerals, and thus usually contains coloring agents, most often iron oxide. Porcelain and china clay are of the first sort, and are prized for their pure white color when fired. Most clay, however, is of the second sort, and is what we think of as *pottery* clay, or *terra cotta*.

The Chemistry of Clay

All clay is composed of molecules of hydrogen, oxygen, aluminum, and silicon. These four elements form three compounds: aluminum oxide, silicon oxide, and water (hydrogen oxide). The aluminum and silicon oxides form crystals which are flat and hexagonal in shape; they can slide over each other freely when lubricated with water. This *water of plasticity* must be present for the sliding to occur, and when it is absent, the clay becomes rigid. Everyone knows that dry clay gets hard. It is the absence of the water of plasticity as a lubricating agent between the flat crystals that is the cause.

It is possible to replace the water of plasticity with another lubricant, namely oil, to make *plasticene* or *plastilene*, a material I will discuss later.

One of the important facts about clay is that because it is composed of molecules which are already well bonded to oxygen atoms, it will not accept any more oxygen atoms, even at high temperatures. That is, it is very stable and resists melting, oxidation, or decay. In short, clay, once fired, is just about the most permanent material known. When you make a sculpture out of clay and harden it in the kiln, it will exist about as long as the earth, unless you smash it to bits. (And if you do smash it, the bits will last.)

USING CLAY

How Clay Is Bought

Clay in the earth is a very different thing from clay that you buy. When found naturally, clay is usually of the secondary variety, that is, it contains a number of elements and compounds that are not clay, but have become mixed with the clay through natural action. Clay merchants begin by mining a rich clay deposit. This material is then dried and pulverized. Sifting removes gross impurities, such as sticks, rocks, and bits of glass or metal. Then the clay can be analyzed to determine its chemical content. Sometimes unwanted substances can be removed by air floating or mixing with water and floating them off. Other times they are reduced in percentage by the addition of purer clays from other sites. When the dry clay is the desired purity and mixture, it is either bagged as dry powder, or mixed with water, *pugged* (stirred and kneaded by machine) and bagged. It can be bought in either form.

Mixing Dry Clay

Usually, it's easiest to buy clay in the wet (mixed) form, since turning dry clay into workable moist clay is a big job. If you do buy dry clay and want to make moist clay out of it, here is the basic technique: Mix the dry clay with water in metal or plastic garbage cans. It should mix readily into a cream-like liquid. This is called *slip*. Stir thoroughly, then allow it to stand for several days to settle. You should get a thick sludge on the bottom, with a clear liquid above. Siphon off as much clear liquid (water) as you can, then turn the sludge out onto a drying surface. Usually this drying surface is made of large flat tubs of well-dried plaster, called *drying bats*. You make these by casting large plaster forms over shallow raised mounds, such as wood forms, well greased (Figure 4-2). The thicker the sections of plaster the better, since their job is to draw moisture from the wet clay. Make them well ahead of time and allow them to dry thoroughly, then dump the clay sludge into them, and keep turning it until it dries evenly. Dry powdered clay can be sprinkled on wet areas to speed drying.

As the clay approaches a workable state, kneading can begin, with wet areas placed against the plaster to speed drying. Particularly dry areas can be covered with pieces of plastic to slow drying.

Another drying surface that can be used, though it is slower and messier, is a large concrete floor. Sweep it carefully first, then spread the clay sludge all over it in a thin layer. Keep turning the clay over as it begins to dry, to get wet stuff next to fresh floor. You won't get nice even clay this way, but you will get clay which can be cut, wedged, and kneaded until it is pretty good.

If you have a pug mill, the whole job is easier. Make the slip and let it settle to sludge as just described. Then begin running it through the mill, adding dry clay as needed until you arrive at the desired consistency. You will probably have to run the whole supply through more than once, adjusting the moisture content with dry clay or added water.

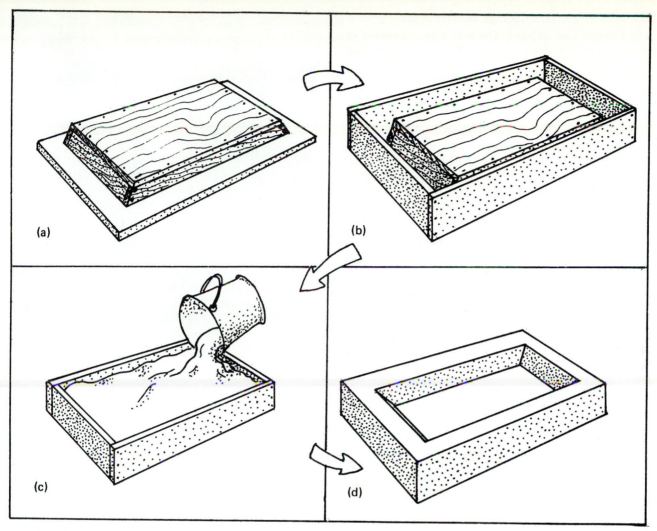

FIGURE 4-2 Making clay drying bats: (a) making the form; (b) the form complete; (c) pouring plaster; (d) the completed bat.

Wet Clay

Obviously, it's easier to buy clay ready made, moist, smooth, and all packaged in plastic bags. But which kind? First, what you buy depends on what you're going to do with it. If you're going to fire it and make it permanent that way, you want to consider both the temperature recommended for firing, and how that relates to the kilns you have available. You must also consider the final color the clay gives. Put simply, you have the choice of low fire and high fire clay. You also have the choice of clay which does or does not respond to *reduction*, which is a change of color from firing in a reduced oxygen atmosphere. While it is not the aim of this book to get involved in the pottery side of clay, it is highly recommended that pottery books be consulted if this is the chosen method of making clay sculpture permanent.

If the clay is going to be used for modeling and then made permanent by casting, which is more usual for sculptors, then the firing characteristics are not important. What does matter is the color of the clay as something to look at, and the workability and plasticity of the clay. Most moist clay is either gray or red. Years ago, when faced with the agonizing decision of which of the two colors to buy, I decided to mix the two, and this has become my favorite modeling clay. My formula is this: half red and half gray clay, plus about 10 percent Bentonite to increase stickiness. About one quarter of the water added should be vinegar.

Clay, as mentioned, is plates sliding about on water. But it is also full of bacteria and bacteria waste, which makes it more slippery. *Plasticity* is the word potters apply to good, sticky, slippery clay, as opposed to *short* clay, which is like a short pie crust, and breaks and

crumbles easily. To encourage bacteria to grow in your clay, add vinegar as food. The best way to get clay to become nice and plastic is time. Old clay is better than new clay.

Maintaining Clay

Storage. Clay is full of water, and water evaporates, so it is an eternal battle to keep clay moist and in good condition. Here's my system: I use several metal garbage cans. It's a good idea to paint the insides of the cans first with a good antirust aluminum paint. Some sculptors use plastic garbage cans, which are fine, except they tear or split more easily. Others use sheet-metal-lined wooden bins, which work well, but have less flexibility in terms of moving them to the work or turning them over to dump clay. Also, cans are easy to replace if they rust or leak.

Moist clay goes in garbage cans or bins, as many as needed. When you work with the clay, you dig it out and use it. Any hard bits go in another barrel. Whenever a piece is cast, the clay taken from the mold will be *hard clay* and can also go in that barrel.

Rewetting dry clay. After a while you will be up to your eyeballs in hard clay, and you will need to rework it. If you have access to a pottery department with a big pug mill you are in luck. Let the hard clay dry out on the floor, then break it up with a hammer and add it to water to make a slip, as described for making new clay. Then pug, adding new dry clay until the right consistency.

If you don't have a pug mill, but just a room in which to work, here's how to make dry clay moist again: Dump the hard clay out on a well-swept concrete floor, and go around with a hammer breaking up the big lumps (Figure 4-3). Then wet the whole pile thoroughly with a hose or buckets (Figure 4-4). Take a sidewalk scraper and start chopping the clay up into thin slices (Figure 4-5) until you feel it is well cut up and wet everywhere. Then cover it with a plastic dropcloth and leave it for a day or two. Repeat the chopping and wetting once or twice more, letting it stand in between.

Then, turn the whole pile over by picking up chunks on the scraper and slamming them down hard on a clean part of the floor. It is the slamming that forces the clay together into a mass. Finally, cut it up and slam it down, chunk by chunk, into a garbage can or storage bin, chopping around in the bin every few slams. Be careful not to poke the corner of the scraper through the side of the can.

When that's done, cover the clay with a damp cloth and a sheet of plastic, put the lid on tight, and you have a can of good clay.

FIGURE 4-3 Breaking up dry clay with a sledge hammer before wetting.

FIGURE 4-4 Wetting broken-up dry clay.

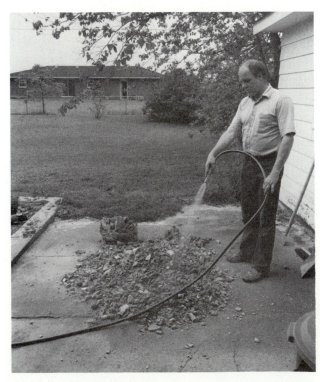

FIGURE 4-5 Chopping up old clay.

Keeping clay damp. Keep prepared clay at a good consistency with damp rags, sheets of plastic, and a tightly closed lid. Don't attempt to wet a can of dry clay by pouring water into it; it will seep straight to the bottom and form sludge. Use damp rags—they work much better.

You must remember two things about clay. Keep it soft, workable, and free of lumps, and keep plenty of it. You can't model sculpture with a few crumbs of dry stuff.

Cleaning clay. Another problem you encounter with clay is dirt and junk getting into it. Bits of plaster, nails, staples, pieces of wood, and all sorts of things can slowly collect in your clay supply, making it difficult to work with.

There are three ways to deal with this. The first is simply to keep junk from getting in there. When you drop a bit of clay, don't just pick it up and toss it in the barrel. Look at it and pull any junk out of it. When you make plaster molds, don't sling your clay back automatically, but inspect it and clean the plaster bits out of it. If a piece falls into the rubbish and is loaded with bits, throw it away—clay is cheap.

The second way to deal with junk in the clay is to clean it. This can be a big job, but if you want to try, here's how: Again, let it dry, break it up, and make slip. Using an electric drill or even a drill press with a shaft

and propeller helps to stir it. Once you have a good slip, strain it through a couple of sieves—coarse and fine. You'll be amazed at the amount of junk you have collected in your clay! Now, proceed as described before, either using a pug mill or drying bats.

The third way to deal with clay full of junk is to throw it away and buy new clay.

Oil-Based Clay

A lot of sculptors love *plasticene*, which is clay made with oil and wax instead of water. It can be made this way: Take a big metal tub and heat it over an old stove or a fire, melting together wax blocks (see Wax, Chapter 8) and cans of motor oil in equal amounts. When the oil and wax are melted, pour in regular dry powdered pottery clay and keep stirring. The result is a thick, yucky mess, but keep adding powdered clay until the mixture is as thick as possible, even though it won't seem much like clay. When you can't stir anymore, pour it out onto a cleaned concrete floor and spread it thin. It will cool and look more like clay, but very granular. To use the plasticene, take a chunk of it and knead it well, and lo and behold, you have plasticene!

A much better idea is to buy ready-made commercial plasticene. It comes in varying grades of hardness, but all plasticene grows softer as it gets warm, which usually means as you work it. Plasticene has a different feel from water clay—more greasy, more slippery, yet stiffer. If you like that feel, then by all means use it, but if you prefer the feel of water clay, then stick with that.

The advantage of plasticene is that it doesn't dry out. It is ideal for making either tiny things with thin parts, or sculptures that demand great detail and a long working time. But there is a compromise. You can make a sculpture of water clay and then, if there are thin projections (fingers, for example), you can make them of plasticene to prevent drying. Just be sure to separate the two materials later.

MODELING WITH CLAY

The most obvious thing to do with clay is to grab a handful of it and start mushing it around. This is a fine start, but it relates to real sculpture like banging your fists on the piano relates to real music. You can get a bit more sophisticated than that. The advantage of clay is that it is soft, easily formed, and can take on just about any shape or texture. The disadvantage is that, being soft, it does not support itself well, and it tends to collapse. Therefore, you must do careful planning for most of the shapes you will make.

Generally, there are two ways of making shapes with clay—making them support themselves and making them with some form of support. Let's consider the first way first.

Reliefs

The simplest way to make sculpture in clay, without any external support, is a *relief*, or flat sculpture. It is obvious that clay can be pressed out flat on a board or table, and then forms can be worked into its surface. No support is necessary, other than the board or table, so the whole operation is very simple. But even relief sculpture presents problems. In terms of the physical support of the clay itself, a relief is not simple. Spreading clay out on a board works well providing you work quickly and can finish the piece in one session. But if you want to work longer and leave the piece overnight, or even for a few days, the broad, flat form will dry quickly—even if covered with a plastic bag. Also, working a relief on a flat table is possible, but it is much better if it can be stood up, so you see it as a painter sees a painting, on an easel. And if you do that, the clay can fall off.

So, here are two ways to make clay reliefs. One way is to use a board with strips of wood around the edges, creating a shallow box at least an inch deep. Shellac the wood and let it dry before putting clay in. The shellac will serve as a moisture barrier and keep the clay from drying right through the wood. When the shellac is dry, clay can be pressed firmly into the box until it fills the box to the level of the edges. Scrape it flat with a long board and you can begin work. The box can be placed on an easel or propped upright on a modeling stand or table, without fear of the clay drying and sliding off. Since it is closed in a sealed box, it can be kept moist more easily than if it were just lying free. Even so, it will tend to dry out, so the box is best stored flat at night, with a damp rag laid over it, and well covered with a plastic bag.

Another, more elaborate but better way to make a relief in clay is to make the shallow box out of plaster. The plaster can then be kept damp, which keeps the clay damp. Of course, the whole affair must be wrapped in plastic at night.

Freestanding Sculptures without Armatures

Coil building. To make sculpture in the round, you must do something to make the clay stand up. A good method is *coil building*. This has long been applied to pots, but it can be applied to sculpture as well. Long snakes of clay are rolled out, then coiled around, building up on top of each other, and smoothed well together. The idea is that clay hardens as it dries, and the lower levels become stiffer as the work continues and they have to support more weight. This technique works well as long as you have planned your sculpture in advance, since it becomes increasingly difficult to make any changes as the work progresses. If you make a small solid model of the sculpture and work from that, you have a pretty good chance of success.

Slab building. Another way to build directly without support is with slabs. You might think this is suitable only for abstract, somewhat geometric things, or for architectonic forms—those that suggest buildings or dwellings—but read Bruno Lucchese's books on figure modeling with clay (see the Bibliography at the end of this book) to see what amazing things can be done with slabs.

Other methods. Clay can be pinched, and worked that way. Clay can be thrown on a wheel, if there is a pottery department handy, and thrown forms, or sections of thrown forms, can be used in combination with coiled, slab built, or pinched work. This piece by the American sculptor Ruben Nakian shows rolls, slabs, and chunks of clay, all worked without an armature (Figure 4-6). Though cast in bronze, you can sense the fresh clay.

Use of supports. Clay sculptures of surprising complexity can be made without internal armatures. For example, the modelers at the potteries in Stoke-on-Trent in England, at places like Royal Doulton or Wedgewood, make clay sculptures that will eventually be cast with the slip casting method (see Chapter 7), but that must be cut apart for the mold making. Thus they can have no wire or other support inside. While I'm not suggesting you make a rearing horse, this description of how the Stoke modelers make one out of just clay will demonstrate the principle of this kind of modeling. You can figure out from it how to make whatever you want.

To make a horse rearing on its two hind legs, the Stoke modelers start with a thick roll of clay roughly the size and shape of the body of the horse. Then they make a clay support on their modeling board, which holds the body at the right height and angle. This support is almost as big around as the horse's body. They then refine the shape of the body—which is held securely in position —until it has enough form to indicate where the legs will be attached (Figure 4-7). The back legs are rolls of clay bent into the right position and attached to both the body and also to the board. The front legs are also rolls bent correctly and attached to the body, but these are supported at the hoofs on mounds of clay. The neck and head may be strong enough to support themselves, but if not, the modelers make another clay support, or even a thin external wood support. They omit the tail at this point.

FIGURE 4-6 Reuben Nakian, Satyricon I. 1980, bronze. DiLaurenti Gallery, New York.

FIGURE 4-7 Modeling a rearing horse without armature. (Note the supports.)

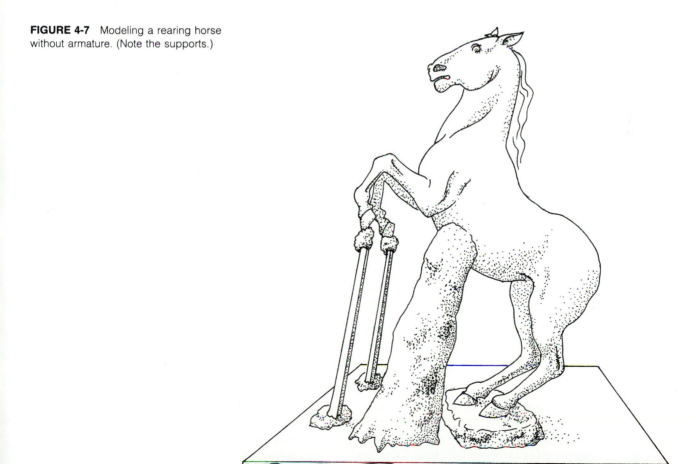

The clay is allowed to harden slightly, and then the actual modeling begins. Essentially, it is gentle carving with little hook tools (such as those described later in this chapter). Small pieces of clay may be added, but there is no large pushing around of forms—only gentle carving and occasional adding.

As the clay stiffens further, the surface is refined. By now, the little horse is quite stiff and solid, but it still has a large clay mass under its belly and smaller masses under its front hoofs. The tail is made about this time, separately, then stuck on, and supported if necessary.

As the modeling progresses, the point where the main support touches the body is slowly carved away, revealing more and more belly. Some, however, always touches.

When the modeling is done and the whole piece is leather-hard, it is cut into pieces—legs, head, tail, and body. At this point, all supports are cut away and discarded, and the areas they touched are refined. These separate pieces are then molded, cast separately in china clay, and stuck together while still soft before final retouching, drying, and firing.

The point of this description is that if you can make a rearing horse, you can make just about anything. This system of building with supports is worth consideration. Remember: use this book as a tool, not an order. There's no way I can anticipate what you will want to make, but if I describe many different processes, you will be able to apply them creatively to your own ideas.

Planning Ahead

When you are deciding how to use clay as a material, you must consider what method you will use, if any, to make the clay sculpture permanent. You may want to fire the clay. If you make a mold from the clay, however, you will have a great deal more freedom in the modeling. Chapter 5 discusses several ways of making clay hard and permanent without casting or molding, and it might be a good idea to study that chapter now, before trying these other ways of working clay. Chapter 6 discusses making molds from clay, and if that is your intent, the following techniques are the ones you will probably use.

ARMATURES

The Head Peg

Usually, clay sculptures are built on some kind of framework, called an *armature*. The armature may be simple or complex, one piece, or multi-part, planned in advance or improvised. But in general, this is true: as goes the armature, so goes the sculpture.

FIGURE 4-8 Head peg, complete. (Note the butterfly.)

Let's start with a simple example. If you want to model a human head (or any sculpture that is about that size and shape), you will use a *head peg* (Figure 4-8). This is a vertical post sticking straight up out of a board, with something on top for the clay to grab onto.

The base. Use ¾ plywood for the base board. Don't use solid wood if you can help it because it will warp too easily, and don't use particle board, except the very dense kind, because it is too soft. Hard particle board with formica on top, however, such as the cutout from a sink, is perfect. Cut a piece about 12 inches by 12 inches, depending on the size of your sculpture. Obviously you don't want a board so small that the sculpture will fall over, or so big that you can't reach the piece. Some sculptors like to nail a pair of cleats on the bottom of the board to making handling the sculpture a little easier.

The upright. The quickest, easiest, and strongest way to attach a vertical is to use pipe. Buy a 15 inch length of ¾ inch plumbing pipe (that's the inside diameter) from the hardware store and have one end threaded. You can often find a scrap piece that is just right. Now, buy a *flange* to fit. A pipe flange (Figure 4-8) is a flat, round thing that the pipe will thread into, and it has holes so it can be screwed to the board. Don't attach it to the board with wood screws, since they can pull out. Use ¼ inch by 20 (that's the thread size) by 1¼ inch (that's the

length) flat-head stove bolts, with washers and nuts. You might have to run a ¼ inch drill through the holes in the flange, since flange holes are often a bit undersize. Then place the flange on the board, mark the holes, and drill the board. Turn the board over and countersink the holes so the flat heads of the bolts will not protrude. Now, with the bolts coming up from the bottom, you can attach the flange securely. Then screw the pipe tightly into the flange. It's quick, simple, and very strong.

The top. You will need something on the top of the pipe to hold the clay, since it cannot stick to just a pipe. Before describing the top loops you will make, we must discuss *armature wire.*

Armature wire. Any armature uses some kind of flexible wire. *Armaloy* wire is a soft aluminum that comes in several diameters from ⅛ inch, which is soft, to ½ inch, which is thick and stiff. You can buy armature wire from sculpture supply houses (see Appendix for list of suppliers). Or, you can travel to London, buy square section armature wire from Tiranti's, and lug it back on the plane.

Or you can use substitutions. A good substitute, if you're not using too much, is ¼ inch diameter copper tubing from the hardware store. It's expensive, but if you only buy a few feet it isn't much money. You must be careful when you bend it or it will kink, so sharp bends are out. If you support and bend evenly and slowly, it works beautifully.

Another cheap and readily available armature wire is aluminum clothesline wire. It comes in 50-foot rolls, at ⅛ inch diameter. One strand is too thin and weak to be of much use, but you can easily twist two or more strands together. First, bend a hook, like Captain Hook's, out of a piece of ¼ inch or ⅜ inch steel rod, and chuck it in an electric drill. Then, take a 50-foot roll of aluminum clothesline wire and clamp one end in a vise. Unroll it, find the middle, and double it back, clamping the other end next to the first end in the vise, so you have a 25-foot loop. Hook your chucked hook in the end of the loop, pull tight, and hit the juice (Figure 4-9). The wire will spin and twist very nicely, and you can stop when you think it's tight enough. If you have a big strong drill and a heavy hook, preferably with three flats ground in the shank for a good grip in the chuck, you can twist four strands together for heavy work.

FIGURE 4-9 Twisting an armature wire with an electric drill.

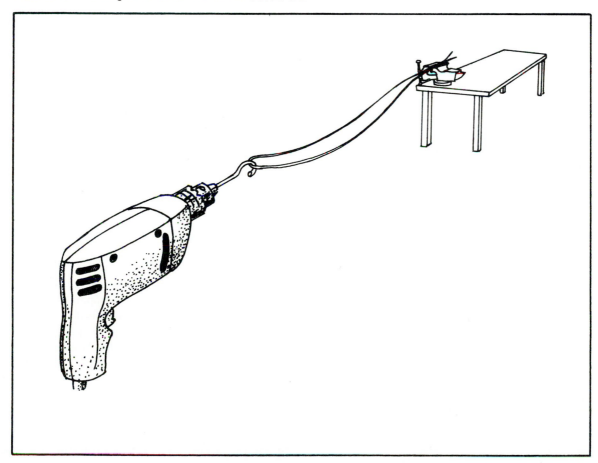

Twisted wire works very well for armatures because it's stiff and the clay gets a good grip on it. It is also cheap, available at hardware stores everywhere, and can be made up in varying thicknesses. Make sure that you don't buy steel clothesline wire; it is very much stiffer and so hard to bend that it is of little use for armatures.

To make the loops on top of the head peg, cut two pieces of armature wire each about 15 inches long, and bend them as in Figure 4-10, so you have two ends, each about 4 inches long, and a loop the size of a grapefruit. Shove the ends down into the pipe, cross them at right angles as shown, and fasten them with simple wooden wedges driven in hard (Figure 4-11). Even though wedges may seem to be a primitive fastening method, there is a very real advantage to this system. First, of course, it's quick, simple, and effective. But more than that, as you'll see later, it allows easy removal of the head peg from the sculpture after you have a mold on it and want to get the mold apart. But you must be sure at this stage that the wedges are driven in hard enough so the wire loops do not wiggle at all. If you leave any play in the loops, the whole thing will get looser and looser as you work, and it will be covered with clay so that you can't get inside to fix things. Make it solid at the beginning.

Head and shoulders. If you want to make a head and shoulders, plot out where you have to have the head

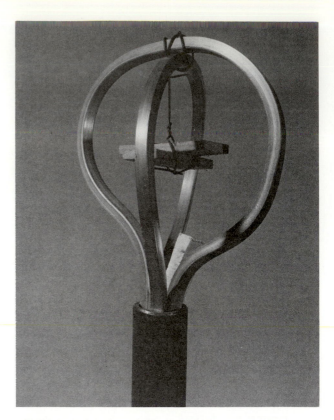

FIGURE 4-11 Detail of the top of the head peg with butterfly and wooden wedge.

FIGURE 4-10 Detail of wire loops for a head peg. (Note the wooden wedge.)

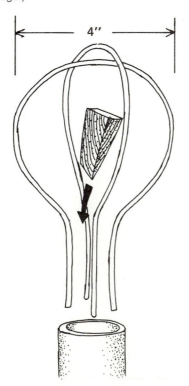

in order to have room for the shoulders, and then use blocks of wood nailed or bound with wire to fill some of the mass of the shoulder forms (Figure 4-12). Let the mass of clay forming the shoulders rest on the board.

Butterflies. Butterflies are useful any time you are adding a lot of clay. To make butterflies, take strips of wood about the dimensions of a yardstick, cut off pieces a couple of inches long, place them at right angles to each other like a little Red Cross, and bind them with wire. The tail end of the wire is used to tie the butterfly to an armature member (see Figure 4-11 and 4-12). As you add clay, hold the butterfly horizontal, and force clay in well around it. Remember butterflies; they are a great help when building armatures, particularly large ones. *Hint*: when you finish wrapping the wire, make sure the tail end of the wire is pushed down flat against the butterfly, because if it sticks up at all, you will poke your thumb on it when pushing in the clay. Believe me.

Armature Requirements

As a framework inside the clay, there are four main requirements for a good armature: first, it must be strong enough so the weight of the clay won't bend or collapse it; second, it must be flexible so you can form it to the

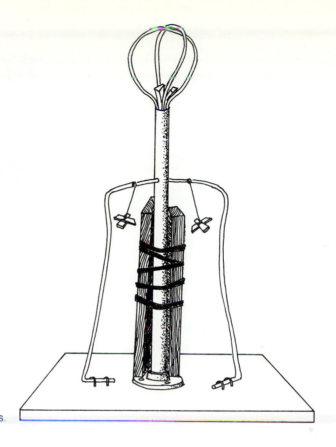

FIGURE 4-12 Head peg with additional support for the shoulders.

FIGURE 4-13 A back-iron type of figure armature.

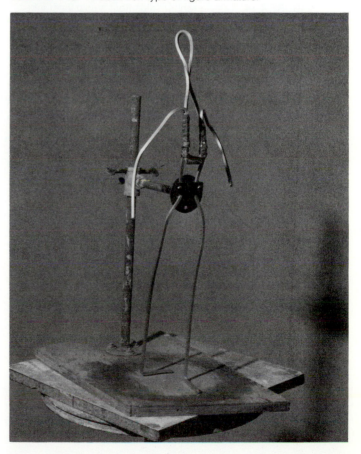

sculpture, rather than the other way around; third, it must go everywhere so it supports all the clay and doesn't let some bits drop off; and fourth, it must be carefully designed so it won't stick out where you don't want it.

Naturally, every armature is different, and you must invent a new one for each sculpture. But in order to meet all four requirements above, there are some techniques that can help.

The armature must be both strong and bendable. These two requirements may seem mutually contradictory, but they are not. If we meet those two requirements, we will also meet the other two.

The back iron. There are two essential components to a strong, bendable armature. The first is a very strong main support, which will not bend; the second is flexible secondary members. A perfect example is the back iron figure armature (Figure 4-13). A *back iron* is a very firm steel pipe structure that comes up from the board and moves horizontally to enter a figure in the middle of the back. Attached to this is a flexible wire armature, which does not need to hold the weight of the clay off the board since the pipe does that, and thus it can be softer and bendable. The head peg is a similar armature, in that the main support is the rigid pipe, while the loops on top can be bent to change the angle of the head after modeling has begun.

Fastening armature materials. One of the important techniques to know in making a back iron ar-

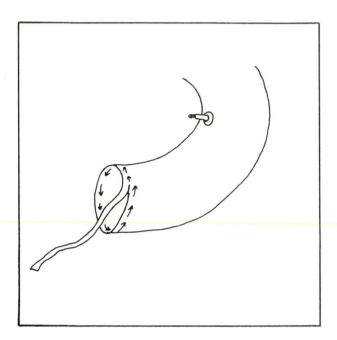

FIGURE 4-14 Cutting rubber strips from an old inner tube.

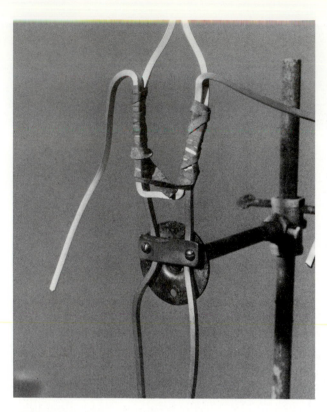

FIGURE 4-15 Detail of a back-iron type of figure armature. (Note the strap holding the armature to the pipe flange, and the rubber binding armature elements together.)

mature is how to fasten the different materials together firmly, quickly, and without fancy technique. Here's how to attach aluminum wire to steel pipe, or wood to the pipe, or anything to anything else that might be used in an armature. Go to a gas station and get some old scrap inner tubes; they give them away free. Using a scissor, cut a strip of rubber from the inner tube. I like to begin by cutting it straight across, and then cutting around and around in a spiral (Figure 4-14). You can cut different widths of strips, from thin ones about ¼ inch wide, up to ½ inch or even more. Cut different lengths, from a foot to about two feet. To attach two pieces of armature, lay them next to each other for a couple of inches and start wrapping, stretching the rubber as you wrap (Figure 4-15). Finish by pulling a wrap over your thumb for a loop, and passing the end under the loop. You'll be amazed at how strong this joint is. It can also be taken apart in a minute. It's waterproof (as it must be, since it will be covered in wet clay), it's reusable, and it's free!

You also must attach the armature wires to the horizontal member of the back iron. Notice in Figure 4-15 that there is a smaller flange attached to the horizontal pipe, and the armature is held in place with a short metal strap and two bolts. If such a flange threatens to protrude

beyond the edge of your sculpture, you can cut it down with a hacksaw.

Self-supporting armatures. Another way to make an armature that is strong and yet bendable is to use very strong materials, and figure out a way to bend them. For example, a steel bar about ½ inch square is very strong and can be bent by heating red with a welding torch. If you want to make a sculpture that doesn't have a back iron poking into it somewhere, plan it carefully, make it out of heavy steel bar, either welded together or bound with rubber, then get it into shape by heating (being careful of the rubber bindings) and bending. The advantage of this sort of armature is that it is very strong and completely enclosed, with no parts sticking out in your way. The disadvantage is that once it's covered with clay, it's just about impossible to modify.

Planning more complex armatures. There are the other two requirements to worry about—making sure the armature goes everywhere to support all the clay, and making sure it doesn't stick out where you don't want it. These, as you can see, are very similar and require planning.

Some armatures will be easy. A head peg, to return to a familiar example, needs to be about the size of a

grapefruit for a lifesize head—much bigger, and the wires will start to stick out; much smaller, and the clay will fall off.

But as soon as you leave the familiar and simple forms like a head, you need to use more careful planning. The best way is to make a rough drawing of your planned sculpture—actual size—and then draw the ideal armature right on the drawing. It's easy to make your armature right over the drawn armature at that point.

Using slides. If you are getting still more complex, particularly when you begin to make large things, you can sometimes use slides. To enlarge from a small model, take a photograph of the model from directly in front—waist high to the piece—and from directly to one side. When the slides come back from the developer, project them onto a wall, piece of plywood, or large sheet of paper, and move the projector or zoom lens until the image is the exact size you want the sculpture to be. Draw the outline from the projected image, and then draw

in the ideal armature, front and side. Make the actual armature by holding it against the drawing.

One way to help an armature hold the clay is to use wood. The beauty of wood is that it takes up room, affords horizontal surfaces to support clay, and is also sticky for the clay itself. Blocks can be cut to shape and bolted to main armature supports or bound on with wire or rubber. Smaller blocks can be bound on wherever bulk can be taken up. Butterflies can be used to support any large masses of clay, particularly those that hang below armature members. This armature (Figure 4-16) for a lifesized figure uses carefully shaped wooden blocks bolted to the main steel members (Figure 4-17).

Large armatures. For works larger than lifesize, styrofoam blocks can be added to build up mass (see Figure 6-5). These can be completely covered with strips of cloth dipped in wet plaster and wound around the armature like a mummy (see Figure 6-6). This will result in an armature that is a slightly smaller version of the

FIGURE 4-16 Lifesized armature.

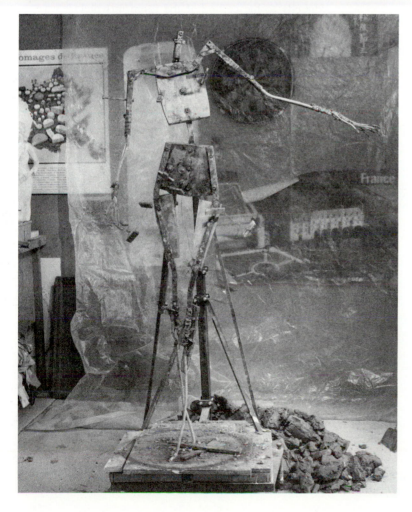

FIGURE 4-17 Lifesized armature detail. (Note the flange to attach the armature to the pipe, and the wooden blocks.)

sculpture itself, needing only a 2-inch-thick skin of clay, thus saving lots of weight, lots of work, and lots of material.

It is generally true that armatures need to be more elaborate and more carefully planned as they get larger. For general figure work, a basic back iron armature can be made that is well proportioned and sturdy, and used for figure after figure, just as a head peg will serve for just about any portrait.

Plumbing parts. For back irons, study the drawings and illustrations to see how common plumbing parts can be modified to serve very well for adjustable supports. T-junctions are particularly handy. Buy a size large enough so the straight section will slip over the main armature support freely. If you can, find a junction where the side hole is smaller than the end holes. Then drill two or three holes into the sides of the T and tap them for thumbscrews so it can lock in any position on the upright (Figure 4-18). One thumbscrew usually isn't enough to hold when the weight of the clay is added. Remember that good plumbing pipe is very strong indeed, particularly when threaded at each end and joined with standard connectors.

Very large armatures can be supported with means other than a back iron or internal support. The armature for my sculpture *Violin Woman*, which was eleven feet tall in clay, was secured by attaching a top extension

FIGURE 4-18 T joint with holding screws for a back-iron armature.

FIGURE 4-19 Detail, demountable arm; lifesized armature.

directly to the ceiling of the room in which it was enlarged. You may need to use the walls or ceiling to support large work.

Demountable armatures. Another kind of armature is the *demountable armature*. This is an armature that can be taken apart during the modeling process for ease of casting. Ideal for this technique is square-section tubing in two sizes that slide over each other. Suppose you are making a lifesize figure of a person and you want to be able to detach the arms. Attach a short section of the large-size tubing to the shoulder, then slide a piece of the smaller size into it, with suitable projection. Braze a nut onto the larger one, drill out the hole, and run an appropriate sized tap through. Then you can insert a long bolt which will bear against the inner tube and hold it fast. A further refinement is to make a stop so the inner tubing goes in a set distance. Attach armature wire to the projecting end of the smaller tube to form the arm (Figure 4-19). While working, leave the locking bolt in place and work around it. To separate the arm, cut through the clay where you think the join is, take out the locking bolt, and slide the arm off. The same thing can be done with a head, leg, or any other kind of projection or part, whether figurative or abstract. It can sometimes be very handy to be able to remove a form, slide its projecting tube into a section of large tube locked in a vise, and work on it with it rotated upside down.

Altering armatures after applying clay. Smaller armatures can often be improvised. If, after beginning with a relatively closed form, you decide to add exten-

sions like arms, you can often get away with simply sticking pieces of wire into the existing clay and going right ahead. If that proves too flimsy, bend the wire that is to go into the existing clay, cut a groove to accept the curved wire, embed it, and fill in.

You may have the opposite problem. If you have built an armature extending where you later don't want it, dig down through the clay to the wire and cut it off. In general, be willing to get at the armature and make changes.

One of the most common problems is that the armature sticks out somewhere. Don't let that alter the sculpture. Don't make a big lump where you don't want it just to cover a bit of wire sticking out. Often you can place a screwdriver tip against the offending wire and tap it back into the clay with a hammer. In more serious cases, you can expose it and cut it out. If the protrusion isn't serious but is a major part of the armature, such as the metal pipe in a head peg, which can't be removed, just ignore it, making your clay form go where it should go. When you cast the work, you can either fill that hole in the mold or carve the extra lump off.

TOOLS FOR WORKING CLAY

The most obvious way to begin working clay is with hands and fingers. There are those who insist you don't need anything beyond sensitive fingers, but I don't buy that. After all, I can think of very few things we humans make without tools. I have a lot of modeling tools of various sorts, and I use them all. I recommend that people take the buying, making, and using of modeling tools very seriously, because it can make a tremendous difference in the final work.

FIGURE 4-20 A selection of blade tools.

Use of hands. First, of course, you do use your hands. The best way to begin packing clay onto an armature is with your hands, driving the clay in deeply with strong thumb pressure. As the preliminary building up progresses, a good idea is to break off small pieces of clay, roll them rapidly between the palms to make little sausages, and apply them. These little rolls give linearity and direction to the clay being applied, avoiding random lumpiness.

Bats. A good homemade tool for controlling the clay form is a simple stick for batting the clay. Almost any stick will do, but I recommend selecting good, heavy hardwood, cutting it as in Figure 4-23, and spending a few minutes filing and sanding so it's a real tool, not just a scrap. Use the clay bat to pat, compress, and unify the clay mass as you build it up.

Blade tools. The next basic category of tool is the knifelike tool. If you are really stuck with no money and no tools, an ordinary table knife may be better than nothing, but not much. Best is to buy the double-ended steel spatula tools (Figure 4-20) from a sculpture supply house. These tools are very hard to make. The manufacturer uses a special steel, which is passed through rollers for even flattening. If you take a hunk of ordinary steel, heat it red with a torch, and start the village smithy routine, you will probably end up with a soft lumpy tool which isn't much good. So these I strongly recommend buying, even though they're kind of expensive. I recommend buying all the same shape, but varying sizes; the smallest should be about as wide as a pencil at the blade. You can purchase them in as many sizes as you can afford, up to one about the size of your thumb. For plaster mold work a big tool about 2 inches across is very handy.

Other commercial tools. Sculpture supply catalogs show page after page of funny looking wooden tools. I have been a sculptor for a quarter of a century, and I still don't know what they are all for. Your Aunt Matilda may hear you've taken up sculpture, and buy you a pack of those things, and you may discover a few that are of some use—good. Otherwise, use the spatulas and hook tools.

Hook tools. The *hook tool* (Figure 4-21) is a very handy tool for dragging across the clay surface. Hook tools with little cuts in the edge produce a surface with ridges which seems a little odd at first. However, the ridges help to cut the clay, and the texture seems to help you see the form. Take a look at the unfinished surfaces of Michelangelo's marble carvings, and you will see the same texture.

Buying hook tools. You can buy good hook tools from the same places that sell the spatulas. Beware of the kind that has a thin band of steel for the hook and of the kind that is made of a wire with another wire wrapped around it for texture. What you want is the kind where the hook is made of wire that is half round in section, with small notches actually cut in the edge. The shapes that are best are those like the ones illustrated in Figure 4-21. Again, there are lots of other shapes available, but I haven't a clue what they might be for.

Making hook tools. Personally, I make all my hook tools, and can make one in about twenty minutes, creating just the right tool for a particular job. You can too. Here's how. First, select the wire you will use. For a tool about an inch across, use ⅛-inch diameter welding

rod. For bigger tools, use thicker rods, and smaller rods for little ones. A tool about 4 inches across would use ¼-inch rod, for example.

Take a piece of paper and draw the shape of the hook you want to make, as in Figure 4-22. Now decide where along the straight piece of wire you will make the actual cutting part of the hook, being sure to leave enough at the ends. Heat that cutting area with a welding or propane torch to an even red, and begin pounding it flat on something anvil-like. Flatten the wire to about twice its original width, making it even and straight. Be especially careful not to make any spot too thin.

Next, grind the flattened wire so it's straight on both edges and sharpened like a double-edged sword. It should not be very sharp, just approaching sharpness (see Figure 4-22).

Now, heating it again, bend the wire into the hook shape you drew. Form the curves at each end of the cutting edge by clamping a round steel thing like a pipe or screwdriver blade in the vise and bending the heated metal around it. Make sure it looks just like your drawing, or just like the illustration, complete with the two tails for fixing in the handle.

At this point cool the tool in water and try it on clay. Add some notches with the corner of a small triangular file, spacing them evenly and using the same number of strokes for each notch. Then, drag the tool across some clay, and make it either sharper or duller until it feels right.

The handle is simple. Use a piece of good hardwood (pine is too soft). I keep scraps of fancy tropical woods around and use those, but any hardwood will work. Cut it roughly to shape, but oversize, and drill

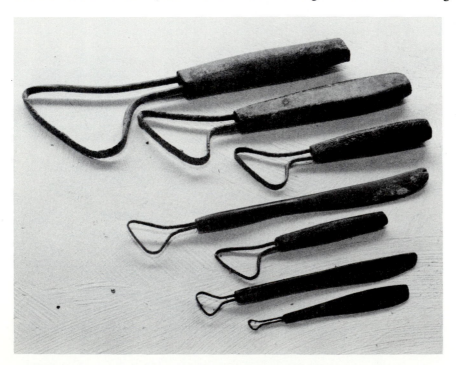

FIGURE 4-21 A selection of homemade hook tools.

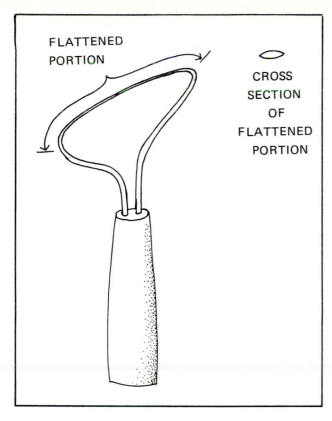

FLATTENED
PORTION

CROSS
SECTION
OF
FLATTENED
PORTION

FIGURE 4-22 A typical hook tool.

two holes in the end for the tails to go in. Then, power sand and file the handle down to shape, working up close to the two holes. This is a good way to get holes drilled in the end of a narrow piece without splitting it.

I used to make handles smooth and shiny, but now I find a finish with a medium rasp leaves a texture on them that is good for holding. A handle that tends toward a cylinder is easier to hold than a flat one. When the handle is shaped, mix a little five-minute epoxy, dribble some down the two holes, and carefully press the tails of the hook home, making sure the hook doesn't distort.

As you can see from Figure 4-21, I make hook tools in all sizes, from big ones the size of your hand, down to small ones about ⅛ inch across. When you are starting, make one of about an inch. Use it, then make more as you need them. Before long you'll get better at making them, and you'll assemble a nice collection.

Other tools. There are a few other tools that are handy (Figure 4-23). One is a thin piece of wire with a little wooden handle on each end (not shown) which is good for slicing off large amounts of clay. Another is a set of calipers. These can be very handy for all sorts of measuring and checking jobs as you work. If you read the excellent books on clay modeling by Bruno Lucchese, you'll see all sorts of ideas for tools which are not tools: things like scrub brushes or pieces of screen. Be willing to use anything to do the job you want—but don't be satisfied with just anything. Take your tools seriously, buy good ones, make others carefully, keep them clean, don't lose them, and learn to let them be extensions of your hands.

Now we're ready to begin making some sculpture.

FIGURE 4-23 A selection of clay tools, including a batting stick (*top*) plus various scrapers.

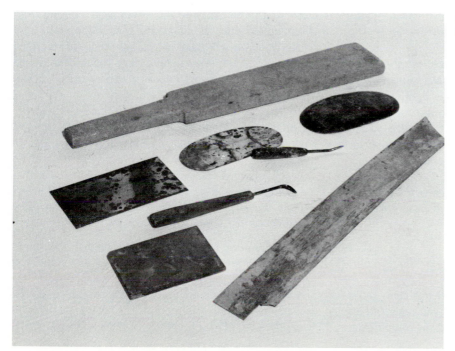

FIVE

Modeling from Life

Just as those prehistoric sculptures of bison in southern France were modeled after real bison, so the most natural thing to try to do with clay is to make some sort of copy. Kids love to play with clay, and they make all sorts of things, from elephants, to airplanes, to houses, to trees —even orange juice. Most children's art is made from memory; the child isn't actually looking at the subject while working. Kids know what houses or airplanes look like, and they just go to work. This is surely what happened in the case of the bison, since it is hardly possible that early artists coaxed real animals deep into their caves.

SEEING FORM

Making an object from memory, however, is not exactly what is meant by "modeling from life." In this chapter you will develop the skill not just to make something from clay, but something far more subtle and far more important—to see form in full three dimensions. Seeing is really what this chapter is all about.

Art teachers constantly talk about "seeing," emphasizing that most people don't really "see" things, but merely glance at them. And they are right. The kind of seeing we need to do to get through the day is very different from the kind of seeing an artist does when working from nature. Just as an army drill sergeant inspecting the troops looks for certain specific things, rather than admiring the soldiers in a general way as a civilian onlooker might, so artists must look past vague concepts like "pretty" or "powerful" and force themselves to see precise sizes and relationships.

MODELING A HEAD

The human head is essentially a spherical shape, and it presents very few technical problems with regard to armature or later casting. It does not present complex en-

closing of space, but is a relatively simple, solid mass. However, it is one of the most subtle and meaningful forms you can find, and it is so complex, when examined carefully, that an artist could make nothing but modeled heads for a lifetime and never exhaust the subject. In fact, many fine sculptors have done exactly that.

A modeled portrait head presents most of the problems of sculpture in a microcosm: mass, proportion, detail, likeness, surface, and on and on. For that reason, I believe it is a good place to start—with the clear understanding that you may start with it, but you'll never finish with it.

The Model

You should work from a living model. I do not recommend working from plaster casts or other such sources, since it is life that we are after, not just correctness. I particularly do not recommend working from photographs, since the *illusion* of three dimensions is so strong that you will believe you are seeing depth when you are not. Also, with a photograph you cannot look at a form from several directions, which is crucial to understanding solid mass.

The choice of a model is both important and unimportant. It is important because some people seem to have shapes in their heads and hair that are conducive to sculpture, while others do not. This has little to do with conventional ideas of "beauty," but more with clarity of form. But the selection of a model is also unimportant, because every head is of interest, and good sculpture can be made from anyone.

Arranging the work and the model. As mentioned in the previous chapter, the head peg is the best armature to use for this job. Make or select a good one and place it on a modeling stand. Place your model on a chair or stool, so that the model's head is about level with your own head (Figure 5-1). Do not allow the model

Rodin's method. The method the great French sculptor Rodin used is as good as any I have found. Here it is, in its simplest form. Begin by building a solid ball of clay on the head peg, pressing the clay well in until you have a grapefruit-sized mass. Next, position yourself directly to one side of the model and begin to make a profile. When you have completed that in a preliminary way, move to the *back* of the head and create that profile. Then, move to the other side and refine the side view, and then move to the front for that profile.

Next, you move to the quarter views, again creating profiles from four directions. Then you do the eighth views—those in between the quarter and the main profiles. At this point Rodin usually climbed up on a ladder to do the profile from directly above. But the essential point of this method is that you work from profiles, since the profile is the clearest view of a form, and the sum of all the profiles *is* the form.

The profile. Let's get detailed about the first profile. Everything takes planning, and building a head on a head peg takes some planning if the head is to be centered and not placed too far forward or backward (Figure 5-2). The problem in all this is the neck. Most

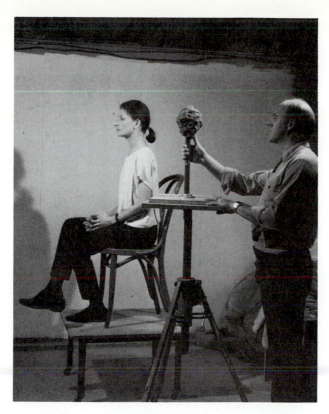

FIGURE 5-1 Proper relationship of artist, work, and model—all on one level.

FIGURE 5-2 Clay head properly centered on the head peg.

to sit in a regular chair on the floor, as the head will be too low, and you'll be looking down at it. You must look across at the model, so place the chair on a box or low stand. Now adjust your modeling stand so the center of the head peg is also at eye level. In other words, you want to look at the model and at your work from the same angle.

Work standing up, unless this is absolutely impossible due to health or physical reasons. You must move constantly as you work, both around the model to see different views, and backwards and forwards to get long views of your work. Sitting down can immobilize you and it makes your work static. If you must work sitting down, be sure to rotate the model and your work often.

Applying Clay

I believe in a certain amount of method for this work, and I avoid a "gob it on" approach. However, I do not use a meticulous method of countless measurements, building the head the way a carpenter builds a house. A certain amount of just plain looking and doing is necessary. My method is to approach the task with logic and order, but to work as freely as possible within that framework.

BE CAREFUL HERE

people's necks slant forward from the shoulders. Yet your head peg is vertical, and if you're not careful, the slant of the neck will hit the vertical pipe. So a good place to start is to establish the pit of the throat. Put a small gob of clay on the pipe where you think that point will be.

Proceed around the profile by what I call a *navigating* technique. If you navigate a ship or airplane, you use two different pieces of information to get where you want to go: first is the direction in which you are moving, and second is how far you have moved. The two together tell you where you are. The same is true here.

Divide the profile up into a series of sections, each of which is, for the moment, more or less a straight line—like the "legs" a pilot will travel while navigating. For each section, there are two questions to be answered: What direction is it (that is, what angle is it)? And how far is it (how long is it)? Beginning with the pit of the throat, look at the front of the model's throat, and ask those two questions. What angle is it, and how long is it (Figure 5-3)?

To determine the angle of the throat, a good technique is to look across the throat at something that is vertical, like the corner of the room or edge of a door or window, and compare the throat to the vertical. Build that angle in clay on the pipe. You'll have to gob clay all around the pipe or it probably won't stick, but concentrate on the exact angle of the throat you see. Another good trick is to sight across the clay throat to the model's throat, lining them up to see if they match.

Then, determine the length of the throat on the model, from the pit of the throat to where it becomes the underside of the chin. You can do this with calipers or just with your fingers for a rough measurement, but adjust the clay throat to match. What you have done is determine where the throat meets the underside of the chin (Figure 5-4).

Now continue out the underside of the chin to the chin itself, using the same method of angle and distance. Never take an angle for granted—always look. And each time you look, look *for* something. In this case, look first to see the exact angle of the surface you are working on. Forget about everything else—the model's expression, or how the nose is shaped—just look for the angle of that surface. Is it level? Does it slope up or down? Exactly how much does it slope? Then, look carefully for the distance from throat to chin, and reproduce it in your clay.

Looking this way is like the sergeant looking for certain definite things. You won't get confused by the mass of information the head is giving you, since you shut it all out—except for one piece of information at a time.

Next, navigate your way from the point of the chin up to the base of the nose (Figure 5-5). Ignoring the lips,

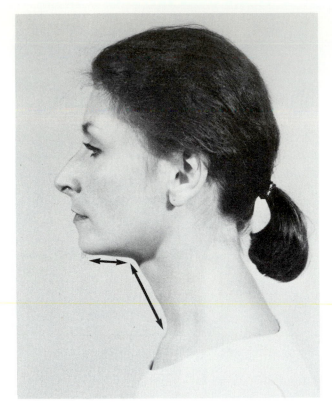

FIGURE 5-3 Angles and lengths of throat and underside of chin.

FIGURE 5-4 Throat and chin modeled in profile.

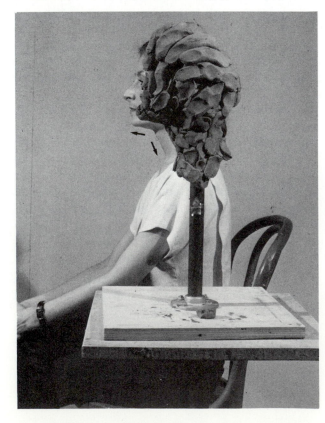

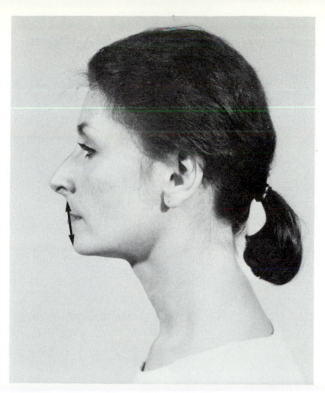

FIGURE 5-5 Angle from chin to base of nose, ignoring the lips.

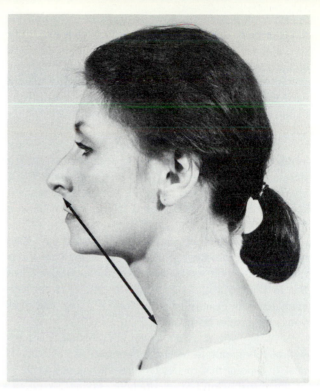

FIGURE 5-6 Checking the base of the nose against the pit of the throat.

think of a single straight line from the chin to the base of the nose. Again, check the angle first: Does it go straight up, or slope out, or lean back, and exactly how much? Then, check for length, either with calipers or with rough finger measurements.

At this point check to see that the new point you've made, the base of the nose, relates correctly to the starting point, the pit of the throat, by drawing a mental line between the two and checking again for angle and length (Figure 5-6).

As you add clay to the profile, you must keep building clay up on the head peg to support it. You will keep going back to the clay barrel and digging out ever bigger gobs of workable clay, which you can pile on your modeling stand as you work. So, as the profile grows, the amount of clay on the head peg will grow.

You can stick a lump of clay on at this point to suggest the nose, but generally ignore it. *Don't* make a nose; just use a lump to give the idea. Move now to the next major point, the bridge of the nose, right between the eyes. Again, determine where it lies relative to the base of the nose first by angle, then by distance.

Once you have established the bridge of the nose, take a good look at the angle of the whole face. Looking at the model from the side, drop a mental plumb line from the bridge of the nose straight down, and note where it comes out relative to the chin (Figure 5-7). It will be either in front of the chin, directly on the chin, or behind

FIGURE 5-7 Imaginary plumb line dropped from the bridge of the nose, striking the chin just a bit back from the edge.

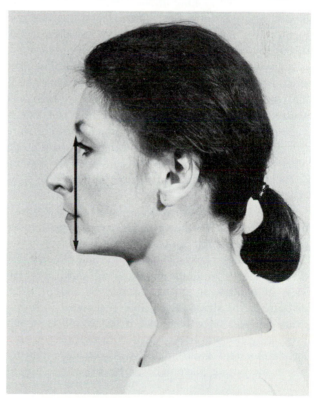

the chin. Note exactly how far in front or behind the model's chin your line falls, and check your clay to be sure it is the same. This is very important, as the angle of the face varies a great deal in people, and is an important part of their likeness. Figures 5-8 and 5-9 show two different models whose faces have very different facial angles. Note how the plumb line relates to the chin.

Now you have to navigate up the forehead and around the head itself. We begin to deal less with straight lines and more with curves here. One way to do it is to break it down into segments again, and take each segment as a combination of angle and distance, even if the segment is a curve.

Work up the forehead to the hairline, if any. Then work back across the top of the head to the very top of the skull. As you work, treat hair like any other form. If a lock of hair sticks up, make it stick up. Look very analytically at exactly what the form is doing, and make your clay profile do it too.

When you start down the back of the head, you will be navigating to meet the bottom of the back of the neck at a point that relates to your starting point, the pit of the throat. Don't slack off here, saying "Well, it's just the back, it's not so important." The back of the head is just as important as the front. For example, you can usually recognize your friends from behind in a movie theater: the back contributes strongly to a total likeness. Treat the back and the front with equal care.

Once you have navigated all the way around, you'll have a Mohawk-looking affair, a thin silhouette of the model. Study it for a few minutes, adjusting and correcting here and there, but don't get stuck on details (Figure 5-10).

Now go to the back of the model, and place your work where you can see the back of your sculpture at the same angle as the back of the model's head. Once again, do a profile, this time starting from one side of the base of the neck and working around. Use the same technique of angle and distance to navigate back to the other side. Keep adding clay so you don't have a couple of flat slabs intersecting, but begin to get a ball-like form, at least in back.

Now go to the other side, and work the profile from there. Check each segment again, using angle and distance, and refine the profile.

You might say to yourself, "Profiles! When do I do the face?" Well, the profile is the most important view of a head. It is like the keel of a ship, which determines the shape of the hull. If the keel is wrong, every rib will be wrong, and if the profile is wrong, everything else will be wrong. If, for example, you place the chin too far forward, then even if you made it nicely, it's in the wrong place. The profile establishes the *lo-*

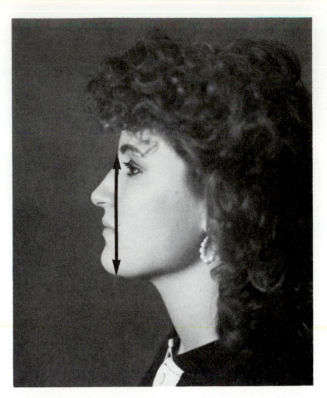

FIGURE 5-8 The same imaginary plumb line falling well behind the edge of the chin of a different model.

FIGURE 5-9 A third model, with the plumb line falling in front of the point of the chin.

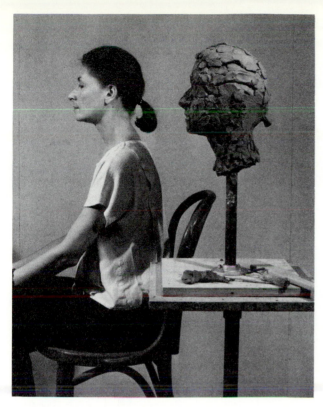

FIGURE 5-10 Sculpture in the profile stage.

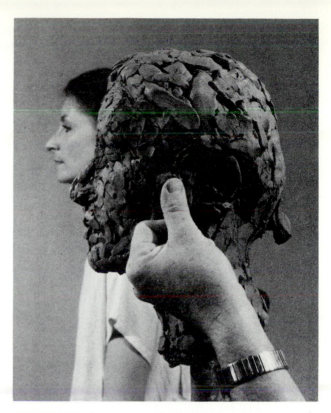

FIGURE 5-11 Applying small pellets of clay with the thumb.

cation of everything else, and must be correct *before* you do anything else.

Once you are reasonably satisfied with the profile, you can face the model directly—but *do not* begin to model the face. Instead, model the profile you see, that is, the forms around the ears and the horizon you see as you look from the front. Again, begin to fill in the spaces between profiles, to get something like a spherical form.

At this point, position yourself so you can see one of the quarter profiles easily, and turn your sculpture so it is facing the same way. Look over the edge of the form and begin to model the profile you see. Work around all four quarter-profiles, just as you did the four main ones.

Handling Clay

At this point I should explain some things about handling clay. First, I believe in putting clay on and taking clay off, but *not* in pushing clay around. My technique is to hold a big gob of soft, workable clay in my left hand (I'm right handed—reverse if you're left handed), and to take off small pieces with my right hand and apply them (Figure 5-11). I build the form with small bits, so it grows in a controlled, even fashion. Sometimes it's a good idea to tear off small bits, roll them quickly in your palms into little sausages, and apply them almost

like brush strokes, to build form and give direction at the same time. I touched on this technique briefly in Chapter 4. When using it, be sure to work the clay sausages in well after applying them, because the whole sculpture could get so loose it could fall off the armature in one wet lump. This isn't pottery, however, so you don't need to worry about driving all the air pockets out. Just stick the clay on, making sure it's pressed in tight enough to adhere, and don't worry about trapping air.

If you build someplace up too big, don't claw at it with your fingers or smear it around, but take a spatula tool and slice it off (Figure 5-12). If you smear it around, you disturb the clay next to it, and pretty soon everything gets mushy and out of control. If you slice with a tool, you not only get rid of the extra clay, but you create a plane as well, which helps define form.

Another good tool at this stage is a batting stick. Gently swat the clay form, particularly large forms, like the top and back of the head, and pat down all the little bumps of clay, giving continuity to the surface (Figure 5-13).

Perhaps the biggest mistake you can make right now is to smooth out the surface, smearing it with your thumbs. I have seen hundreds of students spend countless hours smearing away, making everything nice and smooth, all to no avail. First, it is a great waste of time to make

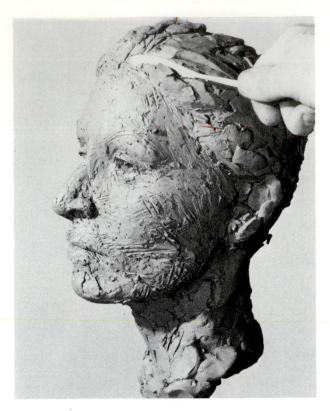

FIGURE 5-12 Cutting clay off with a blade tool.

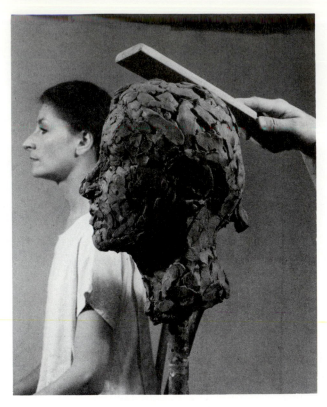

FIGURE 5-13 Using the clay bat to compress the clay.

FIGURE 5-14 Using the hook tool to refine the surface.

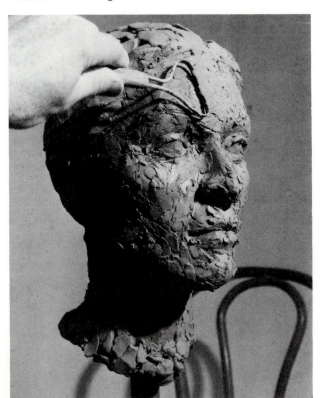

clay smooth only to cover it up with more forms. Second, it is very hard to work freely when the clay is smooth, since anything you stick on *looks* stuck on and doesn't blend. Third, smearing the surface smooth is not making form, and I can't stress too much the idea that you are making form—solid structured mass—not a face. If you want to pull the surface together without smearing, use the hook tool (Figure 5-14). Do not just drag the tool all over the surface, but use it with care to even out the form. Scrape off high areas, fill in low areas, but always concentrate on clarity of form.

Storing Work Between Sessions

If you got this far in your first session, you're doing well. Cover your clay head with a plastic bag tied well around the pipe, with the air squeezed out. This will keep the sculpture moist between sessions. However, you'll find that it slowly dries as you work, so you need to keep wetting it. You can spray water on from a spray bottle, or even pour it over the sculpture. If the head starts getting really dry, cover it with a soaked cloth before putting the bag on at the end of a session. Usually, by using or omitting wet rags you can maintain the head at just the right level of moisture. You'll want it soft at the start, and then gradually harder as you get further along.

Never let it dry completely, because it will crack as it shrinks over the rigid armature inside.

To save or tear down. If it's your first time making a head, a good idea is to work for one session (say, three hours) doing what has just been described, and then tear the head down, putting the clay back in the barrel and cleaning off the head peg. Next session, do it again from scratch, the same way. You'll get to where you finished the first time in about half the time, and the head will be better. Tear it down again, and start a third time. This time you will be better still, and will probably want to continue.

This tearing down is really like drawing, where you use a pad of newsprint and tear off and throw away sheets. It keeps you from coming in the next day and inheriting your mistakes from the previous day. It gives you lots of experience in pushing clay around and manipulating form, and it keeps your sculpture from getting too precious. After all, everyone has to practice and to throw the practice sessions away.

Moving Further

Assuming you have built the head up to this preliminary stage, it's time to go a little further. At this point, whether it's after one day or several, you should have a solid mass of clay which looks pretty much like a head, but with no details. It should have the feel of a neck, of the skull sitting on the neck, and something of the model's profiles, including the masses of hair. (You may wish you had picked a model with little hair or short hair. While lively, luscious hair is wonderful, when translated into heavy wet clay it's something else, so I like to find models that don't present that problem.)

Take a long look at your work and the model. Notice how the neck sockets up into the skull, so that the back of the neck hits the skull at a point level with the base of the nose (Figure 5-15). Notice the general angle of the neck, how, in most cases, it juts forward from the shoulders. This angle of the neck is crucial in establishing the *gesture of the head*. Think of the stereotype of the old skinflint, rubbing his hands together, thinking about his money, his neck jutting forward at a sharp angle. Then think of a West Point cadet "bracing" at attention, his neck perfectly vertical. The difference in these two is the *angle of the neck*. In both cases the head remains essentially upright.

Next, notice the total angle of the head, particularly the angle of the face. In Figures 5-8 and 5-9 you can see two heads, both perfectly normal, yet with very different facial angles. Check the angle of the face you have made against the model. Look again at the surface under the chin, to make sure that it has the same angle as the model.

Now look at the top of the head. Lots of people

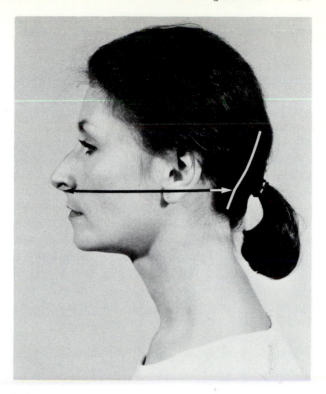

FIGURE 5-15 Checking the level of the bottom of the nose against the back of the neck.

have a slight slope to the top of the head, running uphill from the forehead going back, rising to a high point usually slightly to the rear of the center of the head. Notice the curve of the back of the skull. Remember, there is a ball-like form at the back of the skull—the part that contains the brains. Don't short-change that bit!

Perceiving Form

When we perceive the world, we do it through various senses. Usually, the more senses that are involved, the better we perceive. Merely looking at a forest is very different from walking through it—smelling the pine scent, feeling the rough tree bark with your hand, hearing the bird songs and the wind in the treetops, and tasting the berries you find. That forest is truly real in your mind. Likewise with sculpture. We can perceive form by looking, but also by feeling, and that second sensory perception reinforces what we have seen. Try this: Look at the curve around the back of the skull. Now, pass your hand over the back of your own head, feeling how much like a ball it is. Then touch your sculpture the same way. It is said that sometimes Rodin would move very close to his model, touching a spot on the face, and then touching the same spot on his sculpture, back and forth, feeling his way along. While we can't just run our hands all over models, there are times when the sense of touch can reinforce what we see.

Modeling the Face

Now you are ready to tackle the next step. Consider the face. Notice how the forehead seems to curve down in a plane, and how the main plane of the cheeks recedes back just a bit (Figure 5-16). Work the forehead carefully, looking at the curve from the side and the curve from below. Carve some semblance of sockets for eyes, and begin to work the cheeks, making them a plane receded back a bit from the forehead. Keep the nose and the center of the mouth region like a ridge down the center of the face. Be careful that you don't let the cheeks creep forward. This is a great danger: if you stand directly in front of the model and work that way, you will not see clearly how far back the cheeks are, and you might make them come forward. We all have a tendency to think of the face as a mask, like a flat disc with eyes, nose, mouth stuck on. But in fact the face is built as though on the corner of a box, with the cheeks receding rapidly back. Try this: put your hands on your cheeks, as though you were covering your face in agony. Holding your hands perfectly still, move them away and look at the angle between them. It's almost a right angle (Figure 5-17). Do the same thing on your clay sculpture to check the angle between the cheeks.

As you work the face during the next several sessions, work from the side as much as possible. Beware of working from directly in front because of the tendency to flatten the face. The face is part of the head, and you are making a complete head. Be careful that you don't make a lump with a face stuck on the front, but that you devote equal (or nearly equal) attention to all parts of the head. As you work the face, keep looking at its relationship to other parts of the head.

The Eye

Look at the eye of the model, and notice how it is a lump set in a hollow, like an egg yolk held in the hollow of a hand. Since the eye itself is a lump, don't dig out great sockets, but make a shallow socket and put a clay lump in it. As you work the eye, remember that it is the structure of the area around the eye that is most important, not the eye itself. If you create a really convincing structure surrounding the eye, you can be quite free with the eye itself and it will work. But if the surrounding structure is wrong, the most detailed and perfect eye will look wrong. Imagine modeling a perfect eye in the middle of the cheek! It would be wrong. Get the surroundings right.

Above the eye. As you work the eye, concentrate first on the upper-lid area. By that, I mean the area between the eyebrow and the upper eyelid, the part where some people put eyeshadow. When you have a complex form that is hard to understand, think of it as a simple

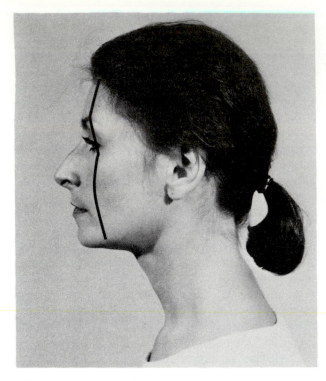

FIGURE 5-16 The set-back of the face relative to the forehead. (Note the backward-sloping angle from the eyebrow to the lower lid.)

FIGURE 5-17 The backward-sloping angle of the face planes.

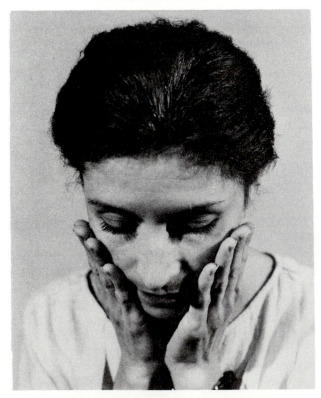

form, one easy to understand, and then put it through a series of distortions, each easy to understand. You can comprehend a complex form by breaking it down into a series of easily understood parts.

The surface over the eye is the key to getting the eye area to work. Think of the surface this way. Imagine a flat strap of skin about three inches long and one inch high standing on edge like a little wall. You might want to make a little strap of clay to see this more clearly. This little wall will go through the three distortions described below to become like that eyebrow area.

Distortion 1: Twist. Give the little wall a not-quite-90-degree twist by grabbing each end and turning, so it looks like an airplane propeller. Look at the model's eye. The part of the eyebrow that is close to the nose is like a ceiling, but the part near the temple is like a vertical wall. That is what the twist accomplishes.

Distortion 2: Bend. Bend the little wall so that it curves around the head. Again, look at the model. The part of the brow near the nose runs side to side, but as it nears the outer corner of the eye it *bends* to go back towards the ear.

Distortion 3: Bulge. The little wall itself has to bulge outward, particularly near the outer end. Look at the brow on the model and notice how it bulges. If you try to make the brow area by sliding your thumb along the clay, your thumb, being a bump shape, will create a hollow in the clay, which is opposite to what occurs on the model. (Figure 5-18).

The important point is that although everyone has a different shape to every part of his or her body, there are similarities. With this simple form—a flat strap—and three simple distortions—twist, bend, and bulge—you have a complex shape *which can be compared to* the model before you. Given a standard, you can more easily determine exactly how the individual brow is formed.

The shape of the eye. Now look at the model's eye from directly in front. Notice the shape of the eyeball itself, between the lids, or, in other words, notice the shape of the opening in the lids. Look at the inner corner of the eye, the little tear duct. That is where you start. From the tear duct, follow the line of the *upper* lid. Notice how it rises rather steeply, then moves across and slightly down at the outer corner. Following the *lower* lid, again from the tear duct, notice how it moves more or less straight across, and then rises at the outer corner to meet the upper lid (Figure 5-19). The two lids do not make two simple almond-shaped arcs, but the upper moves *up* and *over*, while the lower moves *over* and *up*. As a result, the outer corner of the eye is usually slightly higher than the inner corner.

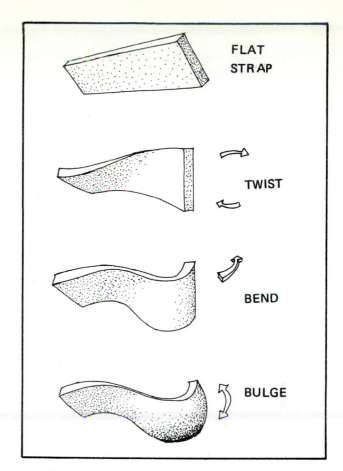

FIGURE 5-18 Three distortions of a clay strip, suggesting the shape of the upper eyebrow.

FIGURE 5-19 Diagrams of eye structure: (a) the lids moving up and over, then over and up; (b) the bulge of the eye from below; (c) the backward slope from eyebrow to lower lid.

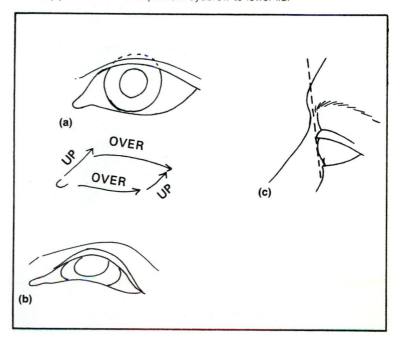

53

The upper eyelid. Now get down on your knees and look at the model's eye from as close to directly *below* as you can, and notice how much the upper lid curves *out* from the head (Figures 5-19 and 5-20). The eyeball itself is a sphere about the size of a ping-pong ball. The eyelids cling tightly to the ball, like band-aids on a ping-pong ball. Thus, they curve *outwards* exactly as much as the ball does. One mistake many beginners make is to create flat eyes, eyes in which the lids rise and fall nicely, but do not project forward in space.

As you work the eyes, keep a section of a solid ball of clay in the space to represent the eyeball. Make sure it is round, that is, that the curve from top to bottom is the same as the curve from side to side. Don't make a football, where the curve in one direction is different from the other, but rather a ping-pong ball. Let the lids follow the curve of that ball exactly. Keep looking at the model and checking your work from below to make sure that the lids project as much as they should.

The upper lid is like a garage door that lifts to open and retracts back on itself to get out of the way. Watch the model's eyes open and close slowly and notice how the lid retracts on itself. Note very carefully the crack that runs along the top of the lid where the fold is. The amount of lid that actually shows varies quite a bit with different individuals. On some, like Sophia Loren, you see a tremendous expanse of upper lid. On others, you see less upper lid. And on some people, it disappears altogether behind a fold of skin beneath the eyebrow (Figure 5-21). What often happens is that the crack along the upper edge of the lid is visible at each corner of the eye, and disappears in the middle. Watch for this, and model it carefully.

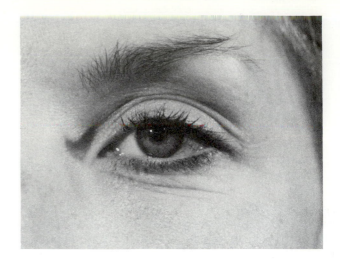

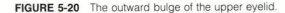

FIGURE 5-20 The outward bulge of the upper eyelid.

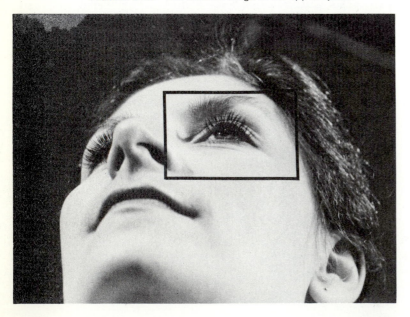

FIGURE 5-21 Three different eyes, showing variations in the width of the upper lid.

Modeling the other eye. Do not make one eye, and then model the other from it. Do each eye *from the model.* Now go back and work each some more so they relate the way the model's eyes do. People's faces are not symmetrical, but that's not the only reason for working from each eye directly. The eyes are mirror images of each other, yet you model each with the same hand. Thus, your hand does different things on each eye. By looking and working directly from each eye, you can cancel out the natural error you build in as you work. You can continue to adjust the eyes as a pair, so they relate to the model.

Aligning the eyes. A big problem in doing eyes is the alignment. There are three levels of alignment. One is up and down. Is one eye higher than the other? Do they tip at the same angle? A good way to check is to look carefully at the model, noticing the lower lids. Make the lower lids mentally into one continuous line across the face, and see what that line looks like. Then look at the eyes you have modeled and see how their lower lids relate (Figure 5-22).

A second problem is side to side. Is each eye the same distance from the nose? A good way to check is to draw a light line directly up the center of the nose onto the forehead. Now draw light lines directly up onto the forehead from the inner and outer corners of each eye. Look at the lines on the forehead, ignoring the eyes, and see if they have even spaces on each side. If they don't, make them even, extend them back down, and adjust the eyes accordingly.

The third level of alignment is in and out. Is each eye as close to you as the other? This is a tricky one, and is best seen by getting below the sculpture and looking up at the eyes.

Any of these alignment problems can be seen more clearly with a hand mirror. Look for any of the three problems described above in a small mirror, and any error will appear double to you.

Working around the model. Don't work too long on any particular spot, but leave it, work somewhere else, and come back to it over and over. Making sculpture is like giving a massage—too long in one spot and it

FIGURE 5-22 Possible misalignment of the eyes: (a) eyes on different levels; (b) one eye tipped more than the other; (c) eyes not centered on the nose; (d) eyes at different depths.

(a)

(b)

(c)

(d)

starts to hurt. Start working one eye, then spend a few minutes on the back of the head, then return to the other eye, then work on the neck, and so on. That way you can alternate between small and large areas, and you can constantly relate the smaller things to the larger ones. Also, be sure to look at each form from several angles to build a composite picture in your mind of its full three-dimensional reality.

The nose. Get the overall size of the nose right, and then start looking more carefully. Notice how, at the top of the nose, there is a blunt inverted pyramid form between the eyes that becomes broader and projects forward as it goes up. The main part of the nose, between the bridge and the tip, usually has a slight outward bulge, if you look at it carefully from the side. Beware of modeling ski-slide noses—they generally don't exist.

The bottom of the nose is the tricky part. First, looking from directly in front, notice how the very bottom isn't flat across, but slopes up to each side, making a shallow V shape. Looking at the nostrils from below, observe their kidney shape, and look carefully at the flesh that surrounds them (Figure 5-23). Don't think of nostrils as holes punched in the end of the nose, but rather as spaces left as the nose lobes arc out and away from the nose. The *columnella* is the ridge in the center between the nostrils. It attaches to the upper lip, its outer edges forming ridges that frame the groove called the *philtrum*. The nostrils flare around, and as they return to the nose, they don't just join the face, but drive in and upward into the nostril space.

The mouth. The lips and eyes are the two most expressive parts of the face. Everything else remains rather static. As facial expressions change, it is the lips and eyes that change first, often beginning with the smallest movement. We are extremely sensitive to those tiny changes. So you must be extremely sensitive to tiny details of lips and eyes in your sculpture if you are to have any control over that elusive quality called expression. The great portrait sculptor Despiau used to say "La bouche, c'est tout": "The mouth is everything."

Lips are best conceived of as two forms, two bumps added to the face, rather than a cut made in the face. The upper lip is longer from side to side, and the lower lip has a sharper curve from side to side.

The most important feature of the lips to get right is the line between the lips. Looking from directly in front, notice how the line between the lips does not move straight across, but in fact rises slightly to the center, dips a little, and then drops. (Figure 5-24). That is, it moves up, over, and down, forming a slight downward curve. Each outer corner then turns back up just a bit. This line is crucial. Get it wrong and no amount of fussing will make the mouth look right.

Now look at the mouth from the side, and notice how the upper lip usually sticks out a little farther than the lower lip. Also, see how the skin between the nose and the upper lip (where you grow a mustache) usually drops straight down from the nose. The lower lip often curves sharply in at the bottom before heading back out for the chin (Figure 5-25).

Look at the lips from underneath, observe their strong outward curve. Don't make the mistake of modeling flat lips, but make them curve sharply around, imagining the teeth, with their strong horseshoe curve, just underneath.

The corners of the mouth recede behind the plane of the cheeks. Look at the model again and see how, if you were a tiny gnat crawling along the lip and you got to the corner, you would have to crawl *uphill* to reach the cheek, since you would be in a little hollow. This is very important. A common mistake is to make the corners of the mouth raised on a little mound *above* the cheeks, making the whole mouth look like an addition stuck on the face.

Once again, don't work too long on any particular part, but roam all over the head as you work, trying to keep all parts relatively even. A good rule is always to work on the part that has been worked on least.

FIGURE 5-23 View of the nose from below. (Note the asymmetry of the nostrils.)

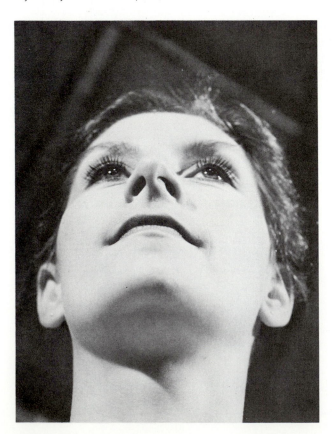

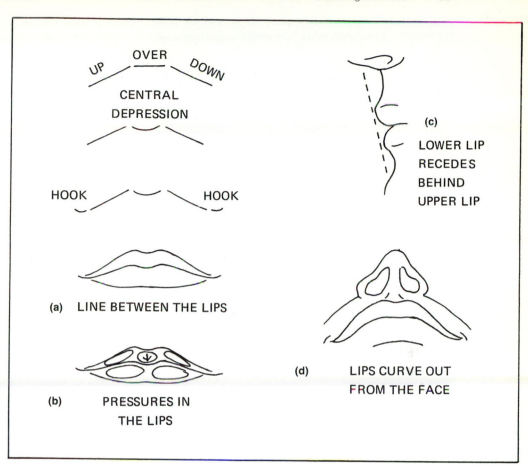

FIGURE 5-24 Diagram of the mouth: (a) the line between the lips; (b) pressures in the lips; (c) lips from profile showing receding of the lower lip; (d) the outward curve of the lips.

FIGURE 5-25 Lips and chin from profile.

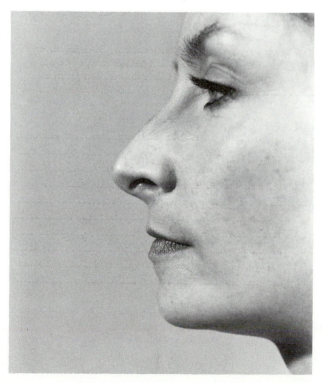

Ears. You were hoping you could find a model with long hair so you wouldn't have to deal with ears. But ears are really easier than you think, once you understand their forms. Every part of the ear has a name, which helps to remember its form.

The ears are attached to the head at their front edges, but the back edges flare away from the head. Look at the ear from behind and below to see how this happens, and don't glue them on like a pizza (Figure 5-26).

Think of the ear itself as a flange or flap of skin, moving backwards. The edge of this flap is rolled, creating a crease that goes over the top of the ear and most of the way down the back. This rolled form is called a *helix*, because it moves like a helix; that is, as it comes over the top and to the front, it spirals down into the inner ear. The bit of the flap or flange just inside the roll is called the *antihelix*; it bulges away from the head toward the center of the ear. Look carefully at the antihelix, since it is crucial to getting the ear right. Its inner edge is a cliff, which drops down into the great hole of the ear called the *concha*. The antihelix makes a hump between its inner edge and the helix. As the antihelix moves up towards the top of the ear, it forks in two, and the double hump heads up and forward, to disappear behind the roll of the helix.

FIGURE 5-26 The ear from behind. (Note the section between the helix and the head.)

At the front of the ear is a little bump attached to the head, called the *tragus*. Just below the tragus is a little notch, and just opposite the tragus is a smaller bump, called the *antitragus*. The little notch has the wonderful name of the *intertragic notch*. Below the intertragic notch is the lobe. You will notice from looking at people that there are two kinds of lobes, hangers and blenders, or those that droop down, and those that blend into the head (Figure 5-27).

It's one thing to get the ear looking right as a two-dimensional pattern, but the real ear projects three dimensionally away from and into the head. Look carefully from behind at how the antihelix often projects out farther than the helix. Notice how the plane formed by the antihelix changes angle as it approaches the lobe. The short column of skin at the very back of the ear that connects it to the head is the back of the concha.

The neck. Don't neglect the neck. It is a complex form, and it is part of the head. The muscles of the neck comprise one of the most complex muscle groups in the body, rivaled only by the forearm (which controls the hand). It is too complicated to detail here, but in general, it can be thought of as four main parts (Figure 5-28):

First is the spine, which runs up the back of the neck and supports the skull.

FIGURE 5-27 Parts of the ear.

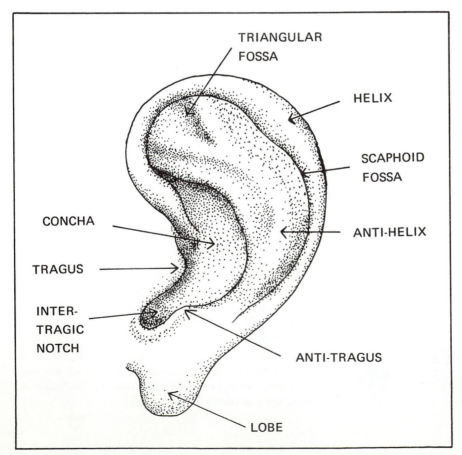

TRIANGULAR FOSSA

HELIX

SCAPHOID FOSSA

CONCHA

ANTI-HELIX

TRAGUS

INTER-TRAGIC NOTCH

ANTI-TRAGUS

LOBE

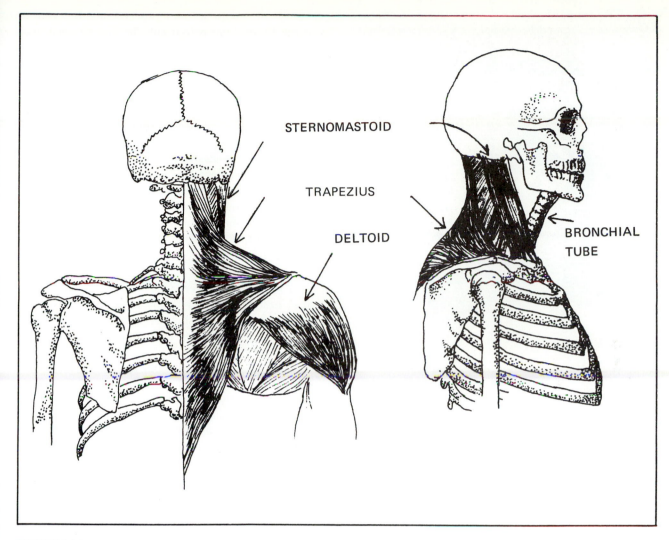

STERNOMASTOID

TRAPEZIUS

DELTOID

BRONCHIAL
TUBE

FIGURE 5-28 Major muscle groups of the neck.

Second, rising from the tops of the shoulders and running up either side of the spine are the *trapezius* muscles, which support the head, keeping it from falling forward. They are interesting muscles, since they are under tension most of the time yet don't seem to get tired. You can tell how they work if you've ever fallen asleep during a boring class. The first thing that happens is that the trapezius muscles relax and your head falls forward.

The third group is the pair of *sternocleidomastoids*. Their name is not actually as hard to remember as it looks. They are named for their two ends. They start at the *sternum*, the pit of the throat, and rise on either side of the neck, up and back, to attach to the *mastoid process*, which is the knob under your ear—thus sternomastoid. *Cleido* refers to the the bottom of the muscle, which branches off to the *clavicle*, or collarbone. These two

muscles form a V-shape, but the important thing about them is the way they wrap around the neck, like barber pole stripes, beginning together in the front and ending up on each side by the ears.

The fourth element of the neck is the *trachea*, or throat. This is a big pipe, like a vacuum cleaner hose, that connects the mouth to the lungs. It runs down the front of the neck, diving between the converging sternomastoids. It slopes forward; it is invisible down by the pit of the throat, but very prominent at the top.

The sternomastoids turn the head from one side to the other. The one on the side opposite to the direction the head is turning does the pulling. Thus, if you turn your head to the left, the right muscle does the work; it tenses, becoming more prominent (Figure 5-29). Also, as your head turns, the muscle that is doing the pulling becomes more vertical. If you rotate your head to the

FIGURE 5-29 The sternomastoid drawn tight.

left, your right ear rotates above the pit of your throat, and the right sternomastoid becomes vertical. The trachea slants, and the left sternomastoid almost disappears in a fold in your neck.

Looking. Enough elementary anatomy. You must learn more by looking carefully at the model, and looking carefully at other people (trying not to be too obvious about it with strangers). Notice all the variations, but notice the common ground within the variations. It is also important to read books on anatomy and on modeling the head. You can continue to learn all your life, but there will always be more to understand.

The other very important thing to bear in mind is that sculpture is making form. By that I mean you are creating shapes that relate to geometry. The head is essentially a spherical shape, and that must underlie everything you do. Constantly try to sense the big shapes underlying forms, such as the ball in the eye, the spheres behind the forehead and at the back of the skull, or the cylinder of the neck. The clearer those shapes are, the more structure the head will have. If you ignore those shapes, you end up with a weak form covered with surface undulations, which is poor sculpture.

The likeness. Getting a likeness is always a big concern and a big problem. The likeness is the total of

thousands of careful accurate observations. But even if you get all the little parts right, the portrait head may still not look like the model, because you didn't get the big parts right. Many times I have neared completion of a portrait, only to find that something is still not right, and discovered the solution in a major proportional change, like making the head a little wider or the forehead taller. Usually the likeness comes not from getting the eyes and lips right, but from getting the forehead and cheeks right. The back of the head, the neck, and the gesture are also important. Remember that you can recognize your friends even when they are sitting in front of you in a dimly lit theater where you can see no details. Make a sculpture which "casts a shadow" like the model, that is, in which the major shapes are right. Don't depend on details to create the likeness.

Finishing. If everything has gone well until now, you are nearing completion of the head. As with so many other things we do, finishing is important. It is not just a matter of quitting when everything is right, but is a stage in itself.

First, make sure that both the major proportions and the details of the head are correct. Stand back from the work and really look at it. Sure, you've been looking at it all along, but now look differently. Imagine finding this sculpture in the attic. Would you bring it downstairs, or leave it up there? In other words, what kind of object have you made? Does it repel you, attract you, mystify you, bore you? Be objective. Forget the fact that you made it and it's yours, and try to see it as a stranger would, since it will be seen by strangers if you allow it to become a sculpture. Think about how hard you are on many things you see—clothes, furniture, cars, movies—and how easily you say "Eh" and pass things by as not interesting.

This can be a depressing part of making art, but it's essential. As you do this, think of ways to make your sculpture more interesting, more intriguing, more exciting, more beautiful. Work toward those ends, rather than just trying to make an ear look like an ear.

And begin to think about finishing. One of the most important aspects to finishing is knowing when to stop. Finishing a sculpture does not necessarily mean smoothing it all out, nor does it necessarily mean bringing it all to the same level of finish. Evidence of your hand pushing the clay or tool marks can enhance the vitality of the work. And creating focus may mean that some areas must be worked more completely than others, to bring a sense of importance to those spots.

Getting a final surface on clay isn't easy, because smearing it can look just awful. Try instead not to *apply* a texture, but to work in such a way that you are always trying to make form. The best surface may be the natural

one that results. Use the hook tools not to smooth so much as to refine, to bring out nuances of the form, to make the surface taut. As you near completion look at your work long and hard. Be an artist.

MODELING FROM THE FIGURE

Most of what has been said about the head applies to the figure as well, so this section is shorter. However, the complete figure is more complex than just the head, both technically and anatomically.

For first attempts at the figure, it is best to have the model take a simple standing pose, one that does not involve a lot of twists and contortions, and that allows you to see most of the body. At least for your first attempt, have the model pose naturally and comfortably, in a pose that has interest without extreme complexity.

The Armature

The armature is much more important in figure work than in head work, because it is more complex and comes nearer to the surface. The previous chapter described ways to make armatures for figure work using back irons. Using those techniques, make an armature of the appropriate size. Half-size is a good size to begin with. It's big enough to avoid fussiness, but small enough to avoid the problems that come with lifesize work.

Adjusting the armature. The most important part of adjusting the armature is getting it to stand like the model. The best way to do this is to set four cardinal directions from the model—front, side, back, other side—at right angles to each other, and mark them. Now, stand in front of the model, and place your armature, facing front, between you and the model. Move back and forth until the armature appears superimposed over the model in your eye (Figure 5-30). You will be able to see instantly if it is standing correctly, and can bend it accordingly. Move to each of the four directions and do the same (Figure 5-31), until the armature begins to look like the model. Then you are ready for clay.

Applying Clay

As with the head, build with clay pressed well into the armature. Next start adding small pieces, or sausages (Figure 5-32). Use the technique of working all four profiles, then working the quarters, and finally the eighths. As you work, remember that you are making form. The essential form of the human body is a cylinder on top of two other cylinders. Think about the cross section of the body, how round it is. Look at the sculpture you are making, and consider the cross section carefully.

FIGURE 5-30 Figure armature visually superimposed over the model.

FIGURE 5-31 Armature superimposed over the model from the side.

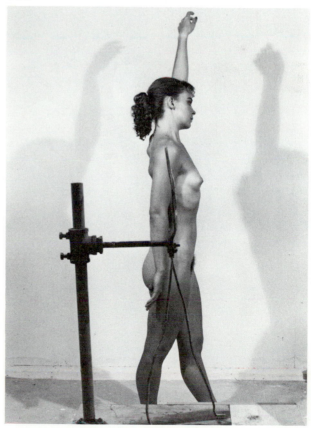

FIGURE 5-32 Applying clay in small sausages to the armature.

FIGURE 5-33 Model standing with her weight over a supporting foot.

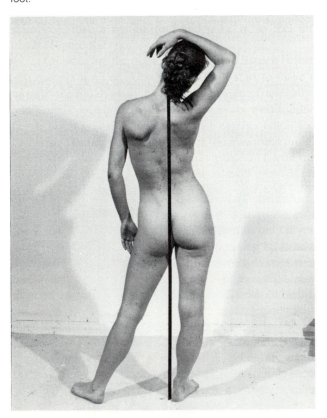

A common tendency is to make the body too flat, like a paper doll with a front and back but no sides. Using the idea of input from senses other than sight, place one of your hands on your chest and the other on your back, and sense how far apart they are, how thick you are from front to back. Be sure your sculpture is not too flat, but has this thickness. Look at the model's sides, and make them in your sculpture.

The stance. From the very start you must consider the stance. When we stand up, we place our center of gravity directly over the support. Our center of gravity is usually just about at the very center of our chest—from side to side and from front to back. If we stand on both feet, weight even, this center is directly over a point midway between our feet, even with our ankles. If we stand on one foot, the center of gravity moves directly over that foot. Usually, we stand with most of our weight on one foot and some on the other, so our center is over a point near the weight-bearing foot. Observe this carefully in the model, and be sure your sculpture corresponds (Figure 5-33).

Understanding the Figure

The human body is among the most complex things we can observe, yet it follows several elementary rules that always apply. The most important are: the chest contains an egg-shaped ribcage; the hips contain a box-shaped pelvis; and the two move relative to each other (Figure 5-34). The portion of your spine that is between the ribs and the pelvis (the *lumbar vertebrae*) is the hinge of the trunk, and the place where most of the bending occurs. Some bending happens in the ribcage itself, as, for example, when you bend over backwards or hunch over frontwards, but most bending takes place in those five important vertebrae between ribs and pelvis. What this means is that the ribs are often aligned in a different direction from the pelvis. Sensing this difference of alignment and conveying it in clay is the key to modeling the figure.

Structure. When we draw or paint, we can create the illusion of depth on a flat surface. With sculpture, there is no illusion of depth—the depth is real. In sculpture, however, we create the illusion of hard and soft, or the feeling that there is something under the skin. This is at the heart of modeling the figure, since the human body is composed of hard forms under a skin.

The key is to sense the angle of the ribcage, which is always egg shaped, lying under a tube of skin, and then the pelvis, lying often at a different angle under the skin of the hips. Seeing the angles of the ribs and hips and rendering them is the primary task in making a figure.

Look at the model from the side (Figure 5-35).

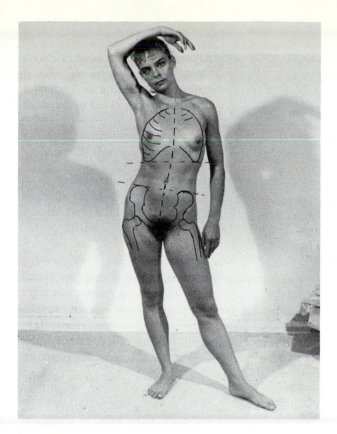

FIGURE 5-34 Relationship of ribs and pelvis from the front.

You will notice that the ribs lean slightly back, and the hips angle slightly forward, giving a slight swaybacked look to the figure. That subtle curve is essential. Don't stand the ribs straight up on the hips as if you were stacking boxes, or your figure will be awkward and rigid.

When a person stands naturally, weight mostly on one leg, that leg presses up and tips the hips (Figure 5-36). The other leg bends a little at the knee, placing the hip on that side closer to the ground. From this tipped platform, the spine rises, then bends to correct, so that the ribs lean just slightly the other way, usually putting the base of the neck directly above the crotch. This curve, which occurs up the entire body, is called *contraposto*; it is what gives life and animation to the standing figure. It must be carefully observed. Draw center lines in your clay, indicating the curve, and get it right both front and back.

The leg on which the weight rests curves back, then forward, placing the ankle almost directly underneath the center of the body, while the other leg usually moves forward and out from the body, then back and in after the bend of the knee. When a person stands in a relaxed position, the bent leg often rotates away from center a little.

FIGURE 5-35 Relationship of ribs and pelvis from the side.

FIGURE 5-36 Pelvis tipped with the weight on one leg.

Anatomy. There is no room in a book of this sort for any detail concerning the bones and muscles of the body, but I urge you to study books on anatomy and to become familiar with the major muscle groups. Don't worry too much about the deep-layer muscles, since you can't see them, but concentrate on understanding the basic shapes of the major superficial ones, such as the *deltoids*, the *pectorals*, and the *latissimus dorsi*, and so on. Musclemen posing all greased up in bodybuilding magazines often isolate various muscle groups so they can be seen clearly. Use such photos as reference only, and limit your creation of sculpture to a direct response to the living model before you.

Artistic considerations. A word of caution. Avoid creating "calendar art," that is, the extreme mannered look of the professional poser that we see in such places as muscle magazines or men's magazine centerfolds. Your aim in working from life is to confront life, in the form of a living model in a real pose. The heart of sculpture is dealing with the endless complexities of form, structure, balance, proportion, and humanity.

To understand better what I am talking about, study sculpture. Study it in books, museums, and galleries. You can never see too much sculpture, or look at it too closely. And think about it. Think about why humans have insisted on making images of themselves, and what those images mean. Read what artists, critics, and historians have said about figure sculpture, and try to form your own ideas about what you want to say with this new language you are learning.

Beware also of histrionics, that is, figures gesturing in extreme pain, agony, or bliss. The best way to avoid corny, trite sculpture is to concentrate on form and structure. Look at Cézanne, look at Matisse, look at the Egyptians and the Greeks, look at Hindu sculpture, look at Moore, and Manzu, and Marcks. Look, look, look! And work. You never exhaust the potential of modeling the figure. No matter where fashions in art may lead, we will always feel a need to make images of ourselves.

RELIEF SCULPTURE

Relief sculpture is a different ballgame. Technically, in terms of handling the clay, it is easy, since there is little problem with armatures. As discussed in Chapter 4, you do need a good support and a way to hold the relief vertically like a painting on an easel. Don't try it flat on a table, since that is very difficult.

Kinds of Reliefs

Looked at from a mathematical viewpoint, the relief is a set of three coordinates—side to side, up and down, and front to back. The side to side and up and down coordinates are left alone in a relief, and the front to back (or depth) is shortened in varying amounts. Traditionally there are four types of relief. Reliefs are classified arbitrarily according to the amount of shortening of the depth. In *high relief* the depth is shortened very little, if at all (Figure 5-37). In *mezzo*, or *middle, relief* it is shortened about halfway, producing figures that project but do not curl around back (Figure 5-38). *Bas* or *low relief* (pronounced "bah," not "bass") is flatter still, like a coin. *Secco*, or literally *dry relief*, is extremely flat, with so little projection that it is almost drawing. This relief (Figure 5-39) shows several kinds of reliefs in one work.

Creating a Relief

Drawing. Drawing is the key to a good relief. If the drawing is right, the relief will look right. If the relief looks wrong, it is because the drawing is wrong. A good way to work relief is to draw, then model, then draw again, then model again, going back and forth, to constantly sharpen the sense of observation in a drawing sense. When working in the round, you must move around the model all the time. In contrast, when doing a relief, you must fix yourself in one spot and never move.

Controlling light. To obtain effects of light and shade, you simply tip surfaces. A surface tipped back will catch light and look bright, and one tipped towards you will collect shadow and look dark.

The degree of projection. If you were making a relief of a beer can, a high relief would have a mostly complete beer can attached to a background. A mezzo relief would have about half a beer can stuck on a background. A low relief would have a very flat beer can on the background. However, the cross section of the low relief beer can would not be a perfect arc. Instead, it would rise quickly to full height, move almost straight across, and drop back again into the background.

Take a coin out of your pocket and study the way the edge of the face rises quickly to full height, then moves straight across. There is some gentle mounding throughout the form, but generally it rises faster at the edges. If it didn't, the edges would be so flat that they would be indistinct. A secco relief beer can would be little more than edges, with roundness indicated by such things as the drawing of the curves on the ends of the can.

So the whole idea of relief is trickery. It is not realistic, but is a clever device to imply a three-dimensional image. Again, as a last word on relief, think drawing.

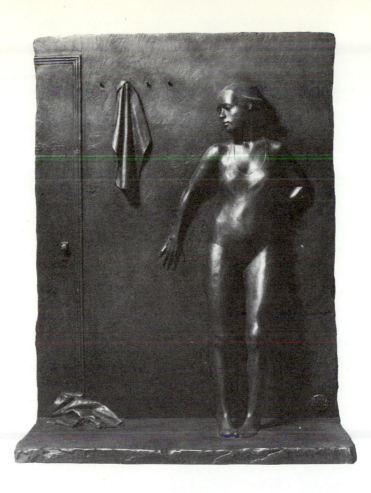

FIGURE 5-37 Tuck Langland,
Swimmer Alone. 1980, bronze.
Collection of the artist.

FIGURE 5-38 Tuck Langland, Adagio with Landscape. 1979, bronze.
Collection of Indiana University at South Bend.

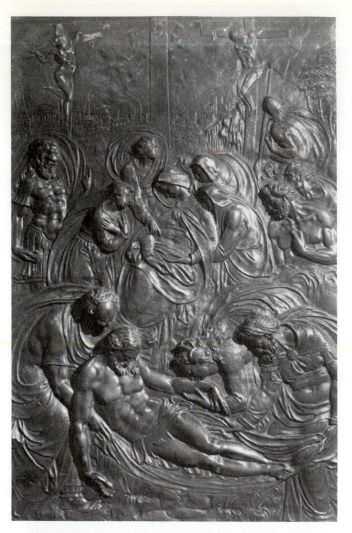

FIGURE 5-39 After Gugliemo della Porta, The Descent from the Cross. Italian, 16th Century. Snite Museum of Art, Notre Dame, Indiana.

MODELING OBJECTS FROM LIFE

I'm not speaking here of abstract form, which I will discuss in Chapter 6, but rather of the re-creation of objects, like teacups, books, or even drapery, in clay. An interesting example is this work by the English sculptor, Dorothy Haworth (Figure 5-40). She has modeled a most untypical subject, a small fragment of a landscape. Her work demonstrates that virtually anything can serve as a subject for representational or semirepresentational sculpture.

I can only make a few generalizations about modeling objects. The key is observation. As mentioned early in this chapter, your observation must be analytical. The reason we spent so much time discussing how to navigate around the profile of the head is because that same method can be used for observing just about anything. Break down whatever you see into a series of profiles, and then a series of segments, each of which has angle and distance. Get each angle and distance right, and each profile right, and the solid three-dimensional form will appear. Sooner or later you must leap between the profiles and simply make form, but this technique allows you to grapple with complex forms with some method, some way to keep control.

Drapery

Drapery is a special case. Most people are covered with drapery most of the time, and when dealing with the figure it becomes necessary, sooner or later, to deal with drapery. The problem is that there are as many

FIGURE 5-40 Dorothy Haworth, Late Summer. 1978, bronze. Collection of the Kirklees Education Committee.

different types of drapery as there are different kinds of cloth, and it won't hold still. When the model moves, such as to take a break, the drapery moves. It will never be the same as it was. Practice making drapery from something inanimate. Drape a box or pot and model from that. Once you have become familiar with the way cloth folds and moves, you can work from the living model by quickly blocking in the major lines of drapery during a single session, then working them up later from memory and familiarity.

Kinds of drapery. The word *drapery* seems to imply a flowing Greek toga sort of thing, but of course it simply means cloth. It is doubtful that you will want to make antique drapery, but highly likely that you will deal with contemporary clothing. Blue jeans are drapery; they have a particular tautness and feel, as do heavy wool coats or thin silk blouses. While all cloth follows similar general principles, different kinds of material have different particulars, and they must be observed carefully to "read" as the kind of cloth it really is.

Learning to do drapery. Helpful discussions of the particulars of drapery can be found in various sculpture books. The best way to learn it is from experience, although some advice is helpful. Study the way a fold *breaks*, when it bends, and the *eye* that it forms (Figure 5-41). Cloth almost always bends in simple curves (see Chapter 1). It only bends in complex curves in certain long curves. This point is important. Think of cloth as *always* forming cones or cylinders, but never balls or saddleshapes. Pay as much attention to the bottom of a

curve as the top. That is, the cloth forms waves whose tops stick right out at you and are easy to work. The troughs of the waves, however, form the same kind of curves and need just as much attention (Figure 5-42). Cloth is very thin. Where it lies against the skin it is so thin that you don't need to add any clay at all. You only need it where the cloth pulls away from the skin.

The next chapter will deal with abstract forms modeled in clay, but I'd like to close this chapter with this thought: All forms are abstract, but some remind us of things more than others.

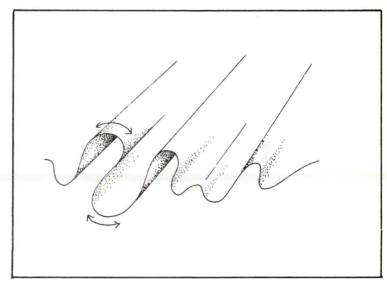

FIGURE 5-42 Curves at the top and bottom of folds in cloth.

FIGURE 5-41 An *eye* in a fold of cloth. (Notice the cylindrical and conical sections.)

SIX

Abstract Modeled Sculpture

Abstract art is one of the most important artistic movements of the twentieth century, but since midcentury abstract sculpture has usually been created with means other than modeling. Is modeled abstract sculpture then no longer valid? The answer is that modeling is a way of creating a wide variety of forms, and thus it is highly appropriate for any kind of sculpture, whether realistic or abstract.

Abstraction versus Realism

The previous chapter concluded with the idea that all forms are abstract, but that some remind us of things more than others. That's a good way to look at representational art, which, no matter how real it looks, is never "real" in the sense of being the object portrayed. It stands at a distance, separated by a change in material, scale, color, or other qualities. It is not usually the similarities of a realistic work of art to its subject that is of interest, but the differences. Even a sculptor like Duane Hanson (Figure 6-1), who casts sculptures directly from his models and then colors them, adds hair and dresses them in real clothes to look as real as possible, is ultimately dealing with the idea that they are not real. He places a person made of resin and paint in a gallery, and it looks just like a real person standing there. The interest for the viewer lies in the discovery that she isn't real, but a work of art. Imagine an artist hiring a real woman with a shopping cart to stand in a gallery. How pointless that would be!

Art as metaphor. But beyond that, there is the idea that art creates a new, consistent world, a world in which things mean different things than they do in this world. Art lives on suggestion, inference, implication, and symbol—not the literal depiction of reality, which, in any case, is impossible. When the first cave artists took a charred stick and began to draw the outline of a bull on the wall of the cave, they never intended that the marks would *be* a bull, only that they would *mean* one, or be a substitute for one. And that was enough. Naturally, the closer those lines came to looking like a bull, the easier it was to believe one saw a bull, but no amount of accuracy could change those drawings into a living, breathing animal. Realism has rarely been taken as the primary goal by artists, but is most often used as a means to other ends.

Metaphor means describing something in terms of something else. A good example is the phrase "Mother Earth." Metaphor is an important tool of poetry, and it is also crucial to representational art. It is often the second or third level of meaning lurking below the surface that makes art alive.

In *abstract* or *nonobjective* art the need to appear like some other object is eliminated, and the artist works with line, mass, color, and balance for their own sake. Such works are not fundamentally different from representational works; in both the artist is concerned with the manipulation of form in space. Both kinds of art are communication. Much abstract art is involved with metaphor, inference, and suggestion. Some, however, particularly *minimalist* works are intended to exist only as what they are, without added meaning beyond their presence.

To understand the nuances and implications of contemporary art, you must visit as many galleries of contemporary work as you can, and read as much as you can about it. I urge this not because you should ape current styles, but because more knowledge is better than less knowledge, and understanding is more useful than knowledge alone. Contemporary art is a field of vast complexity, subtlety, and variety. Things are rarely as simple as they seem. Works that mystify you, that sug-

FIGURE 6-1 Duane Hanson, Supermarket Lady.
1970, polyester resin, fiberglass, polychromed in oil.
Courtesy O.K. Harris Works of Art, New York.

gest the artist is fooling the public or has no ability, often contain levels of meaning not immediately obvious. You must study and contemplate them to perceive and understand them. It is often true that the simplest work in appearance is the most complex to unravel. Don't give up too soon. Work at understanding. What is needed in contemporary art is not harder work, but harder thinking.

Sculpture can, and does, move easily between representation and abstraction. There is no barrier. All representational sculpture has some abstract interest, and I believe all abstract sculpture has some element of representation. In fact, it is impossible to create a form which does not remind someone, somewhere, of something. The wonderful thing about the human brain is that it is such an enormous garbage can. It seems to keep every piece of junk tossed its way, dragging them up in dreams and flashes of memory and association quite beyond conscious control. As conscious creatures, we seem to be riding a great beast that we do not control, and that beast is the sum total of all our memories, all our experiences. And, though no one is sure of this, some suggest that our brains also contain vast amounts of information inherited from a thousand generations previous to our own birth.

The subconscious. Most information in our brains is locked away from our conscious thought. We cannot gain access to it at will; rather, it seeps and oozes out at odd times, and may elude us when we want it most. How can such a system possibly communicate with another similar system? One way is through art. Art has the capacity to trigger memory and association. Art heads right past the living room of the brain and goes straight for the attic, where it rummages around all those dusty old trunks of memories we never even knew we had. That, I believe, is why art appears to be the earliest form of recorded communication among people, and has not lost any of its power in the centuries since.

Because art operates on the level of trigger and prod, realism or abstraction is not the issue. Arguments about the relative merits or validity of these two poles of the artistic spectrum miss the point. They are both part of a continuum, and thus are ends of the same stick.

In the discussion of figure modeling, I emphasized attention to form as a pure thing outside the requirements of anatomical accuracy. The head is a sphere, the torso is a cylinder. These abstractions lie at the heart of all sculpture, no matter how realistic or abstract. The abstract structure of a sculpture determines the sculpture.

If it is weak in the abstract sense, it is weak. Period.

So creating abstract modeled sculpture is not a departure from life modeling, but a continuation of it.

GETTING IDEAS

Experience

When giving a talk on his work, Neil Simon, the playwright, was once asked, "Where do you get your ideas?" He answered, "Schenectady." The question was silly, since the answer was obvious. Writers get their ideas from life. Only an extremely insensitive writer could walk even one block in a city and not see something to trigger an idea. It is the same for an artist. We assume that artists are people whose eyes perceive a lot, and who are more sensitive to what they see than to what they perceive with the other senses. But seeing, like anything else, can be enhanced by concentration, effort, and training. It's not enough to drift through life experiencing everything. The artist must look closely and deeply at nature, at the world, and at art in order to create objects that communicate with other people in a visual way.

Hidden memory. Henry Moore is a perfect example of an artist involved in "abstract modeled sculpture." While many of his works relate strongly to the human figure, many others are removed from such imagery and depend on such natural forms as rocks, shells, bones, or trees. About the time Moore created his massive Lincoln Center *Reclining Figure* (Figure 6-2), he mentioned in an interview that as a child his family had gone for picnics to a spot in Yorkshire where he remembered a great rock jutting up from the earth. The interviewer tracked down the spot and saw the rock, which was very much like the upright portion of the Lincoln Center piece. That natural form had been lying dormant somewhere in Moore's mental attic, and only then had come out. The point is that, for Moore, there was no such thing as "getting ideas" since he already had enough ideas for a lifetime of sculpture. The problem was in digging them out and turning them into sculpture.

The task of the artist is not so much to seek external ideas, but to liberate internal ones. A famous quote states: "How do I know what I think till I've heard what I've said?" There is a lot to that idea.

Henry Moore found that certain kinds of things attracted him. When he and his friends went to the beach, while others swam or played games, Moore found himself collecting stones with interesting shapes. He didn't do it because he thought he ought to do it, but because they interested him. Many of the Pop artists of the Sixties found they were more interested in billboards or cigarette wrappers than they were in landscapes and posed nudes, and they reflected this in their art.

FIGURE 6-2 Henry Moore, Two-Piece Reclining Figure. 1963–65, bronze. Lincoln Center for the Performing Arts, New York; photograph by Ezra Stoller. © ESTO.

So the first rule for "getting ideas" is to be open to your environment and open to what attracts you. Given the variety in the art scene, it is pretty safe to say that nothing is inappropriate as a subject for art.

What to avoid. In my view, however, there is an area that ought to be avoided, and that is an area that is heavily drawn upon for "art ideas." I mean the art magazines. There is probably more art created today in response to art seen in magazines than from any other single source. Because of a desire to be "with it" and to create work on the "cutting edge" of art—whatever that is—art students and others buy the newest publications and page through them, looking for something to do. Freshman art students in Kansas end up turning out works that look just like those in the latest SoHo exhibitions. It is far better, in my opinion, to create works that come out of your own uniqueness as an individual, than to toe the current party line. New art automatically becomes old art with the passage of time, but good art never becomes bad art with time.

Form and Material

So far I have been talking about sculptural ideas that come from nature. The forms of rocks, bones, and shells, not to mention the human body, provide a never-ending source of imagery for the sculptor. But what, you might ask, of other kinds of forms, such as geometric or mechanical, minimal or conceptual? I am suggesting in this chapter that modeling is more appropriate for the kinds of forms we find in nature, and that other materials and processes lead more naturally to other kinds of forms.

Modeling usually leads to sculpture that is monolithic, a solid mass. It also lends itself to forms that constantly modulate and change. It is not the best method for things like cubes and boxes. It is quite unsuitable for open constructions. As with any kind of art, the material determines the form, and the form determines the material.

Imagined variations. Instead of just walking through the woods and making drawings of lumpy natural forms, you might try to begin to think not just about shapes, but about processes. What does a lumpy rock look like when cut cleanly with a diamond saw? The rock is a natural form, the sawcut an artificial form. What combinations of natural and artificial forms can you think of?

What happens when you begin to repeat forms? Nature creates only one each of every twig, leaf, and pebble. But as an artist you can mold and repeat them.

What about combining forms? Can you conceive of two or three forms that never occur naturally together, but might be interesting if they did?

Shapes come from areas other than the visual. For example, you could conceive of shapes that express the feeling of leaping into the air or sinking into a deep pool.

Try to invent a form that you've never seen. It's tough. I mean, don't just make a shape that you haven't specifically seen before. Invent a form with the order and logic of an orange slice or a turtle shell, but one completely new and fresh. The trick here is to study nature, and see what kinds of logic it applies to the many forms it creates. Then try to create your own logical pattern, and then make a form to fit.

Make the most beautiful form you possibly can, by your own private standards of beauty. Actually, when you do that, you will be an artist.

DRAWING FOR SCULPTURE

The best way to run through lots of ideas is through drawing. Paper is cheap, and you can scrawl out the craziest, daftest things with no big loss. One way to open all those old trunks of memories in your brain is through stirring up ideas by free association. Take a small sketch pad with you, and draw whatever comes to mind in spare moments. Looking back through pages of odd ideas, you will often find things that are interesting—terrible, maybe, but interesting—and that can be developed further. Often developing an idea is like inventing the light bulb. How many filaments did Edison try before he got one that worked? It would have been easy for him to give up somewhere along the way, but he believed in his original idea, and kept going until he found a way to make it work. The Wright brothers' first airplane was a pretty lousy airplane but the idea wasn't too bad. So work with rough scribbles or dumb concepts in order to extract what lies beneath. You may find something that you can develop.

Drawing from Imagination

Drawings are hard enough to do when you're trying to draw something you can see, but they're even harder when you're trying to draw something that doesn't exist. One way to improve your ability is to work at it, by sitting down for practice drawing sessions. Set an object like a teapot in front of you and draw it. Then, without moving it, draw it as seen from the other side, above, or below. Draw it fattened out, or tall and skinny. Then draw an object that you know well—say, a chair in your house—but that you can't see. Again, draw it from different angles. Learn to visualize an object in your head. It is possible to learn to "see" something clearly in your mind, almost as though it was in front of you. Some chess masters learn to play without a board, and can see the game so clearly that they get confused when they

have a real board before them. It was said of Beethoven that after he went deaf, with the noise of the world silenced, he heard music of much greater purity and clarity, and only then did he write his greatest masterpieces.

Another thing to work at while drawing this way is to see things that are normally invisible, like cross sections. Try to dissect a form in your mind, and draw it taken apart. Again, paper is cheap, so don't worry about crumpling up sheet after sheet. You'll get better. You'll learn to visualize better and to draw what you see in your mind. You will develop the ability to draw forms that only you can see or imagine, which is the first step towards making them.

SMALL MODELS

The next step is to make small models of what you have in mind. The term many sculptors use for small models is *maquette* (pronounced "mock-ette"); *bozetto* is the Italian word for the same thing. No matter how well you visualize something, you never see it as clearly as when it exists, so select from your drawings and make maquettes. Clay is a great material for this, but plasticene or soft wax is even better. The idea is not to make a miniature sculpture, but to create something that has the masses and forms in roughly the right relationship, so you can see it and hold it in your hand, feeling it as an object, instead of just an idea. Wax needs no armature, can support itself even in very thin forms, and will not dry out. Another advantage is that, should you create a maquette which is particularly nice, it can easily be cast into bronze directly from the wax.

Have a lot of wax or plasticene on hand, and make lots of maquettes. Don't just mush one bit of stuff around again and again or you will lose your earlier ideas. If you make lots of maquettes, you can line them all up and look at them.

Work from a successful maquette, making changes by creating a new one, rather than changing the old one. The reason is twofold: first, you don't lose the original source of your idea; and second, you become more familiar with it by making it again.

Plan on making ten drawings for every idea you model, and making ten maquettes for every one you enlarge. Those are only suggested numbers, of course. You must rummage around in that attic of yours for a long time before you come up with good ideas. Often you will make maquettes, and months or years later dig them out and work them some more.

ENLARGING

Little wax maquettes are nice, but sooner or later you will want to make a real sculpture, which usually means a big sculpture, at least bigger than the little thing you

FIGURE 6-3 Maquette of **Polymnia** in enlarging frame. (Note the sturdy wood uprights to resist movement, and the adjustable cross piece and depth needle.)

hold in one hand. That means enlarging, but enlarging needn't mean a suspension of all artistic input in the midst of a purely mechanical process. Actually, enlarging is a creative activity in itself, as well as a useful technique, and it usually contributes to the quality of the final work.

The principle of enlarging is to take a series of measurements from various key points on the maquette, which are increased proportionally and transferred to the enlargement. These measurements are generally taken from a single key point, or *master point*, and consist of *up*, *over*, and *in* measurements.

The armature. First, make an armature at the full size, using methods described in Chapter 4. You might use slides of the model for this preliminary enlargement. The next step is to turn the maquette and the armature to face the same way. Third, establish a size ratio for enlarging, such as double or triple, and use it for all measurements. Fourth, make a measuring frame for both the maquette and the enlargement. The two frames should be in the same ratio as your enlargement ratio, and positioned exactly the same in relation to maquette and sculpture. Figures 6-3 through 6-9 show such frames, and they may explain the process to you more clearly than a lot of words. Notice that the frames are made so they can stand either in front of or behind both maquette and sculpture, so measurements can be taken from both sides.

Once the frames are made, it is a simple task to begin measuring. To save time, make a scale for each

FIGURE 6-4 Basic armature for enlarged **Polymnia**. It stands on a turntable, and behind it is the full-size enlarging frame.

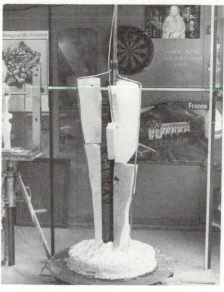

FIGURE 6-5 Styrofoam blocks loosely inserted in an armature to take up volume.

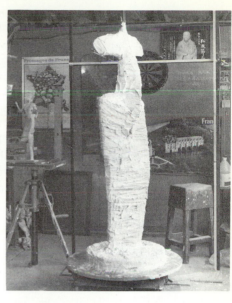

FIGURE 6-6 An armature wrapped with plaster-soaked cloth ready for clay.

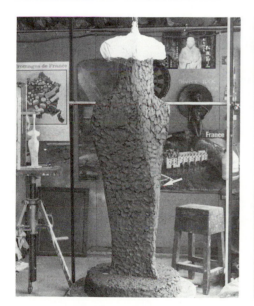

FIGURE 6-7 First layer of clay being applied. The white arrow indicates the tip of a small stick placed to indicate a point taken from the maquette.

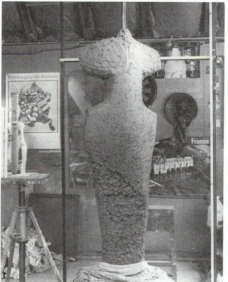

FIGURE 6-8 The final skin of clay going on. (Notice that the neck, which is thin and can dry out, is being saved for last.)

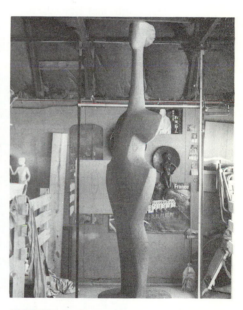

FIGURE 6-9 Clay enlargement complete. The enlarging frame can be seen behind the piece. The wooden fence-like affair on the left of the photo is part of a scaffold to reach the top.

frame. For example, I copy a centimeter scale onto the small frame, then make a proportionate scale on the large frame. I do it by making pencil marks on strips of wood. If my enlargement is three times, I make every mark three centimeters apart, and fill in the tenths. I number the marks, and then I can read directly from small to large without having to multiply everything.

The process. Once you begin making measurements, use bits of clay and little sticks, such as wooden matches, to record those points on the sculpture. Gob some clay on the armature, and put a short stick in it, so the end of the stick marks your point. A stick is visible at the arrow in Figure 6-7. As you fill in with clay, build right up to the sticks until just their tips are showing. At

that point you can pull them out, because you won't need them any more.

Don't spend too long with the measurements and the points, but use them to establish an enlargement that really starts to look like your piece. Then you may take the frame away and just make sculpture. You can skip this whole process, of course, and just model from profiles, like life modeling. This often works. But using an enlarging frame is better the larger you go, since it becomes more and more difficult to make changes in large work. You need to be as sure as possible of where the big forms go, and enlargement by this method can save a lot of time.

WAYS TO WORK TOWARDS ABSTRACTION

Types of Abstraction

Abstract sculpture uses two types of forms: those that seem to derive from something seen, but have been changed into pure form; and those that come from the realm of things not seen, which are completely *nonobjective*. The works of people like Moore (Figure 6-10), Hepworth, and Brancusi are of the former category, while the works of sculptors like Donald Judd, Tony Smith, and James Rosati (Figure 6-11) are of the latter. This piece by the English sculptor Dennis Westwood (Figure 6-12) was inspired by sailboats, yet is clearly an abstract sculpture, while this work by Yvonne Tofthagen (Figure 6-13), although similar in feeling, originated from purely nonobjective sources.

Selecting a starting point. The derived sort of sculpture usually begins with some form the artist has seen and been interested by. Often sculptors see an object, draw or model it, then put it through a series of alterations and modifications until they come up with something quite different. The starting point can be just about anything, from the human figure, to artificial objects, to natural forms, even to other sculptures. Anything can serve as an idea for abstraction.

Running variations. Once an image, or several images, have been selected, it's a good idea to begin to transform them in various ways, to see how the transformations alter the original. Here is a list of some of the kinds of transformations you can use. I'm sure you can add to this list with many more concepts of your own.

Isolate a portion of the object.
Slice through the object at various planes.
Enlarge a small section.

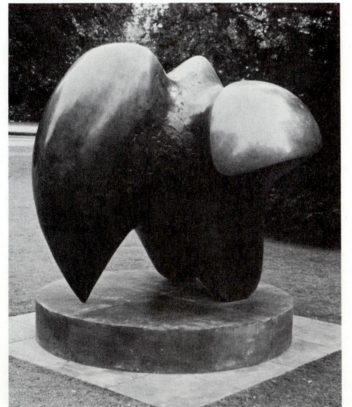

FIGURE 6-10 Henry Moore, Three-Way Piece No. 1, Points. 1964, bronze. Battersea Park, London.

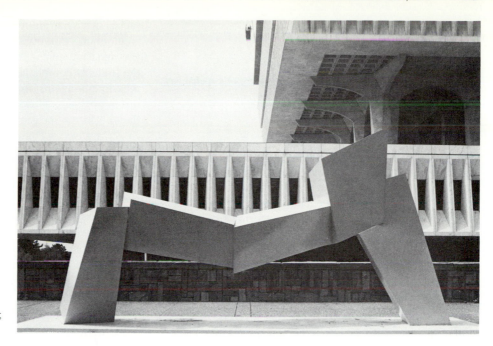

FIGURE 6-11 James Rosati, Lippincott I. 1965–67, painted Cor-Ten steel. Albany, New York; photo by William Knorr.

FIGURE 6-12 Dennis Westwood, Odyssey. 1985, bronze. Courtesy of the artist.

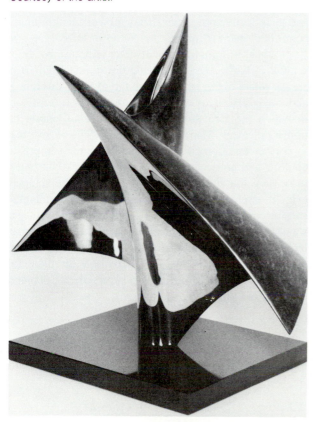

FIGURE 6-13 Yvonne Tofthagen, Windflower I. 1979, polished bronze.

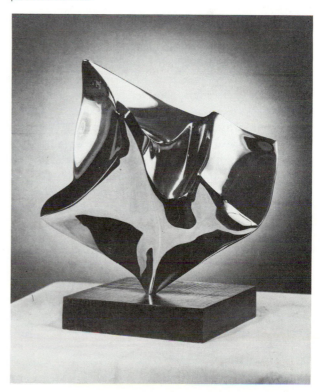

Compress or stretch certain parts.

Combine forms, to simplify.

Look for underlying geometric forms.

Let your imagination take over, and let the object change and grow without restriction.

Inventing Forms

Another way to approach abstraction is to invent forms in your mind, without basing them on objects actually seen. Because of the way the human brain seems to work, coupled with our educational system, the first things that come to mind are geometric forms, like boxes. These are usually the sorts of forms that are best made with materials other than clay, but clay becomes the material of choice when you make certain alterations.

Imagine, for example, beginning with a reasonably well-made cube of clay, about one foot on each side. That's a pretty large mass of clay, but it can be built up fairly quickly with no armature. Now you can begin making the kinds of alterations mentioned above—cutting, pressing, squeezing, repeating—until something completely different emerges. The idea here is not to make a sculpture, but to manipulate form, and to discover how one shape can soon become something completely different. Working without restrictions, the most amazing things can happen to that block of clay. And if you have a bad idea, it's just clay, and can be stuck back together at any time.

Restrictions

Most of the great art of the past was made under conditions we would consider restrictive. Much art was commissioned by the church, which had strict rules about iconography, materials, and even facial expressions. Yet masterpieces were created. These restrictions, rather than holding the artists back, actually gave them greater creativity. Some years ago, while teaching beginning sculpture in Sheffield, England, my colleagues and I tried an experiment. We told the class to make clay towers, with no hint of what they were to look like, only that they were to be exactly 12 inches tall and no more than 4 inches across at any point. As the students worked, we went among them with rulers, commenting only on the two measurements. Interestingly enough, even though the students complained bitterly about these restrictions, they fought against them and produced towers of wildly different types, showing a great deal of creativity (and they all fit the measurements!).

In a second project some weeks later, we again told them to make towers, but this time we removed all restrictions, and let them do anything they wanted. After some uncertainty, one student began, and then the others more or less copied that student. In the end all their towers looked similar, showing far less creativity than before (and they were all close to 12 inches high and 4 inches across). The moral of the story is that when people are confined, they fight for freedom. When people are given freedom, they tend to seek direction.

Thus restrictions will usually strengthen art. Since we don't get restricting commissions from church or prince any more, we must supply restrictions for ourselves. Look at important contemporary sculptors, and notice the self-imposed restrictions. Sol le Witt works almost exclusively with open cubes in mathematical relationships; Kenneth Snelson limits himself to tension-based constructions; Larry Bell deals only with coated glass and its reflective properties. They all work within tightly controlled, *self-set* limits.

Thus, it is not true that abstract sculpture is "free" sculpture, while figurative sculpture is restricted. Both are, or ought to be, restricted, in the sense of disciplined and controlled. This even applies to *expressionistic* art, in which the free flow of the artist's emotions is the primary element. Many actors and musicians believe that, to portray emotion, it is important to remain in artistic control, and not to feel the emotion yourself, but rather to be sure the audience feels it. Likewise the sculptor, even if expressing powerful emotions, must maintain careful control to avoid a self indulgent display of personal feeling. To understand this, look at the great masterpieces of emotional art of the past, such as Van der Weyden's *Descent From The Cross* or a turbulent Rubens. The demands of art always supersede the demands of emotion.

SEVEN

Making Clay Sculpture Permanent

Turning Clay Hard

The whole idea behind modeling is to manipulate a soft material, and then somehow turn it into a hard material. There are two common ways of doing this.

The first is to select a soft material which can, by its own nature, become hard. A perfect example of this kind of material is clay, which can be modeled while soft, then dried and fired to become hard. This is the method discussed in this chapter.

A second way is to use a soft material and then substitute a hard material for it through the casting process, with some kind of mold. This is a very common process, with almost endless complexities, and it will form the main thrust of the next three chapters.

CLAY AS A MATERIAL TO BE FIRED

The most obvious way to turn soft clay into hard sculpture is to fire the clay. We now enter the world of pottery. It is not the aim of this book to dwell for long on ceramic sculpture or ceramic techniques, because this book would become much longer than it ought to be, and also because there are already dozens of very good books on the subject.

We can, however, cover a few general points to give you some idea of how to begin with ceramic sculpture. The bibliography at the end of this book lists several appropriate books to take you further, should you wish.

Clay for Ceramic Sculpture

Almost any natural clay can be fired. There are a few requirements, however. The first is that the clay be clean. Clay that you purchase has already been purified of nonclay elements. It is very important to prepare clean

work surfaces and to avoid using the clay near people using plaster. Do not put back hunks of clay that have fallen on a dirty floor. Plaster is the chief enemy of fired clay. Small bits of plaster are usually found around sculpture studios, and they get into clay easily. The bits of plaster retain moisture during the drying process and then release it all at once in the kiln. They may pop out hunks of the clay in tiny explosions, sometimes even shattering the piece and neighboring pieces.

Consult pottery books, or the pottery department of your school, about what kinds of clay are available in your area. Generally, you will deal with two sorts: low-firing *earthenware*, and higher-firing *stoneware*. The traditional terra cotta is earthenware; it is softer after firing, and usually presents a more uniform surface color. Stoneware fires harder and often becomes slightly speckled on the surface. In general, earthenware is more suitable for sculpture than stoneware, depending, naturally, on what sort of sculpture you contemplate.

THICKNESS OF THE CLAY

It is very important to think about the thickness of the clay from the very beginning. You generally cannot fire clay that is thicker than an inch at any given point, and should aim for an average thickness of about ¼ to ½ inch. Therefore, unless your sculptures are very small, they must be hollow, and that takes some rather careful thinking and planning from the beginning. One thing you can do to allow your clay to be fired thicker is to add *grog*, or sand, to it. The more grog and the coarser it is, the thicker your piece can be, but of course the grog makes the clay gritty, giving the surface a different quality. This can be an advantage or a disadvantage, depending on what you are after, but it must be considered.

Grog or no grog, sculpture of any size but the tiniest must be hollow. There are four ways to make clay sculpture hollow.

Hollowing Out

First, you can build it solid, and dig it out from below. Suppose you are making a sculpture that looks roughly like a pyramid. Make it solid on a board, and then let the clay become somewhat harder than modeling consistency. Because clay changes hardness when it loses moisture, and gets harder on the surface than inside, you can dig out the relatively soft inner areas without deforming it. So let the clay stiffen, then turn it on its side on a cushioned surface, and carefully hollow it out from the bottom. You can easily feel the thickness of the sides, and work towards a thickness of ¼ to ½ inch all over. Try to avoid big differences in thickness, such as thin spots next to thick lumps. Uniformity helps.

This technique works for many sculptures. I used a pyramid as my example because it is an easily understood form, one perfectly suited to this technique. If you look at the terra cotta sculptures in museums, you will see many that have a pyramid shape, even though they may in fact represent a cluster of erotically entwined bodies or whatever.

Cutting and Hollowing

A second technique is a variation of the first. It involves cutting a sculpture into two or more parts, hollowing out the parts, and sticking them back together. Suppose you make a portrait head on a head peg. Proceed as usual, and when you finish modeling, allow the head to harden somewhat. Using a long thin knife or a wire with two handles, cut the head in two, making the cut in a place that can be restored without too much bother. The usual place to cut a portrait head is vertically just behind the ears, or perhaps behind one ear and in front of the other.

To remove the two halves from the armature without distorting them, use a long blade. Reach in and slowly work one half loose. When it is off, you can easily dig the other free. Then you can hollow out the two halves in the same way as you did the pyramid.

A trick that helps with this job is to fill the center of the head peg, or other armature, with something else besides clay. Tightly wadded newspaper works, and the clay comes off easier, and already partly hollowed. Or, cover the inner mass of clay with a thin plastic bag and add the new clay over that. You can place a long thin wire on this inner form in such a way that it can be pulled out later, cutting the clay in half (Figure 7-1).

Joining the halves. After you've hollowed them out, you must join the halves back together. If this is done badly, a crack will appear at the join after firing.

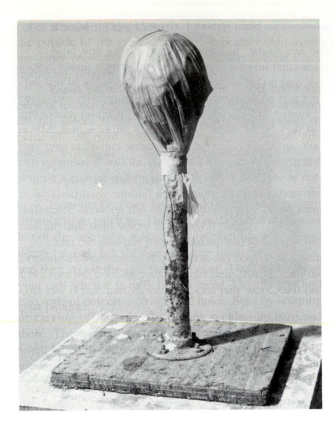

FIGURE 7-1 Head peg with the inner clay form covered with a bag to ease removal of clay head. (Note the wire in place which can be pulled out later, cutting the completed head in half.)

To do it well, first make sure each half is about the same hardness, that is, has the same moisture content. If one half has dried more than the other, they will change size relative to each other while drying, and crack, so this whole operation should be done more or less in one go, to keep everything the same.

Next, score each side of the mating surfaces with a needle. Use little hatching strokes (Figure 7-2) to roughen these mating surfaces. Mix some slip from the same clay. An easy way to do this is to form a cup of soft clay, put a little water in the cup, and swirl a brush around in it, making a puddle of slip (Figure 7-3). Brush this slip onto both mating surfaces, working it down into the little scratches (Figure 7-4). Now press the two halves together well. If you can reach inside, take a needle again and "stir" the clay together over the joint. Then smear it smooth with a finger or thumb. If you can't reach inside, you can do a little of that from the outside. Rework the area over the seam to resemble the rest of the surface, and then let the piece dry slowly and evenly before firing.

Building Hollow

Building with slabs. There is a third way to make clay sculpture hollow for firing, and that is to build it hollow. The most obvious way to build hollow is to use

FIGURE 7-2 Scoring the edge of clay for joining.

FIGURE 7-3 Making clay slip in a bowl of clay.

FIGURE 7-4 Brushing clay slip on the scored edge.

slabs of rolled out clay. Roll them out when soft, allow them to stiffen a little, and then join them. Use the slip method described above if they are very stiff. Otherwise just knead them together. See Bruno Lucchese's book on terra cotta sculpture for a complete discussion of this technique. He describes how to build human figures hollow, directly from slabs. The techniques he demonstrates are applicable to virtually any sculpture you might want to make with this method. You can also invent your own techniques.

Coiling clay. Another way to build hollow is the coil technique. This is just like making a coil pot (any elementary ceramics book will describe how), but you make sculpture instead of pottery. The trick is to build from the bottom up, letting the work stiffen before proceeding, so that the lower clay supports the upper without collapsing. This means that you have to know what you're doing, because you cannot make big changes later on. If you were making a portrait head, for example, you would begin with the neck. You would have to get that right, even without the head to judge it by, since by the time the head was modeled, the neck would have become quite stiff.

Pinching. The pinch technique is similar to the coil technique. You start with a wall, and pinch on dabs

of clay until each one becomes part of the wall. This is similar to coiling in practice—actually, coiling is just an orderly way of doing this. You must remember to get each dab pinched on tightly enough so no air is entrapped, which could cause trouble in the firing.

Combinations. Naturally, there are numerous ways these methods can be combined. Part of a sculpture could be slab built, or even wheel thrown (another way to build round things hollow), and part added on with coils or pinches. Some sections could even be modeled solid and hollowed out. Clay is a very special material for which some people have an immediate love and feel. If clay responds to your manipulations, by all means, use it.

CASTING CLAY

Casting into clay is a fourth way to create hollow clay sculpture. It depends less on manipulating clay directly. Virtually all the dishes you buy are either round or not round. The round ones are almost always made with some variation of the wheel, usually a jig affair where clay is forced into a spinning mold. Just about everything not round—square bottles or cream pitchers shaped like cows—is cast. And the most common way of casting is slip casting.

Slip Casting

The principle of *slip casting* is simple. A porous plaster mold is made from the original model and allowed to dry; that is, to lose its excess moisture. Into this mold is poured clay slip, as thin and runny as cream. The porous plaster immediately begins drawing the water from the slip that is next to the plaster, so a firm clay layer begins to appear. After an appropriate time, when the layer is as thick as the finished clay cast is supposed to be, the rest of the slip is poured out, and the clay deposit allowed to dry further, which both strengthens it and draws it away from the mold. It can be removed, any seams cleaned off, and fired as is, or it can be joined to other parts for more complex works.

Slip casting as a tool. You may have seen ceramic hobby shops in your town that have dozens of large plaster molds waiting, and ''sculptures'' are cast from them. These sculptures might be poodle dogs, or Laurel and Hardy, or big heads of Elvis. They are then painted in bright colors by people who take classes at the shop, fired, and set proudly on the holy of holies in most homes, the TV.

The reason I mention this is that slip casting conjures up this sort of activity, and many sculptors throw up their hands and back off, muttering comments about ''real art.'' However, all techniques are merely tools. The right tool in the right hands applied in the right way will give good results. Slip casting is a way to make form. Period. If you model good sculpture and slip cast it faithfully, you will end up with good sculpture. So view techniques independently of other associations, and turn them to your own advantage.

How to learn slip casting. Slip casting is complex and requires learning many little tricks. Learning it is similar to learning to bake a great cake. I suggest four things if you want to do it. First, read some of the many books on the subject. Second, do not use regular molding plaster, but buy special *pottery plaster*, as its porosity is higher, and it works better. Third, make your mold carefully. It must be in enough pieces so the clay will *draw* from each piece, without undercuts or places for it to hang up. (See Chapter 8 for a discussion of undercuts and piece molds.) The pieces should be thick, 2 inches minimum, to allow the plaster to absorb enough moisture. Also, the whole mold has to be made so that it can be strapped together as a single unit, picked up, and turned over to empty, without anything shifting or falling apart. Read carefully the mold-making techniques in the next two chapters to learn the principles for making a slip mold. And fourth, take very special care with your clay slip. Either buy it readymade for slip casting, or follow a well-tried formula, using the correct defloculant. Small quantities of sodium silicate or sodium carbonate increase the fluidity of slip without adding extra water. This is called a *defloculant*.

Figures 7-5, 7-6, and 7-7 show a well-made slip-casting mold. Notice the thickness of the mold pieces, and the keys for aligning the various parts. Notice, also, the way the pieces, when fully assembled, form a cube-like mass, which can be strapped tightly together, and handled without its shifting. These pieces were made with soaped masonite walls to divide the pieces, in order to get nice flat edges.

Filling a slip mold is very easy. When the mold is dry and securely tied together, the slip is poured in gently until the mold is full. Rock the mold back and forth to free any entrapped air, then fill it to the top. Usually the mold is made with an extension above the sculpture to cast some extra which can be cut off later.

Watch the slip at the edge, and rock the mold a little to see how thick the clay is growing. When it has reached at least ⅛ inch, but preferably ¼ inch, pick up the mold, turn it over, and pour out the remaining slip.

Let the mold stand for a while, a half hour or more, until the clay inside has stiffened considerably and drawn inward, away from the mold. When you can feel that it is hard enough to handle, take the mold off carefully piece by piece. Let the clay cast stiffen some more, then *fettle* it, taking off any seams with a little knife, and retouch it to your satisfaction.

FIGURE 7-5 A plaster mold for slip casting, taken apart.

FIGURE 7-6 A plaster mold for slip casting, detail of registration keys.

FIGURE 7-7 A plaster mold for slip casting, assembled, ready to pour.

Advantages of slip casting. Slip casting is one of those processes, like baking a cake, which you may fail at the first time or two. But it is not too difficult to iron out the problems and get consistently good results before long. With slip casting you can create very thin, very light clay sculptures of great complexity. It records the finest details of your original model. It enables you to make fired clay sculptures cast from originals other than clay (old shoes, food, whatever), and you can create multiples. Look back at Chapter 2, and think about the possibilities of repeating a single form many times, or repeating a form with variations, like cutting or deforming.

Press Molding

Slip casting is not the only way to cast clay. You can also *press mold* it. Using either regular plaster or pottery plaster, you can create molds from a model and simply press in layers of clay, allowing them to stiffen somewhat before removing. There are a few factors that determine when you can do this. The first and most important is whether you can get at the inside of the mold. If you were doing a little figure, you could not reach inside, so slip casting would be the only way to cast it. But you can press mold a relief or other open form where you can get your hand to all points of the mold.

Molds for press molding. Again, the mold must be made with care. The mold must come off in pieces, each of which will draw freely, and it must be made so the pieces fit together securely. Illustrated in Figure 7-8 is a job I did a few years ago which demonstrates the press-molding technique perfectly. I was commissioned to make an edition of little sculptures that could be given as rewards to significant donors to the new Art Center in town. These were to be quality works of art, but inexpensive.

The mold. I modeled a small mask of Rembrandt in clay (Figure 7-8), and then made a two piece plaster mold from it. I split it right down the middle and held it together with metal brackets (Figures 7-9, 7-10). I then pressed clay into this mold, let it stiffen for a few minutes, removed it, cleaned it up, and fired the masks. The masks were then mounted on blocks of polished tropical wood. After pressing about forty of them, I noticed I was having to do more and more work in the clay to sharpen detail from the slowly eroding mold, so I pressed one more mask, worked it especially carefully, and made a new mold from that. I kept on until I had made well over sixty masks.

Pressing the clay. Lightly dusting talcum powder inside the mold before pressing in the clay helps it to release. The technique of pressing is crucial. If you just

gob in clay and press it down, you will end up with all sorts of little cracks and wrinkles on the surface when you take it out (Figure 7-11). It is almost impossible to avoid this problem completely, but it can be reduced by pressing in the clay this way. Squeeze a small gob of soft, workable clay into one corner of the mold. Place the next gob *on top of* the first gob, and squeeze it so that the clay flows out across the mold (Figure 7-12). Keep adding new clay on top of the clay at the edge, and pressing it forward. This minimizes cracks and fissures in the surface.

Pressing coiled clay. Another way to apply clay is with the coil technique, by laying in coils of clay, pressing them down somewhat, then smearing the inner surface together. When taken out of the mold, the sculpture will have a strong coil pattern, which can be used to good effect.

Other pressing techniques. The pressing technique can be expanded. For example, differently colored (but similarly bodied) clays can be pressed in to create multicolor effects. Various textures can be used, such as heavily grogged clays with smooth clays. Any time you explore a new technique, try to think of the possibilities it affords for doing things that were not possible other ways. Those possibilities may suggest new ideas and means of expression, so that technique and idea begin to interact, one affecting the other.

SELF-HARDENING CLAYS

There are a number of products on the market for sculptors who have no means to cast or fire clay. These self-hardening clays come in various forms, but all have one thing in common. They turn hard with little or no effort.

Air-hardening clays. Some self-hardening clays will simply dry hard. Leave them out in the air, and they gain hardness with time alone. They will become hard enough after several days to sand, file, paint, or stain. Some of these clays shrink as they dry, and therefore cannot be used with a rigid armature, since they will crack. Others, however, are made to dry without shrinkage, and can be built over rigid supports, like wire armatures, pipes, or bottles.

Ultra-low fired clays. Another kind of easy hardening clay can be "fired" at temperatures so low you use the kitchen oven. This is not really firing in the sense of transforming clay with high heat, but rather a sort of forced drying. Again, some of these clays shrink and some do not, so you must read any advertising copy

FIGURE 7-8 Tuck Langland, Mask of Rembrandt, after the Kenwood Self Portrait. 1977, fired clay.

FIGURE 7-9 The plaster mold for press casting the mask of Rembrandt.

FIGURE 7-10 Detail of brackets holding the mold section together.

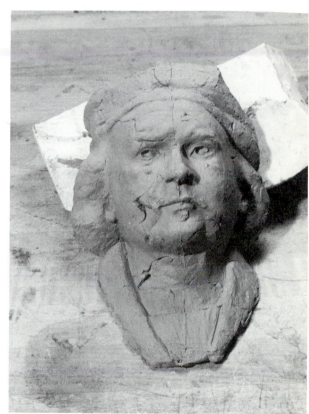

FIGURE 7-11 Press cast of the mask, with the clay simply pressed in, showing imperfections in the surface.

FIGURE 7-12 The proper method of applying clay for press casting.

carefully before purchasing them to be sure of whether you can use an armature. If no armature is possible, you are limited in what you can make with the clay.

Disadvantages of self-hardening clay. I find these self-hardening clays difficult to work with. They do not, in my experience, respond well to the fingers or to tools. They are a little like cookie dough—malleable and formable, but not very responsive. Also, they are rather expensive. They come in small packages of a pound or so, and the tendency is to get a few packages and fool around with a lot of little things. I can hardly conceive of making any large or even medium-sized work in this material.

When hard, they are permanent. They are probably most useful for small maquettes. They may also be very useful in the classroom for learning formal concepts when there is little time and equipment. Self-hardening clay is too expensive for a lifesize head or similarly sized sculpture, however.

There is one other problem with self-hardening clays, and that is that they *are* self-hardening. If you buy a box, planning to use it at some future time, there is a good chance that when that time comes, it will have gone hard in the box. Be careful about buying quantities for future use. Instead, buy a few boxes for specific projects as you need them.

OTHER WAYS OF MAKING CLAY PERMANENT

Aside from firing clay or using self-hardening clay, the only serious way to make clay permanent is to cast it. Casting is complex and highly varied, and it could well be the subject of an entire book. In the next chapters I will describe three levels of casting, from the simple plaster waste mold, through casting resin and cement in plaster and rubber molds, and finally metal casting. While casting may seem complex or expensive at first, you will learn ways of casting in these three chapters that will prove possible and useful. Casting is one of the sculptor's most formidable tools, and the concepts and practices of casting are inescapable if you pursue sculpture for long. With the ability to cast comes the ability to create and re-create form, as well as to change the material of something without changing its form. Learning to cast is well worth the effort.

EIGHT

Mold Making

This chapter will describe how to make several kinds of molds in plaster and rubber. Plaster molds are best when taken off clay originals, and are useful for casting into plaster, cement, polyester resin, or clay slip. Rubber molds are more suitable for complex shapes and surfaces and for filling more than once. They are more difficult to make and more expensive, but generally worth it. The next two chapters will deal with filling the molds.

PLASTER

But before getting into mold making, we must say a few words about plaster itself. There are many kinds of plaster on the market, but the kind most sculptors use is called *moulding plaster*—what U.S. Gypsum calls Number 10. This is sold in 100-pound bags at most lumber and building supply stores. I do not recommend buying little bags of dental plaster, patching plaster, or plaster of Paris at the hardware store, partly because you pay many times the price per pound over the large sack, and also because it is intimidating to have only a small amount of material to work with. Use a large plastic garbage can with a lid to store plaster, and always empty the entire sack into the can. Never leave the sack on the floor and cut into it. By keeping it in a garbage can, it is controlled and doesn't get tracked around, and the lid keeps it dry and clean.

The chemistry of plaster. Plaster is made from gypsum, which is a naturally occurring substance consisting of calcium sulfate and water locked in a crystalline structure. The gypsum is pulverized, then heated, driving off the water of crystallization. The resulting powder is

plaster. When water is added, it recrystallizes into a hard substance. Depending on how the plaster has been manufactured, the chemical process can be very rapid or very slow. Moulding plaster is a rapid plaster, usually going hard within about fifteen minutes.

Setting versus drying. The important thing to remember about plaster is that it *sets* chemically, by reforming crystals with the water molecules. When it sets, excess water always exists in the pores of the hardened mass, and freshly set plaster feels damp to the touch. If you allow plaster to stand around for several days, this excess water evaporates, and the plaster feels dry. This is what is meant by *drying*.

There is an important distinction between *setting* (going hard chemically), and *drying* (losing excess moisture). The reason this is important is because dry plaster is porous. If you try to add fresh plaster to dry plaster, the porosity will suck the water from the fresh plaster before setting can take place. To prevent this, fill the pores of the old plaster with water by soaking it until they absorb no more. Then the new plaster can set without problems.

Now, I'm going to say that again, because it's important. Remember, once plaster has set, it is waterproof. If you want to add new plaster to old plaster that has been sitting around for more than an hour or two, be sure to *soak the old plaster in water* first.

Dealing with plaster. Since plaster sets chemically, it will set underwater. If you rinse your hands and tools in a normal sink, the plaster will settle in the trap and harden, even underwater. There are two ways to prevent this.

First, and best, is to use a sink with a proper trap

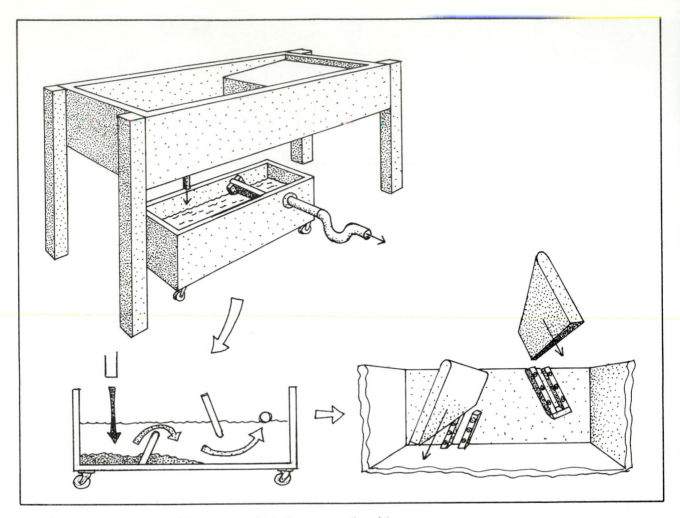

FIGURE 8-1 A sink with a special plaster trap. (Note the cross section of the trap, lower left, showing plaster-laden water entering the trap, then dropping the plaster as it flows over the baffles, allowing only clear water to exit the drain. Drawing on the lower right shows a method of making removable baffles for easy cleaning.)

system. You can make one either out of plywood covered with several layers of polyester resin and fiberglas, or out of welded stainless steel. A plaster trap is basically a box that sits below the sink. The sink drain should be a short straight pipe which drops just a few inches and ends over the open top of the box. The box itself should have a baffle or two, then a horizontal exit pipe two-thirds of the way up one side, which can be easily fitted to the drain pipe by means of a hand-turned screw fitting (Figure 8-1).

Plaster-laden water drops into the box and, because of the baffles, the plaster sinks and clear water rises and flows out. After a while the box will fill with plaster sludge. Disconnect the box from the drain and take it outside, where the water can be dumped and the sludge removed.

But here is something important to watch. The diameter of the pipe in the bottom of the sink must be about half the diameter of the pipe leading to the drain. Otherwise, if you fill the sink and then pull the plug, the water will go into the box faster than it can get out, and the box will overflow.

If you can't make a plaster trap or don't want to go to all that trouble, rinse everything—hands, tools, etc.—in a bucket of water first, then wash in the sink. Sludge will sink to the bottom of the bucket, and can be thrown out later. Use soft plastic or rubber bowls to mix plaster in. Let the plaster harden in the bowl, and later crack it out into the waste bin.

I'll talk about the actual mixing of plaster below, but all the above suggestions apply to any work with plaster.

THE WASTE MOLD

A plaster *waste mold* is the most elementary way to cast from a clay original to a permanent material. But, though it is elementary, it is still very useful, and is the primary method of casting, at least for the first stage of production, in professional studios around the world.

The Idea

The simplest mold is a waste mold, that is, one that does not worry about undercuts, but simply pulls off the clay, taking projections or whatever with it. After it is filled with the new material, it is chipped off in pieces, thus *wasted*. The simplest kind of waste mold is made in a single piece on a relief. We will skip that and move directly to a two-piece waste mold, since after that discussion, the relief mold will be obvious.

As an example, we will make a waste mold off a portrait head—again, mainly because a head is such an easily understood form. The first thing to consider is dividing the mold, so it can be made in two halves, and thus taken off the head. The two most common methods of dividing a plaster mold are the clay wall method and the brass shim method. I will describe both, because each has advantages.

The Clay Wall Method of Mold Division

The idea is to make a wall of clay about ¼ inch thick and about 1 inch wide, and to stand this wall all around the head where the division is to be. The first half of the mold is made against the front of this wall. The wall is then taken away, exposing the edge of the first half of the mold. This exposed edge is lightly greased or soaped, and the second half of the mold is made, thus creating a seam between the two halves (Figure 8-2). That's the principle, now for the practice.

Making the wall. To make the wall, you need two sticks, a rolling pin, and a good spatula or blade tool. The two sticks should be ¼ inch thick, between ¾ inch and 1 inch wide, and about 36 inches long—something like yardsticks. A wooden rolling pin is fine (Figure 8-3).

Take a workable piece of clay about the size of a grapefruit, and knead it in your hands until it is smooth and coherent. Squeeze it out into a long sausage, about an inch in diameter. Work either on a clean smooth board laid on a table, or a well-swept area of a concrete floor. Lay the sausage down pointing away from you, place a stick along each side of it, and begin to roll it with the rolling pin (Figure 8-4). There are a few tricks to this. Only roll from your end away from you, so that you press down your end first, and the rest is free to expand and slide as it gains length. Only press it down a little, then pick up the clay sausage (slightly flattened) and move it to a clean area of the board or floor. Otherwise it will stick. Also, roll on a clean part of the rolling pin. After about three or four of these passes and moves, you should be pressing the rolling pin right down on the sticks, thus establishing the even thickness of the wall.

Making sure the clay isn't sticking, use one stick as a straight edge and cut the edges of the clay with the spatula to produce a perfect wall, as shown in the illustration (Figure 8-5). Often the rolled-out strip of clay is wide enough for two walls, as shown in Figure 8-6.

Applying the wall. The head to be cast is the one made to demonstrate portrait modeling, and is shown completed in Figure 8-7. To apply the clay wall, pick it up and place it carefully on the head where you want the mold division to be. The best way to divide a head is from the bottom of one side of the neck, up past the ear, over the top, down, to the other side of the other ear, and ending at the opposite point on the neck (Figure 8-8). When you place the clay wall on the clay head, just press it lightly into place. Do not squeeze it down distorting the perfect wall you just made (Figure 8-9). *Neatness counts!* Try to make the wall stick on the head the way a cake decorator makes a rose out of icing. Get it right the first time and don't fuss with it. You can reinforce the strength of the wall by sticking gobs of soft clay on the back side, as shown in Figure 8-10. You can add more pieces of wall, if your original one wasn't long enough. Small pieces of wall can be cut to fit in odd places, and you can use your ingenuity to make it go around any uneven spots.

The Brass Shim Technique

The second way to make a mold division is called the *brass shim* technique. This is the more usual method of the two, and is certainly faster. It does involve buying brass shim, and it is slightly more limited in certain applications, but it is still a useful method. I recommend learning both techniques, and using whichever is best for the job at hand.

The idea. Brass shim is thin brass sheet, manufactured for machine shops, and used to shim machines into exact alignment. It comes in varying thicknesses, with .005 inches the best for sculpture. You may substitute soft drink or beer cans. Cut the ends off, flatten them out, and proceed as for shim.

Instead of the clay wall, you make a thin wall of brass shim and then put the mold on both sides at once. Since the brass is so thin, there is no noticeable gap in the mold. The trick is making the wall.

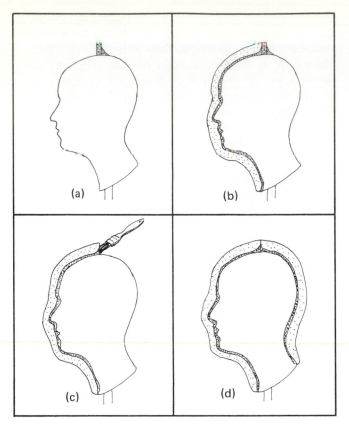

FIGURE 8-2 The clay wall principle: (a) wall in place (section); (b) first half of mold on; (c) wall removed and exposed edge greased; (d) second half of mold on.

FIGURE 8-3 Equipment necessary to make a clay wall: board to roll out clay, rolling pin, two strips to control clay thickness, blade tools for trimming.

FIGURE 8-4 Rolling out a sausage of clay.

FIGURE 8-5 Trimming the rolled-out sausage to make the walls.

FIGURE 8-6 Completed walls, the strip being wide enough to cut two.

FIGURE 8-7 The clay head complete, ready for casting.

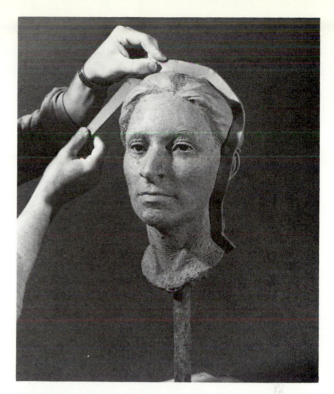

FIGURE 8-8 Placing the clay wall on the head. (Note that it goes on in a simple manner, without undue disturbance to the wall.)

FIGURE 8-9 Detail of the clay wall in place. (Note how it touches the head at a clean right angle.)

FIGURE 8-10 Back view of the clay wall, showing buttresses for support.

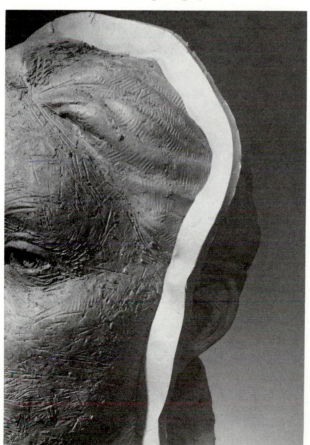

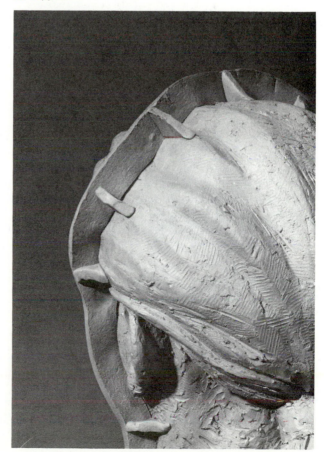

Making a shim wall. Using ordinary scissors, cut the shim into strips slightly over 1 inch wide. Now cut the strips into short pieces, each about 1 ½ inches long. Cut them with slight angles, so they are all trapezoids. Make some wider and some narrower. Now begin to stick them into the clay, standing in a row, to make the wall (Figure 8-11). Because they are cut in trapezoids, they form easily around curves, either outside or inside. Overlap their edges to form a continuous surface. Make *keys* every so often by folding a zigzag into a shim, as shown in the photo. These will align the mold when you reassemble it.

Align the top edges of the shims carefully, then trim with a scissor to form an even line which will not snag a tool as you clean it of plaster. Or, you can roll out a long rat's tail of clay and fit it along the top edge (Figure 8-12). This ties all the shims together, and makes them a little easier to clean as you apply the mold.

If you use the clay wall method, you apply one complete side of the mold, then remove the wall and apply the other. If you use shims, you can apply both sides at once.

FIGURE 8-12 Brass shim with rat's tail of clay to ease in cleaning the edge.

FIGURE 8-11 Brass shim in place. (Note the bent shim forming a key.)

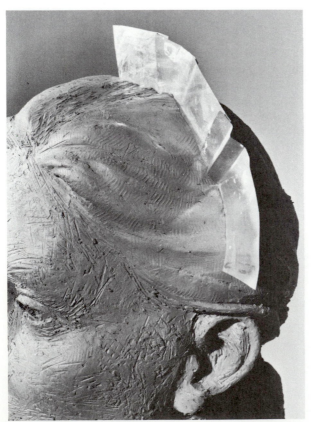

Applying Plaster: The Blue Layer

The idea. The mold itself is made in two layers of plaster. The first one is thin and colored. The reason is that later, when you are chipping the mold off the internal plaster head, you will need to know when you have chipped through the white mold so you don't chip the white head. A colored layer is a warning that you are close, and when you see white again, you know that is the head itself. There are a lot of ways to color plaster, but the best is old-fashioned laundry bluing. It is very cheap, keeps, doesn't stain, and colors the plaster without affecting its setting qualities.

Mixing plaster. To mix the first layer, get a plastic wash basin about 14 inches in diameter. When mixing plaster, always put the water in the bowl first, then add the plaster to the water. When mixing a colored layer, add the color to the water first, then the plaster. For the first layer of the first half of the mold, you will need no more than ½ inch of water in the basin. Use roughly double that amount if you are using shims, and plan to apply the blue layer to both sides at once. Hot water will make the plaster set a little faster, so at first use cool or

cold water. Later, when you get quicker at this job, you can use hot water and it won't get away from you, but for now use cold and give yourself time to work. Squirt a little laundry bluing into the water and swish it around.

Here's how to add plaster:

1. Add all the plaster you're going to add before stirring.
2. Let the plaster soak up wet before stirring.
3. Stir.

Here's how you know how much to add: Start by sprinkling handfuls of plaster evenly over the surface of the water (Figure 8-13). Notice how the plaster sinks to the bottom. Keep sprinkling until some plaster has piled up to the surface. For this first coat, you want plaster to appear all over the surface of the water—no lakes or ponds, but no big mountains either. Just a nice swampy layer of sodden plaster right at the surface of the water will make a creamy smooth mix (Figure 8-14). When you have no more lakes and all the plaster is wet, stir it with your hand—the ultimate stirring device. A good way is to place your hand flat on the bottom of the bowl and move it quickly side to side. The mix should be smooth and creamy, and no skin should show through when you pull your hand out (Figure 8-15). If it is milky and runs off your hand, it is too thin and won't set hard. *Don't use it!* Don't ruin weeks of work trying to save about a dime's worth of plaster. You can add more to a batch that's too thin, but then you have to work to get the lumps out. If it's too thick (really gloppy) add some water and stir it well.

Applying the First Layer

Do you remember being in summer camp, all lined up with the other kids at rows of sinks brushing your teeth in the morning, and you wet your hand and flicked water in another kid's face? That's how you put this layer on. Catch your finger tips with your thumb and flick them out towards the sculpture (Figure 8-16). Do not touch the sculpture, because you'll mess up the surface, but try to drive the flicked plaster in everywhere. It's a good idea to hang up a plastic dropcloth behind the head for this operation, as well as something on the floor, unless you work in a studio with a concrete floor that can be scraped and swept.

If you are using a clay wall, flick the plaster on the front half only. Get it on the front face of the wall, and try not to get it all over the back of the head. Some people cover the back half with wet newspapers, which is a good idea, but not essential. Try to cover all the clay, and, as the plaster begins to thicken, keep flicking so the first coat gets about ⅛ inch thick, and ends up rough, like the surface of the moon. This is so the next

layer has something to grab onto. Plaster is not a glue —it does not naturally stick to things—and needs a rough surface to grip (Figure 8-17).

Cleaning the wall. *Do not forget this step. Do it every time you finish applying plaster to a mold—front or back.* Take a spatula tool and carefully clean the edge of the wall, so the plaster is on the front face only. This is crucial. Remember every time (Figure 8-18). This is no less important for the brass shim technique. Gently slide a spatula over the top edge of the shims so there is no plaster looped from one side to the other, and a fine dark line shows. If you used the rat's tail of clay, expose it with a tool.

Applying the second layer. When you have finished the blue layer and cleaned the wall, you can start the next layer right away. This layer will have no blue and will be a lot thicker. The blue layer recorded all the detail, but this layer will give strength to the mold.

Mixing the second layer. Put about 1 ½ inches of water in a clean bowl. This should be enough for one side of a head. If you're using the shim method, don't use twice as much because you probably won't be able to get it all on. Do the front and back separately, at least until you have gained confidence and speed working with plaster.

Now begin sprinkling in plaster. You have to add much more than before. Sprinkle in plaster until it has built up to the surface as before, but then keep on sprinkling until you begin to build little areas of dry land, and then bigger areas of dry land, until just about the whole bowl is covered with a thin layer of dry plaster over the swamp (and of course, no lakes). You should have enough plaster in the bowl so that it takes a few minutes for it all to get wet. If it gets wet right away and looks really soggy, add some more. Now, when you stir, you should have a mix that is a good deal thicker than before.

Applying the plaster. You can't begin putting on the second layer until the plaster has begun to set. If a handful falls out of your hand when you try to pour it, it's too thin. Wait until you can hold a handful sideways without it plopping out. Now you can begin applying it to the mold. This time you can put it on with your hand. The blue layer will be hard by now. Start at the top, plopping a handful on the top of the head, right up against the wall. Make certain that you get the plaster well into the base of the wall (Figure 8-19), and that you get an even thickness all over.

I like to begin, after the initial plop on the top, by patting plaster into the base of the wall all the way around. Then I start applying handfuls to the whole head, working down from the top, trying to keep track mentally of how thick it is. You want about ¾ inches on top of

FIGURE 8-13 Adding plaster to water containing bluing, for the first coat.

FIGURE 8-14 Plaster added in the correct amount for the first coat, before stirring. (Note the swampy appearance, without any areas of clear water.)

FIGURE 8-15 The correct thickness of plaster on the hand.

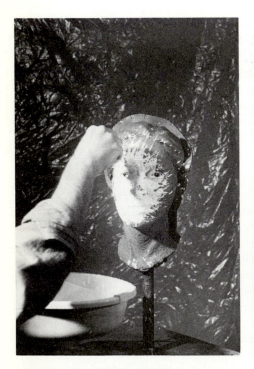

FIGURE 8-16 Flicking on the first layer of plaster. (Note the plastic sheet to catch spatter.)

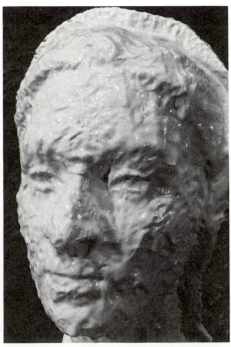

FIGURE 8-17 The first coat complete. (Note the rough surface.)

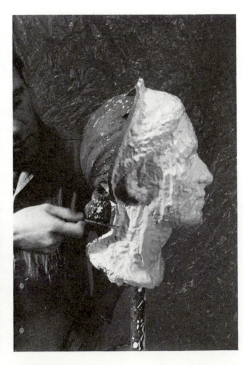

FIGURE 8-18 Cleaning the edge of the clay wall after applying the first coat, while the plaster is still soft.

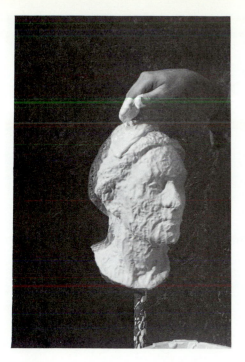

FIGURE 8-19 Applying the second coat of plaster, being sure it goes into the base of the wall.

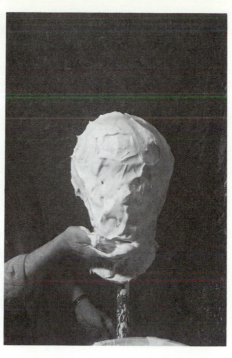

FIGURE 8-20 Applying the second coat of plaster, getting it up under the chin.

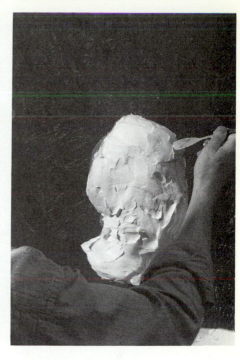

FIGURE 8-21 Checking the thickness of the second coat while it is still soft by piercing with a blade tool.

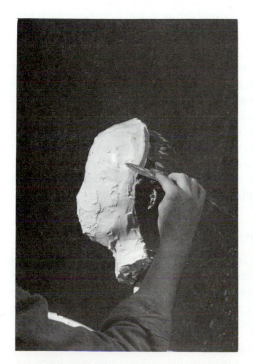

FIGURE 8-22 Cleaning the edge of the clay wall after finishing the second coat, but while the plaster is still soft.

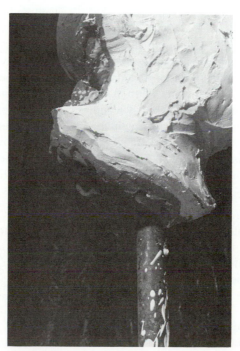

FIGURE 8-23 Detail of the bottom of the neck, showing neat trimming of the edge of the mold.

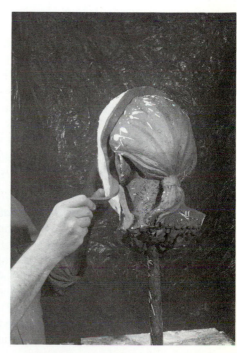

FIGURE 8-24 Removing the clay wall after the second coat has set.

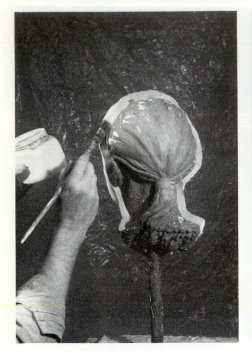

FIGURE 8-25 Applying Vaseline to the exposed edge of the plaster.

FIGURE 8-26 Cleaning the front half of the mold after the first coat of the back half has been applied.

FIGURE 8-27 The cleaned seam after the second coat on the back half is finished. You should be able to see the fine seam all the way around the mold.

the blue layer. Save the under-the-chin part for last, when the plaster is thick enough to stick (Figure 8-20). If in doubt about an area (like over the nose, which is usually skimped), take a spatula tool and poke in to feel the depth (Figure 8-21).

Chances are the plaster will begin to harden before you can get it all on. Don't rush. Don't start to make a mess of the mold, applying hardening plaster frantically, just because you want to use that few cents worth in the bowl. Let it go hard, and calmly mix another batch and carry on. The neatness of the mold is the important thing. Now, what do you have to remember to do? *Clean the edge of the wall, now, before the plaster gets hard!* Always finish each batch with a nice clean wall edge (Figure 8-22).

Removing the clay wall. This applies only if you are using the clay wall technique. When you have covered the entire front half of the head with a relatively even and neat layer of white, cleaned the edge, and cleaned neatly around the bottom of the neck (which is left open, so you can fill the mold), you are done with the front half (Figure 8-23). As soon as the plaster is reasonably hard, you can peel off the clay wall (Figure 8-24). Use a jar of Vaseline and a brush and lightly grease the newly exposed edge of the mold (Figure 8-25). An alternative is to use soft soap, but the Vaseline is much

quicker, and helps prevent moisture from moving from the new plaster to the old on the seam.

Now simply turn the head around on the modeling stand and repeat the whole process, flicking on a blue layer, and cleaning the edge of the first half of the mold so no plaster laps from one half to the other, but there is a clearly visible dividing line between them (Figure 8-26). When that layer is complete, apply a thick white layer, again getting it well into the base of the wall, and again cleaning the old mold so there is that clearly visible dividing line (Figure 8-27).

If you're using shims, be sure you clean well after each application of plaster, so you can always see the fine dark line that is the tops of the shims, or the clay line that is the rat's tail.

Removing the Mold

You can tell when the mold is hard enough to remove by cracking the remains of the last batch of plaster you mixed out of the bowl. If it breaks cleanly, it is hard, but if it crumbles and mushes, wait a while. Usually a half hour is plenty of time.

Removing the head peg. Remember when we made the head pegs, how we drove two wire loops into the pipe with a wooden wedge? Here's where that system

comes in handy. With someone else's help, if you need it, take the whole thing off the modeling stand and set it on the floor upside down. Now, with someone holding the head, or holding it yourself with your feet, as shown, take the base of the head peg and twist it rapidly back and forth, pulling up. Usually you can get it free of the loops inside this way, and pull it out (Figure 8-28).

Splitting the mold. There are two things you need to get the mold off—water and patience. Pour some water into the hole left by the head peg and let it stand. It will slowly soften and expand the clay. Take a stick, about 2 inches × 2 inches × 2 feet, and sharpen one end to a point (the kind you'd drive it through a vampire's heart), and slowly drive it down into the softening clay. Pour more water in, and wait again (Figure 8-29). The effect of the stick plus the softening and expanding effect of the water will cause a fine crack to appear around the seam (Figure 8-30). With more water and more prodding, the mold will soon come apart.

Other methods. Here's another way, if the mold is small. Fill a sink or large tub with water and submerge the mold. The water will seep in, expand the clay, and in about a half hour the mold will just about drop off.

If you can't get at the bottom, and can't submerge it in a sink, there is still another way. Make several small wood wedges. Use hardwood, and make the thin edge really thin. Using an old chisel with a wide blade, select a spot near the middle of the mold that has a straight seam and solid edges. Lightly tap into the seam to begin a fine crack. When a fine crack starts, widen it just enough to insert a wooden wedge. Move a little ways from that wedge and start another. See if you can get wedges in every few inches all around the piece. Then it's an easy task to tap them all in rotation and slowly force the mold apart (Figure 8-31).

Fixing broken pieces. If you have made one part too thin, or you're too rough taking it apart, it can break. If that happens, don't panic. Save the pieces. When the mold is completely taken apart and cleaned up, assemble it again, and patch the broken pieces together from the outside with more plaster.

Cleaning the mold. When the mold is finally off, you have to dig the clay out (Figure 8-32). Usually one half pulls off cleanly, and the other half remains full of clay. This can be a difficult job, but there is a way to do it. Set the clay-filled mold on a good work surface, and have a scrap clay barrel handy. Use a strong hook tool and begin to dig out the center of the clay mass. Try to make the clay thinner and thinner toward the mold. Be very careful you don't drive the tool into the mold,

scraping off detail. When the clay is down to less than an inch in thickness, try to roll it out of the mold. It usually comes out cleanly with this method.

Put the clay back where it can be recycled, clean off the armature, repair it, and leave it ready for the next use. Now take the mold to a sink, and wash it carefully with a brush and water. Soaking it for a while softens the clay film and makes this job easier. Don't scrub violently or you scrub off detail. Light brushing should get the clay out.

Take a careful look at the mold (Figure 8-33). To repair chips, bubbles, or other faults, mix up a small batch of plaster in a styrofoam cup, and use a small spatula tool. Be especially careful around the edges, though, because any extra plaster on the edge will keep the mold pieces from fitting together properly.

THE PLASTER PIECE MOLD

The Idea

A plaster piece mold is almost the same as a plaster waste mold, except that it is made in enough pieces so that each piece pulls cleanly from the model with no undercuts. Figure 8-34 shows how the mold hooks onto the form. Any such places are called *undercuts*. With the waste mold, undercuts don't matter, because you rip the clay apart taking the mold off, and chip the mold apart taking the cast out. But if you are taking a plaster mold off an original model of plaster or other hard material, or if you need to remove the cast without disruption or without destroying the mold, as in slip casting, the piece mold is the technique to use.

You can use either the clay wall or brass shim technique for a piece mold. Read the section below on making a plaster support mold over a rubber mold for a description of locating the pieces. The principle is the same.

One difference is that a plaster piece mold often contains so many pieces that it is hard to hold together later. The solution is to make what is called a *mother mold*. To make a mother mold, you create the piece mold, leaving small grooves between the pieces by bevelling the top edges of each piece as it is made. The outer surface of the pieces must be such that a larger mold can be placed over them without more undercuts. Once all the pieces have been made, the outer surface is greased or soaped (I find Vaseline superior to soap). Using clay walls, an outer mold of no more than three pieces is made. When the whole thing is removed, the inner pieces should nestle nicely in the ridges cast into the mother mold.

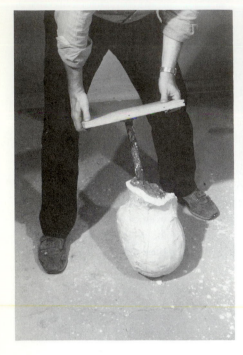

FIGURE 8-28 Removing the head peg from the head.

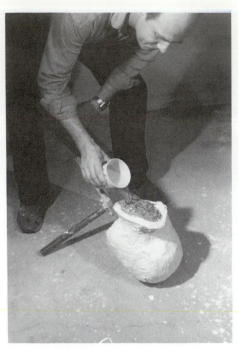

FIGURE 8-29 Pouring water into the hole left by the head peg.

FIGURE 8-30 A fine crack appearing at the seam. Be alert for this.

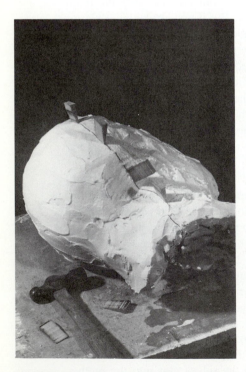

FIGURE 8-31 Wooden wedges being driven into the crack. Tap them in rotation to spread the mold evenly.

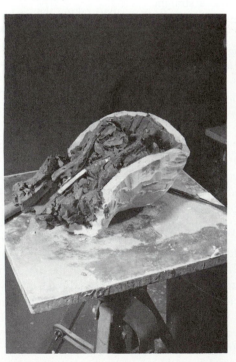

FIGURE 8-32 The mold after opening, still full of clay.

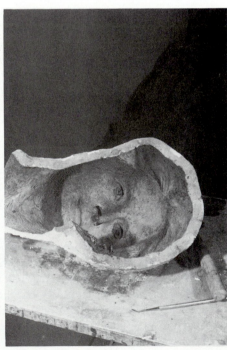

FIGURE 8-33 The front half of the mold after the clay is removed. Inspect it for flaws.

FIGURE 8-34 Diagram showing undercuts. The single piece on the left has undercuts and will not pull off; those on the right have no undercuts and will pull off cleanly.

RUBBER MOLDS

The idea of a rubber mold is simple. The original model is coated with a flexible rubber material, which is then encased in a plaster piece mold. So every rubber mold consists of two parts: the rubber shell and the plaster support mold.

The Rubber

There are a lot of different materials on the market, and you may want to experiment, but I use a polyurethane molding compound called Smooth-On (see Appendix for company address). It comes as a creamy white liquid plus a brown liquid. For every 100 parts of the creamy white liquid (called Part B), you add 10 parts of the brown liquid (called Part A). It becomes a strong flexible rubber in about six hours. There is also a clear liquid called Part D, which you can add in small amounts (0 percent up to 2 percent) to make the liquid thicker, so it can be brushed or buttered on like mayonnaise.

Smooth-On a has few other qualities that I like. It's one of the least expensive flexible molding compounds on the market; it's clean to use; it's very strong yet flexible; and it gives off no annoying or toxic fumes. Black Tuffy is a polysulfide commonly used, and it's good too, but the black seems to get everywhere, and it does not seem to be as strong as Smooth-On. Another commonly used type is silicone rubber, but it is a great deal more expensive. It has a far higher tear strength and

casts hundreds of parts, but since sculptors usually cast just a few, the expense isn't justified, in my opinion.

Dividing the Mold

There are two ways to divide the flexible mold. The one I prefer is to apply the Smooth-On all over the piece to its full thickness, and then to make a plaster support mold using the clay wall technique. This allows you to cut the rubber somewhere other than where the plaster mold is divided.

The other technique is to use brass shims. You place these in the clay, then divide both the rubber and plaster with the shims. Be sure to apply a light coat of Vaseline to the shims before applying the rubber, though, or it will stick.

Preparing the Model

The next thing to worry about is a release agent. The Smooth-On sticks to some things, and other things inhibit its setting.

Wet clay. For putting Smooth-On on wet clay, Slide Epoxy Dry is best, bar none (see Appendix for supplier). Spray two coats from the aerosol can on water-based clay (Figure 8-35), letting each coat dry to the

FIGURE 8-35 Spraying the clay model with Slide Epoxy Dry.

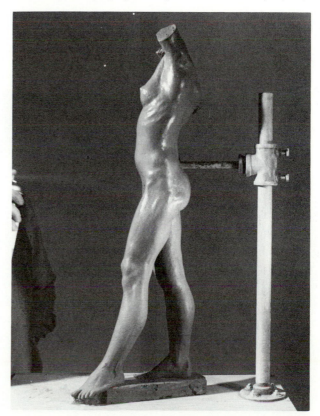

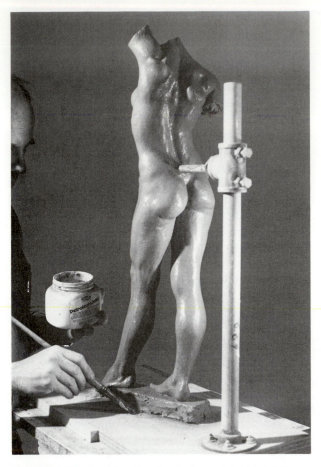

FIGURE 8-36 Applying Vaseline to the wood on the base. (Note that the Vaseline should also be applied to the horizontal pipe entering the figure.)

touch (about five minutes each). This assures the Smooth-On will come off cleanly and fully set. Another approach is to spray the clay with shellac, then spray that with any of the many polyester mold release agents available. However, Smooth-On will stick very tightly to untreated shellac. In fact, you can use it should you want the Smooth-On to adhere to something.

Plaster and other materials. Smooth-On comes off dry plaster, though a little paste wax or Vaseline helps. It comes off bare metal, but with a struggle, so, again, I use a little Vaseline. It sticks pretty tightly to wood, so use Vaseline on any exposed wood (Figure 8-36). In general, follow this rule: If in doubt, try it out. Experimentation can save hours, and more important, it can save pieces.

Mixing the Rubber

What to buy. Once you have prepared your original model with an appropriate release agent (if it requires one), you must mix the rubber. Make sure you order a pint of Part D in addition to the usual kit, which consists of a big container of Part B and a smaller one of Part A.

The next thing you need is a good scale. Don't try to mix this stuff with a kitchen scale or try to eyeball it. It won't work, and you'll waste time, materials, and sculpture. Smooth-On is good, and it does set, but only if you use a good scale and follow my directions. Buy a metric triple beam balance, or other laboratory quality scale. Mine measures to ¹⁄₁₀ gram (a couple of drops will register), which is ideal (Figure 8-37).

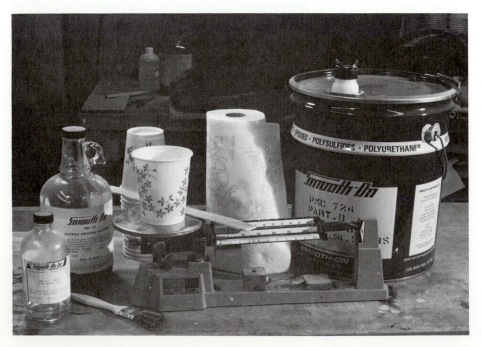

FIGURE 8-37 Equipment necessary to mix Smooth-On flexible molding compound: (*from left to right*) Part D, Part A, an inexpensive throw away brush, a scale with cups and stirring stick, paper towels, and a large can of Part B.

Next, get some sixteen-ounce disposable wax-lined paper cups. I buy boxes of 1,000, but you can get some from drive-ins and places like that. Get some stirring sticks, like the kind hardware and paint stores give out with their name printed on them, or make some. And get some cheap one-inch brushes that you can throw away. Have a calculator and paper and pencil handy.

Understanding Part D. Now you're ready to mix. First, you must understand how Part D (the flow-control agent) works. If you add none of it, you get a liquid rubber with about the consistency of latex paint. This is good for a detail coat, but is so thin it often runs off. If you add 1 percent Part D, the thickness goes up to that of heavy cream—a little thick for a detail coat, but still brushable. If you add 2 percent, you get a mixture the consistency of mayonnaise, which you can apply with a spatula to build up thickness. There is not much point in adding more than 2 to 2.5 percent.

But there's one other wrinkle to understand. For every gram of Part D you add, you must add an equal amount *extra* of Part A. Always add Part D *first*, and stir it in *thoroughly*. Then add Part A.

Sequence of coats: Most molds require the following three or four coats:

1. A detail coat at .5 percent, brushed on.
2. A thickness coat at 2 percent, buttered on.
3. A second thickness coat at 2 percent, where needed.
4. A smoothing-out coat at 1 percent, brushed on, to cover the buttering strokes.

The method. Read the method carefully, and if you don't understand, read it again. Then try a dry run through. Then review it mentally until you get the idea.

Step 1. Zero your scale so it balances when all the weights are at zero. This step assumes that you are familiar with your scale and can use it without making mistakes.

Step 2. Put an empty cup plus a stirring stick on the scale and weigh them. Write this weight down. It is your *tare.* Everything you weigh will have *both the cup and the stick* on the scale.

Step 3. Pour some Part B (the white component) into the cup, trying to estimate how much you will need for the first batch. Weigh it (including the stick). Enter this number into your calculator, and press the Memory + button, so it is also entered into the memory.

Step 4. Press the subtract (−) button and enter the tare. Then press the equals button (=), and you have the weight of the rubber alone. Write this number down.

Step 5. Decide how much Part D you will use (how thick you want the rubber to be); then press multiply (×) and the percentage of Part D you are adding (1 for one percent or 1.3 for one and a third percent). Then press the percent (%) key. The window should tell you how many grams of Part D you must add. Write this number down.

Step 6. Now press + , then Memory Recall, then = , and you will have how much the cup, plus the stick, plus the Part B, plus the Part D will all weigh together. Write this number down and draw a box around it.

Step 7. Now press + , then the amount of Part D you must add (see Step 5; push in the actual number of grams, not the percentage). Then press + and then 10 percent of the amount of rubber alone, which you figured in Step 4 (move the decimal point one space to the left). Then press = and you should have the grand total of cup plus stick, plus Part B, plus Part D, plus Part A. Write this number down and draw a box around it.

Step 8. Set the weights on the scale to the number you got for Step 6—the number in the first box you drew. The scale will tip. Bracing your arm carefully, very slowly pour the Part D directly from the bottle into the cup of rubber on the scale, watching like a hawk for the first sign of movement of the scale (Figure 8-38). What you are doing is pouring in just the right amount to make it balance. When you have done that, you will have added the correct amount of Part D. You may feel clumsy at first, but soon you will learn to pour easily and precisely. You'll notice how just a couple of drops affect the scale. If your bottle is very full, pour some into a spare cup and pour from that.

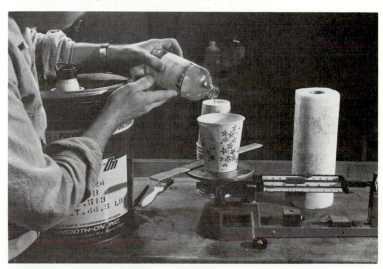

FIGURE 8-38 Pouring Part D very slowly into the mix until the scale, which was preset for the new total, balances.

Step 9. Stir the rubber. Use the stirring stick (which is already on the scale) and stir the Part D thoroughly into the Part B. If you forget this step, you get cottage cheese. When you have really mixed it well, mix it a little more, then leave the stick in the cup. The scale should still balance.

Step 10. Now set the weights on the scale for the final figure, the number in the second box you drew. But here's a little hint. Since you have to pour in much more Part A, and you don't want to stand dribbling slowly forever, set the scale 10 grams light, then pour quicker. When the scale tips, set it to the correct amount, and pour the last 10 grams slowly.

Step 11. Stir the whole thing together. Mix every last smidgen of the brown Part A completely into the white Part B. If you want to be really sure it's mixed transfer everything to a new cup. Then the good mixture on the top ends up on the bottom, and the streaky unmixed material on the bottom ends up on top, to be stirred some more. Now you have a good mix of rubber.

Some hints: Do the math twice, to make sure you have it right. Don't forget to stir in all the Part D before adding Part A. If you get a mix that looks funny, don't use it. All mixes should be the same color. If one comes out too light or too dark, don't use it. Chances are it won't set. If you use a mix that was mixed badly, and it is still runny or sticky after several hours, waiting around won't help—it won't set. Years later it'll still be sticky. Scrape it off as best you can, then wash the model with acetone, with plenty of ventilation, and *no smoking*! Let it dry, and do it again.

Smooth-On is not the only urethane rubber on the market, and you might want to try two or three others. A new product called Por-a-Mold is produced by Synair Corporation (see Appendix), and it has a couple of advantages. First, it is designed to mix 50:50, so you don't need a scale or calculator. It comes in three different hardnesses, as well. If you have a piece with a lot of complex undercuts, get the soft variety; for most work get the medium; and for large flat things, where sagging could be a problem, get the hard.

It also comes in pourable or brushable thicknesses. Get some of each, and brush on a first coat using the pourable, then trowel on the *thixotropic* mix, to thickness. To mix a batch, pour some in one cup, pour an equal amount of the other component in another cup (equal means eyeballing it, not weighing), then pour together and stir.

Another source is Perma-Flex (see Appendix), which makes 21 different kinds of rubber. Some of these are also 50:50 mixes, and are easy to use. So chase down some sources, get samples, and try them out. Everyone has slightly different requirements, so pick the product that's best for you. Then keep your eyes open for improved products, because the field is growing fast.

Applying the Rubber

The first coat. Brush on the first coat with a throwaway brush. Don't scrub all over. Just lay heavy gobs of rubber against the surface and push it to get it on (Figure 8-39). The rubber drips down some. Let it run into the detail rather than scrubbing it in, because you can scrub detail away. If the model is small, you can sometimes pick it up by the base and hold it upside down for a few moments to let rubber run up into cavities such as armpits. Cover all the clay with the first coat. Even if you are doing a piece where some parts of the clay won't be cast, like the bottom of the neck of a portrait head, cover them anyway. The mold-making process takes a few days, and you don't want the clay drying out and shrinking.

Clean up. When you've got everything covered, throw the brush and cup away. Keep a roll of paper towels handy, and wipe up every tiny spill as it happens, so

FIGURE 8-39 Applying the first coat of Smooth-On by brush.

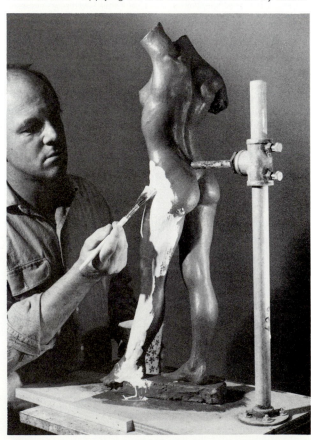

there is no mess. The unset Smooth-On is like honey or pancake syrup, and if you're not careful, it gets everywhere and makes everything sticky. It doesn't wash off easily—you have to use acetone, which is nasty. The best approach is to treat it like acid or poison, and just don't get any on you.

Don't try to apply another coat until the first one is no longer sticky. If you do, you may disturb it, pull at it, or lift it, and mess up a spot underneath.

Setting time. This varies with the temperature in the room. On hot days, around 80° F., rubber will set firmly in three or four hours. At 70° F., it may take ten hours. Don't use it at temperatures under 65° F., as setting will not be complete. Feel some of the material that has run off onto the board. If it is firm but sticky, that is ideal for the next coat. Later coats will stick, however, even if the first coat is set completely and has lost all tackiness.

The second coat. Mix your next batch when the first coat is hard to the touch. Mix a bigger batch with 2 percent Part D. This will stir up a lot thicker, so it is important to transfer it to another cup for thorough mix-

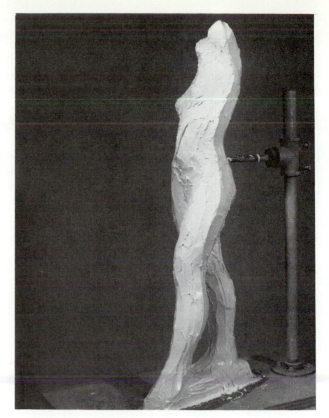

FIGURE 8-41 The mold after two coats of 2 percent mix, showing a ridge for later dividing. It also shows many swirls in the surface, which will be covered by a final coat of 1 percent mix.

ing. Apply this one with a spatula tool, as though you were frosting a cake. Be neat. Make every little stroke as smooth as you can (Figure 8-40). Try for about ¼ inch thickness everywhere. Also, try to make as simple a mass as possible—that is, fill in undercuts. You can make an ear, for example, a generalized mound on the side of the head. Look at the mold in the light of having to take a plaster piece mold off it with no undercuts.

The third coat. It's a good idea to apply a third coat, also at 2 percent, but less thickly than the second coat. Fix up uneven spots, fill in undercuts, smooth out rough places, and, in general, model the form to be simple and ready for a plaster piece mold. At this point I often decide where I will cut the rubber mold to take it off, and I begin to make a ridge along that line (Figure 8-41). If you are using shims, look at each section of the mold to make sure a plaster piece will pull off cleanly. Fill in where necessary with rubber.

The last coat. Finally, when the third coat has set, mix a 1 percent batch and brush it all over, getting the whole thing nice and smooth, so you can pull off a plaster mold without hooking into spatula swirls.

FIGURE 8-40 Applying the second coat of thick Smooth-On with a spatula.

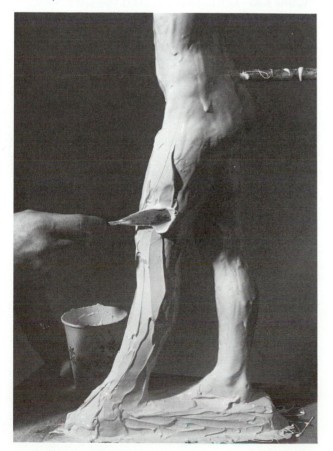

The Plaster Support Mold

If you were to remove the rubber mold from the clay without making a plaster support mold, it would flop around like an overshoe, losing its shape. So you need a support mold. This will be a plaster piece mold. If you have used shims, it is very clear where your pieces go. Apply plaster neatly to a level equal to the top of the shim wall.

Otherwise, make clay walls for your mold divisions. Have a quantity of very soft clay on hand, and use little gobs of it on the back side of the wall to be sure the wall sticks (Figure 8-42).

How to divide the mold. The trick now is to make a series of pieces of the plaster mold that fill two requirements: first, each piece must pull off without hooking on any undercuts; and second, the pieces must be capable of being held together for casting, without dropping apart.

The first piece. Usually, you make one major piece running all the way down one side of the sculpture. Then you make smaller pieces that relate to the main one. Find an area on the rubber mold that can be enclosed

FIGURE 8-43 Bottom pieces and long front piece of the support mold in place.

FIGURE 8-42 Clay walls in place for the first pieces of the support mold. (Note the smoother surface of the rubber after the final coat of 1 percent mix.)

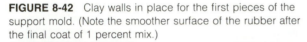

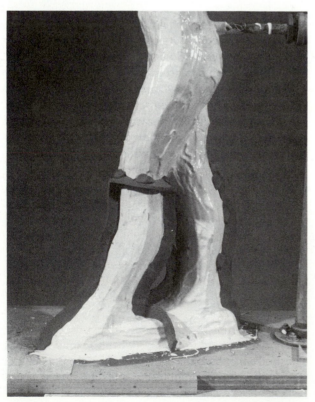

in a clay wall, so that every part of the rubber within that wall can be seen from a single vantage point. If there is a hummock or mound that you can't see around without moving your head, then the mold will hook on that. Try to find an area you can enclose this way, and try to make that area as big as you can by pushing the wall toward the horizon as far as it will go, without going over the horizon. If you have just a small spot here and there that looks like an undercut, you can fill it with a little clay; the rubber is stiff enough to support itself in small areas.

Applying plaster. Once you have determined a major area for the first piece and built a wall around it, mix a good thick batch of white plaster (there is no need for two layers or for colors in the plaster) and apply it. Put it on with a large spatula tool. You can use your hands as well. Aim for ¾ inch thickness, almost without regard for how large the piece is (Figure 8-43). When pieces get very large, don't make them thicker, but reinforce them with steel bars, cloth, or pieces of wood.

Again, clean the tops of the walls carefully after every batch. Make the mold neat, because everything will be much easier later if your mold is clean and solid.

FIGURE 8-44 Blind piece (arrow). This must be greased before the larger piece goes over it. (Note the clay around the pipe to allow some room so the plaster piece can be removed.)

The remaining pieces. For the next piece, take the clay wall off, Vaseline that edge, and add another clay wall, moving as far around the piece as you can before you go over the next horizon. You are now looking at the piece from a new vantage point, again trying to make as large a piece as you can without undercuts. This may sound a little confusing, but once you begin to look at a piece in terms of areas without undercuts, the idea will become clearer. The illustrations may help, too. There is no substitute for trying, however.

Fixing mistakes. If you get a piece that won't come off, crack it off with a chisel, then remake it in two parts. Or, if it seems to be stuck just a little, see if you can pry it off; then look at the inside for the offending obstruction and file it away.

Blind pieces. Another helpful hint is to make what I call *blind pieces*. If you have a situation where you could put a large piece on except for one area where it wouldn't pull off, say a depression, you can fill that depression with plaster, making a small piece that will

pull out. Grease it, and lay the large piece right over it. You can see one of these in Figure 8-44.

Removing the Mold

Removing the support mold. Once the last piece is complete and has set hard, you can use a Surform file to make all the seams smooth and perfectly aligned (Figure 8-45). Take the plaster mold off by working a thin tool into a likely crack and prying a piece loose. With one piece removed, the others should come off easily. If you have trouble with a piece, you have gotten an undercut. Work the piece off as best you can, then file away the undercut portion in the plaster mold.

Removing the rubber. Once the plaster is off, you have to remove the rubber. Using a good sharp knife, like a mat knife with a new blade, slit the rubber where you want it divided (Figure 8-46). But where do you want to divide it? On a portrait head, you start slitting at the bottom of the back of the neck, come straight up the back of the head over the top to just about where the hairline is at the forehead, and stop. Also, cut out the disc at the flat bottom of the neck. Then peel the mold off like an overshoe. It is not divided in two, but only slit. It will go back in the plaster mold, and you can reach inside with your hand to be sure the seam has fallen straight again.

FIGURE 8-45 Plaster support mold complete.

FIGURE 8-46 Cutting the rubber mold. Use a new sharp blade for easy cutting. (Note how the cut is made along the ridge.)

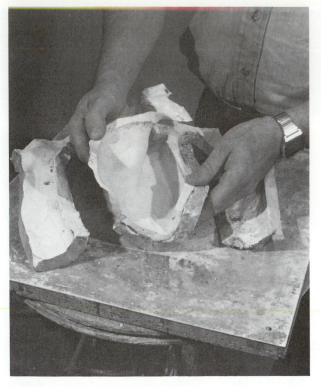

FIGURE 8-47 The leg section of the rubber mold cut on one side only, thus remaining in one piece.

FIGURE 8-48 The upper section of the mold cut in two pieces, each in its own section of the plaster mold.

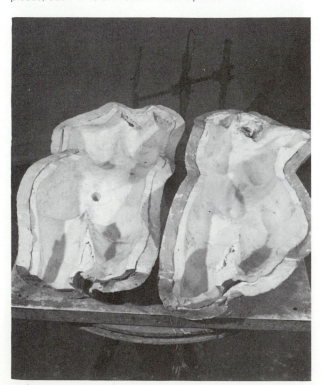

In general, use the same principle for other sculptures. Try, if you can, particularly with smaller pieces, to slit the rubber so that one side remains attached (Figure 8-47). For larger pieces, you may want to slit the rubber so it falls into two halves, which will lie neatly in sections of the plaster mold (Figure 8-48). This illustrates the one disadvantage of using shims for rubber molds. With shims, the rubber and the plaster divide at the same point. While this is fine in many cases, there are times when you may want to divide them at different points. Also, with shims, the rubber will be in as many pieces as the plaster, which may create extra seams in the cast. By using the clay wall, you can make the plaster in as many pieces as necessary, but cut the rubber only minimally, helping it hold its shape and reducing the number of seams to clean up later.

You can clean any clay residue out of the rubber mold by washing it with water. Clean any clay off the plaster mold, and then trim the rubber mold any place it needs it with scissors. That's it.

Storing Rubber Molds

If you want to store a rubber mold after use—and you almost certainly will—you can just leave it if it is small, but it is better to fill it with something. If you fill

it with plaster, you should rub the inside of the mold well with Vaseline first; otherwise the plaster and the rubber grow together and get stuck. It's even better to spray the mold with silicone and then fill it with wax. Having something in the molds prevents them from collapsing and preserves them better. If you really want to save one for posterity—like years and years—it is best to take a good plaster cast from the mold and save that, as the rubber will deteriorate with time, but plaster is permanent. New molds can be made from plaster at any time.

Poured Rubber Molds

The idea. The poured rubber mold is another technique many sculptors use. In a nutshell, it works like this: The plaster support mold is made first, with a gap left between it and the sculpture. Then liquid rubber is poured into the gap, forming the rubber mold.

The process. First, it is important to understand that some sculptures are more suitable for this technique than others. Works that have a bottom that sits on a board are best, such as standing figures. Pieces that are suspended in air on the armature are more difficult, and need some sort of bottom built beneath them.

As an example, let's consider a simple piece, a monolithic figure (Figure 8-49). The first step is to be sure the figure is securely anchored to its board.

Next, the sculpture needs to be covered with a layer of clay, which will represent the layer of rubber. Soft clay can be rolled out in sheets about ⅜ inch thick, then

FIGURE 8-49 The steps in making a poured rubber mold: (a) the model; (b) the model covered with clay blanket; (c) the plaster mold in place; (d) the plaster mold removed; (e) clay removed, and plaster mold secured in place; (f) rubber being poured in.

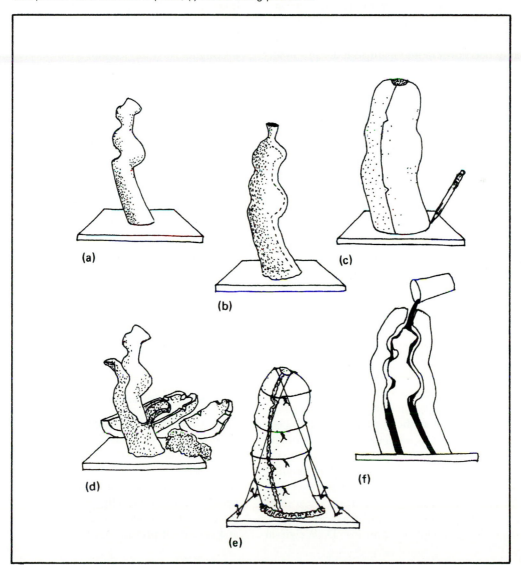

(a)

(b)

(c)

(d)

(e)

(f)

carefully placed over the sculpture. There is some danger of disturbing the surface of the piece, so some sculptors cover the piece with thin plastic, like Saran Wrap. If the piece is plaster, there is less of a problem.

The clay is formed over the sculpture just as the rubber will be, that is, forming a shape from which a plaster mold can be taken in two or three pieces. It is not important to press the clay tightly to the sculpture, since it is only creating a space into which the rubber will eventually flow.

At the top of the clay mass create a pouring spout (see Figure 8-49), which will remain an opening in the top of the plaster support mold through which the rubber will enter.

When the clay is formed, make a two- or three-piece plaster support mold, or mother mold, over it, using either a clay wall or shim technique. When the mold is complete and in place, draw a line on the board around its base, so you can replace it exactly in position.

It is a good idea at this point to provide a means of holding the mold firmly in place. Think ahead. Before you pour rubber into the cavity, you must have the plaster mold securely tied down to the board so it doesn't float. At this stage you might screw some hooks or eyes into the board, and arrange wire or strong straps to tie the mold securely in place.

Now remove the plaster mold and all the clay from the piece. Save the clay in one place, and clean the piece as necessary. At this point, apply a release agent to the piece, and Vaseline the board around the piece and the inside of the plaster mold. You are now ready for the rubber.

The actual pouring of the rubber can be a little frantic if you're not prepared. First, make sure you can replace the plaster mold exactly in position, securing it very tightly together and very tightly down to the board, in fifteen minutes or so. In other words, have everything ready, and rehearse that operation.

Now you must determine how much rubber to mix. That is why you saved the clay you took off the piece. There is an easy way to measure the volume of the clay. Fill a bucket to the brim with water and place it in a larger basin. Immerse the clay completely in the bucket, causing it to overflow. The water that overflows into the basin equals roughly the volume of the clay, and thus represents the volume of rubber you will need. Weigh this water (remembering to subtract the weight of the cup you pour it into), then multiply that weight by 1.4 (which is the specific gravity of most rubber molding compounds), and you will have the approximate amount of rubber to use. When you figure the Part A you must have, you have a 10 percent excess, which is about right.

Now mix your rubber, with no Part D. Weigh an empty cup (you don't need the stick on the scale). Then add to that weight the amount of rubber you need, and fill with Part B until the scale tips. There's no need for super accuracy on this. Just get enough, and then weigh it carefully and make your calculations. Figure exactly how much Part B you have by subtracting the weight of the cup; then add to your total (Part B plus cup) 10 percent of Part B alone (just move the decimal point one place to the left); set the scale for that total, and pour in Part A to balance. Stir thoroughly.

Brush a layer onto the sculpture, making sure you coat everything and there are no bubbles. Working efficiently but not in a panic, assemble the plaster mold correctly in position according to the lines you drew on the board, strap it tightly together, and tie it down securely. Then press fresh soft clay into all the seams so you are sure it is absolutely sealed.

Slowly pour the rubber into the pouring spout at the top, rocking the piece to release any trapped air. Fill it up completely. Have some soft clay handy, and keep your eye on the mold for a half hour or so to spot any small leaks and stop them. Then let it stand at least overnight. Next day, remove the plaster mold, and cut the rubber in the usual way.

Advantages and disadvantages. This process is quick, since you can apply the clay and plaster in a short time, then pour the rubber, and leave it. You need about three days for a brushed and buttered mold, though your time is not used constantly. Also, with the pouring technique, you can be sure of getting a good plaster mold with no undercuts.

However, the pouring technique will generally use more rubber than brushing does, which means more money. Also, for pieces that are complex, brushing is easier. It is also easier for large pieces. Also, you run relatively little risk of disastrous leaks with the brushing method. There is no doubt that as you approach lifesize, brushing is clearly superior.

By now you know my philosophy on this sort of thing. Think about it, and use whatever works best for your particular situation.

Some Additional Thoughts

These techniques are not the limits of mold making by any means, but should serve for most applications in sculpture. As you work with molds, you will develop techniques that work for you, and discard those that don't. Be sensitive to the whole problem, and above all, be neat and careful. Usually the difference between a good mold and a poor one is a series of little things. Neatness and care must prevail in a hundred little ways.

NINE

Filling Molds

PLASTER

Casting consists of filling the molds with a liquid which becomes solid, and then removing the mold so you have your object reproduced. Let's start with the simplest, which is filling the plaster waste mold with plaster to make a plaster cast.

Release Agent

First, you must prepare the mold with a release agent. The best release agent to separate plaster from plaster is soap. You can use some dishwashing detergents, but not all work. Those based on real soap work; otherwise you have to experiment. A safe release agent is any kind of soft soap. Another way is to to boil small leftover pieces of soap until a thick paste is produced. Apply the soap all over the inside of the mold, and then, with a brush and some water, lather it up (Figure 9-1). Build up a rich lather everywhere, and let it stand about ten minutes. Then lather some more, and let it stand again, so the soap soaks into the pores of the plaster mold. Rinse all the suds off carefully, without violent scrubbing. Make sure to get the slimy film out. At this point, the mold should also be well soaked with water.

Next, brush in a fine film of oil (cooking oil works) by putting a little oil on your hand, stroking it with a clean paint brush, then brushing that in the mold. You're not gobbing oil on—just a whisper is all you need.

Joining the Pieces

You can either put the pieces of the mold together or fill them separately. If you have a portrait head, for example, it's not a bad idea to join the two pieces by fitting them together, supporting them carefully with something like wooden blocks, and then applying a good layer of thick plaster all around the outside of the seam (Figure 9-2). When this has set, you have a spherically shaped mold, open inside.

Filling the Waste Mold

To fill the waste mold, you repeat the process used to make the mold, but with some differences. Mix a first layer of plaster about the same consistency as your blue layer, but without any color; leave it white. Pour this into the mold, roll it around until all surfaces are covered, and then pour it out (Figure 9-3). When this coat is beginning to stiffen, mix a thicker, larger batch, pour that in, and roll it. Keep doing this until you have built up roughly 1 inch thickness all over. Each time you finish, use a tool to clean up the end of the neck, or wherever it is you're pouring the plaster in and out, so it doesn't run all over (Figure 9-4).

Adding a support pipe. If you want to mount the head, insert something on which to mount it, like a piece of electrical conduit (galvanized steel pipe). The end that goes in the head should be flattened somewhat with a hammer to give the plaster a grip. Pour or gob plaster around it, both at the end (in the top of the head) and where it touches the neck (Figure 9-5).

Cloth reinforcing. If you're making a relief or a larger piece, you can treat the mold pieces separately, like open-face sandwiches. With this kind of piece, you have the advantage of being able to add cloth or hemp fiber to the plaster after the first detail layer has set. This way you can make lighter, stronger casts. Cloth is all right as a reinforcement, but *plasterer's scrim*, a soft, open-weave burlap, is better. Best is hemp fiber (see list of suppliers).

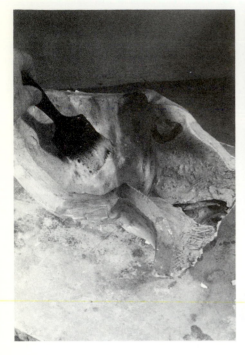

FIGURE 9-1 Brushing soap into a waste mold.

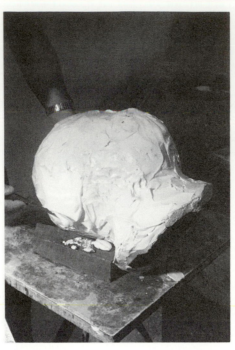

FIGURE 9-2 Joining the two halves of the waste mold. (Note that they are propped to stay in position, and thick plaster is being applied to the seam.)

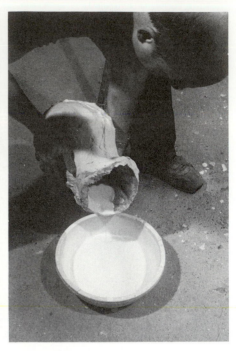

FIGURE 9-3 Pouring the first coat of plaster. After being rolled around inside, the plaster is poured out. The mold is rotated at this stage to coat all surfaces.

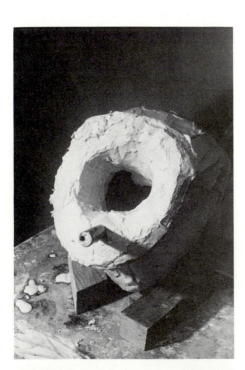

FIGURE 9-4 The mold completely filled, with the mounting pipe in place. (Note the definite finish to the cast.)

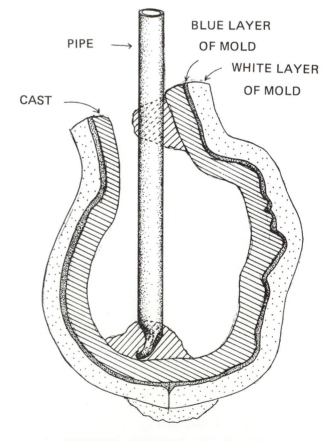

PIPE

BLUE LAYER
OF MOLD

WHITE LAYER
OF MOLD

CAST

FIGURE 9-5 A steel pipe placed in the head.

If you are reinforcing with cloth or scrim, tear or cut the material into strips about 1 inch wide and about 6 inches long. Soak these in water. Mix a batch of plaster for your second, or even third layer in the mold. Wring out a strip of cloth, and work it around in the plaster until it is thoroughly impregnated, then pat it into the mold. Make sure you press the cloth down thoroughly everywhere, so you don't end up with air spaces beneath it. Use your finger tips, and press each piece of cloth well in; then slop more plaster over the top. If you use hemp fiber, do the same thing. The mass of fiber conforms more easily to the inner surface of the mold, and it is stronger than cloth.

Pieces can be put together after individually filling by strapping them in place and pouring in plaster on the seam, or reaching in to pat it in place. Some ingenuity is usually needed here.

Casting Long Thin Forms

Interior reinforcement. I don't really want to say "figures" here, because this technique applies to any forms other than squat, compact ones. When you have any long form, you must consider interior reinforcement. Steel rods can be used, but you must shellac or paint them first, and let them dry, or they will rust and stain right through the plaster. You can also use strong brass or bronze rods. Aluminum is too soft to be of much use. In general, several thin rods give more strength than one thick one. Bend the rods here and there so the plaster can grip.

Filling. With the mold lying open, before filling, design your reinforcements so they lie nicely in the mold (Figure 9-6). After they are shellacked or painted, support them in the mold by mixing a small batch of plaster and letting it thicken a little. With the mold well prepared and soaked, apply little mounds of plaster to support the reinforcement, and set the reinforcement rods in the mounds, away from the mold surface. When they have hardened, assemble the mold and fill by pouring solid, or by the following method.

A large mold. When you make a large mold (life-size or bigger), you should reinforce mold pieces with strips of cloth and with wood or metal braces. Suppose you are making a mold of a lifesize standing figure. Make one piece of the mold the whole length of the figure, all down the front half. Make the back half in a series of pieces, feet to knee, knee to hip, hip to midback, midback to neck, and finally neck to head (Figure 9-7). When you fill the mold, you lay the reinforcing bars into the large piece as just described, then fill each piece of the mold

FIGURE 9-6 Reinforcement for a figure. (Note the heavy rods for main elements, lighter rods for smaller elements such as arms or fingers. Also note the mounds of plaster to support the reinforcement.)

separately. Attach the first back piece, feet to knee, and reach inside from the top to seal the seams. Attach the second back piece, and reach in again, and so on. Use a *squeeze joint* for the final joint.

Removing the Waste Mold

Back to our demonstration cast of a portrait head. When the last batch of plaster has set, get a small cold chisel ½ inch wide and a hammer or mallet, and chip the mold off. For a portrait head, I recommend starting at the base of the neck in the back. Do the back first for two reasons. First, when you get to the other side, it's the back that is lying on a cushion, possibly getting marred a little, not the face. And second, by the time you get to the face, you'll have had some practice.

FIGURE 9-7 Plan for dividing a lifesized figure mold, with one large piece on the front and several smaller pieces on the back.

Use the chisel and start to chip away the mold, looking for the blue layer. In general, go straight down with the chisel, and don't rake along the surface. Once you find some blue, very carefully chip it away to reveal the white underneath. That is your sculpture.

Create a cliff face, where the mold drops down through the blue layer to the cast. Keep chiseling on the cliff face, moving it constantly back as you chip it away, always keeping the chisel straight down toward the head (Figure 9-8).

When you write with a pencil, you rest the heel of your hand on the paper. You don't write with your arm hanging free, not touching anything. Handle the chisel similarly. Always brace your forearm, wrist, or the heel of your hand on the sculpture, so the chisel action is just the wrist, not the whole arm (Figure 9-9). That way you can keep from plunging the chisel into the cast with every stroke. You will chip the cast here and there, but don't panic. It can be fixed.

When you approach delicate things like ears, try to figure out where the ear is, and isolate it under a mound of mold. Work carefully towards the ear until you un-

cover a bit of it (Figure 9-10). Leaving mold all around the outside of the ear for support, delicately chip away the inner parts; then slowly work on the outside mass remaining (Figure 9-11).

Resist the temptation to work the chisel under the edge of a piece of mold and drive it in sideways to whap off big pieces (Figure 9-12). You'll get big pieces to come off, all right, but they'll take things like ears and eyelids with them.

Repairing the Cast

Even the best cast has the odd chip, nick, or seam irregularity to patch up. I maintain that the best craftsman is not the one who makes no mistakes (such a person doesn't exist), but the one who can minimize mistakes, and then repair the few that do occur. Look carefully at your cast when it is fully free of mold. Usually you find two sorts of defects—bumps and holes. Start by scraping or carving off the obvious bumps sticking up here and there. Then, soak the cast for a few minutes, mix a very small batch of thick plaster, and patch up the most obvious holes. Remember, never add new plaster to old unless the old plaster is thoroughly soaked. When you apply small amounts of plaster to patch nicks and holes, don't smear plaster all over, but use care and discretion. Use a very small blade tool for this work, and apply the smallest amount of plaster possible to each flaw, working it carefully until it just fills the depression. A dampened finger can apply that final smoothing to a small repair.

Working the dry cast. You can make some repairs with the cast soaked and wet, but after a while it begins to dry out, and you may still have to repair holes. Rather than soak the whole thing again, buy a can of the vinyl spackling paste that is made for repairing holes in walls. It is white like plaster, dries about as hard as plaster, and is designed to go on dry plaster. Patch here and there as necessary with spackle, and let the whole cast dry thoroughly. This may sound obvious, but I must say it: don't forget to put the lid back on the can of spackling paste. I've seen many cans wasted because of forgetting that simple thing.

The completed plaster cast, chipped out, repaired, and ready to mount is shown in Figure 9-13.

Mounting Plaster Casts

Designing the base. As a simple guide, an average portrait head usually looks good on a 5 inch cube. The base should be big enough to support the sculpture easily, but not so big it dominates. In general, keep bases simple and clean. Old gnarly logs or driftwood may command more attention than the sculpture itself. As you visit museums and galleries, check out the bases, to see how the "pros" do them.

FIGURE 9-8 Beginning to chip off the waste mold. (Note how the chisel is driven directly into the mold, rather than raking along the surface.)

FIGURE 9-9 Chipping off, showing the heel of the hand supported on the mold to prevent the chisel being driven into the cast.

FIGURE 9-10 Chipping off, showing the ear being exposed, leaving mold in place behind it for support.

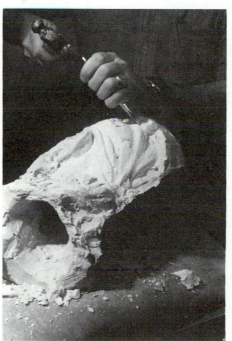

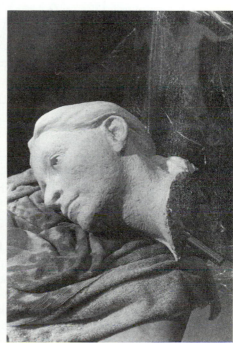

FIGURE 9-11 The ear cleared of the mold. Chipping can now continue.

FIGURE 9-12 The *wrong* way to chip off. Such an approach will remove large pieces, taking smaller details with them.

FIGURE 9-13 The plaster cast completely chipped out.

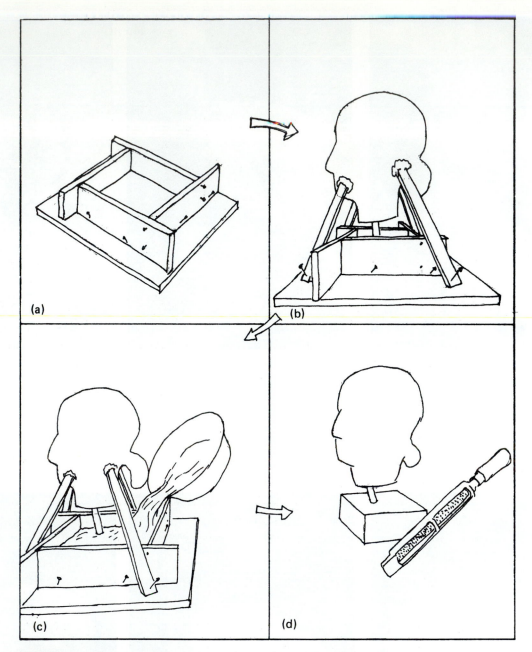

FIGURE 9-14 Mounting a head on a plaster base: (a) the base mold made of wood; (b) centering the head in the mold and supporting it; (c) pouring in plaster; (d) the finished base.

A simple plaster base. If you cast your portrait head with a galvanized steel pipe sticking about two inches out from the bottom, you can mount it on a base so it stands upright. An easy way to make a plaster base is to build a wooden box the size of the base, Vaseline the inside, then nail it down to a bottom board (Figure 9-14). Balance your sculpture on its protruding pipe, exactly the way you want it to be on the base. Use chairs or boxes or boards or anything handy to balance the piece. Then pour plaster into the box to the height you want

the base to be. Reach in with your hand or a tool, and jiggle the fresh plaster to level it. When the plaster is hard, remove the box and tidy up the plaster base with a Surform file.

A wood base. A solid piece of thick wood— 2 inches thick or more, and cut about 6 inches by 6 inches—makes a good base for a head. Another easy way to make a wood base is to build a box of ¾ inch clear pine lumber. Make it carefully, joining the parts

with glue and recessed finishing nails. It can be finished by applying several coats of latex paint with a roller (which fills the wood grain and imparts a slight texture), sanding lightly and spray-painting from a spray can. To attach the sculpture, drill a hole in the box the same size as the pipe in the sculpture, insert the pipe, and glue with epoxy. The problem is at what angle should the hole be drilled so the sculpture stands at just the right angle? Mounting a sculpture at the wrong angle is absolutely fatal, and the angle can be very subtle.

Here follows Langland's super method of getting the angle just right. It may sound confusing at first, but follow it, think about it, and you can do it.

Langland's Method

Step 1. Decide which face of the base you have made is to be the front, and exactly where on the top you wish to drill the hole. Mark an arrow showing the front, and then eyeball carefully where the hole is to be drilled so that the sculpture will be centered as you want it. Do this by holding the sculpture as though it was on the base, and center it from the front (Figure 9-15). Draw a line on the top of the base from front to back, along which the pipe should go. Then center the sculpture from the side, and draw a side-to-side line. Where the lines intersect is your spot (Figure 9-16).

Step 2. You need a drill press for this step, because a drill press drills absolutely vertical holes. Find a thick piece of scrap wood and drill a vertical hole in it, the same diameter as your pipe. Now stick the sculpture on that piece, and you'll notice that it's probably at the wrong angle (Figure 9-17).

Step 3. Take two pieces of plywood, each about 10 inches by 10 inches by ¾ inch, and set them on top of each other on a stand. Put the sculpture on its scrap base on top of those. Cut some little wooden wedges, and start to shove the wedges between the two pieces of plywood to make the top piece angled, until the sculpture seems to be standing at the angle you want. Look at it carefully, and get it just right (Figure 9-18).

Step 4. When the wedges hold the top piece of plywood at the correct angle so the sculpture looks right, take the sculpture off the plywood, and put your real base on, *but put it on facing backwards from the way the sculpture sat* (Figure 9-19). Don't ask me to explain this, but if you think about it enough, you'll understand why this works. Now pick up the whole affair—the two pieces of plywood separated with wedges and the base on top—set it all on the drill press, and drill your hole as marked (Figure 9-20). The hole will be at just the right angle (no matter what combination of directions) for the sculpture to sit perfectly (Figure 9-21). This trick

works for any jobs involving getting a compound angle right. And the beauty of it is that you get to see the sculpture at the desired angle (on the plywood pieces) before drilling.

FILLING PLASTER MOLDS WITH CEMENT

Not many sculptors use cement anymore, but it is still a good material for sculpture, particularly outdoor work. It has an earthy, rough quality, even though it can take extremely fine detail.

Kinds of Cement

There are many different kinds of cement, but all involve the same principle. There is the cement itself, and it is filled with an aggregate. Portland cement, the most common one, is available at any lumber yard. You can buy it either straight (just the cement) or premixed with an aggregate. Premixed cement usually has a brand name like Sakrete. Aggregates vary from sand to coarse gravel. Sand is preferable for smaller sculpture, while larger works require gravel aggregate. For very large works you can use commercially prepared concrete delivered by truck. That gets into the realm of serious construction, however, and moves beyond the scope of this book.

There are various specialty cements, the most useful being the *alumina cements*, often called *Ciment Fondu*. These are black, faster setting, and stronger, but more expensive. The cost factor is not great in terms of sculpture, but would of course be very great in building construction. In general, the alumina cements are better for sculpture.

Filling Plaster Molds

Filling plaster molds with cement is similar to filling them with plaster. Use a soap mold release, and make sure the mold is very wet. Fill each half separately. If using Ciment Fondu, paint in a layer of pure cement mixed with water to a heavy cream consistency. Brushed well in, this will give you the detail. With Portland cement, make the first layer a rich sand mixture, perhaps half and half cement and fine sand.

Mix a batch of cement with aggregate (sand is best for all-around purposes) and be sure to use plenty of aggregate, two or three times the amount of cement. Mix this batch so that you can squeeze a handful and it will hold its shape when released. The water content is all-important here. If the mix is too sloppy to hold together, add more cement and aggregate in the correct proportion. If it is too dry and crumbles apart, add more water—just a little at a time. Take your time until you get a mix

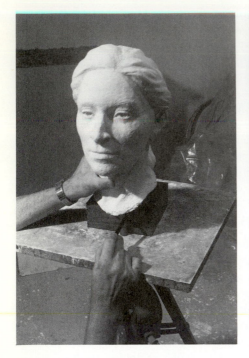

FIGURE 9-15 Centering the head on the wooden base, marking location of the pipe.

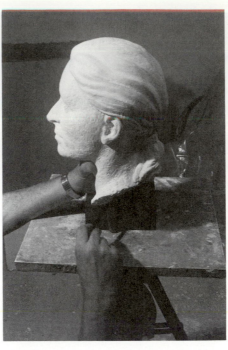

FIGURE 9-16 Centering the head from the side. The intersection of the two marks is the place to drill the hole.

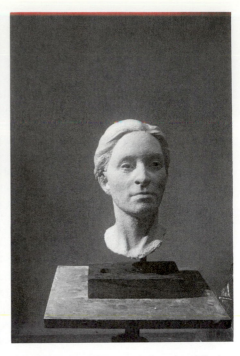

FIGURE 9-17 The sculpture on the drilled test block, sitting at the wrong angle.

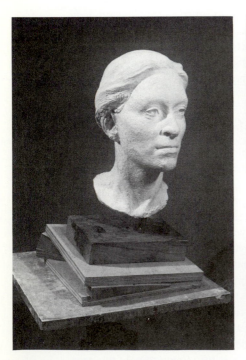

FIGURE 9-18 The sculpture on the test block, wedged to the correct angle by two boards.

FIGURE 9-19 The wooden base placed on the two wedged boards, but facing backwards from the way the head was placed.

FIGURE 9-20 Drilling the base, placed backwards on the wedged boards.

that is soft enough to be formed and not crumble, but dry enough so it won't drop out of the mold when you turn it upside down. Pat and press this mixture into the halves of the mold, driving it well in against the brushed layer, and working it to a thickness of about ¾ inch. At the edges, taper it back just a little to allow the two mold halves to fit together (Figure 9-22). When this is complete, test your mix by turning one mold half upside down. The cement should stay perfectly tight, with no hint of loosening or falling.

For long thin works or thin extensions, add steel reinforcements in the same manner as you did in plaster casting, with the exception that you hold the armature in place with small mounds of cement instead of plaster.

Joining Mold Sections

To join the mold sections, make what is called a *squeeze joint.* Apply a healthy bead of pure cement and water mixture the consistency of cream all around the edge of the mold, with most of it on the actual cement surface (Figure 9-23). This bead should be nice and even. Then press the other mold piece down onto it, making sure that it is lined up correctly, and that it is pressed

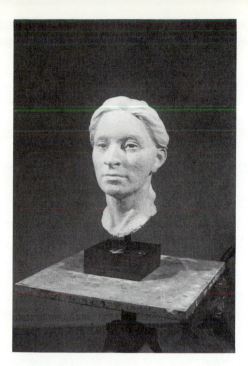

FIGURE 9-21 The head mounted on the wood base.

FIGURE 9-22 Edge of cement filling in the mold. Drawing on the upper right shows cement mounded above the mold edge, which will prevent the molds from seating properly.

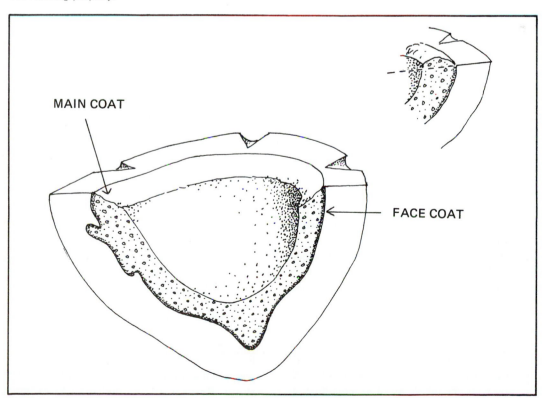

MAIN COAT

FACE COAT

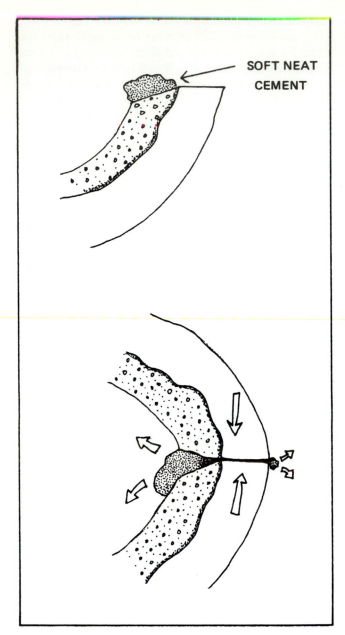

SOFT NEAT CEMENT

FIGURE 9-23 Forming a squeeze joint in cement: (*top*) piling soft neat cement on the edge; (*bottom*) the squeeze.

down tightly all the way around. Sometimes you can wrap the assembled mold with loops of rope into which you twist a strong stick or pipe, making a tourniquet, to apply real pressure on the squeeze joint. If you can reach inside with more cement to reinforce the joint, so much the better. Pack aggregate-filled cement in from the inside wherever you can.

Curing the Cement

Strap the two mold halves together so they won't shift; then wrap them in soaked cloths, and cover with a plastic bag. You want the whole affair to remain damp

and cool for the best setting action of the cement. Give it three or four days to get hard and to cure, keeping it wet and cool all the time. Chip the mold off the same way as you did for the plaster cast. You'll find it will come off faster and easier. Repair is again the same as for the plaster—file off the high spots first, then fill low spots with more cement (soak the cast first).

FILLING PLASTER MOLDS WITH RESINS

Kinds of Resins

There are a large number of products available for sculpture casting that are based on resins. However, though the variety may seem confusing, all the different kinds can be categorized according to certain factors.

The resin. First, there are two kinds of resin—*polyester* and *epoxy.* Epoxy is more expensive, stronger, and harder. You mix it with a half-and-half mixture of resin and hardener. Polyester is cheaper, not as hard or strong, though hard and strong enough. You mix it by adding roughly 2 percent of hardener. But there is another important difference. Polyester can have an irritating smell and be a skin irritant, but epoxy releases toxic fumes that can build up in the body, much like lead poisoning, and it can be very harmful or fatal. My strong advice is to stay away from epoxies (except for little tubes of glue) and to stick with the polyesters. The advantages of strength are not worth the very serious health risks. Even so, there are some serious risks with polyesters that I will discuss below.

The filler. Resins must have something added to make them stronger. Usually glass fiber is the main re-inforcement. There are also powder additives, some for color, like metal powders, and some for flow control, to thicken the mix. There are differences in the setting action of resins. Some are formulated to set well in thin layers, but will overheat and crack if allowed to set in thick sections. These are generally called *lay-up resins.* Others are made for thick sections, and are called *casting resins.* If you go to the auto repair store and buy polyester resin, you will be getting lay-up resin. You cannot pour thick sections of it, but must build up thickness with several brushed layers. When you buy commercial sculpture casting products, like Monzini, you will get powder-filled casting resin, which can be poured thick and solid.

Mold Preparation

Resin will not set properly against anything wet. Resin and water do not work together (unless you add water to the resin to form an emulsion, but that's another story). Resin is a glue, and it sticks to things. In fact,

straight polyester resin is used by stone workers to glue stone together. It sticks to bare plaster tenaciously.

Plaster molds. Plaster molds can work perfectly well for casting resin, however, if they are prepared correctly. First, let the molds dry completely. This means leaving them for at least a week in a normal room. You can also force-dry them in a couple of days by placing them in front of a hot-air vent and turning them from time to time. Hold the plaster mold against your cheek, or even your bare stomach, to feel for any dampness. Think of this: you can put your hands on the bathroom sink in the morning with no problem, but lean your bare stomach against it and *whoo-ee*! So use your stomach to feel for the slightest bit of dampness.

Second, you must apply a three-step release layer, as follows:

Step 1. Buy clear lacquer, and apply it with a brush. The first coat will soak in immediately and look dry right away, but wait about an hour before applying the second coat. Let that dry and do a third. The entire surface of the inside of the mold should be slightly shiny, including the edges. If there are any dull areas, keep applying lacquer until they are shiny. Let it all dry thoroughly.

Step 2. Apply paste wax with a soft brush to the whole inside of the mold. Brush it in carefully, and after about fifteen minutes, go over it with a clean brush to buff it as best you can.

Step 3. Brush on a layer of Poly-Vinyl Alcohol (PVA). Buy this release agent from your resin dealer. It is a green liquid that thins with water. Brush it on carefully, and be particularly careful not to start it foaming. Dip the brush gently into a cup of PVA—just the tip—and brush slowly and evenly, trying to build a fine green layer everywhere. Brush out any puddles, and keep working it until it is thin and even.

Resin Lay-Up

When the PVA layer is completely dry, you're ready to put in the resin. There are different ways of doing this, depending on the mold and the kind of resin you've got. If your mold is either in pieces or a relief, you will probably want to brush in and lay-up.

Mixing resin. There is no hard and fast rule for the amount of hardener to add when mixing lay-up resin, but 2 percent is about right. If you are in a very warm place, add less, maybe 1 percent, or it will set too fast. If you're in a cool place (but never try this under about 65° F.), add a little more, perhaps up to 3 percent. You can use the same method we used to mix rubber, or, if you don't have a scale, you can eyeball it. Stir it well.

WARNING: The hardener for polyester resin is called Methyl Ethyl Ketone Peroxide, or $MEKO_2$. This stuff is very irritating to the skin, and you should never touch it. But more important, a single drop in your eye blinds you instantly and permanently! WEAR GOGGLES WHEN MIXING! Don't lose an eye to this stuff!

Thixotropic agents. If you painted the resin in the mold as is, it would probably be so runny it would puddle in the low spots and run off high places, so some thickener is advisable. Usually these are powders that you can buy where you bought the resin, if it was a plastics dealer. Fumed silica, called Cab-O-Sil, is a good thickener, since it is very light, but it "gels" the resin, so it is still brushable but doesn't run. Cab-O-Sil is very fine silica and should not be inhaled. WEAR A MASK WHENEVER YOU USE IT!

You can sometimes buy ground walnut shells or ground cherry pits, and these natural, harmless powders are as fine as flour, and they thicken resin nicely. They also color it. Walnut shells make it look just like chocolate sauce, and cherry pits make it look like butterscotch sauce.

The gel coat. Paint your thickened resin mix into the mold, making sure to cover everything carefully and being sure to keep the mating edges absolutely clean. As with the rubber, try to keep resins off your hands. Treat it like acid and avoid it. In particular, if a tiny bit gets on the brush handle or on your finger, immediately wipe it off with a paper towel moistened with acetone. Staying neat is easier and more pleasant than getting messy and trying to clean up later.

Glass reinforcing. After the first layer has set but before you apply the glass fiber, mix a second batch of resin with more thickener, and go over the inside of the mold again, trying to fill deep hollows. Glass fiber bridges over deep holes, leaving a bubble underneath, so work to get the inside of the mold as smooth as possible (Figure 9-24).

Glass fiber comes in a variety of forms. The finest is glass tissue, with a texture like toilet paper. Then there is chopped strand mat, and there is the cloth itself. You can also get loose chopped short pieces. It is best to buy some of all four kinds. Start with small pieces of the tissue, torn into bits the size of postage stamps. Apply a little straight resin (mixed with the hardener, of course), and then put some tissue down on the wet resin. Using the ends of the bristles, stipple more resin into the tissue to soak it completely. Cover the whole inside of the mold this way. When it is set, apply more glass, this time using the chopped strand mat. Cut this into pieces the size of playing cards. If it is too thick, you can usually pull it apart to make two thinner pieces. Again, paint in resin first, lay down the glass, and stipple with a loaded

FIGURE 9-24 Fiberglass being placed in a plaster mold: (a) glass bridging over hollows; (b) first layer of resin; (c) second thick layer of resin filling hollows; (d) glass placed over filled hollows.

brush until fully saturated and completely pressed down. Finally, you may want to add a layer of glass cloth, done the same way. But use plenty of glass, built up carefully in layers. Don't bridge over holes, leaving gaps underneath.

Clean up. All the time you're doing this, you need to worry about clean-up, because the stuff is messy. I recommend using cheap brushes and throwing them away, rather than having cans and jars of acetone all over. Use acetone to wipe up small spills and to clean bits off your hands, but in general, it's not a good idea to use it to clean all your brushes, because it releases fumes into the air and poses a great risk of serious fire.

DO NOT SMOKE anywhere near the resin area. Also, only work in an area with very good ventilation.

A proper ventilation system with explosion-proof motors is best. Next best is a strong fan at your back, blowing fumes away from you towards an open window or door. Don't work in an area where electric motors such as air compressors or furnace motors may turn on automatically. Most electric motors emit sparks upon starting and running, which can cause an explosion.

Joining Mold Sections

To join pieces of mold, first be sure the edges are clean, and that you have finished applying resin and glass to each piece. Line the pieces up and strap them together. Pour in a slightly thickened batch of resin, rolling the mold so it runs all around the seam. Reach in with a brush, perhaps one taped to a long stick, and try to lay

in as much glass as you can over the seam itself. One trick is to use glass cut into tiny bits, like a box of hair; mix that with the resin, and pour around the seam.

Mold Removal

To remove the mold, you need not chip carefully as with a plaster or cement cast. Begin by hitting the mold with a hammer all around it to start cracks and fractures. Soon great chunks will fall off, and you can pick off the small stubborn bits. If you didn't get your release agent on just right and some of the mold sticks tight, soak it in water for a couple of days, and the plaster will soften and come off more easily.

Repairing the cast. Repair of a resin cast is best done with commercial body putty, which you buy in auto parts stores. This is polyester resin mixed to paste consistency with an inert powder. It comes with a special cream hardener in a tube. Follow the directions on the can, and you have about five minutes per mix. Again, the principle is to carve off the high parts and fill in the holes. Coloring and finishing are discussed below.

Cold Cast Bronze

Cold cast bronze is a term used to describe a resin cast loaded with bronze powder, often a substitute for foundry casting. Essentially, you mix your first batch of resin, but instead of adding any thickeners, you add a good slug of bronze (or other metal) powder, until the mixture is very thick and creamy. You can also buy resin and metal powder already mixed. This batch is painted into the mold (or poured in and rolled around) and allowed to set. The metal grains actually sink to the mold surface, forming a nearly solid mass of metal at the surface itself. The cast is then backed up with glass in the usual way, or sometimes filled solid with casting resin loaded with slate powder, iron filings, or other inexpensive filler.

Filling a Mold with Poured Resin

If you have a small mold or one which cannot be easily divided, you can fill it by pouring resin. Devise a method of hanging the mold mouth downwards—for example, by tying a rope sling around it and hanging it from a strong hook. Place a large sheet of plastic on the floor beneath it. Mix a batch of resin thin enough to run, but thick enough to leave some on the surface, and pour it in the mold. Roll the mold around until you are sure every spot inside is covered, then hang it upside down, and let the excess slowly drain onto the plastic sheet. Apply a second coat the same way, but a bit thicker. Then apply coats to which you add chopped resin—little hairs—making the resin mix look a little like sauerkraut. These coats provide strength, so do about three pours

like this. A cast made this way is not as strong as a proper lay-up job, but it is strong enough.

You can also pour molds, either hollow or solid, with various *casting resins*. The best-known of these are the many Monzini products (see Appendix for supplier). These are casting resins filled with colored powders. For example, Carazini is white and is supposed to look like Cararra marble. (Actually, it looks more like solidified vanilla malted milk, but it comes up nicely with steel wool and wax.) Granzini looks like granite; Bronzini, Ironzini, Alumazini, and Pewtazini look like various metals. These are mixed according to instructions, and then poured into the mold. Small things can simply be poured solid. Pour some in, then roll the mold around to release air bubbles, then pour in some more, roll, then some more, roll again, and finally fill up. Or they can be *slush cast*, by pouring some in, rolling, and hanging upside down to drain, then adding more layers until the desired thickness is achieved.

FILLING RUBBER MOLDS

Rubber molds are easier to fill than plaster, mainly because they are easier to take off and need less preparation. To cast plaster or Hydrocal (a harder form of plaster) from a rubber mold, no mold preparation is necessary at all. Molds can be filled full (again, by pouring in plaster, rolling to release air, pouring some more, and rolling again, etc.) or slush cast, as with the plaster mold. Removal is easy. Work the plaster support molds off, and peel the rubber away. However, there is one problem. Suppose you have a small undercut on one of the plaster mold pieces. Chances are there was enough give in the clay so the mold pulled off all right. But rigid plaster has no give, and any mold piece with a slight undercut will stick tight. So, before filling a rubber mold with plaster, be sure to examine each plaster mold section very carefully to find and file away any undercuts. If a mold piece gets stuck, you have to make a choice. Do you destroy the mold piece and save the cast, or do you break up the cast and save the mold? Usually the latter is better, but this is an individual decision.

Rubber molds can be filled with cement, as described above. A light coat of paste wax rubbed in the mold first helps. This also helps for resin casts, which are done as described above. I'll talk about taking wax casts in Chapter 10.

FINISHING CASTS

Plaster

The easiest way to finish a plaster cast is to leave it as it comes from the mold. This sounds a little simple, but it is surprising how effective a sculpture material raw

FIGURE 9-25 Completed head with white latex paint to even out the color and a coat of spray gloss fixative to protect from dust and add sheen.

or a lot. The oil paint does not soften the acrylic, and it allows you a long time to play with it. You're on your own on this one. Use invention, sense, and sensitivity.

Imitating Metal Colors

Imitation metal (bronze, for example) can be achieved by painting the sculpture first from a spray can of brass or copper paint, then, when completely dry, oil painting over that. The high spots show through where the oil paint rubs off. Use a dark brown for bronzy looking things, or a pale turquoise for antique green things.

But I must add my two cents here. I'm not generally in favor of making one material look like another. It can be handy for a sculptor to send a plaster to a foundry for casting, and to color it as an indication of the desired patina, but to go around coloring plaster to imitate something else seems dishonest to me. It seems better to me to leave it white.

Other Materials

The same finishing ideas can be applied to cement and resin, though cement really ought to be left alone. But don't feel that the whole piece must be the same all over. I have seen cement pieces with small spots touched in with gold leaf, for example, and areas of color can be applied to great effect. Resin can be painted with acrylics, and then oils applied over that and rubbed. You can also treat resins like boats or sports cars, and spray them shiny and slick with auto paints. Any pigment-filled resins, like cold cast bronze or the Monzinis, should be worked over with steel wool and waxed.

white plaster really is. Plaster must be protected against dust and dirt, though, and a coat or two of white shellac or clear lacquer works well. If there is discoloration in the plaster, you can paint it with thinned white latex paint. The head in the illustration has been painted with thinned white latex paint, then sprayed with a gloss fixative to protect the surface from dust, and to give a slight sheen (Figure 9-25).

Coloring Casts

Plaster or resin casts can be colored very effectively. In general, you don't just want to paint them, but want to give some depth to the color. A good way to do this is to use two coats of paint, the first slightly lighter in tone than you want on the finished sculpture, and the second slightly darker. Use acrylic paint for the first coat, and let it dry overnight. Use oil paint thinned with oil and a few drops of dryer for the second coat. Brush it on thoroughly and wipe it off. You can wipe off a little

Effects of Color

As discussed earlier, color can have a powerful effect on sculpture, and can easily become overwhelming. Forms change character profoundly as they change color. A white plaster sculpture, when painted black, becomes quite a different sort of object. If a form is divided with color—one half white, one half black, for example—the division can be visually stronger than the form, though there is no actual form change.

Whenever paint is applied to a sculpture, all the associations paint carries become involved. If paint is sprayed on in a very mechanical and slick manner, that quality is grafted onto the form. If paint is applied freely, in an Abstract Expressionist manner, as in this bronze by Manuel Neri (Figure 9-26), the energy of the paint's application becomes part of the feeling of the sculpture, as does the expressive quality of the colors chosen. So

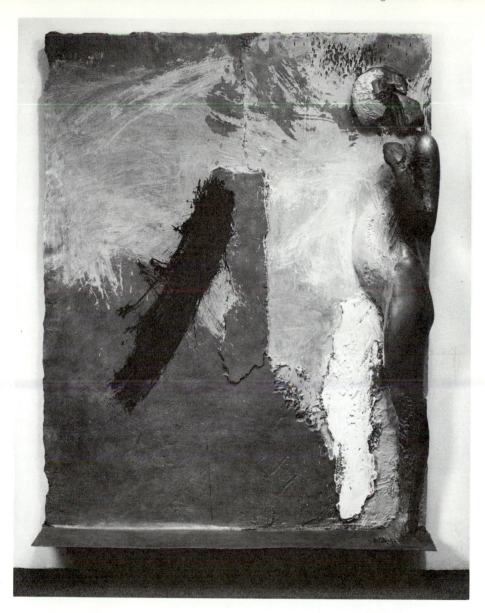

**FIGURE 9-26 Manuel Neri,
Mujer Pegada Series No. 1.**
1985/86, bronze with enamels.
Charles Cowles Gallery.

coloring a sculpture is not an afterthought without much importance; it is vital. When you see a painted sculpture, what you are really seeing is paint.

Casting with various kinds of molds filled with various materials could be a life's work, and many commercial foundries employ people who do nothing but this sort of casting, and they become very expert at it. I once knew of a man, for example, who went around the London art schools casting student portrait heads in plaster with a waste mold. This was all he did, and he was good.

How good? It was said he could do one, from start to fully chipped out, in one hour!

But as a sculptor, though you need to know how to cast, never forget that it is *what* you cast that matters. Always apply your greatest efforts to making the best sculpture you can, and let these technical matters serve the more important ideas you have created.

The next chapter will deal with metal casting in a somewhat elementary way, since this book clearly cannot say all that needs to be said on that complex subject.

TEN

Metal Casting

INTRODUCTION

Metal casting is one of the most exciting and satisfying sculptural processes. It produces works with an infinite range of form and surface possibilities. Metal is extremely durable and strong; it is a rich and widely varied material. Metal casting also cuts right across any stylistic or historical considerations. It is perfectly at ease with the most traditional or the most contemporary sculptural thought.

Of course metal casting is highly technical and complicated, involves lots of fancy equipment, and can be dangerous. The alternative—sending your work to a commercial foundry—is usually so expensive as to be beyond the means of any but well-established sculptors, or those with significant private inheritances.

But I argue in this chapter that casting your own work is not the enormous task many people feel it to be. Metal casting, like so many other activities, can exist on many levels, from easily accomplished small works, to the large and complex products of major foundries. This chapter provides an overview of some of the different kinds of metal casting, then runs through typical college foundry techniques, and finally discusses ways you can do metal casting without owning a foundry.

DIFFERENT KINDS OF METAL CASTING

For sculpture purposes, there are two major divisions of metal casting: sand casting and investment casting. *Sand casting*, which was widely used in the nineteenth century, is now usually limited to very large works. *Investment casting* is used for most "home sized" pieces—what most of us make. Since sand casting is a more complex form of casting, requiring special equipment and materials, it will not form a part of this discussion. I refer interested readers to books specifically covering that subject.

Investment Casting

Investment casting really means *lost wax casting*. Suppose you took a candle and buried it with just the end showing in a coffee can full of plaster. When the plaster went hard, if you put the coffee can upside down in an oven for several hours, the candle would melt and run out, leaving a candle-shaped hole in the plaster. If you poured molten metal into this hole, and then, when it cooled, broke the plaster off, you would have a metal candle. That's the idea. A wax sculpture is covered with a fireproof material, the wax is burned out, metal is poured in replacing the wax, and the cast is broken out.

Terminology. At this point we need some definitions so we can communicate. The *wax* refers either to the material wax or the sculpture made from wax. A *sprue* is a wax rod attached to the wax sculpture to serve as a channel for the metal to flow into the mold. The *gates*, which lead metal from the sprue to the sculpture, *vents*, which allow air to escape out the top, and *pouring cup*, which serves as a funnel into which to pour, make up the *sprue system*. The *investment* is the fireproof material that is placed around the wax. If the wax sculpture is made hollow, the material that fills the inside so the metal will also be hollow is called the *core*. The process by which the investment is heated to drive off the wax is called the *burnout*, and the act of pouring in the metal is called the *pour*. Many other terms will arise as we proceed, but these are necessary to start.

Kinds of Investment Casting

There are two kinds of investment casting in general use by sculptors: *ceramic shell* casting and *solid investment* casting. They are the same in principle, but they differ in the material used for the investment itself, and thus differ in practice for such things as spruing, cores, and burnout.

Ceramic shell. The ceramic shell technique uses a relatively modern material for the investment, which consists of a colloidal silica liquid and various refractory (highly heat resistant) powders or grits. The wax is dipped into the colloidal silica, and then, while wet, dusted with powder. When this is air dry, it is dipped and dusted again, with a coarser grade of powder. After several dippings a shell is built up, about ⅜ inch thick, all over the wax and its sprues. This is fired in a kiln or other furnace until red hot, which both eliminates all the wax and fires the ceramic component of the shell, making it very hard. While still hot, the metal is poured in.

Solid investment. The solid investment technique uses plaster filled with an aggregate such as sand for the investment material. This is poured around the wax, into a container, to form a large solid mass. This mass is then burned out at much lower temperatures, for a longer time, and the metal poured in. This method is also called *traditional investment.*

There are advantages and disadvantages to each method. I don't want to make a case here for one or the other, but just describe how they work, so that those of you getting started in casting can decide which to use. Naturally, the best solution is to be able to use both methods, selecting whichever one is right for a particular job.

Advantages of shell casting. Most commercial foundries and many college foundries use the shell method. Its advantages are great surface detail on the bronze, ease of handling the molds, and rapid burnout. Shell castings usually have surfaces that are more sound, which is important if you plan to polish the work. Due to the high heat of shell burnout and the ability to flush burned-out molds with water, shell is much better for sculptures involving materials other than wax, such as wood, plant material, cloth, or insects. And the possibility of attaching many small sculptures to a single sprue to be shelled all as one often makes shell the method of choice.

You have to arrange some kind of special furnace to burn out molds, but this can often be made of such materials as 55 gallon drums, ceramic wool insulation, plus some heavy gas burners. You need to buy the colloidal silica, commonly called ''*slurry*'', and it is ad-

visable to use a mixing device to keep it stirred so it won't settle and go hard. Many foundries have a large box for the stucco material, with an air source at the bottom blowing up through a zillion tiny holes, creating a miniature sandstorm through which the wet wax can be waved for coating. But large flat trays also work well. And you need a drying area with good ventilation.

Disadvantages of shell casting. There are some disadvantages to this process as well. It takes several days to shell a wax, though you only spend a few minutes a day working on it. A commercial foundry, with a constant flow of waxes, can shell them very efficiently in an assembly-line process. In a college foundry, however, where students come in only two or three times a week, it might take even longer to shell a piece, since the students have to dip and dust, then let it dry a few hours, and perhaps not dip and dust again for two days (the next class period). Thus, shell casting works better for large numbers of works, but solid investment is better for the occasional work.

Another disadvantage to shell is the general difficulty of cores. Usually pieces have to be cut up in order to get the slurry to flow and dry inside pieces, which means welding pieces together. While not a serious disadvantage, it is a consideration.

Another disadvantage is in casting large works where sections must be aligned and welded. When a large wax is dipped in liquid, the chances of its bending are great. With the solid technique, waxes can be partially invested while still in their original molds, thus assuring that there will be no distortion at all, and perfect fit later.

One other thing about shell is that although the burnout is quicker, I find I have to spend more time at it. Solid investments can be placed in the kiln and left for 48 hours, then pulled out and poured. Time spent by worker: putting in and taking out only. Shell castings are put in and fired for two hours, then pulled out. Time spent by worker: two hours, since you must hang around for that job. After they cool, they are usually rinsed, repaired, and fired again, which can be an advantage in the casting, but also takes time. Also, more precision is needed in the pour itself with shell, since the molds should be poured hot, and they cool quickly. Solid molds hold their heat so long that you have much more time for the pouring operation.

Advantages of solid investments. Some of the advantages of solid investments, in addition to those mentioned above, are cheapness and the ready availability of the materials. For shell casting you must special order rather expensive materials. It is easier to adapt existing pottery equipment to the burnout process. And often, investing is faster.

FIGURE 10-1 A burnout kiln—actually a gas-fired pottery kiln. The pyrometer can hold the temperature to the correct level.

FIGURE 10-2 A No. 30 bronze melting furnace. (Note the skimmers on the left, lying in a cast iron container for slag.)

Disadvantages of solid investments. Solid investments use heavy molds, which usually require special equipment to move them around. They have long burnout times, use more fuel, and require kilns that can be left overnight (sometimes against the law in public institutions). There are also occasional problems of surface.

I will devote most of my description here to the solid investment process, although I also refer to the shell method. I have two reasons for this. I believe the solid method is somewhat better for the average college foundry, and there is a wonderful book on shell casting, *Methods for Modern Sculptors* by Ron Young, to which the reader can refer (see Bibliography).

EQUIPMENT NEEDED FOR METAL CASTING

You must have or improvise two things to cast metal: a way to burn out molds, and a way to melt metal.

Burnout Kilns

For solid investments, the burnout can be done in a pottery kiln—either electric or gas—which many colleges already have (Figure 10-1). It might be difficult to talk the ceramics people into using their kiln, but they may have an older or little used one which can be borrowed. It is not too difficult to make a burnout kiln, since the temperatures required are much lower than for pottery use—around 1000° F.

You can use a pottery kiln for shell, though at higher temperatures, but a specially made *flash kiln* is better. These are not difficult to make, and are described in the Ron Young book.

As I will discuss at the end of this chapter, other means can be employed to burn out smaller waxes without elaborate equipment.

Melting Furnaces

To melt metal, the best thing to use is a professional quality metal melting furnace. There are many on the market; Speedy-Melt, by McEnglevan, is ideal for the small foundry (Figure 10-2). I have read many descriptions of how to make furnaces with lined 55 gallon drums and burners made from old vacuum cleaners, but my advice is *don't*. Here's why: First, the time you take to make the thing could be spent making sculpture. Second, the result is inevitably less efficient than a professional furnace. It takes longer to melt and uses more fuel. Third, it won't have the safety devices of professional furnaces, and you could blow your head off (not worth it!).

The furnace shown is equipped with special safety features that are more or less standard on commercial furnaces (Figure 10-3). These include automatic ignition, by means of a spark plug in the flame port, and automatic

FIGURE 10-3 Controls for the bronze melting furnace. The two valves are gas (*left*) and air (*right*). The flat box to the left contains the automatic ignition and shut-off equipment.

shut-down in the event of flame failure, by means of an ultraviolet eye, which sees the flame and turns off the gas in one-tenth of a second, should the flame blow out. This is extremely important, since, if the flame blows out due to too much air, raw gas enters the chamber in high volume and can build up very fast. A lingering spark can ignite it, causing a serious explosion.

Sizes of furnaces. Furnaces are numbered according to the largest crucible they will take, and crucibles are numbered according to how many pounds of aluminum they will hold. Since bronze weighs about three times as much as aluminum, triple the number of the crucible to calculate how many pounds of bronze you can pour. A number 10 is a small one, but I have cast a six-foot sculpture with a number 10, so don't underestimate its capacity. A number 30, which will pour 90 pounds of bronze, is a medium-sized one. I recommend buying something like a number 30. If you go much smaller, you'll soon wish you had a bigger one. But if you go much bigger, you may not use it to capacity very often, and thus it is a waste. A 90-pound casting is pretty good size, and large works are usually made up of smaller castings welded together. So I recommend a furnace between number 20 and 45, depending on your budget and ambition.

Additional equipment. You also need various tongs and shanks to handle the hot crucible. Be sure you get clamps or hold-downs on the shanks, so the pot won't fall out when you pour (see Figures 10-31 through 10-35).

You also need a way to handle heavy solid investments (Figure 10-4), or the hot shell molds, as well as finishing tools. I discuss this equipment in more detail later in the chapter.

FIGURE 10-4 Placing an investment in the burnout kiln with a small, manually operated forklift.

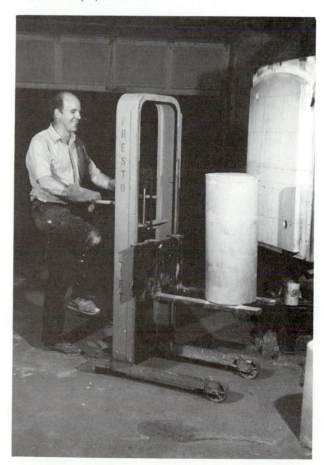

You must also be aware of safety equipment. Casting metal is the most potentially dangerous of all sculpture operations. I discuss safety precautions as we go along, and then summarize them at the end of the chapter.

CREATING WAX PATTERNS

There are two ways to create a wax pattern (or sculpture). One is to make it directly out of wax, and the other is to cast it.

Wax

First, we must discuss wax itself. The most common sculpture wax is *microcrystalline wax*, a petroleum byproduct. One called Victory Brown is the most usual (see List of Suppliers). You need an electric hot plate and a good three-quart cast-iron sauce pan to melt wax in. Get one with a good pouring spout, and wrap heavy cord around the handle for insulation (Figure 10-5).

Direct Building

Modeling. There are two different ways to work directly in wax. One is to use it like clay, building on an armature with lots of little gobs pushed around with the fingers or tools like clay. Microcrystalline wax, however, is too hard for modeling as it comes from the box. So, if you want to model with wax, you can either buy special formula modeling wax from sculpture suppliers

(listed in the Appendix), or you can make your own modeling wax. Essentially, that means softening the wax and increasing its stickiness. You make modeling wax by melting wax and adding other ingredients. Vaseline or motor oil softens it. Dance floor rosin increases stickiness. Experiment by adding some of an ingredient, then taking out a bit of wax, cooling it, and seeing how it feels. Make notes on how much of what you add as you go, so that when you get a good batch, you are able to repeat it.

Many modelers use wax over a metal armature. This must be molded and cast again in wax to remove the armature. But if you use stiff wax as an armature, and model on that, you can invest and cast directly, without mold making. However, be careful of thickness. Try not to go beyond 1 inch anywhere, or the metal may shrink and leave cavities.

Working with sheets. Melted wax can be poured out onto teflon or Silver-Stone-lined cookie trays to form thin sheets. After cooling and removing, these can be cut and stuck together to make just about any shape. A good way to stick wax pieces together is to buy *sticky wax* (see Appendix), melt it in its own pan, then dip the edges or ends of pieces into it and press together. Also, buy a small soldering iron (Figure 10-6), make a flattened blade for it, and use that to fuse joints.

A variation on the joined sheet method of working wax was developed by the Belgian sculptor Roel d'Haese. He begins by dipping pieces of gauze or cloth cut to the size of playing cards into hot wax. When these stiffen, he joins them one to another, bending or distorting them as he goes. In this way he can build form directly in space before him, without any kind of armature. He can also dip such things as gloves or anything else that burns out into the wax to help him create form.

To support these constructions, he has set many hooks into his ceiling. He suspends the wax pieces from these hooks with strings, adjusting the strings until everything hangs as he wants. I saw a figure he was doing that hung from ceiling to floor this way—and that was only from its head to its knees! The knee-to-foot portion had to be made separately.

He has complete freedom to change forms by cutting away with scissors, adding, or bending shapes. When the piece is as he wants it, he takes the parts down from the strings, drives them to a foundry where they are invested and cast, then hauls the bronze pieces to his other studio, where he welds them together.

Casting wax. The other, and perhaps more common, way to make a wax pattern is to cast it. Simple shapes can be cast from plaster molds, provided there are no undercuts, but with this caution: Always be sure the plaster is damp—soaked, but not dripping wet. If

FIGURE 10-5 A cast iron pan for melting wax. The spout was made of bent steel, brazed onto a cut-out in the pan, which greatly eases pouring wax. (Note the insulation on the handle.)

FIGURE 10-6 Two hot knives for working wax. The longer blade remains cooler for more delicate work.

you put melted wax onto bone-dry plaster, it sticks like mad but it comes off of damp plaster.

Usually, sculptors make wax patterns from rubber molds. Before pouring wax into a rubber mold, however, coat the inside with spray silicon (available in hardware stores), and rub it in well with your hands. Also, be sure the plaster support mold is damp. With the rubber lined up perfectly, strap the whole thing together tightly with rubber straps.

Pouring. Always use a thermometer for the wax. Buy a cooking thermometer, with the main area around 200°. Melt wax to about 220°, then pour some carefully into a rubber mold, set the pan down, roll the mold gently to coat all surfaces, and drain out excess wax (Figure 10-7). Let it cool a few moments, and repeat. Repeat this five or so times until, by cutting at the edge, you see a thickness of about 3/16 inch.

Brushing. Another way to put wax in a mold is to paint it in with a good brush. Brush wax into larger or open molds, but be very careful with the first coat. Try to brush it on in heavy swipes, keeping everything very liquid (Figure 10-8). Heat the wax a bit hotter for brushing this first coat, around 240°. Or, if possible, pour the first coat in.

Removing the wax. Wax holds a lot of heat, so don't try to take it out too soon. You can cool it with water, but cool it for at least ten minutes, or let it stand

FIGURE 10-7 Pouring wax into a small mold piece. The wax is rolled, then poured out, and the operation repeated until the proper thickness is reached.

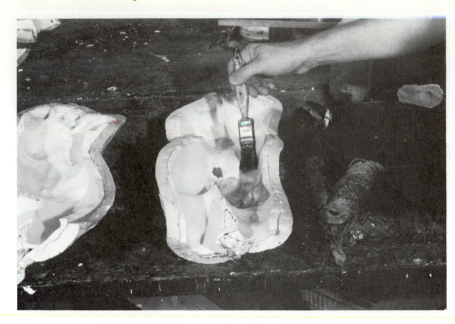

FIGURE 10-8 Painting wax into a large mold piece. Smooth strokes are used to avoid dribbling or scrubbing.

at least a half hour before removing (Figure 10-9). If you don't cool the wax thoroughly, small bits may still be soft and tear off.

Examine the unmolded wax for thin spots or other problems. It is not uncommon to have to take several casts from a mold before figuring out the particulars of that mold, and just how to roll the wax to get it right. So don't be discouraged if there's a hole or bad area. Just do it again. Hold the wax up to the light and look inside for thin areas. You can pour some cooler wax (150°) into the wax cast and roll it onto thin areas, then cool it in water, to fix those spots.

Finishing the cast. Take the fresh cast and pour dishwashing liquid directly on it. Then scrub it with a

soft paint brush under running water to remove any silicon film picked up from the mold. Now go over the wax carefully to remove seams, fill pits, or fix other faults. If you buy *patching wax* (see Appendix), you can smear it in almost like soft clay to fix problems.

SPRUING

Terminology

As we mentioned earlier, a *sprue* is a wax rod attached to the sculpture which, when burned out, forms a tunnel to let the bronze flow to the piece. A *gate* is a wax rod connecting the sprue to the sculpture itself. And

FIGURE 10-9 Removing the completed wax from the mold

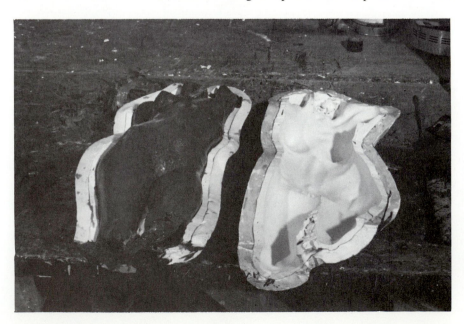

a *vent* is a channel off any high points in the sculpture, running straight up to the top of the mold, to let air out as the cavity fills. The *pouring cup* is a cup attached to the top of the main sprue to give you something to pour the metal into (Figure 10-10).

You can make sprues, but it is easier to buy them ready made. They don't cost that much more per pound than raw wax, and they save lots of time. Use square section sprues, and buy ¾ inch, ½ inch, and ⅜ inch. For large works I have used 1 inch, but never anything bigger than that. For pouring cups, use styrofoam coffee cups.

Types of Sprue Systems

Top feed. There are two main ways to sprue a piece: *top feed* and *bottom feed*. In top feed, you attach the main sprue to a high point on the piece. This is suitable for small things, and also for shell (Figure 10-11).

For solid investment, it's a good idea to position the wax so that any opening is to the top. This allows any gases built up in the core to escape upwards.

Bottom feed. For bottom feed, you run the main sprue (use ¾ inch in most cases) to the bottom of the piece, where it is attached, then add gates (usually ½ inch) as needed up the side of the piece. As a general rule, metal will flow easily for at least 6 inches through a sculpture before you need another gate. All gates should go *uphill* from the sprue to the piece so metal does not run down them prematurely. Finally, run a vent, or vents, off any isolated high points. These vents can be ⅜ inch sprue (Figure 10-12).

You can also sprue inside a piece. For a head, for example, with the neck opening up, run the main sprue to the bottom, inside, then attach gates up around the neck area (three usually suffice), and vents off any high points (Figure 10-13).

FIGURE 10-10 A typical bottom-feed sprue system.

FIGURE 10-11 A typical top-feed sprue system.

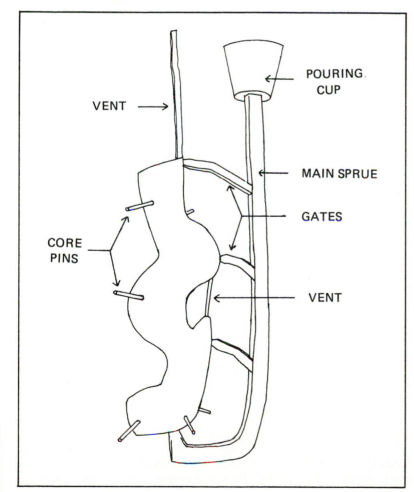

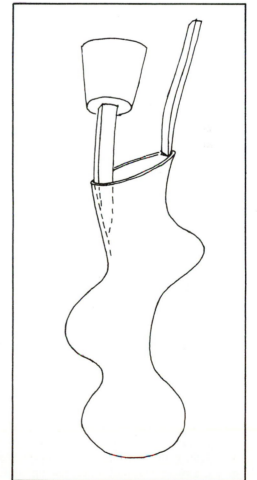

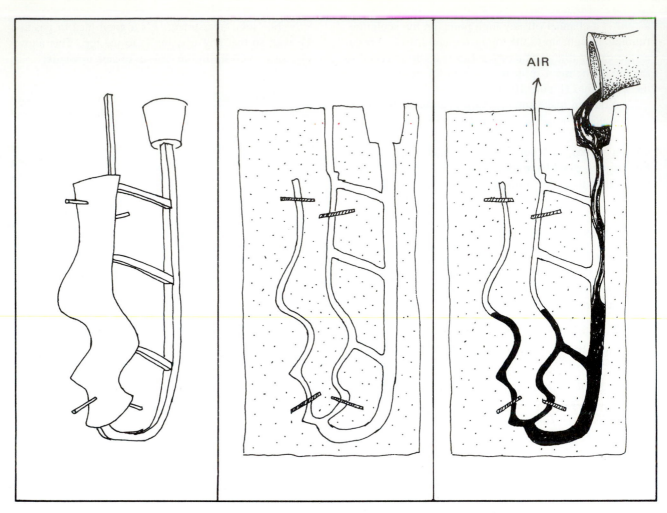

FIGURE 10-12 Bottom-feed sprue system: (a) the wax; (b) invested and burned out, showing cavity created (note core and core pins); (c) metal flowing into the cavity.

Most descriptions I've seen of spruing show far too many sprues, in my opinion. In some pictures, the sculpture looks like it's inside a thorn bush. Such a large number of sprues increases the amount of work necessary to remove and retouch all those attachments. Hot bronze flows very fast, and through very small openings. I have sprued many sculptures of about 12 inches tall with one bottom feed, one at the top, and nothing else.

Another consideration is a drain. Small investments (beer-keg size and under) can be turned upside down for wax drainage during burnout. But larger investments ought to have a drain so they can remain upright the whole time. A good way to make a drain is to extend the main sprue below the piece itself, and then attach a ½ inch-diameter smooth steel rod from the lowest point of that sprue running horizontal but slightly downhill to and through the edge of the basket. When the investment is complete, grab the protruding end of the rod with pliers, give it a twist, and pull it out, leaving a nice hole from wax to outside. After the burnout and just before pouring, slide the steel rod back in, plugging the hole for pouring.

How to Make a Sprue System

To stick the sprues to the wax you need the following tools: a knife, like a mat knife, to cut the sprues; a pan of sticky wax, which you buy from the sprue maker (or make by adding dance-floor rosin to melted wax until it's good and sticky), melting on a hot plate; and a small soldering iron, with the tip flattened into a blade.

After planning your sprue system, cut the various parts to length, and trim the ends until they fit together neatly. Begin by dipping just the mating surface of one piece into the hot sticky wax and pressing it to its mate. Using the soldering iron, fuse and melt around the joint until it is neat and smooth. Now cool it under cold running water. When the system is put together, attach it carefully to the wax sculpture with the same technique.

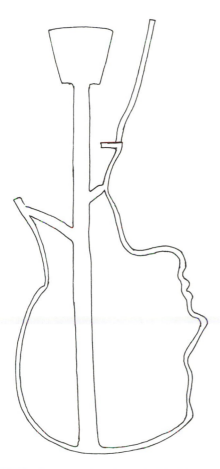

FIGURE 10-13 Cross section of a typical inside sprue system.

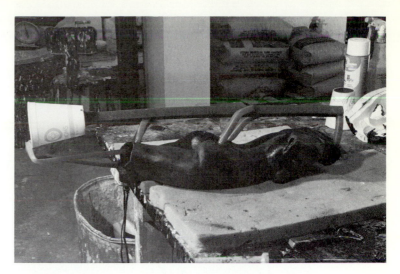

FIGURE 10-15 A wax sculpture with sprue system complete. (Note the narrowing of the gates as they touch the wax, and the vents supported on the pouring cup.)

Next take a styrofoam coffee cup, turn it upside down, and pour a little regular brown wax onto the bottom to fill and level it (Figure 10-14). When cool, attach it to the top of your main sprue with some sticky wax.

Vents, because they are thin, almost always fall off if you just stick them on. Make them a little long, and bend them over at the top to attach to the lip of the pouring cup. Figure 10-15 shows a piece completely sprued, with pouring cup and vents. Study it a moment, identifying the main sprue, the gates, the vents, and the cup. Notice how all the gates go uphill from the main sprue, and how they taper in just as they meet the piece.

CORES

Cores for Shell Investments

The core is the mass of material that fills the inside of a hollow wax and keeps the bronze hollow. With shell casting, making the core is usually simple. Cut a window in the wax roughly opposite the main opening, avoiding critical detailed areas. For example, a head would have an opening about the size of a playing card cut in its top. It is probably best to cut long thin works, like figures, in half, but again, each piece needs an opening in each end. The window that you have cut free is then attached to a sprue to be welded in place after casting (Figure 10-16).

The purpose of the window is to allow air to flow through the piece to dry the shell inside, and also to hold the inner shell at two points for strength.

There are other core techniques for shell that you may want to research, but the two-opening method works well in most cases.

FIGURE 10-14 Styrofoam coffee cups with wax poured on their bottoms to serve as pouring cups.

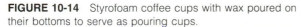

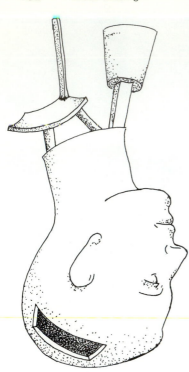

FIGURE 10-16 A wax head with a window cut for a shell investment. The window is attached to a sprue.

FIGURE 10-17 Core pin placement. (Note group of pins at the bottom, with pins at the top for support.) Thin wires in the core help prevent core breakage. Pins can go right through narrow sections, as on the right.

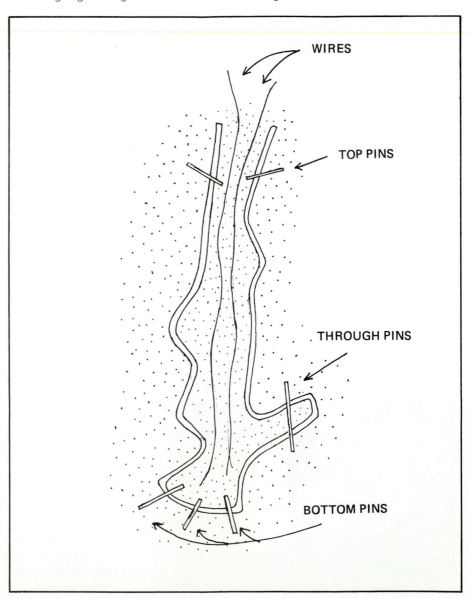

Cores for Solid Investments

Core pins. In traditional investment the core is simply investment material poured into the inner cavity. However, the core needs to be supported after the wax has been burned out in the kiln; otherwise it falls down in the hole created. The usual way to support the core is with *core pins.* The best core pins are silicon bronze welding rods, cut into 1 inch lengths. (If you are pouring silicon bronze, you will want to weld it, and you will have bought silicon bronze rods. You can use the little stubs left over for core pins.) The rod comes in a variety of thicknesses; $\frac{1}{8}$ inch is heavy; $\frac{3}{32}$ inch is average; and $\frac{1}{16}$ inch is light. These three thicknesses are perfect for core pins, and you can select an appropriate size for the core you are supporting.

To use core pins, shove them about halfway through the wall of the wax, so that some of the pin is inside the sculpture and some outside. To decide where to place the pins, hold the wax in the position it will be in after investing (usually with its major opening to the top), and imagine the core inside. Imagine how many and where to place pins to support the core. Usually two or three near the bottom, two or three near the top, and a few in the middle work (Figure 10-17).

Core rods. Another way to support cores is with *core rods.* For example, for a portrait head, instead of punching pins through the wax, use three heavy steel rods, about $\frac{3}{8}$ inch in diameter, that are long enough to stick out of the neck about 6 inches if placed inside the head like umbrellas in an umbrella stand. These rods work best if you bend them a little here and there. They serve to lock the core to the remainder of the investment, and work perfectly without any core pins (Figure 10-18). On a head or other form with a large opening at the bottom, you can sprue from the inside and use core rods, thus creating no disturbances on the surface of the piece.

INVESTING

Investing refers to covering the wax with the investment material prior to burning out and pouring. Shell and solid investment casting differ most in this stage, so I will discuss them each separately.

Investing with Shell

If you're serious about using shell, read the Ron Young book carefully (see Bibliography). Here, however, is a general description of the process to give you an idea of what is involved.

To invest with shell, you must have a container of slurry large enough to dip your piece in; usually a full

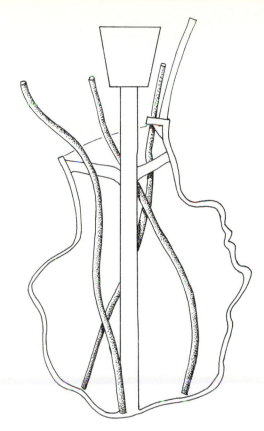

FIGURE 10-18 Core rods placed in a wax head. Random bends in the rods help.

size plastic or metal garbage can works. You must also have a dilute mixture of shellac, or a commercial de-bubblizer, and you need trays of two grades of stucco material: 80 grit for the first three coats; and a coarser one, 40 grit, for the rest. Stainless steel wire or mesh is also helpful. For drying, you need wooden slat type racks and a good fan.

First, coat the wax with the 50 percent dilute shellac, and allow it to dry. Commercial debubblizers also work. Then lower the piece into the slurry mix for about ten seconds, withdraw, and allow it to drip, checking to eliminate any bubbles. Sprinkle the still wet piece with the 80 grit stucco until it is evenly covered and no more can be made to adhere. Place it on the rack, and dry it before the fan. When dry, dip and stucco it again. After the third coat, switch to the 40 grit, and keep going until you have a thickness of at least $\frac{3}{8}$ inch, $\frac{1}{2}$ inch for larger pieces.

Steel wire or mesh can be wrapped around the piece, particularly at points of stress, and more shell applied over it.

Solid Investing

The basket. For this process you will need a container to hold the investment. Easiest and best is a basket made of expanded steel lath. Cut the lath in a strip as wide as the investment will be high, and as long as the circumference of the investment, plus a couple of inches for overlap. Bend the wire into a cylinder, and tie it together with five or so short pieces of black binding wire. Bend the binding wires into U-shapes, push them through the overlapped lath, and twist (Figure 10-19). For all but very small investments (under 6 inches in diameter) make a bottom of lath and wire it on. Cut a strip of tar paper slightly wider than the investment is high, and wrap it around two or three times, tying it with rope or string. Set this basket on a sheet of plastic on the floor (Figure 10-20).

Supporting the wax. You have to support the sprued wax to put on the first layer of investment. Sometimes waxes can stand on their own; other times they can be placed over a stick or pipe, or tied to an upright. Figure out what's best for your piece (Figure 10-21).

The first coat of investment. With your piece supported, spray the wax with alcohol. I assume that you washed the wax well with detergent and water after taking it out of the rubber mold, to remove the silicon release. If you didn't, the alcohol will bead up. If you washed the wax well, it should wet nicely.

Now, mix some investment. The basic mix is one part plaster and two parts sand, with enough water to make a creamy consistency. As a general rule, one part water, one part plaster, and two parts sand usually comes close. Adjust it by adding either water or plaster and sand after stirring, if the consistency isn't right. Mix a small batch for your first coat, and *brush* it onto the wax (Figure 10-22). Don't flick it, don't dip it, and don't try to pour investment around the wax into the basket, because you will cover the surface with bubbles. Your bronze will come out covered with little beads of metal, each one of which has to be individually chiseled off. Brushing eliminates that problem. Coat the wax completely, then build up the thickness to about ½ inch, leaving it rough (Figure 10-23).

Filling the basket. Next, seal the bottom of the basket. The best way to do this is by mixing a batch of investment and pouring it in. From this point on, you must mix larger, consistent batches. Get a supply of buckets, such as plastic buckets from the hardware store or surplus plastic containers. You also need two six-quart buckets with volume markings on the inside, and an empty three-pound coffee can. It's helpful to have a heavy duty long rubber glove, if you can find one.

To mix your basic batch, first pour three quarts of water into your mixing bucket (measure this water in one of your six-quart pails). Fill the three-pound coffee can just level with plaster, and pour it in. Wait a few moments, until the plaster settles, and then give it a little stir with a stick just to break up lumps. Fill the other six-quart bucket level to the brim with sand, and pour that in. Using two buckets means you have a wet one and a dry one. Use the rubber glove, if you have one, to reach in and start stirring. It will be work. Make sure to get all the sand from around the bottom edges, and soon it will blend into a good creamy mix. If the mix comes out a bit thick, add some water. With practice, you can add the coffee can of plaster with a little scooped out, and the sand just below the rim of the six-quart bucket. Soon you'll be making mixes either thick or runny, on command.

Take your first mix, and pour some of it into the bottom of the basket. A little might leak around the edges, but don't worry. When it begins to set, plop the rest in. If it's thick enough, it won't leak anymore. Build up about a two-inch layer; then reach in and roughen it with your fingers.

By now the investment you brushed on the wax is hard. Pick it up carefully and set it in the basket, with the pouring cup at the top. Arrange it so it's in the middle, equidistant from all sides, and either prop it there, or get someone to hold it. Mix creamy liquid batches of investment and pour them in (Figure 10-24). At some point the first one or two will set hard enough to hold the piece, and you can remove any props. Also, at some point you will pour into the core. If the core has a tiny opening, you might mix a special thin batch and pour it in carefully. Make sure there are no trapped air pockets in the core. Remember to place your core rods if you are using them.

Finish filling the basket, coming just up to the rim of the pouring cup. The cup should show clearly, all vents should stick up, and the investment should come just to the top edge of the wire lath. If extra lath sticks up, cut it off after the investment is hard.

And now comes the important part. When the investment is just getting firm but not hard, add your personal hex mark to the top (Figure 10-25). This should be a mark with meaning to you, something you take seriously, because the Sculpture Gods are watching. Who are the Sculpture Gods? All the sculptors who have gone before you—Michelangelo and Donatello and the Greeks and the Chinese—all of them are looking down to see whether this young whippersnapper has the stuff to join their ranks.

When the investment is nice and hard (usually by the time you wash up and put a couple of things away), you can take the tar paper off. I like to bevel the top edge a little. I often pull the pouring cup out and clean the cup edge, too (Figure 10-26).

For large investments, you need interior reinforcement. The easiest and best is chain. Place one end of a long chain in the bottom of the investment before you pour in the first batch. Wrap it around the inside one turn for every bucket you pour, spiraling it up through the mass. But other reinforcements can be used as well, such as steel bars or rods placed where points of stress might be.

BURNOUT

Shell Investments

In shell casting, burning out is usually done in a flash kiln. You can dewax with a welding torch, starting at the cup and working up, catching the wax in a pan of water as it comes out. Dewaxing with a torch is a good practice for three reasons: first, you avoid burning all the wax, which sends clouds of smoke into the neighborhood; second, you save the wax to use again; and third, thrusting the full shell into the kiln sometimes expands the wax before it can run, cracking the shell.

When they are reasonably clean, place the dewaxed molds in a kiln which is around 1500° F until they are good and red all over. At this point take them out of the kiln and let them cool completely so you can fill them with water. This accomplishes two things: first, it flushes out any waste left behind; and second, it checks for leaks. If you find leaks, fix them from the outside with commercial kiln cement, let dry completely, and retest. When tight, the molds are ready.

In shell casting, the molds are always brought back up to red heat before pouring to drive off all traces of water. Pouring bronze into a mold that still contained water would cause a disaster, probably injuring or killing you, not to mention ruining the cast. *Always pour into very hot molds.*

Solid Investments

For solid investments, put the molds into a good gas pottery kiln with thermocouple controls. Place the molds upside down (pouring cup down), unless you have made large molds with bottom drains. Set them on fire bricks so they stand up from the kiln floor, with cup and vents clear (see Figure 10-1). Light the kiln and adjust it so it holds a steady temperature right around 1000° F. Some sculptors prefer a slightly higher temperature, around 1200° F, but there is a danger of seriously weakening the plaster anywhere around 1000°, so I recommend the lower temperature for a longer, gentler burnout. Let it sit at this temperature for 24 to 48 hours, depending on the size of the molds. Small molds, 12 inches or less in diameter, can go 24 hours. Large ones, 24 inches or more in diameter, need 48 hours minimum. For those in between, use your judgment. Obviously, you burn out a load according to the largest mold. If you are unsure, guess on the long side.

Many kilns have a system to hold temperature. Also, good kilns have pressure gauges on the burners. I have been able to find a pressure at which the kiln holds the perfect temperature, and after a few burnouts you can too.

If plaster gets too hot, it begins to break down, losing strength, and also giving off gas. If the investments actually get red, that's too hot. The kiln should glow red inside, but the investments should hover just at the threshold of red heat. Turn off the kiln six hours before pouring. The molds will still be hot, but any gases being driven off will have stopped.

THE POUR

I have known a lot of guys who feel that pouring hot metal is the central masculine rite of sculpture, and they love the idea of sweating in the reddish glow of molten bronze (particularly with a bevy of wide-eyed females ogling them). I regard all this as rubbish. The pouring operation is a critical part of casting, to be approached professionally and carefully, but, if done right, it is almost anticlimatic, as routine as pouring coffee. It is also dangerous, so I will speak at some length about safety.

Metal

Bronze. The metal most commonly used by sculptors and professional foundries is silicon bronze. The two main kinds on the market have the brand names Herculoy and Everdur. They are very similar, the main difference being that you can buy Everdur welding rod, which matches perfectly. It matches Herculoy very well too, but perfectionists prefer the Everdur ingot.

Traditional statuary bronze is usually 85–5–5–5, called Eighty-five–Three–Five which means it is 85 percent copper, and 5 percent each of tin, zinc, and lead. By comparison, Everdur is 95 percent copper, 4 percent silicon, 1 percent manganese, and trace elements. Eighty-five–Three–Five melts with more smoke and fuss than Everdur, but pours well. It is more brittle, but softer to work, and many say you get nicer patinas with it (I know I do). However, it is very difficult to weld. You can weld it with Everdur rod, but then the match is poor for color. If you use more than one kind of bronze, keep them and the crucibles, skimmers, rods, and ingot molds separate.

Other metals. White Tombasil is a copper-based alloy containing quite a bit of zinc and some nickel. It is nearly silver in color, with a faint yellowish quality.

FIGURE 10-19 Wire lath baskets for investment, ready for tar paper.

FIGURE 10-20 Baskets wrapped with tar paper, ready for filling. (Note the sheet of plastic on the floor to prevent the investment from sticking to the cement.)

FIGURE 10-21 Wax sculpture supported for application of investment. It is lashed to an armature upright with a rubber strap. A small amount of investment applied to the bottom helps support the weight.

FIGURE 10-22 Applying the first brushed-on coat of investment.

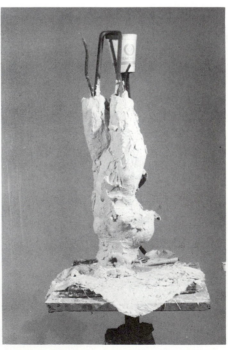

FIGURE 10-23 Face coats of investment complete.

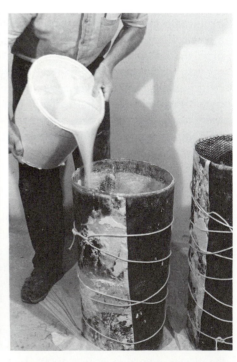

FIGURE 10-24 Pouring investment into the basket to seal the bottom. When set, the coated piece is placed in the basket and filled with more investment.

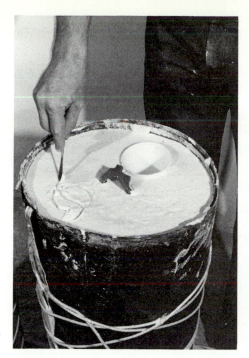

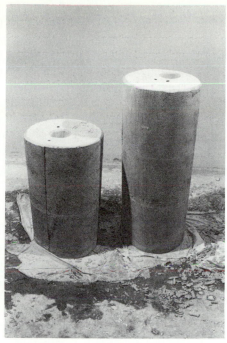

FIGURE 10-25 Making a hex mark on the completed investment.

FIGURE 10-26 Complete investment, tar paper removed, edges beveled, cup removed, and hole cleaned up.

When melting and skimming, it emits weird blue flames, like something out of a sci-fi movie, but it pours about the same as bronze. To weld, cast several long thin strips to use as rod, and use the TIG welder.

Aluminum is easy to melt and pour, and easy to work and weld with the TIG. Read a good welding book to learn to weld aluminum (see Bibliography). The only complaint is that it's a somewhat boring metal in appearance, but if it suits your project, it's wonderful. Again, I recommend buying ingots of a casting alloy.

Lead and pewter are discussed below in the section on casting without a foundry. Some college foundries pour iron, but that is a separate problem beyond the scope of this book.

Buy ingot from a smelter. Don't buy scrap. You could work for weeks or months on a piece, only to ruin it by trying to save a couple of bucks on the metal. Buy good metal, and save your own scrap. Try to use about 30 to 50 percent of your own scrap to new metal each melt.

Pouring Equipment

To pour bronze you need, in addition to the melting furnace, a set of tongs to reach into the furnace and grab the pot (crucible) to pull it out; a shank, into which the pot is set so it can be picked up and poured; a skimmer or two for cleaning the dross off the metal; a long steel rod to feel around down in the metal; a pyrometer to test the metal temperature; and an ingot mold or two for the excess metal.

Safety equipment. You also need safety clothing. I am not a believer in dressing up like an astronaut to pour, but you must take several precautions. First, wear good boots—heavy leather ones that can actually shed some molten bronze. Next, I recommend a pair of denim coveralls over jeans. The double layer of denim is amazingly resistant to heat, and can actually shed the odd splash of metal. Wear your pant legs outside your boots, so no metal can splash down inside. If there is a way for metal to get down inside your boots or shoes, it will find the way. I am not a proponent of heavy leather aprons, simply because they are something to get in the way. You need to move freely and naturally. Third, for your upper body, either a regular winter jacket or the coveralls will do. Fourth, wear good leather welding gloves. Fifth, it is *essential* that you wear a full face shield. Some people wear hard hats with face shields attached, which is a great idea. *Never* fool around with hot metal with your face unprotected. In just a fraction of a second you could be blind for life (see Figures 10-31, 10-32).

I have already discussed melting furnaces above. Read the instructions carefully, and follow them to fire up the furnace. Load a crucible with ingots of new metal,

and light the furnace according to instructions (Figure 10-27). There are two things to remember: first, always light the furnace with the lid open, and then close it after the flame is adjusted; second, fine tune the flame after the furnace is closed. In general, leave the air valve all the way open, and adjust with the gas. The loudest noise will give you the best flame.

Pouring shell molds. Next, get the molds out of the kiln. If shell, wait until they are glowing bright red and the metal is melted and actually out of the furnace and in the pouring shank. Then quickly, with tongs or very heavy asbestos gloves, pull the molds out, stand them in a big box of sand, and pour.

Pouring solid molds. Take solid investments out while the metal is melting (Figure 10-28), inspecting the cups and vent holes. Be sure no crumbs linger around these openings, and brush them clear while still upside down. Set the molds right side up on a heavy bed of sand. They should be clean and white with no trace of wax smell. If they are dirty or smell even slightly, don't pour them, but put them back and burn them out some more. If you pour with wax still inside, at best you'll ruin the cast; at worst metal will come flying out.

There is some debate about burying molds for pouring. Many foundries have a pouring pit filled with sand to bury the molds up to their necks before pouring. This is a safety measure in case the molds burst and metal runs out. However, other foundries do not have such a pit, and they either build boxes or bins in which to bury molds, or do not bury them.

My argument is, if you make the molds strong enough, they don't need to be buried. Use good fresh steel lath well wired together, plus internal reinforcement such as chain or other steel, and keep the burnout around 1000° F. Always pour them on a bed of sand to catch any spills (Figure 10-29). Naturally, any suspect molds or very narrow relief molds ought to either be buried or encased in a container of some sort filled with dry sand.

Completing the Melt

Probably you won't be able to fit enough cold metal into the crucible for the pour, and will have to add more during the melt. *Always preheat metal before adding it.* Place any ingots or other scrap to be added on the top of the furnace, around the edges (not in the flame) for several minutes (Figure 10-30). To understand why, take an ingot that's just lying around, one that's nice and dry. Place it on the furnace lid so one edge is just catching the flame, and watch it carefully. You'll see moisture appear and burn off. There is moisture on everything. If you lower the ingot into molten metal without preheating it, *it will explode*, sending a geyser of hot metal all over you and the room.

There is some more preparation you should do be-fore the metal is ready. Get the ingot mold or molds out, along with the skimmers. Light an acetylene torch with acetylene only—no oxygen—and soot the inside of the molds and the skimmers. This will prevent metal from sticking. After the last metal has been added, place the ingot molds on the furnace to preheat, and, when you're sure all moisture has been driven off, place them on the sand in a handy spot for filling. Place the skimmers where they are handy, and be sure the whole area is clear of any items you might trip over.

Checking the Melt

After you have added all the metal and it looks melted, you can test to see if you're ready to pour. Everdur should be poured at between 1950° F and 2050° F. If you don't have a pyrometer, here is a good method of testing the temperature. Take a long steel rod, ½ inch in diameter, bent so you can poke one end in the pot. Reach down (wearing your gloves and face shield) and feel around for lumps. If it is lump free, pull the rod up and look at the end. Metal should run off, leaving it rather clean. If metal sticks and builds up, it's too cool. If you do have a pyrometer, shut off the furnace, stick the end in the metal, and read the temperature.

Pouring

When the metal is ready, shut off the furnace, open it up, and pull the pot out (Figure 10-31). You should have rehearsed this before lighting, so you know exactly what to do. Set the pot in the shank (Figure 10-32), and put the tongs out of the way. Note that there is a slab of steel under the shank to isolate the hot pot from the concrete floor. Now skim it. Everdur usually has very little slag, and a couple of quick swirls with the skimmer should be fine (Figure 10-33). If you have a lot of skim-ming to do, use one skimmer for a couple swirls, then the other. That way they will be easier to clean later.

Now pick up the pot in the shank, set the hold-down clamp, and move to the molds. Position the lip of the pot cleanly just over the first pouring cup, as close to the cup as you can get it, and pour rapidly and smoothly, without stopping (Figure 10-34). Try to keep the cup full as you pour. Don't let the metal trickle down the sprue. Let it rush as fast as it will go. It's a good idea to have another person around, with a shovel, just in case there is a run-out. If that should happen, stop pouring (the piece is shot), step back, and have your partner shovel any bronze onto the sand. When it's all collected, pour the other molds. Pour steadily until you either see the cup fill, or it rises in the vents. When you're done, pour the remaining bronze into the ingot mold (Figure 10-35). Replace the pot in the furnace to cool slowly. Never leave bronze in the crucible to cool, as it will expand on the next heating and crack the crucible.

FIGURE 10-27 Bronze ingots in the crucible ready for melting.

FIGURE 10-28 Burned-out investment being removed from the kiln while the metal is melting.

FIGURE 10-29 Investments placed on a bed of sand, ready for pouring. It is not necessary to bury them if they are properly made.

FIGURE 10-30 Ingot preheating on the lid of the furnace to drive off all moisture before adding it to the melt.

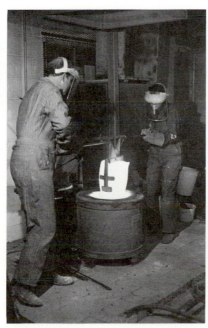

FIGURE 10-31 Removing the pot from the furnace with tongs. (Note overalls, boots, gloves, and face shields. Trousers should always go over boots.)

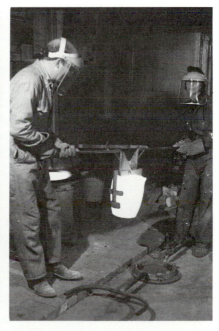

FIGURE 10-32 Moving the pot to the shank. Rehearse this to avoid problems.

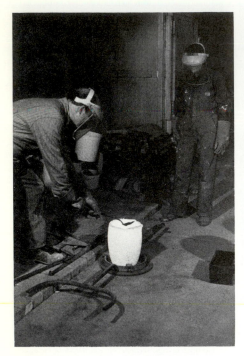

FIGURE 10-33 Skimming the metal. The pot is in the shank, and is sitting on a disc of heavy steel to isolate its heat from the concrete floor.

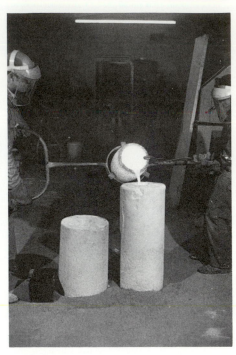

FIGURE 10-34 Pouring. Maintain a smooth, steady stream, keeping the cup full, and do not pause or stop during the pour.

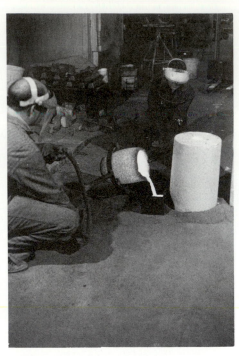

FIGURE 10-35 Pouring excess metal into the ingot mold. Never leave excess metal to cool in the crucible.

DEVESTING

Shell

Devesting means getting the bronze out of the investment. Shell castings cool quickly. You can usually begin taking the shell off Everdur after about an hour, though it can cool completely without problems. Begin by hitting the pouring cup with a hammer to crack off large pieces, then by tapping and winkling, get the rest off. Smaller bits will come off with sandblasting or wire brushing.

Solid Investments

Solid investments can be opened after about an hour when filled with Everdur, but its best to let Eighty-five–Three–Five cool completely overnight; otherwise, thermal shock will crack it.

Take the investment to a spot near your rubbish collector (dumpster), and begin by chopping into the side of the investment to find the seam of the wire lath (Figure 10-36). Using a hammer with a blade on the end, find the seam, chop through the ties, and pull the whole wire lath off. Now begin to work around the investment, hit-ting the sides in an all over pattern, just thumping away. What you're doing is inducing cracks all through the thing. Soon large cracks will begin to open up, and you can start knocking big pieces off (Figure 10-37).

Keep going this way, but be very careful not to hit the metal, as it is still quite soft and will dent *very* easily. If there is a chain inside, find the top end, loop it around your hammer handle for a grip (it's hot!), and begin to unwind it, opening the investment like a ziplock strip.

When the bronze form inside is showing, with some but not too much investment still clinging to it (Figure 10-38), drag it a little way off and hit it with a stream of water from a hose (Figure 10-39). Great clouds of steam will come up, and you will hear lots of popping and hissing, but just about all the investment will come off (Figure 10-40). You can even gets lots of core out with the stream. Don't do this with 85–3–5, or it will crack. Work on it next day, when it's cold. When you get close to the bronze, begin removing investment with wooden chisels. That's right, wooden ones. Make them out of a good hardwood, like cherry or maple. Sure, they dull fast, but a quick lick on a sander and they're sharp again. They cut the investment but don't mar the bronze.

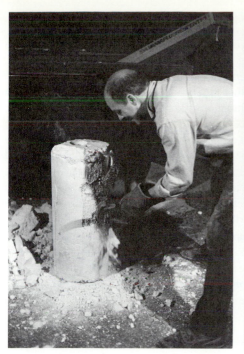

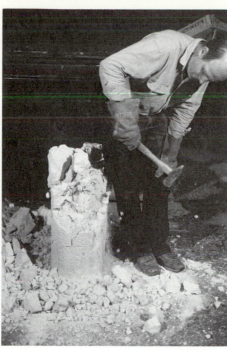

FIGURE 10-36 Removing the layer of lath from the investment.

FIGURE 10-37 Hammering the investment to induce multiple deep cracks. Care must be taken not to hit the bronze.

FIGURE 10-38 Most of the investment removed. The piece is ready for the hose.

FIGURE 10-39 The hot bronze being hit with a stream of water, creating steam and popping off remaining investment. Never do this with 85-5-5-5, only with Everdur.

FIGURE 10-40 Rough bronze cast after hosing off.

CHASING

Chasing those old Renaissance bronzes in the museums, the ones with the immaculate finishes, sometimes took a year or two. There are at least three reasons we can cut that time drastically. One reason is power tools. A second reason is philosophy, which permits sculptures to be shown "as cast," in the Zen sense that accidents are a viable part of the finished work. And a third reason is we can cast better than they did.

Removing Sprues

But you've got to do some work, no matter what. First, you have to get rid of the sprues. There are two ways. One is to use a 4 inch electric disc grinder (get one anyway, because they're handy for so many things), and fit it with a muffler-cutting disc. Wear gloves and a face shield. With the piece clamped in the vise or nestled in a sand-filled leather pillow, use the edge of the disc like a saw to cut sprues off (Figure 10-41). Make a first cut a little bit away from the piece; then later get close with a more controlled cut.

The second way is to fire up a big welding tip on the oxy-acetylene welder and melt the sprues off. Again, start a bit away from the piece; then melt carefully towards it. Watch the piece to avoid overheating and melting. The torch also works for cutting off interior sprues. As you go into an enclosed space, though, you have to increase the oxygen.

Removing the Core

Next you have to get the core out, which can be tricky. Using a ¼ inch steel rod with one end flattened, chucked in an electric drill, drill long holes up into the core. Use other steel rods, bent as needed, to reach in and loosen things up. Bang on the piece with a hammer, on the spruce stubs, to knock the core loose. Pull the core pins out either with a wire cutter or a vise-grip. You can sometimes drill the odd core pin hole out bigger and wiggle a rod in. When you think all of the core is out, it isn't, so bang around some more. You can hear the difference between the clear ringing of the clean areas and the dull thud where there's still core.

You can also use water. Soaking and flushing helps. Soaking also overnight helps. Some say pouring in Coca-Cola rots the core out, and it does help. But getting the core out is one part cleverness, one part work, and one part patience.

Casting Flaws

Once the sprues are off, it's a good idea either to sand-blast the piece, if you have a blaster or access to one (gravestone makers will usually do it for you), or to give it a good all-over wire brushing, to see what you really have.

Chances are you won't have a perfect cast, and will have to deal with flaws (Zen consciousness aside) such as:

FIGURE 10-41 Removing sprues with a muffler cutting wheel. The piece is supported on a leather pillow.

Flashing: thin ridges of metal, which flowed into cracks in the mold (Figure 10-42). This photo shows a somewhat excessive amount of flashing, probably due to slight overheating of the investment. Even so, the flashing is quickly removed with a chisel (Figure 10-43).

Holes: metal that just isn't there, due to freezing prematurely, gas forcing a bubble through the molten metal, or core slippage (Figure 10-44).

Surface shift: a step in the surface (often along a flashing) where the mold not only cracked, but shifted.

Seeds: little beads of metal which flowed into tiny air bubbles in the mold surface. To avoid this, carefully brush the first coat of investment. Remove seeds with a chisel.

Boogers: odd globs of metal in cavities like arm pits and noses, where you didn't get the investment fully brushed in (Figure 10-45).

Cold shut: metal that flowed together from two different directions and didn't fuse.

Areas full of *mold clutter*.

And of course you have *sprue stumps*.

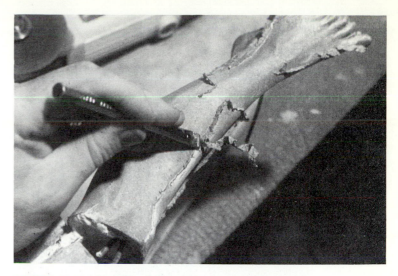

FIGURE 10-43 Removing flashing with a cold chisel.

FIGURE 10-44 Holes in a cast, caused by gas. (This is a different sculpture; the one used for the other photos had no holes.)

FIGURE 10-42 Flashing on the leg section of the cast. (This is somewhat excessive flashing, though not serious.)

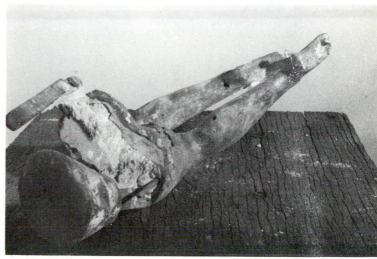

All of these fall into one of two categories—too much metal or not enough metal. To fix flaws, you grind off excess metal, weld in missing metal, then grind again.

Chasing Tools

For chasing, you need the following tools (some power tools are shown in Figure 10-46):

4 inch disc grinder with grinding discs, muffler-cutting disc, and sanding discs.

High speed die grinder (25,000 RPM or so), either electric or air. Use carbide bits if you can afford them, steel if you must, and the occasional small stone, but get the

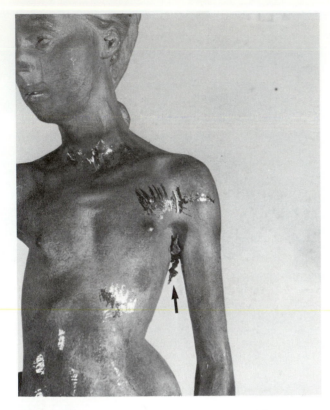

FIGURE 10-45 Boogers in the cast, caused by failure to get investment up into the space in the arm pit.

FIGURE 10-46 Power tools for chasing bronze: (*clockwise from the large grinder at the top*): 7-inch body grinder; air-powered die grinder; air-powered right-angle die grinder (*center*); random-orbit sander; electric die grinder; air-powered disc sander (*bottom*); and 4-inch body grinder.

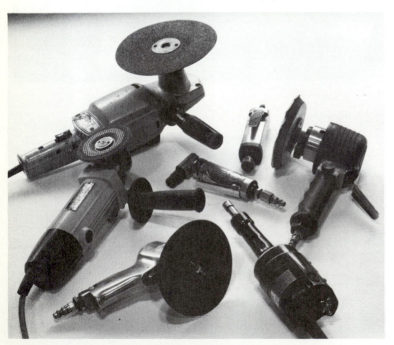

high-speed kind, not the electric-drill kind, which may fly apart. A selection of die grinder bits is shown in Figure 10-47.

Random orbit sander. These are usually air, but there are some electric ones on the market. Buy self-stick sanding discs. The tool wobbles around in a random pattern which does wonders on bronze. It's worth its weight in gold.

Other grinders, such as right-angle grinders, electric drills, and pneumatic files can also be handy, but are not indispensable.

You also need hand tools (Figure 10-48). A good collection of files and rifflers is indispensable. A file renders a wobbly surface constant and smooth better than anything else. A wood rasp used on bronze produces a rough scratchy finish that, when sanded, isn't smooth and blends better with cast bronze. You also need cold chisels, stamps, and punches. Small chisels are wonderful for pinging off seeds, dislodging boogers, mowing down flashings, and the like. Stamps and punches can beat down all sorts of odd little flaws and put hiding textures into low spots or other places (Figure 10-49).

Sandpaper is also useful, whether sheets used by hand, discs on sanders or random orbits, or flap wheels in a slowed-down die grinder. Wear a respirator when using flap wheels because they throw a lot of grit into the air.

You also need a welder. The best welder for bronze is a Heliarc, or TIG, welder. These machines are expensive but easy to use, and they produce the best welds. You can weld Everdur very successfully with an oxy-acetylene outfit and a can of brazing flux. I'll discuss welders more fully in Chapter 14.

Once you have worked the piece to your satisfaction, give it a good sandblasting and/or wire brushing and inspect it carefully. Now is the time to fix things, not later. Also, at this time, do any of the drilling and tapping of holes in the bottom that you need for mounting it.

FINISHING BRONZE—PATINAS

This section could be a whole book, but I will work on a simple principle. Often the dominating aspect of a bronze piece is the patina. I have felt for some time that you make form for the critics, but you make patinas for the buyer.

Polishing

Bronze can be polished to a bright luster. Work the surface with sandpaper, going from coarse papers to finer ones. Use the sandpaper first on disc sanders, then

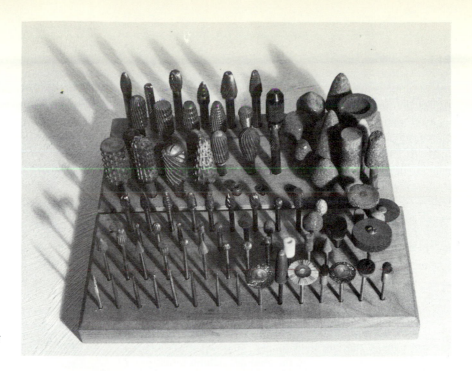

FIGURE 10-47 A selection of die-grinder bits: (*top tray*) ¼-inch shank carbide tools in top row; high-speed steel in next row; stone to the right. (*bottom tray*) ⅛-inch shank carbide in top row; high-speed steel in the center rows; stones and others to the right.

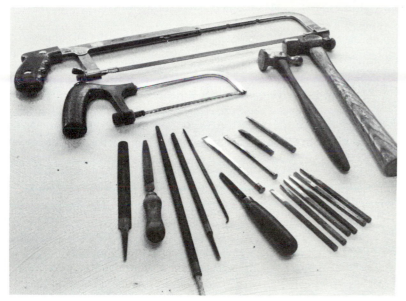

FIGURE 10-48 Hand tools for chasing bronze: hacksaws, hammers, cold chisels, chasing punches, and files.

FIGURE 10-49 Detail of ends of chasing punches with various textures and shapes.

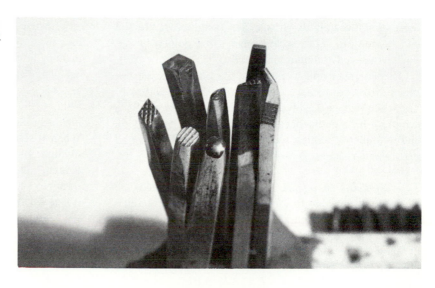

on the random orbit sander, and finally by hand. Sand-papers are numbered according to the amount of grit per inch, so that 24 is very coarse, and 80 is about average. Do heavy cutting with 36 or 50, then refine with 80, and move to 120 and 240. Then continue with the fine sand-papers, like 400, 800, and finally 1200, if you can find it (it's rare, but 3M *does* make it). After sanding, polish with cloth buffing wheels and polishing compound on a bench grinder, or hand held in a die grinder.

When you finish, you will probably be aware, for the first time, of all the waves and undulations in the surface, which didn't show up before, but look terrible now. The best way to get rid of them is to go back with a file and work them out. Then go through the grades of paper again, and polish again.

Keeping a piece polished is a different story. People can't resist running their greasy hands all over polished bronze sculptures, and the acid left behind quickly tarnishes the bright metal. (Remember this when you're looking at someone else's polished works!) One solution is to lacquer the piece, but you can see the film on the metal, and it detracts from the high finish. A second solution is to make sure all tiny pits and holes are completely filled, and then have the piece first nickel plated and then gold plated. It will stay bright and beautiful. A third way is to wax it well, ask people to keep their hands off, and repolish and rewax as needed.

Patinas

But chemical patinas are a different subject. With chemicals you can make just about any color. But for practical purposes, you can make browns, from a light gold through rich browns to black, and you can make blue/greens, both light and dark, greenish and bluish, and you can combine the two. There are other patinas, such as whites, which are expensive and difficult, and, it seems to me, show off the cleverness of the patineur more than the sculptor. Still, experimentation can be fun and rewarding. Always remember to be guided by the ideas you want to communicate.

You must understand how the chemicals are applied. Most patinas are applied with spray a or brush. The chemical is dissolved in water. It is rare to dip a sculpture for a patina because you'd need such a big tank and so much chemical. Dipping works well for small pieces and production work, however.

Applying chemicals. Most patinas are applied hot. Heat the bronze with a big bushy flame, either on a welding torch or a natural gas or propane torch. You can also use an oven. The heat speeds up the process, both by drying the solutions faster and speeding the chemical reaction. Cold patinas also work well, though they are

slower, and may take days. In many cases, completely different colors can be obtained from the same chemicals if they are used cold instead of hot.

To apply patinas, ordinary spray bottles, commercial air brushes, or even paint sprayers work. Brushes are also useful, particularly to blotch and stipple for less even effects.

Chemicals used. The most common chemicals used for patinas are:

Liver of Sulfur (called *Sulfurated Potash*): stinky tan rocks that must be kept tightly sealed from moisture or they loose potency. They dissolve in water and make browns and blacks.

Potassium Thiosulfate: clear crystals that produce browns (more chocolaty) and blacks.

Ferric Nitrate: white crystals that produce reddish browns.

Cupric Nitrate: blue crystals that produce blues and greens, and can add richness to browns.

With these chemicals you can make lots of patinas. You don't really need a chemistry set to make beautiful sculpture. You need skill, patience, and sensitivity.

Preparing the bronze. You also need a clean bronze. The best cleaning is sandblasting; next is wire brushing; and often the two together are great. Don't touch the bronze with your grimy fingers after you clean it. Mount it in such a way that it is raised up off a stand, is stable, can be turned easily, and is mounted on something that won't burn (Figure 10-50). Another often overlooked element is light. People sometimes apply a patina in dim light, then display the work in the bright spotlights of a gallery, and see things they hadn't seen before. Shine heavy spotlights on your piece as you work, or, even better, work outdoors.

Some Patinas

Basic browns. Take a pint of hot water and drop in a piece of Liver of Sulfur the size of a pea—just a tiny bit. Watch it ooze yellow as it dissolves. Now slowly heat the sculpture with a torch. If you use oxy-acetylene, be sure you have a *rosebud tip*—lots of little holes for a big, bushy flame (Figure 10-51). Test the heat by touching the bronze with a brush dipped in your patina mixture. When it sizzles, you're ready. Either paint or spray the mixture on, watching what happens. It will begin to darken, but unevenly. Brush or spray the lightest spots, trying to keep things even. Watch it carefully, and when it's as dark and even as you want, quit.

Sodium Thiosulfate, mixed about one tablespoon per pint of hot water, gives you a different, warmer brown. It also creates light surface deposits, which will wash off.

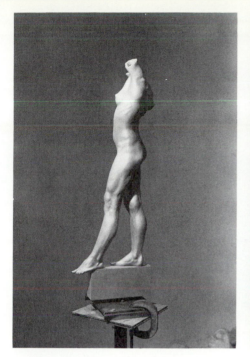
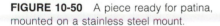
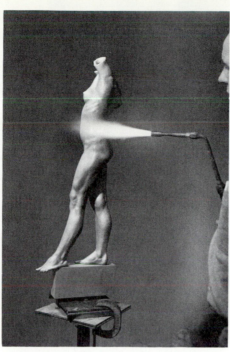
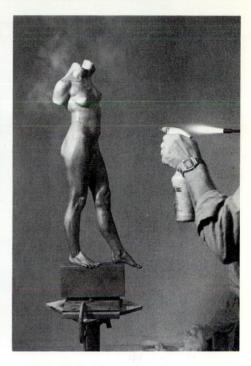

FIGURE 10-50 A piece ready for patina, mounted on a stainless steel mount.

FIGURE 10-51 Heating bronze with the rosebud tip.

FIGURE 10-52 Spraying on patina chemicals.

Reddish browns. To use Ferric Nitrate, mix it strong—one to two tablespoons per pint—and get the bronze a good deal hotter, so you have strong sizzling (Figure 10-52). The brown will be much redder. You now have two choices: rinse or don't rinse. If you rinse, you'll notice that much of the brown comes off. It isn't patina, but just red oxide on the surface. But the bronze is a little browner after rinsing. Repeat, keeping the bronze good and hot until you get the color you want. If you choose not to rinse, and wax over it, you get gorgeous color, but much of it is really just iron oxide held on with wax.

Black. Here's a fun one! Dissolve a tablespoon of Sodium Thiosulfate in a pint of hot water; then add a tablespoon of Ferric Nitrate, and watch what happens. It turns instantly black . . . then clears to a reddish color. Applied hot, this mix makes a strong dark color on Everdur. It is good for blacks. Be sure to rinse this patina.

Greens. Cupric Nitrate is used like Ferric Nitrate. Use two tablespoons to a pint of hot water, and get the bronze really hot. Stipple with a brush, heating after each stipple. This will give an opaque turquoise blue. You can tone it down with one of the brown mixtures. Then alternate browns and greens to build richness.

Rinsing green patinas is particularly effective. Rinsing in hot water leaves the color slightly greenish, while rinsing in cold water tends it towards the blue. Also, rinsing often seems to pull a blotchly patina more together.

You can soot the piece, too, by going over it with the acetylene flame until it is all black, then rinsing, and then continuing to add more patina. This gives darkness and richness.

The secret to learning about patinas is in doing them. You will discover good things happening—and problems too. When you make a botch of it, sandblast or wire brush and begin again. I don't give a long list of recipes here, because I don't use them, and many patineurs I know don't either. They go by the principles I've just mentioned, and work from a storehouse of experience. Besides, I've never yet tried a recipe I found in a book and gotten what they said I would get.

Finishing. The best finish for most bronze is wax. And the best way to wax is to hot wax. When you put wax on the bronze, you can no longer work the patina. The only way to change it is to remove everything— wax and patina—by sandblasting, and then start all over. So before you wax, inspect your patina very carefully. Look at it in different lights. Look particularly carefully from below and above to spot areas you missed. It's usually a good idea to let the patina stand a day or two to settle and to allow any changes to take place so that you can deal with them.

When you are really sure the patina is as you like it, give it a final good rinse (if you're rinsing). It will look about halfway between the dry and wet state when waxed. Heat it a final time, carefully, not burning the patina anywhere. Then apply a wax, like ordinary paste

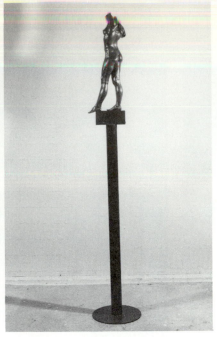

FIGURE 10-53 Applying wax to the hot bronze.

FIGURE 10-54 The finished piece, **Beam Walker**, mounted on a brass pole as part of the total conception.

wax for floors, using a clean paint brush (Figure 10-53). Brush it in well all over, and let the heat in the bronze draw it in. Do not try to buff it until the bronze is room temperature. When it is cool, buff and buff and buff with a soft cloth. You can add more wax and buff again for a good sheen. Figure 10-54 shows a finished piece, *Beam Walker*, mounted on a tall brass pipe that has also been patinated.

You can use colored wax (translation: shoe polish) to enrich color, but there are two cautions. One is that excessive use of shoe polish makes the work start to look a little like a shoe. No joking, it begins to get a leatherlike look! The second problem is that if the bronze gets warm, one touch and the wax comes off, revealing the truth of your nice rich color.

Sometimes, on lovely pale green patinas, wax causes certain areas to go blotchy. To avoid this, spray the piece with ordinary drawing fixative first, then wax.

Various kinds of spray-on hard finishes, like Incralac (see Appendix), are popular and work well to protect bronze, particularly outdoors. Read the relevant section in the Ron Young book for a description of protecting bronze.

Other Finishes for Metal

There are lots of other things to do to metal besides polishing or applying patinas. I know of no commandment that says: "Thou shalt not paint bronze." Oil paint on copper or bronze is extremely durable, and opens up a whole world of possibilities. This sculpture by Manuel Neri (Figure 9-26) gains a great deal of its effect through the bold abstract expressionist brush strokes.

Metal can be electroplated. This costs money, unless you have the set-up, but it can look wonderful. Silver-plated bronze or other colors can be very effective.

Bronze can be left "raw." Giacomo Manzu, the Italian sculptor, adds a percentage of silver to his metal, then leaves his casts their natural color, which is a soft gold.

The limits of final finishes for metal castings exist only in your own mind.

CASTING WITHOUT A FOUNDRY

Many schools do not have a foundry, but they want students to have some experience of casting. There are several ways to do this.

Direct Molding

First, there is a method of casting without using lost wax. Lead and pewter can be cast into pure plaster molds, provided they are thoroughly dry. Molds can be taken off clay or other materials, but they must not contain such great hollows as to make very thick sculptures. Keep forms thin, and it works fine. Dry the molds in an oven at 300° F for at least six hours. They must be absolutely dry before you add hot metal. If you are in any doubt at all about their being dry, dry them some more.

Lost Wax

Lost-wax molds can be burned out in makeshift kilns, or often you can borrow a pottery kiln. Just look

for roughly 1000° F for a number of hours. Small molds of about 6 inches in diameter or less can be burned out in twelve hours or less. A very small mold—the size of a styrofoam coffee cup, for example—can be burned out in just a couple of hours under an inverted coffee can with a hole in the top, placed over a gas burner.

Metals

Lead is not as good a metal to use as pewter for this sort of casting, for obvious health reasons. Use pewter that contains no lead (some does). You can buy it at art supply stores. It can be melted in a cast iron pan on a good gas stove. A piece of window screen fitted with a small handle makes a good skimmer. Whenever you pour pewter or lead into plaster molds, wear a face shield, pour carefully, and keep your face well back from the pouring cup. A blow back from moisture sometimes comes several seconds after pouring has stopped, so don't fill the mold and then peer down the cup. Stand back and let the whole thing cool completely.

Styrofoam Casting

The *full mold* process is also interesting for schools. Styrofoam patterns are buried in sand, and hot aluminum is poured directly on them, vaporizing the styrofoam instantly before the rushing metal. This works well, but *great* (notice, I didn't say *good*) ventilation is needed because of the mass of smoke from the burning plastic. For a more thorough discussion of this process, consult Geoffrey Clarke's book (see Bibliography).

FINAL THOUGHTS ON METAL CASTING

I urge you to remember that casting metal is only a means to an end, and that the end you are aiming for is the meaningful expression of your thoughts and ideas. If your sculptural thoughts seem to indicate expression in the kinds of forms metal can achieve, then pursue this sometimes difficult and highly technical path. If, however, your thoughts fit more easily in other materials, do not be seduced by process or by the aura of "serious sculpture" and tough guy talk.

Thoughts on Safety

I must end this chapter with more thoughts on safety. No sculpture is worth serious injury. Buy the proper safety equipment, keep it in good order, and use it. If you let your face shields get all scratched and dirty, you won't be able to see out of them. You'll be tempted to leave them off so you can see, and that's when bronze can splash in your face. Don't be casual and pour in running shoes or without gloves. Don't leave junk lying

around that you can trip over. Think ahead about what to do in case of trouble. Always have a ready escape route, such as an open garage door, and if a pot should spill, *run like hell*. Concrete floors are not safe for foundries, but most colleges build foundries with concrete floors anyway. If you spill hot bronze on concrete, in about three seconds it starts to pop as moisture is released, and bronze flies all over. And be absolutely sure you have a good industrial fire extinguisher handy, one rated for A, B, and C type fires.

When you grind bronze, wear good goggles or a full face shield, but don't stop there. Long hair can be extremely dangerous. If your hair hangs down below your chin, tie it up or wear a cap. Hair that brushes against a grinder can get caught, and in an instant the grinder is yanked to your head, often pulling out a piece of scalp. I don't mean to be gruesome, but this is serious. Grinding bronze can be very noisy, and you should invest in ear protectors, either the big earmuff kind or small foam ones that you compress and stuff into your ears.

A respirator is very important, since you throw a great deal of rubbish into the air when you grind—not just bronze dust, but abrasive, glue, bits of thread and paper, and other matter. Without a respirator, that all goes straight to your lungs. You can get away with paper masks for grinding, but you need a rated chemical respirator for patinas. Get one good for fumes and mists, be sure it fits, and wear it.

The best safety equipment of all is right between your ears. How often have you heard people speak of "stupid accidents"? When did you ever hear someone speak of a "smart accident"? All accidents are stupid accidents, and they happen because someone didn't think enough, or didn't follow accepted practice. Look around carefully before you start, and get a little paranoid, trying to spot possible trouble before it happens.

Rehearse the operations you will be doing. Before you light the furnace, get the people together who will be pouring, and run through the whole thing cold—actually picking the pot out of the furnace, getting it settled in the shank, pretending to pour, and putting it back—to be sure you have the feel of it. Make sure the people doing the pouring are strong enough, and won't weaken in the middle of a pour. You don't have to be a muscle-bound type to pour, but if one person feels too weak to hold the heavy shank and pot, get someone else.

They say that woodworkers cut their fingers off either the first day on the job or after thirty years. Either they are inexperienced, or they become so experienced that they forget to concentrate, and lose their natural and proper fear of the machines. Never get so comfortable pouring that you stop being afraid of hot metal. Always treat it with the greatest care. May you never have an accident, but only the thrill of wonderful castings.

ELEVEN

Direct Building

By *direct building* I mean modeling in a material that will become hard, such as plaster or cement. There are several advantages to this method. One is that in many cases you can create a modeled sculpture which does not need casting—a particularly good idea for many school projects. Another advantage is the change in the nature of the material, from a soft, easily manipulated one to a hard material which can be carved, filed, and sanded. A third advantage is the possibility of incorporating many more ways of making form into the sculpture, such as found objects or precast forms.

Direct building in plaster is the primary method used by many sculptors, including Henry Moore and Reg Butler, to create the original forms they later cast in bronze. It takes practice and skill to become at ease with direct plaster, but it is not a difficult material to learn to use well, and it provides a way to make forms quickly, easily, and cheaply. Those forms can either be left as they are or cast. They can sit around without deteriorating while a decision is being made.

There are other materials available to build directly, materials which are far more permanent than plaster, and which are final materials, thus eliminating the need for casting altogether. I discuss them below.

PLASTER

Armatures for Plaster Construction

Plaster is the most commonly used material for direct building, the most readily available, and the easiest to use. The first thing to consider when beginning a direct plaster sculpture is the armature. You need something to support the plaster as you build, but, since plaster is strong, the armature need not be strong in itself, only strong enough to hold initial layers of plaster until hard.

Only when you intend the directly built sculpture to be final and permanent must you design and make an armature that provides actual support. Otherwise, just about anything will do.

Simple wire armature. I saw Henry Moore make a small model, about 12 inches high, by beginning with a simple bit of two or three strands of twisted wire stuck in a board, bent the way he wanted the sculpture to stand. He mixed a small batch of plaster, dipped a long strip of cloth in it, and wound the cloth around the wire, covering it more or less completely, and let that go hard. He now had a strong, filled out armature, to which he could then apply batches of stiffer plaster. I made a small sculpture as a demonstration, imitating this process, which is shown in Figures 11-1 through 11-4.

Chickenwire. It is easy to make armatures for larger works out of chickenwire. As described in Chapter 1, chickenwire can be crushed on itself to form complex curves, like balls or saddle shapes. You can cut pieces of chickenwire with tin snips to various shapes, wire them together, bend them, crush them, and manipulate them, to make something like the form you are working toward.

Keep the wire form smaller than you want the sculpture to be, and be particularly careful about openings between forms. Look at Figure 11-5 to see how you must make the spaces between forms larger than you might think, to allow for a thickness of plaster. You add, on average, something like ½ inch all over the surface. Thus, any space between forms must be about 1 inch wider than you want the final gap to be.

Styrofoam. Another very good material for armatures is styrofoam. This is readily available in lumberyards and also as salvage. With a little snooping, you

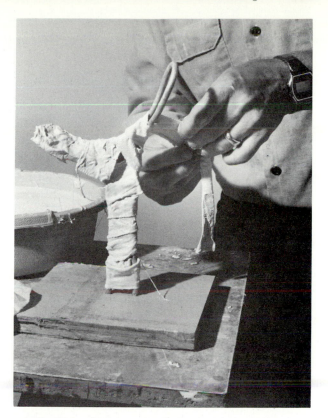

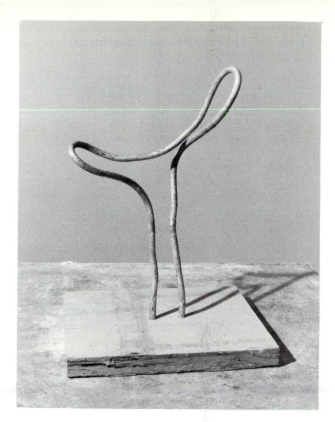

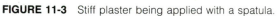

FIGURE 11-1 Small wire armature for a simple direct-plaster sculpture.

FIGURE 11-3 Stiff plaster being applied with a spatula.

FIGURE 11-2 Plaster-soaked strips of rag being wound around the armature.

FIGURE 11-4 Refining the form and surface with a surform file.

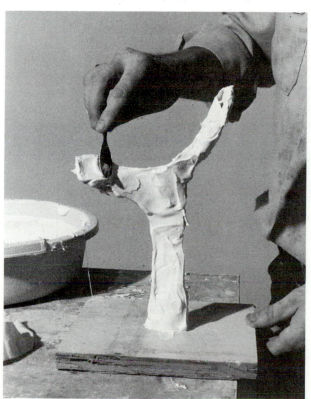

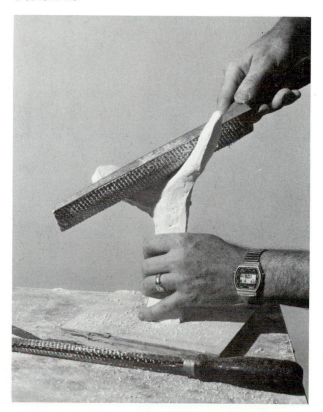

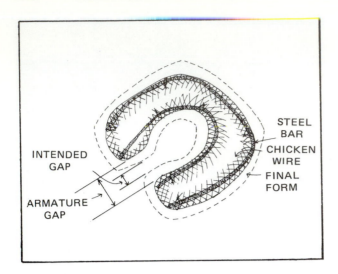

FIGURE 11-5 Clearance necessary in the armature to allow proper final clearance after the plaster is applied.

can probably come up with lots of free styrofoam, nicked and bruised, but perfectly good for sculpture. You can cut it with any kind of saw. The only problem with styrofoam is that you get covered with little white beads that cling and are difficult to sweep up.

Styrofoam blocks can be stuck together with builder's adhesive or *panel cement*—thick brown paste that comes in tubes that fit in caulking guns. Or they can be held temporarily with pins, like welding rods, poked through them, and then later with plaster. That old standby, duct tape (gray tape) holds blocks of styrofoam or just about anything else together. Once you have the styrofoam armature roughly in place, any corners or projections can be sawed or filed off.

I have made a demonstration piece using this technique, shown in Figures 11-6 through 11-8. Notice that the rags dipped in plaster and wound around the styrofoam make the whole thing rigid, and give later plaster layers something to grip.

Wood. If you use wood as an armature, you must solve the problem of expansion. If you just apply plaster to a piece of wood, the plaster sets and hardens, but the wood begins to absorb moisture from the plaster and starts to expand. The expansion often cracks the plaster. You can either shellac the wood thoroughly before applying the plaster, or use it in such a way that it is isolated from the plaster.

Steel. Long or very large structures can be reinforced with steel rod or bar, but, again, it's a good idea to shellac it first to prevent rusting and staining.

In general, take time with your armature, since the old saying still holds: As goes the armature, so goes the sculpture.

FIGURE 11-6 Slabs of styrofoam stuck together with nails. This is very flimsy.

FIGURE 11-7 Plaster-soaked strips of rag being wound on the styrofoam. When this has set, the structure will be rigid.

FIGURE 11-8 Stiff plaster being applied with a spatula.

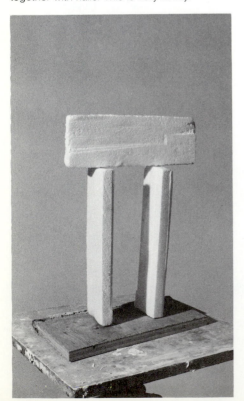

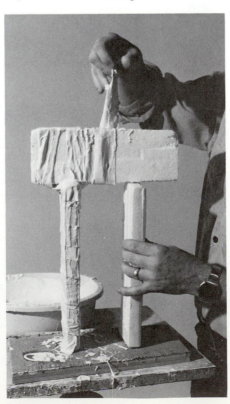

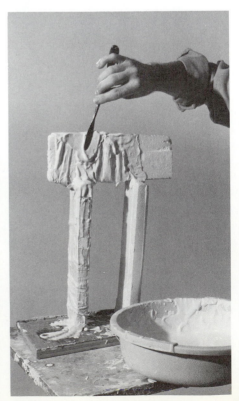

Applying Plaster

First layer. The best way to begin applying plaster to an armature—chickenwire, styrofoam, or whatever—is to dip strips of dampened cloth in plaster and smooth them on. They may not stick well, but persevere, laying them on the top of the sculpture, letting them set, then turning the sculpture so a new areas is on top (Figures 11-2 and 11-7).

Mixing plaster. When the whole piece is covered, you can begin to add plaster seriously. For this you must mix a little differently. For efficient direct building, what you want is a series of small batches of thick plaster, each one ready about the time the previous one goes hard. Collect some small bowls, half grapefruit size. Mix a batch by adding plaster until it heaps up on the surface in dry mounds. When this has soaked up, mix a second batch, but don't stir it. Now stir the first batch and begin to use it. When you have almost finished the first batch, add plaster to a third bowl, stir the second batch and begin using that. Keep up the rhythm of finishing a batch, mixing another, then stirring the one that's been sitting.

Building form. There are a lot of ways to apply plaster. You can gob it on with your hand, you can brush it on, you can apply it carefully with a trowel or wide spatula, you can flick it on for stucco texture, or you can slap and slop it on, in any combination. I believe, though, that the key concept is *control*. Plaster can easily get away from you and produce big, lumpy, awful things. It is easier and more efficient to put the plaster on the way you want it than to pile it on, let it go hard, and then work like mad to carve it off again. Go slowly, use small batches, and *think* as you work.

One way to think of a directly built plaster piece is to imagine it as a core with a skin. The armature, covered with hardened plaster-soaked rags, is the core, to which you apply a thick skin, which is the outside surface of the sculpture. That skin should creep around the piece, batch after batch, with every application coming about to where you want it in terms of thickness and final form, leaving relatively little carving later (Figure 11-9).

There are many tools you can use with plaster, some of which are made for the job, and others that are improvised or adapted. Figure 11-10 shows several plaster tools available at sculpture supply houses. They are all scrapers of various kinds. The ones with curved ends are called *griffens*. You can also use your spatula tools to apply plaster.

Making Changes

As soon as the whole piece is well covered in plaster, you can stand back and assess what you have

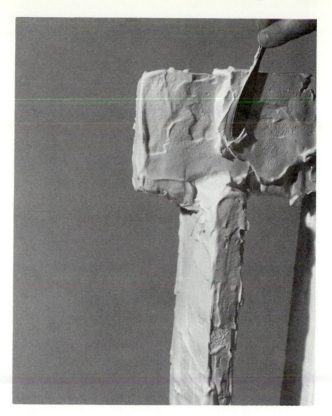

FIGURE 11-9 A good skin of plaster being applied.

FIGURE 11-10 A selection of plaster-working tools: (*from the top*) a small scraper, a plaster-worker's knife, two griffens (*curved ends*), three serrated blade scrapers, and a double-end plaster chisel.

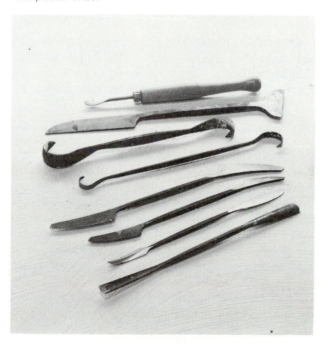

made. Chances are it is different from what you originally had in mind, so you start to note changes that have to be made. These changes will be of two sorts: taking away excess material or adding more.

If you only want to take away a little plaster, use a Surform file, the kind with the little holes in the blade that allow the plaster shavings to fall through. A regular file used on freshly set plaster will last for about three swipes before it's hopelessly clogged. If you need to take more off, use a chisel and hammer, and begin carving. If you need to take off plaster down past the armature, use a hammer or hatchet and chop right in, breaking the armature at that point. Bash in below where you want to be, then add more plaster, building back out to the final form.

If you need to add, you can add an inch or two in the same way that you did the regular building. If you need to add a lot, you might stick a styrofoam block on the form with a plaster-soaked rag, and then build over that.

One of the more frustrating things that can happen during direct building is filing into the form and hitting bits of rag. Try to avoid this at the start by looking at your armature carefully, and making sure no point of it gets too close to the final surface. If you do hit rags at a crucial spot, dig them out and add more plaster.

Another even more frustrating problem is to have a form break or crack. You can't fix a crack in a narrow form by patching it with plaster—it'll just crack again. What you must do is get some reinforcement inside by punching a hole, inserting a heavy steel rod, and pouring plaster in to lock it in place. Then dig a deep groove around where the crack is, and add more plaster.

One way to make extra strong plaster is to add Elmer's White Glue to the water—about ¼ by volume —before adding plaster. This glue-loaded plaster is stronger and harder than regular plaster, and it also sticks better to adjoining plaster. The strength helps structurally, but it is hard to file or sand at that point since it is harder than the surrounding plaster.

Refining Form

At this point I advise rereading Chapter 1 on form, thinking about what you have made in those terms. Look at the various parts of the sculpture, checking for vague, formless areas. Though it is safe to say that all objects possess form, some, like crumpled cloth or heaps of mud, seem to be without discernible structure, and thus form-less in the sculptural sense. Look for spots like that in your work, and make sure every part of the sculpture has a real role to play.

At the risk of stepping on some toes here, I would say that one of the reasons many early twentieth century sculptors *hated* the work of Rodin was because it often included large areas that were formless in this sense. When you examine the Rodin bronzes, you will see many areas that are merely raw clay, carefully cast into metal, with no structure or form. Artists like Brancusi rebelled strongly against this by creating works in which clearly defined form dominated all else.

Surface

To achieve form you can chisel, saw, and file with the Surform file. These produce textures on the plaster, a surface. If you want to refine that surface, you can either use the same tools more carefully, or other means. The Surform file refines the surface well, but so do rasps. As the plaster begins to dry and lose moisture, rasps and even files will work without clogging. Keep a file curry handy to clean files frequently. Small scrapers such as those shown also work well on plaster, and sandpaper is wonderful.

If the plaster is wet, use *wet or dry paper*. Take a basin of water, wet your sculpture thoroughly, dip the paper in the water, and go to work. Rinse the sculpture frequently to remove the slime, and you can create lovely soft surfaces of remarkable smoothness. It is important to remember to rinse any slurry off thoroughly before adding new plaster. Since plaster is not naturally a glue, it helps to roughen any surface to which plaster is added, to help it grip.

If the plaster is completely dry, regular sandpaper works. Be particularly careful when using sandpaper not to wear down any form you have created. Let the sand-paper simply remove the tool marks, but don't let it erode clarity.

Incorporating Casting with Direct Building

Plaster is a wonderful mimic. Pour a little on a crumpled plastic bag, and when it is set and removed, you have a remarkable casting of the plastic, which even *feels* like plastic. It is, of course, a *negative*, or reversed, cast of the plastic, as if you made a mold of the plastic. Poured out on glass, plaster makes glassy smooth pieces. It picks up textures with great fidelity. It also casts objects in the positive sense, using either a waste mold or rubber mold. These objects can be incorporated into a sculpture built from plaster. Or cast objects can be the main interest of the sculpture, held together in an organized manner with directly applied plaster.

Other Ideas for Direct Plaster Sculptures

Here are some ideas for handling plaster which may help you generate more ideas, which may in turn generate still more as you work.

Plaster, poured in sheets on glass, can be broken, giving smooth surfaces with jagged edges. These pieces

can be assembled like lumber, or stacked, or arranged in other ways to create sculptures (Figure 11-11). Richard McDermott Miller, in his book on making figures in plaster and wax, recommends casting, then breaking and rejoining slabs of plaster as a basis for figures, using directly built plaster to fill out form (see Bibliography).

Jean Ipousteguy, the French sculptor, made a large *Woman in the Bath* mainly in direct plaster, then incorporated castings into the work, including life casts of hands and feet, and a cast of his own teeth that he obtained from his dentist. A student of mine in Sheffield once got several sets of such teeth and built them into the mouths of plaster ''snakes,'' which writhed out from the walls of an oppressive room she had created, with terrifying effect.

Life casting refers to taking molds of people's bodies. This is usually fascinating because of the remarkable clarity of detail which can be achieved, right down to skin pores, as well as the interest of nudity that is connected with the idea. But you must bear in mind several cautions before attempting any life casting.

First, any skin on which plaster is placed must be well coated with Vaseline. Body hair can adhere to the plaster with very painful results as the cast is removed. Sometimes it can be smoothed down with Vaseline,

sometimes not. Another very dangerous area is the face. If the eyelashes are not well protected, they may adhere very tightly to the mold, with results I don't even want to think about. If you really want to cast a face, be sure the eyebrows and eyelashes are well greased. Then place small strips of tissue paper over the eyelashes and grease them as well, so there is no chance of any stray lashes getting caught in the plaster. You can insert large straws in a person's nose for breathing, but they must be very well sealed. You must establish a set of clear signals in case something goes wrong. One other caution. When plaster sets it gives off heat, which can actually burn skin.

A better way to make life casts is to buy a product called Moulage from sculpture supply houses. Moulage is a very strange gelatinous material that you warm in a double boiler to turn sort of liquid. Test it with your finger to be sure it isn't too hot. It can then be painted directly onto the skin, with no preparation. A second coat won't adhere to itself, so apply one thick coat with a big brush, very quickly. Then immediately apply a plaster back-up mold. Moulage does not adhere to anything and pulls off even heavy matted hair. You must cast the positive right away, since Moulage is very fragile.

Objects like toys, dolls, buttons, seeds, pebbles, or shells, can be laid out on a sheet. Pour plaster over them, then carefully wire brush it away after setting to partially reveal the objects.

Plaster can take a *reverse cast*. If you roll out a slab of clay, gouge hollows in it, then pour plaster over it, the plaster slab will have corresponding bumps. You can do a double reverse by pressing something like a doll's face in the clay over and over (Figure 11-12), then pouring plaster on the clay (Figure 11-13). You will get a sheet of plaster with the doll's face sticking out again and again (Figure 11-14).

Roel d'Haese, the Belgian sculptor, had in his studio a fat little Napoleon. He had taken a toy soldier of Napoleon and pressed it into clay, rolling it across the clay. The plaster cast gave him a fat Napoleon. The doll's head on the left in Figure 11-14 was made that way.

If you dip an object in thin plaster, the plaster coats it, blurring the details.

I had a student who made complex shapes of wax by pouring hot wax in water. He then embedded the wax shapes part way in plaster, and, when it was set, steamed the wax out, leaving the most complex fissures.

Henry Moore glued pieces of string on the surface of plaster, which, when cast, made fine raised ridges. (See Figure 15-10.)

These various ideas are intended to encourage you to think of plaster as something that will do just about anything. Its only limits are in your mind. As you expand

FIGURE 11-11 Pieces of plaster poured on a sheet of glass, broken, then stacked over a vertical rod.

FIGURE 11-12 Doll's head pressed four times into soft clay.

FIGURE 11-13 Plaster poured over the soft clay.

FIGURE 11-14 The reverse cast. The head on the left was made by rolling the doll's head as it was pressed.

your thinking, plaster will expand with you, doing the most amazing things.

OTHER MATERIALS FOR DIRECT BUILDING

Hydrocal and Hydrostone

These two materials are variations on plaster, made by adding a certain percentage of cement. They are from five to ten times as hard as regular plaster, and a good deal more weatherproof. You buy them in hundred-pound bags, just like plaster (though they are more expensive), and mix them the same way. They take longer to set, and when freshly set they are about the same hardness

as plaster, but when they lose their excess moisture, they harden considerably. Therefore, when working directly with these materials, it's a good idea to keep the whole project damp with wet rags and plastic sheets, just like clay, as long as you are carving and adding material. When the form is virtually complete, and only surface work remains, then let the piece dry.

Glue loading also works with Hydrocal, and adds even more hardness. If you treat it this way, you can achieve casts or structures of remarkable thinness.

Cement and Concrete

You can build directly with many different kinds of cements with great success. Make an armature of strong metal lath, and back it up about a half inch behind the lath with a solid surface, such as a plaster form. Then, force the cement, well mixed with an appropriate aggregate like sand, through the mesh against the inner form, building it up to a half inch over the mesh, and troweling to the final surface before hardening, since it is very hard to chisel after setting.

In general, it is not a good idea to add cement, let it set, then add more, as the bond will not be guaranteed. It works better to plan carefully, then build the full thickness of skin, progressing across the piece.

Resins

Many kinds of polyester resins can be built directly. Body putty, available from auto repair shops, might be used as a direct building material, since it is designed for a similar kind of application on the old banged-up Buick. It is made to stick well to bare metal and to itself in subsequent applications, and to file and sand easily. It is very strong and permanent, and can take a wide

range of finishes, usually paints of various kinds. But it is expensive, and you can find other ways to do much the same thing.

Instead of applying plaster-soaked cloth to a chickenwire armature, resin-soaked glass cloth can be used for a much stronger, lighter result. Since this can be very messy, you should buy many pairs of throwaway plastic or rubber gloves to keep the stuff off your hands at all costs. Do not allow yourself to get sticky and covered with resin and glass. It's like being tarred and feathered, only worse! Treat the resin with great care, never touch the stuff directly, and clean up tiny spills immediately. Wear a respirator, and make sure you have good ventilation.

When the glass cloth has gone hard, body putty or resin loaded with inert fillers like cherry-pit flour can be applied. Like cement, resin gets very hard, so you must apply it more carefully than plaster, working the surface while it is soft so you don't have to take a lot off later. If you use a power sander (like the 4-inch angle grinder with coarse discs) on a glass and resin piece, you must really worry about wearing a good respirator and goggles. Microscopic pieces of glass flying around in the air are no joke. In addition to good respirators and goggles, a heavy fan at your back helps.

Design Cast

This material (see Appendix) is a recent arrival in the sculpture studio. It is a combination resin and plaster specifically designed for sculpture. It is a very hard, white material that can cast with extreme detail or be built directly. It accepts a wide variety of surface treatments, such as paints and stains, and is completely resistant to weather, including acid rain.

Design Cast comes in four types: three types of exterior material and a fourth made for interior use. The three weatherproof types are 62, 63, and 66, and they differ in consistency. Number 62 is thin, and is best for lay-up casting with fiberglas or for pouring solid into molds. Number 63 is thicker and sets faster. It is made for *slush casting* (pour some in, roll it around). Number 66 is the thickest, designed for direct building, using the kinds of techniques described in this chapter. It can be mixed in varying consistencies, from soft mush to stiff paste, and it stays workable for two to four hours. A very important consideration is that new material can be applied over old with good bonding.

The fourth kind, number 47, is a different substance. The first three come as a dry powder and a liquid polymer, to which you add water. Number 47 is a dry powder, to be mixed with water only, and is thus really a sort of "super plaster."

Detailed instructions for mixing, use, surface coatings, and other aspects of Design Cast come with it.

Design Cast is not the only product claiming to do these things, so you may want to investigate others. Send for a sample, experiment, and see how you like it.

WHAT TO DO WITH DIRECTLY BUILT WORKS

If you decide to work in cement, resin, Hydrocal, or Design Cast, you probably intend the directly built piece to be in its final form. With many materials, such as cement or Design Cast, the color of the material can be the color of the piece. These materials need no waterproofing or sealant; they are finished as is. Resin is usually mottled and a rather unpleasant color, but the whole range of paints available to the auto industry, plus all the acrylics used by artists, stick to it very well.

Hydrocal is rather permanent outdoors (measured in years, rather than decades, however), but it can be helped with layers of linseed oil loaded with oil color, heated, and brushed well in. Commercial marine varnish or urethane varnishes also help.

Plaster, however, does not last outdoors. Despite applied finishes, water seeps in, and with the freeze/thaw cycle, plaster flakes off. Indoors, plaster is as permanent as any material, given care. There is a plaster head of Pharoah Akenaten from 1345 B.C. still in perfect condition in Berlin. So, plaster can be a permanent material for indoor use, although not a terribly elegant one. Usually, directly built plaster is intended as a pattern for casting with either a rubber mold or a carefully made plaster piece mold.

Casting from Directly Built Works

When you take a plaster mold from a plaster model, the model is usually quite dry by the time you are ready for it. (If by some chance it is wet, soap it well, and take a mold from the wet plaster.) Shellac or lacquer the dry plaster well; then either wax it carefully with paste wax and buff it, or rub a light coat of Vaseline over the surface.

The piece mold must be designed carefully so there are no undercuts. Even a slight undercut will make it impossible to get a piece off without breaking something. If in doubt, make another piece, or fill the undercut with clay. It is easier to put a rubber mold over it, and forget the undercuts. Remember, when putting Smooth-On on plaster, that you can pull the rubber off bare plaster easily, but if you shellac the plaster and put the rubber directly on the shellac, it sticks tenaciously, and you'll never get it off. Either shellac then wax, or Vaseline thoroughly, or skip all release agents and go on the bare

(dry) plaster. If using another kind of rubber, be sure to experiment.

In the case of directly built works made of other materials, such as Hydrocal, cement, or Design Cast, you probably chose those materials so you wouldn't have to cast. In such cases, when you're done working with form and surface, you're done with the sculpture. You may, however, want to add further elements such as color, other objects, or textures.

You must remember a few general principles when coloring any sculpture. First, the piece must usually be dry. This sounds simple, but most water-based materials (plaster, Hydrocal, cement) retain water for a long time, far longer than you think, and may cause paint to peel. Be sure to give the work good drying conditions and lots of time before painting. Second, choose your paint care-fully. Oil-based paints such as enamel and varnish are generally good for gypsum materials (plaster, cement, etc.) and work outdoors. Acrylic paints, such as artist's acrylics, work beautifully on resins, and can even give a staining effect if thinned with water. And, of course, the general range of auto paints is available, particularly for the resins.

Once again, I urge you to think about your materials and what they will do. Sculpture is always a compromise between the wonderful ideas in your head and the realities of the materials on the bench. Plaster, used in the many ways possible—from casting through direct building and everything in between—can do most of the things you think about, and may also open your mind to new possibilities you hadn't thought of before.

TWELVE

Wood

Wood must be one of the most useful materials on earth! It is light weight, strong, cuts easily, joins easily, has a pleasing color, texture and feel, comes in a wide variety, and is a renewable resource. To realize how much wood has permeated our lives as a material, try these two things: First, look around your house and note how many things are made of wood (and don't forget the house itself). Second, think of all the stoneyards or places where you could go to buy steel bars in your town. Now think of all the lumberyards.

Wood is a wonderful material for sculpture for the same reasons. It is very flexible, in the sense that it can do so many different things and take so many different forms. It is permanent for all practical purposes, as shown by this Egyptian sculpture of wood, over four thousand years old and beautifully preserved (Figure 12-1). And wood is readily available in a wide variety of forms and species.

You may have noticed by now that I like to take complex subjects and break them down into pieces, each piece easily digested. The individual pieces add up to a complex mass of information. In this chapter I discuss wood as a sculptural material in this way.

THE NATURE OF WOOD

Wood comes to us in two forms: the natural form (logs or branches) and the processed form (lumber or wood products). There are two essentially different ways of

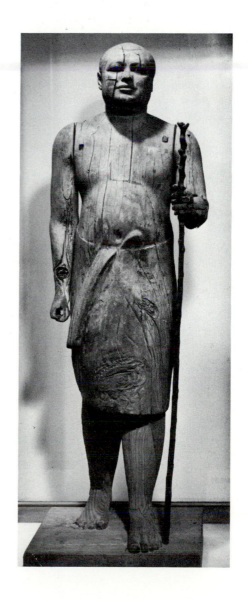

FIGURE 12-1 The Sheik el Beled. Egyptian, 25th Century B.C., sycamore wood with inlaid eyes, Egyptian Museum, Cairo; Hirmer Fotoarchiv.

working with wood: *carving* into it to create form or *constructing* it by joining pieces together to create form. These simple categories are not intended to limit your thinking about wood, as you will see, but simply give us an outline to follow as we discuss the material. There are other forms in which wood comes to us and other ways of treating it, which I talk about later, but the most common and most important forms and ways of working are those just mentioned.

The materials we have been talking about up to this point have no inherent form. Clay, plaster, and even metal, have no given shape, but take the shapes we give them, whether a kneaded lump of clay, a bucket of plaster, or an ingot of bronze. There is no "natural" shape for any of those materials. Wood, however, comes in a given set of shapes, namely cylinders. Everything we do to wood is a disruption of its given natural shape.

We can conceptualize about wood this way: Things made of wood exist on a dual continuum (Figure 12-2). One branch of this continuum involves carving, that is *reduction*. The unaltered log or tree is at one end, and the completely carved sculpture is at the other. The other arm of the continuum involves *construction*, the joining of pieces of wood together. Again, the unaltered log is at one end, and moves through complex constructions such as houses, to completely reconstructed wood such as particle board, which is wood that has been ground into particles and glued back together, or even the pages of the book you are now reading, which are cellulose fibers that have been extracted from a tree, mixed with glue, and formed into flat sheets.

In this discussion of wood as a sculptural material, I will take each arm of the continuum in turn, beginning with carving (reduction) and then moving to construction (joining). But first, we must understand some things about

wood itself as a substance, including something of its structure and its many varieties.

VARIETIES OF WOOD

All wood is composed of two parts: cellulose fibers and lignins. *Cellulose fibers* are all about the same from tree to tree. It is the *lignins*, the "glue" holding the fibers together, that differ, along with the arrangement of the fibers themselves.

Woods are traditionally classified as *softwood* and *hardwood*. This distinction is based botanically on whether the tree has needles or leaves, and also on the circulatory system of the tree. Softwoods have needles, and have a system of vessels carrying sap up and down the trunk that is dispersed throughout the cross section of the trunk. Hardwoods have leaves, and the circulatory vessels are in a ring around the outside of the trunk, the center being for support only (Figure 12-3). While it is true that most softwoods (pines) are softer than most hardwoods, it is also true that English yew, which is very hard, is a softwood by classification, and balsa, the softest wood in the world, is technically a hardwood.

Softwoods

Most of the wood we use is softwood. There is a lot of variety among the various softwoods, such as redwood, spruce, or yew, but most of the softwood commercially available is pine or fir. These woods are similar: They have an even grain, a tight construction without pores in the wood, and are soft and strong. Softwoods are generally "well behaved"; that is, they do not warp excessively or move overly much with changes in mois-

FIGURE 12-2 The dual continuum of carving and construction.

FIGURE 12-3 Sections of softwood (*left*) and hardwood (*right*).

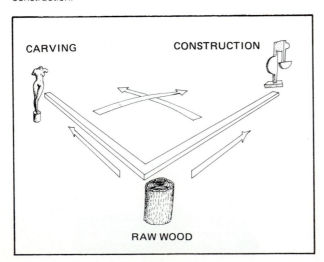

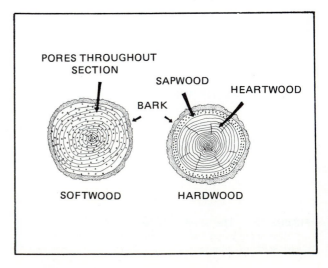

ture. Perhaps the best-behaved wood currently available is redwood, a softwood with a lovely reddish color. Because it comes from enormous trees, very long straight pieces completely clear of knots are available.

Softwood is the basis of just about all plywood, even so-called "hardwood" plywood. The core of "hardwood" plywood is usually softwood, with a veneer of hardwood on each side. There is some all-hardwood plywood available, however.

Hardwoods

Hardwoods offer the greatest variety in the wood scene. Rather than give you a long list of different woods, which can be very confusing, I will again break things down into categories so they can be more easily understood.

One way to divide hardwoods is into *domestic* and *tropical*. The domestic woods are those native to our country, such as oak, maple, cherry, or walnut. The tropical woods are imported woods, such as rosewood, ebony, or teak.

A second way to divide woods is by *open* or *closed grain*. In some hardwoods the fibers are grouped around pores or openings throughout the wood. Other hardwoods are structured much more tightly, with no visible pores in the wood.

A third way to divide hardwoods is by color, either *light* or *dark*.

Domestic hardwoods. Examples of light-colored open-grain woods are: oak, elm, and ash. Oaks come in several varieties, such as white oak, red oak, and English oak (which is a little browner). Oaks are all stable woods of great strength and medium hardness. A unique property of oak is that its lignins grow harder and more insect resistant with age; thus very old oak becomes quite hard. Elm and ash are similar to each other and look like coarse versions of oak. They are common woods, but not terribly stable, and tend to split and warp excessively. While they are too coarse for small work, Henry Moore has successfully carved very large pieces of elm.

The best example of a dark, open-grained wood is American black walnut. This wood has a grain pattern something like oak, but its dark color makes it instantly recognizable. It is a very stable wood of medium hardness, and a very beautiful wood, its color gaining richness with age.

Examples of light-colored, closed-grain woods are maple, beech, sycamore, birch, poplar, and basswood. Maple comes as either hard or soft maple, which look similar but have a slight difference in hardness. Both are tight, dense, rather hard, clean woods. They range from a simple white uniform wood, all the way through the figured maples, such as tiger maple, which has strong wavy lines at right angles to the grain that become very pronounced after finishing, and bird's eye maple, which is filled with little dots. These figured types are hard to cut without splitting and tearing, but they are highly prized for such things as gun stocks, violin backs (tiger maple is also called fiddle-back maple), and fine furniture. The first-class corridors of the *Queen Mary*, which extended in one unbroken line for five hundred feet, were entirely paneled in exquisite bird's eye maple.

Beech and sycamore are similar. Both have a more yellow color than most maple, and distinctive overall patterns. They are stable, well-behaved woods.

Birch is a plain white wood very much like maple. Poplar is a rather soft wood, often inexpensive, and quite stable and well behaved. It is sometimes used as a substitute for clear white pine in small jobs, and is the main wood for musical instruments like dulcimers. Poplar sometimes turns a distinctive greenish color. I have also seen it streaked as dark as walnut. Poplar is actually a lovely, underrated wood.

Basswood is usually available from craft shops in chunks good for carving. It is absolutely even in texture and a near-perfect white color. It is soft and cuts easily, but does not take the high finish that maple takes. The only trouble with basswood is that, because it is without figure or change of any sort, carving it is like carving soap—easy and predictable, but boring.

There are other light, closed-grain woods available occasionally, such as apple, pear, and other fruitwoods. These tend to be very fine grained, very beautiful woods. They are not usually available in large pieces, since fruit trees don't grow very large or very straight. But for small intricate carvings, these fruitwoods, properly cured, are almost unsurpassed.

Chief among the domestic dark, close-grained woods is cherry. This wood looks like a light wood when you see it in the lumberyard, but after finishing, it slowly turns darker and darker until, over many years, it becomes nearly as dark as walnut, though with a redder color. Cherry has quite a different texture from walnut, being close and tight like maple. It is not as well behaved, in that boards can warp and chunks can split. But it carves very nicely, and its absolutely stunning color makes up for the added care necessary to work it successfully. In general, I much prefer it to walnut.

Tropical hardwoods. The divisions of open or closed grain, light or dark also apply to tropical hardwoods. However, few tropical open grain light woods are imported, since they offer nothing that oak doesn't already have. Occasionally you may see such things as Iroko or Banak.

Among the closed-grain, light tropical woods, chief is boxwood, followed by satinwood. Boxwood is the tightest, most closed-grain wood of all, even tighter than

apple, pear, or other fruit woods. It takes the most astonishing detail and a lovely polish. The best boxwood comes from Turkey. Boxwood from Australia is good, but not as fine. Boxwood is poisonous, and workers breathing boxwood dust in the mills all day develop a rash in their lungs, but carving a small piece now and then has no effect.

Satinwood comes from Sri Lanka (Ceylon) and is a luscious golden color. But its best property is only seen when it is cut in slabs, either as lumber or veneer, and finely smoothed and finished. Then the wood appears like satin, its pattern shifting constantly as you move your head. For this reason, most satinwood is sliced into veneers, and carvable pieces are rare. But it carves beautifully, if you should happen to find a piece.

Tropical open-grained dark woods are in ready supply. Such woods are mahogany, purpleheart (amaranth), padouk (vermillion), teak, zebrawood, and the various tropical walnuts. Also included in this group is East Indian rosewood.

Mahogany comes from very large trees, so large, fault-free chunks are readily available. It is the familiar reddish brown color throughout, without pronounced figure, and is among the most stable and well behaved of all woods. It carves beautifully and takes a good finish. Purpleheart and padouk are very strongly colored woods. Purpleheart, sometimes called amaranth, is vivid purple, and perhaps is best used in small quantities, since its color is so strong. It is a somewhat stringy, fibrous wood, but it can be cut cleanly and it finishes well. Padouk, often called vermillion, is a strong orange color, harder than either mahogany or purpleheart, and more dense. It cuts nicely, polishes well, and the color darkens with age to almost black.

Teak is a tan wood (borderline between light and dark colored) with a strong, open grain. It is filled with so much natural oil that it is extremely resistant to weather, and therefore is the traditional wood for the decks of ships. Divers have reported that teak furniture, bolted to the decks of the *Andrea Doria*, which sank in 1956, still appears to be in perfect condition. Teak has a powerful and rather nasty odor when freshly cut, and it may drive others out of the room if you carve in a communal studio. It is also difficult to glue, and you must wash the glue surfaces in strong degreasers.

Zebrawood is a strongly striped wood, as its name implies, with narrow bands of walnut color between narrow bands of maple color. It is somewhat stringy, a little hard to cut without splintering, and tends to finish slightly bumpy unless filled with a good paste filler. The powerful pattern of the wood makes it a bit tricky to use with taste.

There are several tropical walnuts, which are similar to domestic walnut in color and texture, though often of a completely different botanical classification.

East Indian rosewood is not the same as Brazilian rosewood. The East Indian variety is more purple in color, open grained, and softer and lighter than Brazilian rosewood (though still a heavy hardwood). Because of Brazilian export restrictions, East Indian rosewood is becoming the only rosewood available, and is now often called simply rosewood, without the East Indian qualification.

The dark, closed-grain tropical woods are the most expensive, most exotic woods of all. These are woods such as Brazilian rosewood, cocobolo, ebony, and bubinga.

Woods of the rosewood type, which include Brazilian rosewood, cocobolo, kingwood, Honduras rosewood, tulipwood, and some others, are all very hard, very heavy (some will sink), very close grained, and richly colored and patterned. In fact, the wood of the true Brazilian rosewood tree has an even pattern throughout most of its long life (several hundred years), but it is often attacked by a virus late in life, which gives unique variations in color to the wood. These range from golden yellows through browns, purples, and blacks in myriad swirls. There is probably not a more beautiful wood than a prime piece of Brazilian rosewood. Unfortunately, this wood has been cut and exported so furiously that all the great old trees are gone, and young, non-virus-infected trees are being cut, with the resulting rather boring brown wood showing up here and there. The Brazilian government has passed a law prohibiting the export of raw logs or lumber, allowing only export of manufactured goods such as furniture. Thus, the only good Brazilian rosewood to be found in this country is wood that has been here a long time, in an old cabinetmaker's wood stock or some such place. I guarantee that if you find a fine piece of Brazilian rosewood, you'll never carve anything quite as nice. Its smell as you carve is wonderful.

Cocobolo is available, though expensive, and is similar to rosewood. It is often a very strong orange color, although it has the curious property of appearing pale pink when first cut, darkening to its characteristic burnt orange color in a day or two. When first cut, it may smell just like someone was sick in your shop.

Kingwood may be even more beautiful than Brazilian rosewood, if you ever find any. It is very rare, very expensive, and comes in rather small logs, less than 6 inches in diameter. It's about as exotic a wood as you can get.

Tulipwood is more tan colored, with nice figure, and good working properties.

Gaboon ebony is the jet black wood from Africa. It comes from small trees, and is thus very hard to find in sizeable chunks. The pieces you can find are usually riddled with cracks and splits; thus ebony is useful mainly for very small things. Musical instrument makers use

ebony for such things as the nut the strings go over. But if you can find pieces that are solid, and glue enough of them together, ebony makes a superb sculpture wood. Macassar ebony is even more exotic, being laced with light streaks.

Bubinga, often called African rosewood, is a medium brownish tan similar to tulipwood, but it has a very tight, wavy grain that must be worked with great care to avoid splitting.

There are a few other exotic woods you can find now and then. One is *lignum vitae*, which means wood of life. It is the hardest, densest, and heaviest wood in the world; it won't even come close to floating. The color is striking—strong yellow sapwood outside and dark green heartwood inside. The grain is so tight and so closely interlaced in many directions that when you carve it, the wood comes off not in curls or chips, but in tiny fragments that explode everywhere like stone. It is full of natural wax, and polishes beautifully. Even though it is so hard, it carves rapidly. Most carving mallets are made of this wood, as were the waterproof, self-lubricating bearings for the propeller shafts of the great ocean liners.

There are, of course, many other kinds of wood, but virtually all of them fall into the various categories listed.

SEASONING WOOD

Before selecting wood for carving or constructing, you must consider curing or seasoning the wood. The pores of a tree are filled with sap when the tree is alive. After cutting, that sap slowly shrinks and hardens. The outer layers shrink first, since they are exposed to air. As the outside of the log becomes smaller and the inside stays large, the outside cracks. These *checks*, as they are called, radiate in from the outer surface of the log towards the center. In some cases they can split the log in two.

There are several ways to avoid this. One way is to seal the ends of the log (where the most rapid evaporation occurs) to slow the drying, and thus even it out. This is done by painting a heavy layer of wax over the ends of the freshly cut log, then leaving it for a long time—several years—to season slowly. There will usually be some cracking despite this process.

Another method, more suitable for the carver, is to begin carving the green log (freshly cut and still full of moisture), keeping it damp between sessions by enclosing it in a plastic bag, perhaps even covering it with a damp rag, just as you would clay. This keeps the wood wet, and therefore stable, until much of it has been cut away. Thinning the sections and exposing the inner parts to the air allows it to dry more evenly. Late medieval woodcarvers often carved figures intended to be seen only from the front, and then they hollowed out the back as

much as possible, so the final sculpture, though it looked solid, was in fact very thin, and could thus dry quickly and evenly without cracking (Figure 12-4).

Another method is to use polyglycol. This material, similar to antifreeze, is available from various sources (see Appendix). Fill a large tub with it, then immerse your freshly cut log in the polyglycol, holding it submerged with something, and leave it for a time, depending on the thickness of the log. Instructions come with the material. The polyglycol penetrates the pores of the wood, replaces the water in the cells, then hardens without shrinking, eliminating cracking. The resultant wood looks and carves just about like untreated wood, but never cracks. Some woodcarvers swear by the stuff; some swear at it.

Lumber is invariably cut from the green log, then either *air dried*, by stacking it, protected from rain but in the open air, and leaving it for several years, or *kiln dried*, by stacking it in a large oven and force drying it over a period of about one month. Again, woodworkers argue about the advantages of air over kiln drying, but for our purposes both work just fine. Wood moves, however, regardless of how it was dried. I discuss this in the section on construction.

FIGURE 12-4 Gregor Erhart of Ulm, A Prophet. German, 1494-1540, wood with polychrome. The Snite Museum of Art, University of Notre Dame, Indiana.

CONCEIVING OF SCULPTURE FROM WOOD

I am sure everyone has noticed particularly large old trees, often beech trees, and felt a sculptural presence. The twisting, gnarling, knobby, sinewy strength of a wonderful old tree trunk is "nature's sculpture" if ever there was such a thing (Figure 12-5). Henry Moore, among many others, was fond of such old trees, making drawings of them and employing something of their feel in certain of his works.

But however wide open we throw the doors of sculpture, they are perhaps not wide enough to include a living tree, unaltered in the forest. It seems to me that if sculpture, as an art form, is a way of describing our thoughts or feelings through making objects, then something ought to be made different about that tree than if the artist had never come along.

At the end of our first continuum, where the unaltered piece of wood stands, I would argue that something must be done to change tree to sculpture. The Japanese artist Fujii Chuichi comes very close to that end of the continuum. He creates his large sculptures of bent trees by taking a cut log and harnessing it with a complex system of wires, which he then slowly tightens over a period of several years, bending the wood to a new shape. These are displayed almost as found objects,

though they in fact were "created" by the artist (Figure 12-6).

The act of cutting the tree is the first intrusion on the natural state of wood, and further cuts simply continue this intrusion. The German sculptor Rudolf Wachter uses this idea in his minimalist wood sculptures. The initial cut fells the tree, and a second cut isolates a section of log. After stripping the bark, he usually allows himself only one more cut to complete the sculpture, usually a diagonal. Often the sculpture then consists of both pieces of log, slightly separated, as in his 1982 piece, *Schragschnitt* (Figure 12-7).

Another use of wood in a close-to-natural state is in this work by the American sculptor Moira Marti Geoffrion, in which a branch of the tree—not the mass of the trunk—is used either as wood, painted, or cast into bronze. The sculpture explores the natural gestural quality of a thin branch, as opposed to the mass of solid form of the trunk (Figure 12-8).

CARVING

To most people, though, making sculpture from wood using the reductive method—that is, carving—involves

FIGURE 12-6 Fujii Chuichi, Untitled. 1984-85, Japanese cypress. Courtesy of Carpenter + Hochman, New York; photo by eeva-inkeri, New York.

FIGURE 12-5 A "sculptural" tree trunk.

FIGURE 12-7 **Rudolf Wachter, Schragschnitt**. 1982, wood.
Courtesy of Blom and Dorn Gallery, New York.

more than selecting, bending, or slicing a piece of tree. In most cases it means creating new shapes from a piece of wood by cutting away extra material. On our continuum from raw tree to finished carving, we have so far seen works that stay very near the original state of the tree. In a sculpture I made years ago from a marvelous piece of Brazilian rosewood, the log still retains something of its original shape, though it has been deeply altered, pierced, and re-formed (Figure 12-9). At the far end of the continuum is the carving of God the Father by an anonymous sixteenth century German sculptor, in which the mastery of carving is so complete that any indications of the original log are long forgotten, and we are confronted only with the artist's imagination made visible (Figure 12-10).

The Process

Carving is both a conceptual and a physical process. The conceptual involves ''seeing'' the desired form enclosed within the mass of material before you, and the physical involves discovering the most efficient and controllable ways to remove the material.

FIGURE 12-8 **Moira Marti Geoffrion, Karnatic Move**. Wood, paint, papers, pencil. Courtesy of the artist; photo by Westhues.

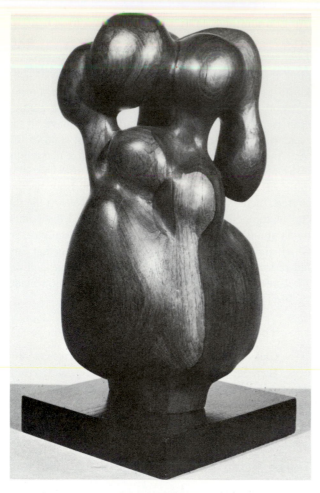

FIGURE 12-9 Tuck Langland, Middle Woman II. 1960, Brazilian rosewood.

FIGURE 12-10 Anonymous baroque sculptor, Head of God the Father. German, 16th Century, wood. Marburg-Art Bureau.

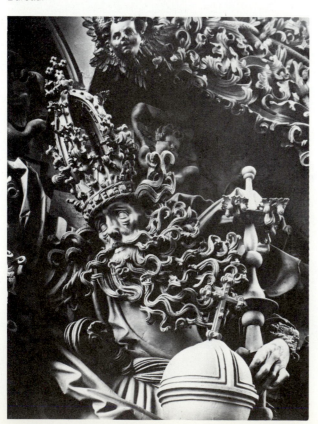

Planning the Carving

Planning the carving is very important. You could get a piece of wood and begin to improvise, cutting here and there as the spirit moves you, but your chances of real sculptural success would be minimal. Carving is a one-way process—carved off bits can't be put back on.

It is better to plan what you are about, and to proceed logically and carefully. Small models in clay are perhaps the best way to plan a carving. You can make dozens of them very quickly, often reworking the same piece of clay until an idea looks promising, then saving that model and making new variations. Plasticene is best since it won't dry, and it is strong enough to hold most small shapes without an armature.

Drawings also help to visualize ideas. Once an idea gains strength in your mind (see Chapters 1 and 2), you can make preliminary sketches of the various sides of the sculpture directly on your log or block.

TOOLS FOR WOODCARVING

Preliminary Wood Removal

Your first step in most carving jobs will be to "waste" large areas of unwanted material. A chainsaw is probably the quickest and most efficient way to waste large chunks of wood, but it makes a horrible noise and is rather fierce. Save the chainsaw for large things, and don't bother with it for small work. By small, I mean beer-keg size and under. With planning, you can decide on a series of cuts that will free the mass of wood you want to carve. You can make these cuts with the chainsaw or with a bucksaw, such as a Swedish firewood-cutting saw.

Woodcarving Chisels

Most carving is done with chisels and mallets. There is a bewildering array of chisels on the market, both in terms of maker and shape. Again, they can be broken down into several categories. First, let's look at their shapes.

Flat chisels are simple and self-explanatory, but generally not too useful for carving in the round. They are cabinetmaker's tools, and useful for construction.

Gouges. Gouges come in two sorts: *in-cannel* and *out-cannel*. This refers to where the bevel is ground. The most common and most useful are the out-cannel, with the bevel ground on the outside of the curve. As you can see in the diagram (Figure 12-11), this allows you to "steer" the chisel as you drive it forward, by raising or lowering the handle and rocking it on the heel of the

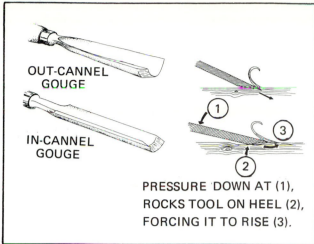

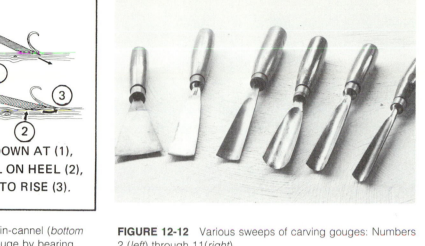

FIGURE 12-11 Out-cannel gouge (*top left*); in-cannel (*bottom left*). To the right, the effect of steering the gouge by bearing on the heel of the bevel.

FIGURE 12-12 Various sweeps of carving gouges: Numbers 2 (*left*) through 11(*right*).

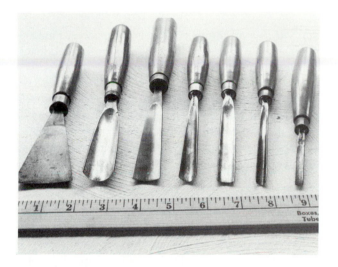

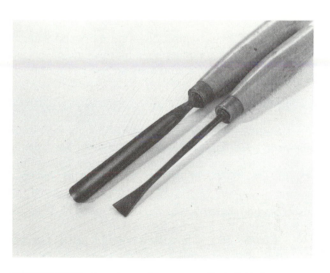

FIGURE 12-13 Various widths of gouges.

FIGURE 12-14 London pattern gouge (*top*); fishtail pattern (*bottom*).

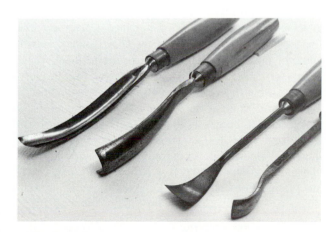

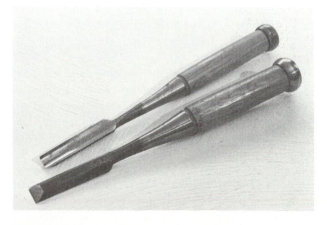

FIGURE 12-15 Swansneck gouges (*left*); spoon gouges (*right*).

FIGURE 12-16 Japanese gouge and flat chisel.

FIGURE 12-17 Carving mallets. The three on the right are the more usual, being lignum vitae with ash handles; the smallest is maple with an ash handle.

FIGURE 12-18 Files and rifflers.

bevel. The in-cannel chisel digs into the wood without control. In fact, it is not designed for this kind of carving and is of very little use to the carver.

Carving gouges vary in three ways: deep or shallow (called the *sweep*), wide or narrow, and straight or curved.

Sweep. The sweep is identified by number, starting with 1 for flat, progressing through 10 for a semicircle. Higher numbers represent still deeper curves, and finally the 40s are V-shaped gouges. The handiest gouges are 10, perhaps 8, and a rather flat one like 5. A 2 is also flat, but angled across the end (Figure 12-12).

Width. Size is measured as width across the cutting edge. The larger the chisel, the more force it takes to pound it through the wood. You can cut wood faster with a 1 inch wide 10 gouge than with a wider one, because the narrow one bites through faster. So a 1 inch deep gouge, and a 1 inch, or even a bit wider, shallow are very handy. Use a ½ inch deep and a ½ inch shallow for smaller forms. You might like to go even smaller for detail work (Figure 12-13).

The *London* pattern is a variation in blade shape in which the sides of the gouge are roughly parallel all the way down. The *fishtail* pattern means they start out narrow at the handle and flare out wide at the end. Generally, London pattern is best for deep gouges, fishtail for flatter ones (Figure 12-14).

Straight or curved. Most chisels you use are straight, but there are two kinds of bends: the long bend, often called a *swansneck*, and the short bend, often called a *spoon*. These are lovely to look at, delightful to hold, but of limited use. If you must spend your money, buy a medium-sized gouge of each (Figure 12-15).

Makes of chisels. Chisels are made in England, Germany, Switzerland, Italy, Spain, the United States, and Japan.

Common English tools are Sheffield tools, like Henry Taylor, Marples, or Ashley Isles. These are all fine tools but need care to maintain their edges. German and Swiss tools are very commonly available and are excellent—perhaps the best all-around buy. Italian and Spanish tools are also easily available. They have somewhat lower quality of finish, though I have seen some Spanish tools of very high quality indeed. American tools are good, notably Buck Brothers, though they don't tend to make classic carver's gouges like the English and others do.

The Japanese are perhaps the best woodworkers in the world, and their traditional tools are excellent. The problem with a steel tool is that if it is made hard for a good edge, it becomes brittle and can break. So toolmakers compromise, hardening the tool, then softening it to reduce brittleness. This is called *tempering*. The Japanese use a different approach. They laminate a small piece of super-hard steel on a shaft of softer steel. These laminated chisels take edges that are far superior to Western tools, but they can only be sharpened back about ⅛ inch before running out of hard steel. The edge is so much harder, however, that the tools need less sharpening and seem to last about as long as other tools. Japanese wood chisels, unfortunately, come only in a flat and a medium depth gouge, although in a wide variety of widths. For cutting soft or difficult wood, a well-sharpened Japanese tool has no equal (Figure 12-16).

Other woodcarving tools. You also need a mallet. Most are made of lignum vitae. This immensely hard wood is not very strong, and the kind of mallet turned from one piece can break at the handle. The kind with

a lignum vitae head and an ash handle is better (Figure 12-17).

You also need rasps, files, sanders, and sandpaper. Good wood rasps work wonders, and the riffler rasps available from sculpture suppliers are invaluable. Also, good sharp bastard files, half round and rat tail as well as flat, are very important (Figure 12-18). Files are like sandpaper, that is, when they become dull you throw them away. Using them after they have become dull is a waste of your time, so always have sharp ones. Disc sanders, random orbit sanders, and jitterbug sanders all work well on wood, but be careful of two things: one, wear a mask so you don't breath all that dust; and two, be careful you don't round off all the nice clear form you obtained with chisels.

Sharpening Carving Tools

All sharpening is done on the same principle. You grind away the metal, approaching a finer and finer edge. But you cannot stop at just the perfect point, so you grind too far, and this curls the edge over, raising a *burr* on the other side of the chisel. You can feel this burr with your finger by running it from the handle over the edge, on the other side from where you have been grinding. Once the burr is even all along the edge, grind lightly on the burr side to remove it. Repeat the process with finer stones and abrasives until the burr is completely gone. You then have a sharp tool (Figure 12-19).

You can use power grinders for preliminary removal of metal, but keep a cup of water beside you and dip the tool in the water constantly. Never let the tool become too hot to touch with your bare fingers, or you can ruin the heat treatment and the edge.

Sharpening stones. Sharpening stones come in at least four varieties: artificial, like carborundum; natural, like Arkansas; the new diamond stones; and Japanese water stones. There are also natural and synthetic hones, and leather strops.

Carborundum and Arkansas stones need light oil to cut well, and stay unclogged best with kerosene. The new diamond stones and Japanese water stones both cut with water.

Use the illustrations and diagrams to get the feel of holding the tools on the stones, moving them with light but steady pressure (Figure 12-20). Learn to feel the burr and to remove it with a few strokes on a curved slip stone on the inside of the gouge. Move from rough stones to medium to fine, and then finish with a hone and strop. If at any point you do not raise a burr with a particular grade of stone, all following grades will do nothing. But if you get an ever-finer burr at each step, you will arrive at a very sharp tool indeed after stropping.

Sharpening machines. There are several wonderful tool-sharpening machines on the market which speed the job of keeping tools razor sharp. Most use a slowly rotating abrasive surface so tools won't overheat.

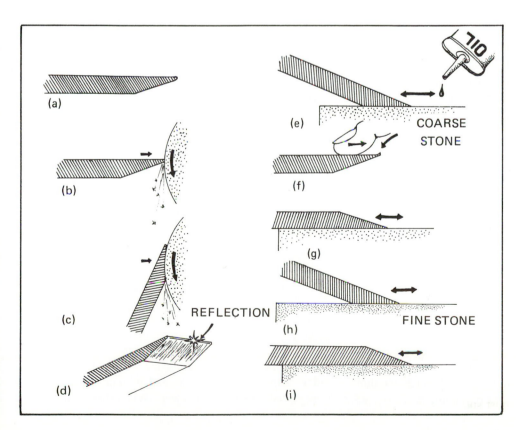

FIGURE 12-19 Steps in sharpening: (a) the dull edge; (b) grinding the edge true on a wheel; (c) grinding a new bevel; (d) light reflected off the ground edge; (e) working the bevel flat on the coarse stone; (f) feeling for a burr; (g) removing the burr on the coarse stone; (h) working the edge on a fine stone; (i) removing the burr on a fine stone.

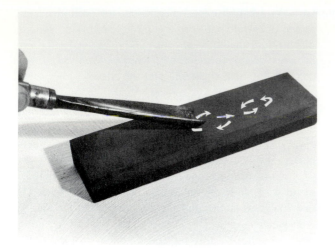

FIGURE 12-20 Movement of a gouge on a sharpening stone by continually rolling the gouge back and forth to cover the whole edge evenly.

FIGURE 12-21 Imagining a log as a bundle of rods, showing the effect of splitting when the chisel cuts away from the center (*right*), but with no splitting when the chisel cuts toward the center or at right angles to it (*left*).

While such machines are certainly handy and highly recommended for the serious carver or woodworker, they are expensive, and you can get results that are just as good with hand techniques on bench stones.

The Process of Carving

Working with the grain. In carving you must be aware of the grain to avoid splitting the wood. Imagine the wood before you as a bundle of rods bound together. The rods run up and down the tree. Imagine carving into that bundle. A cut towards the center of the tree compresses the rods before it. If you cut away from the center, though, you may pull the rods apart, splitting the wood. While you are carving, imagine a line running right up the center of the log. Make your chisel go toward that line, or at right angles to it around the tree. Very soon you'll have the feel of the grain and won't split the wood (Figure 12-21).

Making form. Be logical about carving. Think of the form you are making, and figure out what wood must come off. Then remove that wood with a series of strokes, usually parallel to each other, like a farmer plowing a field. Get the feel of an orderly passage of the chisel across the wood, rather than randomly "chewing" it and making a mess. Stand back and look at your work as it progresses, and draw on the wood with chalk to make clear what you are removing.

Before long you will be *in* the wood, running the chisel around curves and over forms. You can actually start making form, rather than just removing wood. This is the fun part. Refer back to Chapters 1 and 2, and think hard about planes, forms, and relationships. Above all,

consider clarity. Think about the inside of each form you make, and its back side. Think of solids right through the piece, rather than undulations on the surfaces.

Refining form. Rasps and files can clarify form, but generally you can do wonders just with chisels. Use deep gouges to remove heavy wood, then use shallow gouges to remove the ridges left by the deep gouges. Practice controlling and refining your work with the chisels, and see how smooth you can make a form just with cutting. Look at the works in museums by woodcarvers such as Riemenschneider or Veit Stoss to see what can be done with chisels.

FINISHING WOOD

Finishing wood is an enormous topic that has been covered in countless magazine articles, books, even whole courses. You can become very seriously involved in wood finishing, or just use something quick and easy. Here I will not get too heavily involved, but list only a few good, but easy finishes. Obviously, you can explore the subject as deeply as time and inclination allow.

Clear Finishes

Rubbed oils. One of the best finishes for general purposes is a rubbed-in Tung oil finish. Buy Tung Oil Varnish (available at paint, lumber, and hardware stores), and rub it into the wood with a cloth; then wipe it off. Let it dry overnight, and do it again, only this time use less oil, and wipe off more. Do it a third time the next day, wiping on even less, and wiping off carefully to leave only a soft, even sheen. When that's fully dry, a

light lick with very fine steel wool and waxing with paste wax gives a lovely finish. This finish looks natural and brings out the grain of the wood. And it's easy and sure fire.

Other rubbed oil finishes include Watco products, which are similar to the Tung oil finish, and linseed oil, also similar. All of these involve the principle of rubbing an oil into the wood, letting it polymerize (turn hard), rubbing in more, and finally waxing.

Hard finishes. Brushed on finishes are based on either lacquer, shellac, or varnish. Simple varnish is a time-tested finish that is durable and easy to apply. You can buy gloss, semigloss, or flat. The only trick is to be sure the wood is well sanded, then well dusted. The best way to clean wood of dust is to blow at it with an air compressor and blow nozzle. Failing that, brush it well with a dry brush and rub it with a tack rag, which you buy from a paint store. Varnish, and many of the lacquer and shellac products as well, flow on well with a clean brush and smooth themselves out as they dry. They must dry in a dust-free atmosphere. And it is a good idea to work them down well with very fine steel wool (well cleaned off afterwards) between coats.

There are dozens of other finishing products on the market, most of which come with good instructions. You can experiment, but you will probably find one that is a variation on those described above.

Opaque Finishes

Wood can be painted, too. Most paints stick beautifully to raw wood, and can be applied with whatever degree of care or painterliness you wish. If you want a very smooth finish, fill the grain of the wood first, either with a paste filler rubbed well in and sanded when dry, or with a heavy-bodied paint like ordinary latex house paint, again, applied in several coats and well sanded when dry. The best paint to apply for a very smooth finish is spray paint, either from a professional sprayer or from cans. If you spray from cans, spray several light coats to build color, rather than one heavy one which may sag and run.

Stains. Wood can also be stained, although I'm not crazy about the idea of staining one kind of wood to look like another—pine to look like walnut, for example. Stains can be used to add color without covering the woody quality of the wood. They can be purchased or made by thinning acrylic paints with water.

WOOD CONSTRUCTION

Looking back at Figure 12-2, notice that there were two arms to the wood continuum. We have just been dis-

cussing the arm of the wood continuum from tree to carving. Now let us consider the other arm, from tree, through lumber and construction, to completely altered wood.

Lumber

Most people live in a wood construction, sit on wood constructions, eat off them, and work at them. Wood, sawed into lumber, has an almost limitless capacity to be cut and joined to create new forms. However, when wood is sawed into lumber, and something is then made from the lumber, it tends to bear the stamp of that original sawing. In other words, because lumber consists of flat surfaces, things constructed of lumber usually have predominantly flat surfaces.

There are a couple of ways around this. First, lumber can be laminated. Imagine making a small model of a sculpture, say one-third the size you want the final piece to be. Imagine making this model out of plaster, then running the plaster model carefully through a bandsaw to slice it into ¼-inch-thick slices, either up and down or across. Next, each slice is photographed in exactly the same spot by a camera mounted on a tripod and loaded with slide film. Project those slides onto ¾-inch-thick lumber, with the projector pulled back so the image is exactly three times as large as the original slice. Trace the shapes, cut the shapes out on a band saw, stack them and glue them, and you are most of the way towards a carving.

Another way to avoid the constructed look is to use pieces of wood to create the basis of the form, and then carve. For example, a series of 4 inch by 4 inch pieces of wood could be constructed into a space frame, then carved into rounds and gently modeled shapes.

Building sculpture the way furniture or houses are built can make a powerful sculptural statement. This sculpture by Wendell Castle (Figure 12-22) is inspired by furniture, but it is no longer functional and is pure sculpture. It was made, though, with furniture-making techniques such as woodbending, veneering, and traditional joinery. Works such as this one by Siah Armajani (Figure 12-23) evoke portions of houses, private corners; part of their meaning is their similarity to normal building practice.

Woodworking is very complex technically, and there are many books on the subject. It would be foolish for me to try to explain a subject as complex as wood joinery in this short chapter, so I refer those of you interested in this aspect of sculptural expression to appropriate books and magazines. If there is a furniture-making course in your school or a vocational course in wood construction, by all means attend. The same basics of wood construction apply to anything from the most ordinary table to the most eloquent sculpture.

FIGURE 12-22 Wendell Castle, The Midnight Marriage. 1986, ebonized cherry, ebonized walnut, curly maple, and acrylite. Alexander Milliken, Inc.; photo by Bruce Miller.

FIGURE 12-23 Siah Armajani, Dictionary for Building: Garden Gate Series. 1982, wood. (Collection of the Walker Art Center, Minneapolis.)

Wood Movement

I can, however, discuss wood movement in relation to wood construction. Many woodworkers have been deeply disappointed to find their prize project has split open or buckled after six months. This is preventable.

The key point is that wood expands with increased humidity, and contracts with decreased humidity, *across* the grain. It expands very little lengthwise (Figure 12-24).

Imagine making a tabletop of boards glued edge to edge. If you tried to brace the top by gluing pieces beneath it going across at right angles to the grain of the top, it would either split open or buckle with the first change in humidity. A tabletop three feet wide moves at least ¼ inch in width from summer to winter. You could, however, safely brace the top from below by fastening a cross piece on with screws. You put a screw in the middle of the cross piece, then other screws moving out to either end set in slots in the cross piece, screwed regularly into the top (Figure 12-25). That way the top can change width, sliding a little along the slots.

Every time you glue wood together, imagine it expanding and contracting across the grain, but not with

FIGURE 12-24 Movement of wood: expansion across grain (*top*); warping or cupping (*bottom*).

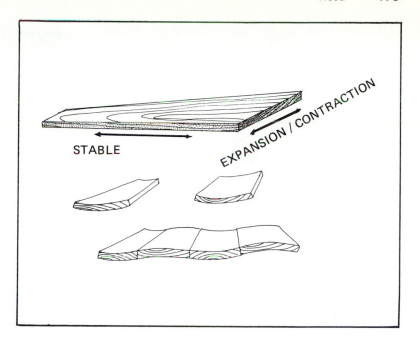

FIGURE 12-25 Gluing a table top with slotted cross pieces to prevent problems with expansion and contraction.

the grain. Always devise a way to let it move along that dimension.

Nonmoving Wood

That is true except when you use plywood or chip board. These materials are stable and don't change size, and you can get away with murder with them, but they don't look particularly elegant. There are many different wood products on the market that are essentially artificial lumber. Plywood is the most common. Most plywood is fir, sliced into thin sheets and glued up. The difference between plywoods is in the number of plies and the kind of glue, whether waterproof (marine plywood) or not. Some plywood actually has a solid core; the lumber is glued edge to edge with veneer surfaces. Most "hardwood" plywood is softwood inside with hardwood veneer. There is something called Baltic Birch, which is actually thin layers of real hardwood glued up, each piece at right angles to the next. It is very expensive, very heavy, but fabulous.

Particle boards and chip boards are sawdust or wood chips mixed into slop with glue and pressed into sheets.

They can be very strong or very weak, very stable or hopeless. Price usually determines the difference. The more expensive ones use more wood and less glue, and are more tightly compressed.

Combinations of Wood and Other Materials

This sculpture by the English sculptor Derek Sellars is made mostly of wood of various kinds, with some parts painted, others finished naturally (Figure 12-26). But Sellars also included some carved stone, in this case to read as clouds, which is a wonderful denial of fact—the heavy stone representing the weightless cloud. With care and common sense wood can be combined with just about any other material—glass, steel, bronze, stone, cloth, wire—the list ends only at the limits of your imagination. This interesting piece by the Spanish sculptor Julio Lopez Hernandez is made of wood and bronze combined most effectively (Figure 12-27).

Wood can be used for its grain, its warmth, its associations with living matter, or simply as material that can be shaped, painted, hidden, covered with leather, or filled with nails. It is a wonderful material for sculpture on the two counts of its ready availability and its total flexibility. Wood has no associations with particular historical periods, and it can easily become the most traditional or the most avant garde sculpture. And, when you make something out of wood, you don't have to cast it!

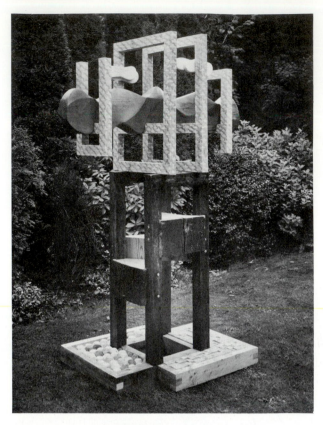

FIGURE 12-26 Derek Sellars, Signpost for Kintail. 1983, wood, marble, and aluminium. Photo by Ken Phillip.

FIGURE 12-27 Julio Lopez Harnandez, Bedroom, (*Dormitorio*). Bronze and wood. Courtesy of the Claude Bernard Gallery, Ltd., New York.

THIRTEEN

Stone

When people think of stone as a sculpture material, they usually think of carving marble or similar stone to make sculpture of great permanence. They also think of stone carving as a very old way of making sculpture, thus not particularly appropriate for our fast moving, highly technological society. This chapter will attempt to broaden and change some of those ideas, to point out many ways stone can be used besides the traditional, and to show that stone is a material without ties to any particular historical period, but is as contemporary as the artist who uses it.

KINDS OF STONE

We must first look at the kinds of stone that can be used by a sculptor. Stone can be divided into many categories, but I will limit this description to four: igneous, sedimentary, metamorphic, and composite.

> *Igneous* rock is rock formed of molten material during the cooling of the earth, like granite.
>
> *Sedimentary* rock is rock composed of layers of sediment piling up over thousands of years, like limestone.
>
> *Metamorphic* rock is sedimentary rock that has been compressed into a still harder form, like marble.
>
> *Composite* stone is essentially particles of various kinds of stone compressed together. An example is sandstone.

Igneous Rock: Granite

Igneous rock is melted rock that was either forced out of the earth by a volcano or that solidified underground. Granite is the most common form of the latter,

which usually cools so slowly that large crystals are formed. These crystals are large enough to be easily seen, and such rock is called *coarsely crystalline rock*. There are also granites with very fine crystals.

Often volcanic rocks are finely crystalline, and sometimes they form a glasslike rock such as obsidian. If the melted rock foams during solidification, it forms pumice, or featherstone.

Granite is a very common stone, and has been used extensively for sculpture, but it has some inherent problems. The first is that it is very hard, thus must be cut with hard tools, such as carbide-tipped chisels, and diamond saws. Because of its large crystal size, it also tends to resist fine detail, working well into more general shapes. It can take a high polish, and it is the most permanent and weather resistant of all commonly used stones.

Generally speaking, the history of sculpture does not include very much granite sculpture, with some notable exceptions. The ancient Egyptians used a lot of granite, as well as other glasslike hard stones, such as diorite, basalt, obsidian, and quartzite, mainly because they wanted their images of pharoahs to last forever, insuring their continued memory and securing a permanent home for the soul, or *Ka*, of the pharoah (Figure 13-1). In the seventh century A.D., at Mahabalipuram in south India, enormous granite boulders were carved into temples complete with attached sculptures (Figure 13-2). There are many other large granite carvings at this site. And this contemporary work in blue granite shows an abstract approach to the stone, using the refined precision of polished surfaces to great effect (Figure 13-3).

However, granite as a material for the beginning or even intermediate sculptor is usually a poor choice. The sheer technical difficulties and quantity of labor nec-

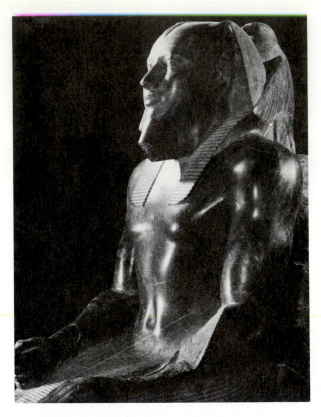

FIGURE 13-1 King Chephren, Egyptian, Dynasty IV, circa 2558-2533 B.C., black diorite. Egyptian Museum, Cairo.

FIGURE 13-3 William Crovello, Blue Hagoromo. 1982, Brazilian blue granite. Photo by Todd Villeneuve.

FIGURE 13-2 Rathas, at Mahabalipuram, India, 7th to 8th Century A.D., carved granite boulders.

essary are not compensated for by the results, which can usually be obtained with far greater ease in another stone.

Sedimentary Stone: Limestone

Limestone, by contrast, is just about the ideal stone for first attempts at carving. It is readily available, cheap (often free), carves easily, presents no serious problems, and can be very beautiful. Limestone is formed of calcium carbonate, which is one of the minerals dissolved in sea water. Sometimes this mineral is deposited on the ocean floor, as during evaporation of large areas of water, particularly seasonally. When this happens, a sediment builds up which becomes hard. Chalk is a soft version of this process, and some very fine grained limestones are of this origin.

Usually, though, limestone is created with help from tiny organisms. Seashells are made from the calcium carbonate extracted from seawater by snails and mollusks and deposited into shells. These shells fall to the ocean floor in deep piles. Given a few million years, they fuse into beds of limestone.

The most important limestone quarries in the United States are in southern Indiana, but there are many others throughout the country, and of course many kinds of limestone in other areas of the world. Near Caen, in northern France, is found *Caen stone*, a fine-grained, cheese-colored limestone, which is the basic material for most of the major Gothic cathedrals. England produced many different limestones, often named for their quarries, such as *Hornton stone* and *Hopton Wood stone*.

Calcium carbonate is also the basic material of plaster, or gypsum, which is really an early form of limestone. Other forms include such stones as alabaster and onyx. Alabaster is very soft, easily carved, and takes a high polish. It is often translucent, particularly in thin sections. These windows at St. Paul's Outside the Walls in Rome (Figure 13-4) are not made of stained glass, but of thin slices of alabaster.

Metamorphosed Rock: Marble

When limestone is subjected to heat and pressure, as when tectonic plates collide, forming mountains and squeezing the sediment-laden seabeds into great crushed wrinkles, the many small grains press tightly together and form marble. There are as many different marbles in the world are there are deposits of marble, since each one contains different impurities and was heated and compressed differently.

In its purest state, marble is white calcium carbonate and magnesium carbonate. Thus pure marble is pure white, and the quarries at Carrara, in northwest Italy, contain the largest known strata of pure white marble in the world. These are the famous quarries where

FIGURE 13-4 The windows of St. Paul's Outside the Walls, Rome, were made of translucent thin slices of alabaster.

Michelangelo cut his marble, as have countless sculptors before and since. At the base of the mountains containing the quarries are numerous small towns, chief among them Carrara and Pietrasanta (Holy Stone), filled with marble-working shops and sculpture studios (Figure 13-5). These small towns have the highest concentration of sculptors and sculptor's services, including bronze foundries, in the world. It is safe to say that the artisans in these studios can carve just about anything for you—if you can pay. One artist had appliances carved from marble, things like toasters and vacuum cleaners—even a car (Figure 13-6). Others have carved enlarged flowers. Here, in this exclusive photo (Figure 13-7), is Michelangelo's *Moses* in progress! (Actually, this is an exact copy being carved from a plaster cast of the original *Moses* in Rome, for a client in Japan).

But marble comes in many many other forms besides pure white. Often it is colored with streaks and blotches, ''marbled'' in a way that detracts from sculptural form. Most colored marbles are cut into slabs and used for architecture to face the surfaces of buildings. Many of these multicolored marbles are good for sculpture bases where the form is so simple that it can be read against the patterned coloring.

Two nonwhite marbles that have been widely used

FIGURE 13-5 The interior of the Nicoli marble-carving studio, Carrara, Italy.

FIGURE 13-6 Marble car in progress. Photo by Todd Villeneuve.

FIGURE 13-7 Copy of **Michelangelo's Moses**. Sculpture in progress, marble. Photo by Todd Villenueve.

in sculpture are Belgian Black, and Roman Travertine. Belgian Black is a very hard, glasslike marble, absolutely jet black, with no white markings at all. Another black Belgian marble called Bleu Belge is black with fine white streaks.

Travertine is full of holes, like cheese. Usually it is an even pale tan color, though some examples can be reddish, dark brown, even odd greens. The holes, which are the result of its forming in streams and around springs, are like miniature caves, full of tiny craggy interiors. They render the marble unsuitable for exterior use in cold climates, as the water can seep in and freeze, with obvious results. But travertine is a very beautiful stone and is soft and easy to carve.

Composite Stone: Sandstone

Sandstone is stone created when rocks are broken down by wind or water into fine particles. The particles settle and are ''glued'' back together by the addition of other minerals, which seep into it and turn hard. It is nature's particle board.

The difficulty with sandstone is that, although it is a soft stone, it abrades tools quickly, because it is composed of particles of hard stone. Sandstone varies widely in hardness, since the binding mineral varies greatly. Some very tight and sound sandstones are useful building materials, and the famous Brownstone houses of New York City are made of sandstone. Although it is often grainy and crumbly, the Mugal stonecutters of seventeenth century India were able to do amazing things with it, including this delicate structure of sandstone. The lighter colored top story is white marble, but the rest is red sandstone, including the intricately pierced screens along the balcony railing (Figure 13-8).

Sandstone is all right for sculpture purposes, but it is not as good as limestone or marble. And though the Indians could do remarkable things with it, the average sculpture student finds it too grainy and crumbly, as well as too hard on tools, to compete well with limestone and marble.

STONE AS A SCULPTURAL MATERIAL

Carving

As with the discussion of wood, I want to describe a continuum of using stone, again along two axes. First, imagine a continuum running from natural uncut stone on the one hand, through successive levels of carving, to the completely carved sculpture on the other end. This work by Carl Andre in Hartford, Connecticut, in which raw boulders are simply placed in an urban setting, is a

FIGURE 13-8 Tomb of Akbar. Sikandra, India. c. 1605, red sandstone and white marble.

FIGURE 13-9 Carl Andre, **Stone Field Sculpture**. Hartford, Connecticut. 1977, 36 boulders.

perfect example of the uncut end of that continuum (Figure 13-9).

A work such as *Ends* by Isamo Noguchi moves a little farther along the continuum (Figure 13-10). Noguchi leaves much of the original block of stone untouched, carving just enough to create the sculpture. I am reminded, in this work of Noguchi's, of giving a gift of a toy locomotive to a child at Christmas. The locomotive is wrapped in paper, but a bit of the paper tears at one end, exposing a small part of the locomotive. The child, doing a little "pre-Christmas cruising" sees the tiny exposed part and knows instantly what is inside the paper, just from the small fragment. I feel Noguchi is tearing away only a small part of the stone "wrapper" to let us see the sculpture within.

Recumbent Figure by Henry Moore (see Figure 1-8) is a completely carved piece, but one in which Moore has maintained a truth to materials, in that the stone is always treated as stone, and not allowed to look like some other material. He has also carved the stone so that it even looks as though it was carved the way nature carves stone, by slow erosion in the bed of a fast moving stream.

The famous *Ecstasy of St. Theresa* by Bernini (see Figure 3-4) has reached the far end of the continuum. Here the marble is made to represent six different materials—skin, cloth, fire (the angel's robe), feathers, hair, and clouds. Each of these materials is fundamentally

FIGURE 13-10 Isamu Noguchi, **Ends**. 1986, Swedish granites. Collection of the artist.

different in character from the nature of stone, and part of the virtuosity of the sculptor is in making stone behave as though it were soft, fluffy, and weightless.

Stone Construction

This entire continuum, from raw stone to completely carved stone, still involves carving—cutting into an original block and revealing something concealed within. Another continuum, which moves off at right angles to the first, involves treating stone very differently.

This other continuum deals with assembling several pieces of stone to form a larger work. Here, it is not the individual stone that is important, so much as its relationship to others, or to other parts of the sculpture. Along this continuum stone is cut, altered, and used as a constructive material. When you carve, you take a large block of stone and make it smaller. When you construct, you begin with small blocks and join them to make something larger. *Welsh Journey*, a sculpture by Derek Sellars, is made of three pieces of stone, each individually carved, then joined to make a larger, more complex work (Figure 13-11).

Moving further along this continuum, here is a small sculpture I made quickly out of scraps of stone, cut from the edges of marble slabs as the marble was trimmed to size for architectural purposes (Figure 13-12). Such thin slats and strips can be found by the dumpster-full at any marble yard. They are useless to the marble worker, yet a treasure trove of material for a sculptor. They can be joined to create most unstonelike structures.

The ultimate, the far end of this continuum, is the Gothic cathedral (Figure 13-13), which is an abstract stone sculpture designed to reveal the nature of the intelligence of God. Here stone is treated as a material almost without weight or mass, flung high overhead with the most daring delicacy and lightness, yet always obeying strict laws of compression, thrust, and counterthrust. If they could fling ceilings such as this one, which is 140 feet high and contains center bosses weighing two tons each, in the year 1220, then what might we do with stone today if we could free ourselves from thinking of it as a hard mass to be carved?

CARVING

How you carve depends a lot of what kind of stone you carve. The best way to begin is with limestone. Once you have established a feel for stone, you can move on to marble, with a new set of tools in addition to those used for limestone.

FIGURE 13-11 Derek Sellars, Welsh Journey. 1974, alabaster and marble. Courtesy of the artist.

FIGURE 13-12 Tuck Langland, Mess Is Lore. 1986, travertine marble.

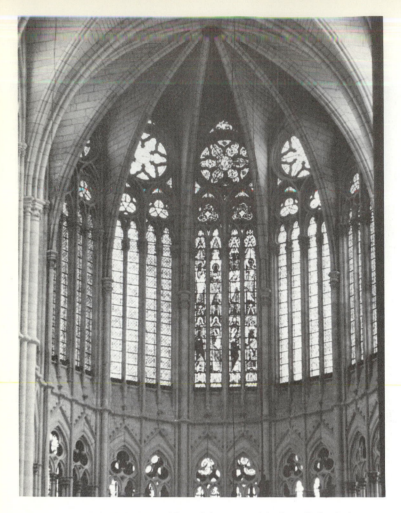

FIGURE 13-13 View of the apse of Amiens Cathedral, France.

Handling Stone

A very important part of stonecarving is the problem of handling heavy stones. Don't muscle them around, or you'll hurt yourself. Always remember when moving anything heavy—use your brain, not your back!

Levers. Certain basic principles can be applied in various combinations to move almost anything heavy. The first principle is the *lever*. An ordinary crowbar can lever a heavy stone enough to slide a board under one end. Do this all around the piece (with help, so as one person levers, the other slips the board in place) and the stone is up off the floor. With a thicker, longer lever, you can raise the stone higher, always a little at a time, always adding heavy wood supports, and using heavy wood as an ever rising fulcrum. With enough supports (such as lengths of 4 by 4 wood) you can actually raise a ton of stone three or four feet in the air to slide a heavy wooden carving table, called a *banker*, under it.

Rollers. Another principle is using rollers to move the stone from place to place. Three-inch pipe makes a good roller, and you should have three or four lengths of it. Lever the stone up high enough to slip a length of

pipe under one end, then under another end, and begin to roll. You need at least three pipes so there are always two under the stone. If you can work long boards up on top of the pipes and under the stone, they even out the often rough surface of the stone, making it easier to roll.

Forklift trucks. An even better way to move stone is with power equipment, such as a strong forklift truck. Check its capacity first. You can estimate the weight of a block of stone by figuring its rough volume in cubic feet, then multiplying that by 175 pounds. Some stones are lighter than this, some heavier, but 175 pounds per cubic foot is a good average. It is enough on the heavy side to give you a cushion when figuring whether a particular piece of equipment has the capacity to lift a certain stone.

Hoists. Perhaps the best way of all to move stones is with an overhead hoist, again first making certain of its capacity. Use strong nylon slings, which you pass under the stone after levering it up on blocks. And always stay well clear of the stone when it is off the ground. Just imagine it falling at any given moment, and be sure you are clear.

Holding the Stone for Carving

Most carvers use some sort of *banker*, or very strong wooden table, to hold the stone for carving. These tables vary in size, but they usually place the stone at a good working height, and are not overly large on top. Two feet by two feet is common. Wooden wedges can steady an uneven stone, and can be nailed in place directly to the top of the banker. A heavy leather pillow filled about two-thirds full with fine sand is a very handy way to cradle smaller stone carvings while working.

Carving Tools

Figure 13-14 shows all the tools you will need to carve (but not to smooth out) a small to medium-sized piece of limestone. The following sections explain their use. Though there will be some variation in tool type for other stones, the basic principles of stonecarving remain the same, and if you learn to use these tools on relatively soft limestone, it will be easier to learn to carve other stones.

Safety equipment. It is essential to invest in some safety gear. Wear good goggles while carving, since little pieces of stone continually fly up into your face. A full faceshield is best, but safety glasses or goggles work well. Also get a stout leather glove for your chisel hand, since your hammer will slip now and then and can make mincemeat of your knuckle before long. A respirator is a good idea, but not really necessary until you begin grinding and power-sanding.

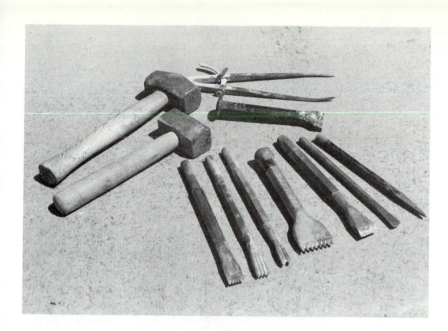

FIGURE 13-14 A selection of limestone carving tools: hammers (*left*); calipers (*top*); pitching tool (*below calipers*); assorted chisels (*foreground*); point (*far right*).

The point. When carving by hand with hammer and chisel, most stone removal is done with a *point*. This workhorse tool is like a fat steel pencil; it is the tool on the far right in Figure 13-14. It concentrates the blow of the hammer on one small point, shattering the stone efficiently. The wider or larger the chisel, the more the force is dissipated, and thus, the less stone is taken off.

The pitching tool. An exception to that concept is the *pitching tool*, which is a wide, very thick, blunt

chisel. It is placed against the edge of a block, as shown and when struck hard it flakes off a piece from the edge (Figure 13-15). An experienced stone mason can trim a rough block to square very quickly with a pitching tool.

Using the point. Practice using the point by knocking off corners or projections on a block of limestone. Find an area where you know a good deal of stone must be removed, and practice knocking off chunks with the point and a good stonecarver's hammer (Figure 13-16). A two-pound hammer is good for a person with

FIGURE 13-15 A pitching tool in use.

FIGURE 13-16 Using the point.

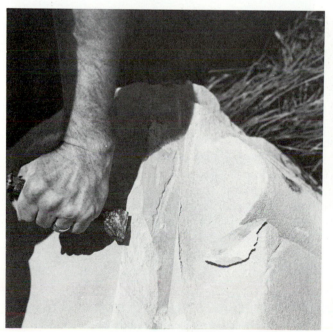

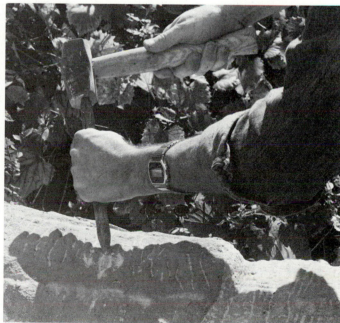

a fairly strong wrist, but may get too heavy if your wrist isn't strong. A hammer that is too big is counterproductive, because, though you can knock off bigger chunks with it, you are soon spending a lot of time rubbing your sore wrist. A lighter hammer, one you can swing easily for a long time, removes more stone in the long run. Also, hold the hammer at the end of the handle, away from the head, to take advantage of the leverage. Experienced stonecarvers work with an even, steady rhythm that they can maintain for a long time. They have learned that it is foolish to attack the stone with violence or a frenzy of energy. The quiet stone passively resists such an approach, but, as water wears away the hardest stone, the patient but steady stonecarver prevails.

When you use the point, work on making your blows orderly. Try not just to bash around, but decide on what you want to remove and go about it logically. As with the wood chisels, move the chisel in rows, like a farmer plowing a field, each set of rows reducing the surface by about a half an inch.

In any good illustration of Michelangelo's late works, you can see areas of point work, where the pattern of carving is very clear and also very orderly. Figure 13-17 shows one of his unfinished *Slaves*. You can see clearly the point work in even rows, particularly near the bottom, just below the bent knee. You can also see tooth chisel work on most of the body.

The point is not just a crude tool for removing vast areas of unwanted stone. A good carver can be very exact with the point, bringing the surface very near to the final one with it. As you work with the point, sense how much control it can give you, and don't set it aside too soon.

Avoiding disaster. There is always the very real chance of breaking the stone. Try to direct the force of the point away from the center of the stone. Think of raking over the surface, knocking small bits off, rather than driving down into the mass. Imagine a crack spreading straight out from the point, and you can sense whether or not you will split the stone. If you want to dig a hollow form into the stone, it is sometimes a good idea to drill a hole in the center of the space for the hollow, using a carbide-tipped masonry bit in an electric drill. You then direct the chisel blows into the hole, so you are still knocking corners off a block (Figure 13-18).

The tooth chisel. When the form is really beginning to take shape, you can move to the next important tool, the *tooth chisel*, or *claw tool* (see Figure 13-14). These chisels have cuts in the end and are, in effect, a series of points held in a row. You can get tooth chisels with anywhere from 2 to 9 points, but the most useful are 3, 4, and 5 points.

The tooth chisel is used like the point, but you will realize instantly that it removes less stone, but with more

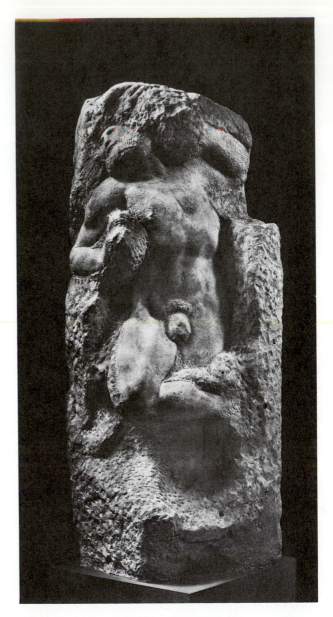

FIGURE 13-17 **Michelangelo, Awakening Slave**. 1530-33, marble. Academia di Belli Arti, Florence; Alinari Art Resource.

control. With a tooth chisel, you can pare away a skin of stone from the real sculpture lying just below the point-worked surface. This is the tool with which you really create the form, coming right down to the final surface and leaving only small ridges. Again, look at good illustrations of Michelangelo's late work and you can see tooth chisel work all over the more finished areas.

The bush hammer. Also at this stage you might want to try a *bush chisel* or *bush hammer* (Figure 13-19). This is a bar of steel, about 1 inch square and 6 inches long. On a bush hammer, it is mounted on a handle, and

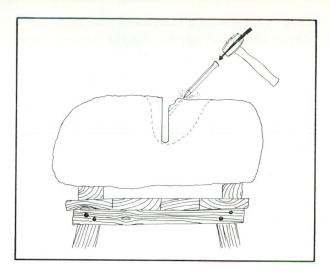

FIGURE 13-18 Carving a hollow by drilling a hole and carving into it.

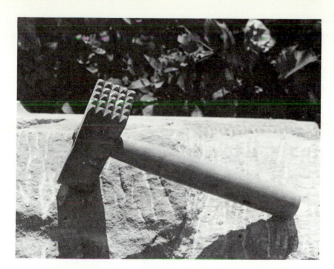

FIGURE 13-19 A bush hammer, used to soften and model the form.

each end is cut into a series of small pyramids. The bush chisel is the same, but unmounted, with one end plain for hammering. It is used by pounding directly onto the stone. The points crush the surface, modeling it.

Flat chisels. When greater clarity of form and surface is desired, flat chisels of various widths can be used (see Figure 13-14). These eliminate the marks of the tooth chisels or bush hammer, and also create refined edges and cuts. If you look carefully at Gothic sculpture that has remained indoors, sheltered from the weather, you can see that the entire surface was established with flat chisels (after the point and tooth chisels) and simply left that way.

Smoothing limestone. You can go still further, first with rasps and rifflers, then with files, and finally with sandpaper of various grades, finishing with wet and dry paper used wet. It is best to use a block of some kind with the sandpaper, to avoid getting a soft, wavy surface. Limestone usually cannot be brought to the high polish marble can reach, so fine sandpaper is about as far as it is practical to go. Finally, rinse the limestone well. It can then be waxed, or left as is.

With a few simple tools and modest equipment, plus easily and inexpensively obtained limestone, you could happily create many stone sculptures. But while it is true that an artist could spend a lifetime working this way (the Gothic sculptors did), curiosity may push you towards trying other stones and other techniques.

The Soft Stones

Alabaster, soapstone, African wonderstone, steatite, and some onyxes are all quite soft. Most are readily available from sculpture suppliers (see Appendix) in carveable sizes. Many of these soft stones are so soft they can be carved with old wood chisels or knives. And many of them take a lovely polish. Alabaster, as mentioned above, is translucent, and thus must be carved with great care. When using the point, for example, be particularly careful to glide the tool over the surface. Never drive it straight down, or you will create bruises beneath the surface of the stone which show like foggy patches after polishing.

CARVING MARBLE

With marble, we come to a whole new array of stones and new carving techniques. The world gives us so much marble, in such variety, that it can be overwhelming. The many names you read in catalogs of carving stones sound like the list of players on a Portuguese soccer team, and are of little help in making a choice. It is best to see the stone first, and, if possible, to try a few practice cuts with a tooth chisel on one corner to test its feel.

It is entirely possible to carve marble just like limestone, using point, tooth chisel, flat chisel, rasps, files, and sandpaper. Michelangelo did, and his works didn't turn out so badly! But marble is a good deal harder than limestone, and we now have many modern methods to waste large amounts of stone, and get at the real carving quicker.

Drills and Saws

A masonry bit in a good half-inch electric drill can run a series of holes a few inches apart along a line where you want to split stone. Special stone-splitting feathers

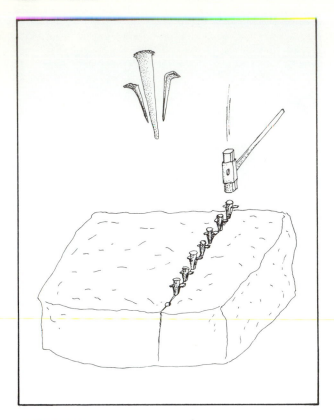

FIGURE 13-20 Stone-splitting wedges and feathers.

and wedges (Figure 13-20) are then placed in the holes and tapped in along the line until the piece breaks off.

A diamond blade is expensive, but if you plan on any serious marble carving, it is a good investment. A 7-inch blade can be fitted to a body grinder and makes deep cuts into marble. Smaller 4-inch blades are good

FIGURE 13-21 Large and small grinders with diamond wheels.

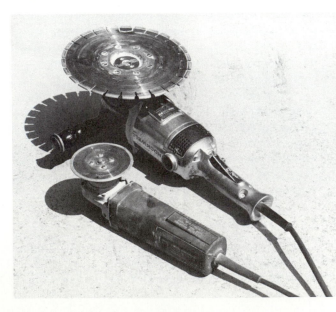

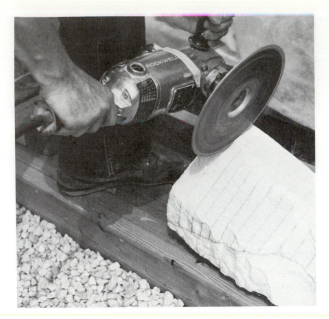

FIGURE 13-22 Using the diamond wheel to cut a series of slots to remove excess marble.

for more delicate cutting. Two grinders with blades are shown in Figure 13-21. If a planned series of cuts are made into the marble (Figure 13-22), the stone between the cuts can easily be broken away, removing large quantities of stone quickly and with good control.

The Air Hammer

The most important advances in marble carving are the air compressor and pneumatic hammer. These are readily available and widely used, with a full range of chisels to fit them. The big expense, of course, is the compressor, which must have an adequate capacity or you will waste your time and not get any carving done. You can carve with a small compressor, such as one horsepower, but three horsepower is better. After about five horse, the extra power won't help.

Air Compressors

Air compressors are intimidating machines, with lots of strange terminology, but they are easy to understand if explained. A compressor consists of the following parts: a motor, the compressor unit itself, the tank to hold the compressed air, and devices to deliver the air to the tool.

The motor. There are two ways of powering a compressor: gasoline or electric power. Gasoline compressors are noisy and emit fumes, but are portable, and are used by contractors and others who go to the job. They are common in the quarries, too, where they can be pulled to any site. Electric compressors are more use-

ful for the shop or studio, where they can be plugged in and remain in place.

The compressor. You may hear talk of *screw compressors*, but these very expensive, very efficient, machines are not generally made in smaller sizes, so you can ignore them. There are two kinds of piston type compressors: single stage and two stage. The single-stage compressor has pistons that compress the air into the tank. The two-stage compressor has one set of pistons to bring the air up to a plateau pressure, then a second set to compress it further. Generally, the two-stage compressors reach higher *PSI* (pounds per square inch), but often that extra pressure is not needed.

Rating compressors. There are two sets of numbers used to rate compressor efficiency. These are the PSI and the *CFM* (cubic feet per minute). Most compressors reach 100 PSI, and many single-stage units run at 125 or even 150 PSI. Most two-stage compressors will be higher than that, with 175 PSI being usual. The CFM, though, is the more important number. It tells how much air is actually delivered, and therefore indicates the amount of work the compressor does. When looking at catalogs of compressors, you will see lists of PSI and CFM figures which seem a little confusing at first, but can be understood if you follow this method:

There are two CFM figures. The first is the displaced CFM, meaning how much the compressor actually pushes out; the second is the CFM coming out of the hose at 100 PSI. The second figure is always lower than the first. Both these figures are related to the *HP* (horsepower) of the motor. Small compressors (½ HP) will yield about 3 CFM displacement and 2 CFM at 100 PSI. A 1 HP should yield 7.5 CFM and 5 CFM. A 3 HP should yield 12 and 8, while a 5 HP yields about 28 and 18. A simple way to come close to these figures is to multiply the HP of the motor by 5.6 to get the rough CFM displacement, then *divide that* figure by 1.6 to get the CFM at 100 PSI. For gasoline powered compressors, these figures are roughly half what they are for electric. If you use this as a guide, you can tell right away whether that discount compressor you're thinking of buying really delivers the way it should.

Maintenance. To maintain a compressor, be sure, above all else, to add oil to the crankcase, and to check and change the oil at regular intervals. If you don't, you'll burn up rod bearings and other crucial parts. Second, be sure the belts are tight and not worn. Third, listen to the compressor running, and be aware of any changes in sound, like wheezing, clanking, or thumping. If you hear a distinct change in sound, shut it down and check it out. The leaf valves in the compressor head can wear or break, and that can often change the sound of the machine. And always listen for leaks, since they can cause the machine

to run excessively. If you hear a leak, however small, cut off the pressure to that joint, take it apart, use pipe joint compound, and refit it.

The tank. The tank that holds the compressed air comes in different sizes. It can be horizontal (Figure 13-23) or vertical (Figure 13-24).

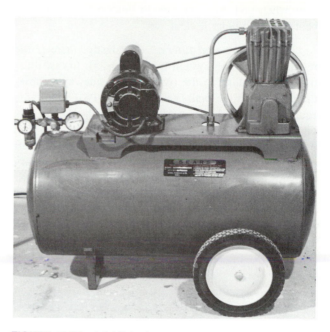

FIGURE 13-23 A 3 HP horizontal tank single-stage compressor.

FIGURE 13-24 A 5 HP vertical tank two-stage compressor.

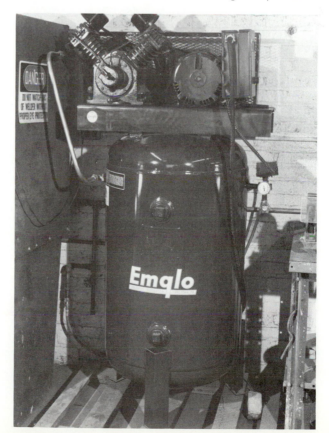

The air tank must be drained of excess water periodically. The best way to do this is to turn off the compressor, and bleed air until the pressure is about 30 pounds; then place a basin under the drain tap, and open it slowly. If you don't bleed off air, you get such a spurt that water goes all over. Sometimes grunge will form inside the tank and clog the drain hole, so nothing happens when you open the tap. In this case, take a short bent wire and poke it clear.

Regulators and filters. And lastly, there is the regulating/cleaning system (Figure 13-25). In this illustration, the gauge to the right, tipped sideways, shows the pressure in the tank (just under 150 PSI). The large square box to its left is a device to turn the compressor on when the pressure drops below a set point, and turn it off again when the pressure is at 150 PSI. To the left of that is a regulator with gauge to reduce the primary pressure to the working pressure, in this case 110 PSI. It is adjusted by turning the light-colored knob at the top. With a regulator like this, you can have a powerful blast of air out the hose, just a whisper, or anything in between. Just below the gauge on the regulator you can see the bottom of a filter to collect water before it enters the line.

Read any literature that comes with the various air tools you buy, and use the recommended PSI. For most

FIGURE 13-25 Gauges and regulator for the compressor: (*from the right*) pressure gauge indicating pressure in tank; (*square box*) control to turn motor on and off in response to pressure drop; regulator to control outlet pressure; gauge indicating outlet pressure; (*below gauge*) filter to remove water.

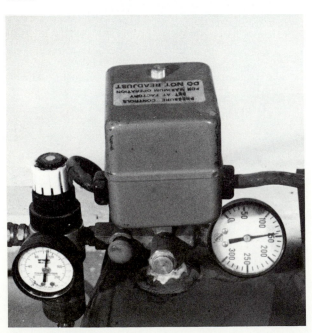

work, you can set your regulator at about 90 PSI, thus cutting down the pressure from what is in the tank. The filter needs to be cleaned periodically or, naturally, it doesn't do any good. Some people place an oiler on the line to feed small amounts of oil into the air to oil the tools. This is fine if you are just running tools off the line, but if you also use the air to spray or to blow off bronzes for patinas, you don't want any oil in it. In that case, omit the oiler, and put a drop or two of oil directly into each tool every day that you use it.

Using the Air Hammer

The air hammer is your most useful tool for carving marble, as well as for making large limestone carvings. Air hammers come in a variety of sizes for various levels of power or delicacy (Figure 13-26). All air tools should be fitted with quick-change fittings. Note that there are different brands of quick-change fittings on the market and that they are not interchangeable, so find a brand you like and can buy locally, and stick to it. You also need a small valve to regulate air flow. This should be placed in the line about two feet from the tool (Figure 13-27).

When you attach an air hammer to the line and open the flow valve, you will feel the hammer begin to vibrate. It vibrates harder as you allow more air through. You use the air hammer as a substitute for the regular hammer. To use, select the chisel you want, and slide it part way into the air hammer. Now hold the chisel with your chisel hand, just as you would if you were going to hammer it, and, holding the air hammer in the other hand, bring the whole assembly to bear on the stone (Figure 13-28). You will feel the air hammer hitting the chisel, and the chisel working through the stone. Carve using the same angles against the stone that you would use with hand tools, changing the air flow valve to vary the force of the carving.

It is absolutely essential that you wear goggles and a respirator for this work, as small pieces of marble fly around, and with much more force than when you hand carve.

Again, use the point to rough out the form (after any heavy stone elimination with a saw or drill), the tooth chisel to create the form, and flat chisels to remove tooth chisel marks and to refine planes and edges. Finally, turn to rasps, files, and sandpaper.

Body grinders can be fitted with abrasive stone-cutting blades to "sand" the form out of marble. This is particularly useful for delicate work, where hammer blows might break thin sections. Likewise, carbide burrs in a die grinder quickly remove stone and create detail. Be sure, when using any kind of high speed abrasives on stone, that you have tight fitting goggles and a *good* respirator. You should also work outdoors, if possible,

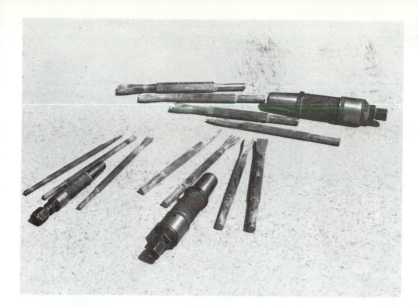

FIGURE 13-26 Three sizes of air hammers with assorted chisels to fit.

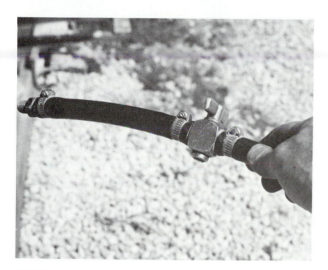

FIGURE 13-27 A valve in an air line to control the air hammer.

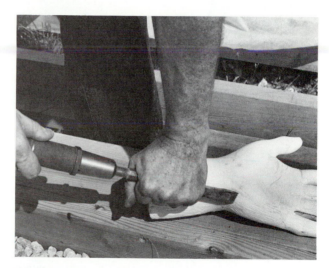

FIGURE 13-28 Using the air chisel on marble.

or have a strong ventilating system. Grinders throw a lot of fine dust in the air that you don't need in your lungs.

Polishing Marble

One of the beauties of marble is its ability to take a high polish. Sometimes, however, this creates a slick, glassy look to the sculpture that destroys the form. The choice of finish, whether rough, matte, or polished, is an aesthetic decision, and depends on the individual work. The two sculptures by Todd Villeneuve on p. 190 are similar in form, yet have received different surface treatments. Figure 13-29 has been brought to an all-over matte finish; Figure 13-30 is highly polished.

Marble can be brought up to a smooth matte finish with abrasive papers, particularly wet and dry papers, used wet. To polish further, use the finest paper (600 grit will do); then switch to polishing compounds on a firm felt pad. There are numerous polishing compounds available from marble dealers. Most are based on pumice powder, oxalic acid, or a combination. They can be liquid or paste, and they are used with a heavy felt pad, which you simply rub and rub and rub hard over the surface. Wash and dry the surface to see how the polish looks. And don't be afraid to go back to sandpaper or even files if you find rough or wavy areas. It is faster to move stone that way, and then repolish, than it is to try to get deep scratches or waves out with the felt pad.

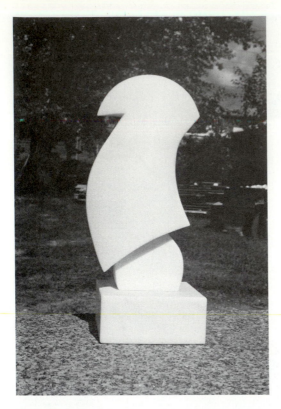

FIGURE 13-29 Todd Villeneuve, Figure Study. Marble. Collection of the artist.

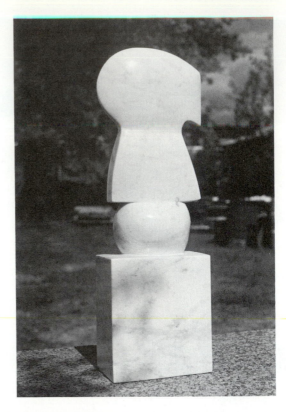

FIGURE 13-30 Todd Villeneuve. Figure Study. Marble. Collection of the artist.

Power equipment can be used to polish, but you must be careful not to burn the surface with excessive heat. Use power tools lightly, never bearing down too hard.

CARVING GRANITE

Carving granite requires carbide-tipped tools, as the stone is very hard indeed. You first bruise the surface with a carbide-tipped bush hammer so the chisels can bite into it, and then use either an air hammer or a very strong handheld hammer and proceed as usual. However, my advice is to leave granite carving to the professionals until you know much more about stone and are sure you want to invest the tremendous amount of time and expense.

OTHER WAYS OF CARVING STONE

There are other ways to create sculpture by cutting into stone other than hammers and chisels. Stones can be split, then reassembled into new configurations. Stone can also be cut with a saw to create form. This piece by Jesus Bautista Moroles is in granite, and uses saw cuts of varying depths to create an inner phantom form, defined by the bottoms of the many cuts (Figure 13-31). At Stone

Mountain, in Georgia, large flame guns were used to spall off the granite in flakes. This flamed surface is common on granite used for building surfaces (Figure 13-32), but it is not too useful for studio carving though there is certainly room for experimentation here.

STONE CONSTRUCTION

As mentioned earlier, stone can be assembled to create sculptures larger than the original stones, but, more important, sculptures that reach further into space. Figure 13-12 illustrated a simple exercise I made from scraps cut from the edges of marble sheets. After looking at the pieces I had and designing the sculpture roughly in my mind, I arranged the stones on the bench to give me an idea of what the sculpture would look like. Then I cut each piece to length using a masonry blade on a circular saw (and wearing a full face shield and gloves). I refined the joints by holding the surfaces of the marble pieces against a disc sander, and trying them over and over until a good joint resulted. For cement I used five-minute epoxy from the local hardware store.

This piece is fragile, but no more fragile than the china or pottery plate you eat dinner off every day. If it is dropped it will break, but if it is not dropped it should last centuries. Marble has a remarkable ability to take

shapes usually considered impossible in stone, as you can see in this illustration, in which I am holding a piece of marble of extraordinary length and thinness (Figure 13-33).

This little exercise didn't take long, and I must admit I don't take it terribly seriously as a part of my sculpture production, but it illustrates two things: first, it shows an approach to stone as a material that is radically different from the traditional one of carving form from a solid mass; and second, it shows that elegant and striking sculptures can be created with a minimum of elaborate techniques. Let this exercise jog your imagination into thinking of other ways to use stone, or for that matter, any material.

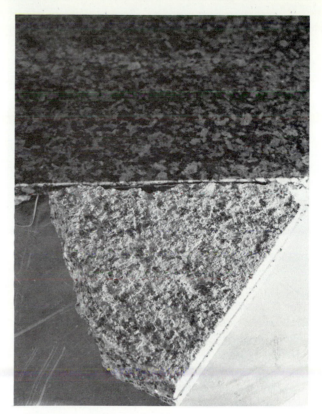

FIGURE 13-31 Jesus Bautista Moroles, Spirit Las Mesas #1. 1985, Dakota granite. Courtesy of Herbert Lotz.

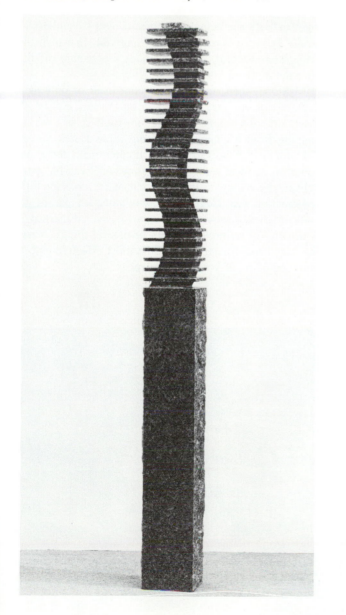

FIGURE 13-32 Flamed surface on granite (*lower piece*), contrasted with polished surface (*above*).

FIGURE 13-33 The author with an exceptionally long, thin piece of stone.

FIGURE 13-34 **Lika Mutal, Granit I**. 1983, granite. Courtesy of Nohra Haime Gallery, New York.

FIGURE 13-35 **Lika Mutal, Granit I**, another view.

To see how concepts of stone sculpture can be stretched, examine these two views of a piece by the Dutch sculptor Lika Mutal (Figures 13-34, 13-35). *Granit I* is actually a movable stone piece based on a hinge. It can be placed in any of several positions.

Signpost to Kintail by Derek Sellars uses stone "clouds" in a wood construction, denying the weight of the stone through the implications of the imagery (see Figure 12-25).

An elaborate construction by Michael Singer, called *Cloud Hands Ritual Series*, shows how stone can become an element in a sculptural conception involving wood as well (Figure 13-36).

The most extreme form of stone construction is pulverizing the stone, then molding the particles in a matrix into a new shape. Concrete is actually such a process, since the aggregate—pulverized stone—is held together with the cement to form a new stonelike material. Terrazzo is another such material, in which the cement has a color, and the stones are ground off flat after the material has hardened.

Stone, then, need not be conceived of only as a material for carving. Its weight and density can be an asset, either by emphasizing it, for example, as a weight hanging from a chain, or denying it, as Derek Sellars did with his *Signpost to Kintail*. It can remain dense and compact, as most stone carvings are, or it can be open, delicate, even lacy, as the cathedrals were, or as my little construction was. Never forget that stone is a part of the earth, that each rock, each pebble, is shaped the way it is because of millions of years of natural forces "carving" it. Those shapes can be the most effective part of your sculpture, if you let them speak.

FIGURE 13-36 **Michael Singer, Clouds Hands Ritual Series**. 1982-83, wood and stone. Walker Art Center, Minneapolis; photo by David Stansbury.

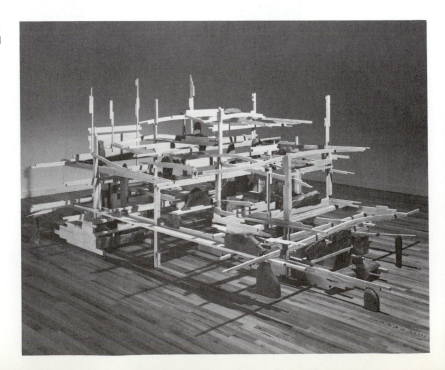

FOURTEEN

Direct-Metal Sculpture

SOME HISTORY

Artists have made sculpture directly out of metal for a long time, but it has almost always taken the form of *repoussé*, or beating a form from a sheet of soft metal, such as copper, silver, or gold (Figure 14-1). Assembling pieces of metal was difficult when there was no welding, though early artisans devised numerous methods of attaching primarily by using a riveting principle. Sculpture before the twentieth century was almost exclusively representational, imitating the forms of humans or animals, and direct-metal fabrication was not as efficient a way to make the multiple complex curves of living form as casting was.

Medieval Metal Workers

A notable exception to this was armor. When I was young I loved to look at collections of armor in museums, and pretend to be a knight wearing the armor. Now, as a sculptor, I still love to look at the armor collections, though I am fully aware of how uncomfortable it must have been, and of its brutal purpose. What fascinates me now is looking at armor as abstract figure sculpture in directly forged steel (Figure 14-2). Not only is the steel hammered and shaped with extraordinary beauty and skill, but the inventiveness of its form always amazes me. The way the parts of the body have been transformed into abstract shapes, which adhere closely to the principles of form outlined in Chapter 1, is wonderful. Add to that the psychological effect these suits must have projected, and you can appreciate them as true works of art. It is the rare sculptor today who has skills that compare with those of the medieval armorers.

Contemporary Metal Sculpture

It wasn't until this century that direct-metal sculpture, as we now think of it, came into being. Julio Gonzales is credited with being the first major artist to employ the material, and with teaching Picasso about it in the 1920s and 1930s (Figure 14-3). From then on, steel or iron became very much a part of the mainstream of sculpture materials, and remains so today. Much of this is due to the development of modern welding methods.

Gas welding as a sculpture tool. In the 1950s the gas welder became widely available, and artists began to use it as more than just a way to stick pieces of metal together. With the flame of the gas welder, metal could be melted onto an armature and modeled almost like clay. Different metals could be combined, brass could be melted over steel, for example, and a new kind of metal sculpture emerged that was very much in keeping with the Abstract Expressionist style dominating painting at the time. Such artists as Theodore Roszak (Figure 14-4), Ibram Lassau, and Seymour Lipton used this new tool to create new images.

Cor-Ten steel. In the 1960s a new material became available called *weathering steel*, or *Cor-Ten* (CORrosion-resistant, high TENsile strength). This alloy rusts, but then forms a hard, weather-resistant coating that grows darker with age, and prevents further corrosion of the steel. At first it was thought to be the answer to a sculptor's prayers. It is an easily worked, relatively inexpensive, yet permanent outdoor material, and it was widely used for monumental sculpture. However, because its surface becomes both matte and dark, absorbing light, it results in hulking, brooding, often hard to see

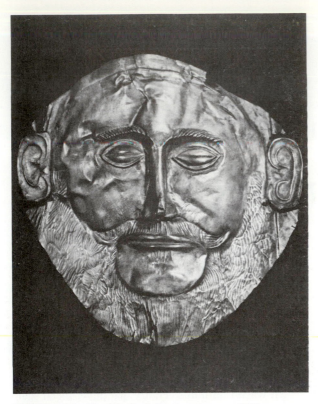

FIGURE 14-1 The Mask of Agememnon. c. 1500 B.C., beaten gold, Mycenae, Greece. New York Public Library Picture Collection.

FIGURE 14-2 Suit of armor. c. 1590, steel. Detroit Institute of Arts; gift of William Randolph Hearst Foundation.

FIGURE 14-3 Julio Gonzales, Torso. c. 1936, hammered and welded iron. Collection of The Museum of Modern Art, New York.

FIGURE 14-4 Theodore J. Roszak, Spectre of Kitty Hawk. 1946-47, welded and hammered steel. Collection, The Museum of Modern Art, New York.

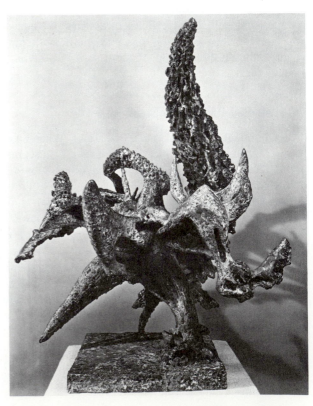

FIGURE 14-5 Richard Hunt, Sculpture, Cor-Ten steel. Niles, Michigan.

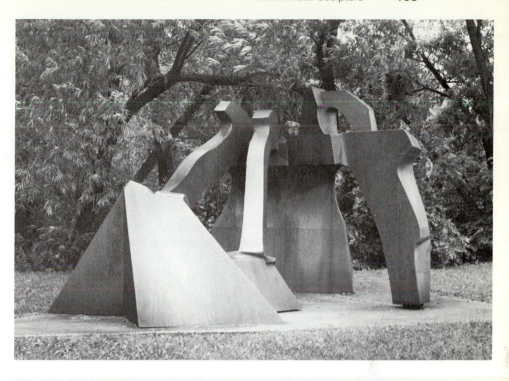

sculptures. It has now lost a great deal of its original popularity. This fine work by the Chicago sculptor Richard Hunt lies almost hidden in shade, and visually seems to disappear because of the dark matte surface of the Cor-Ten steel (Figure 14-5). Richard Hunt now works in direct bronze sheet or stainless steel.

Many other metals figure in direct-metal sculpture,

such as aluminum, stainless steel, brass, and bronze. This sculpture by J. Pindyck Miller uses aluminum machined to suggest modern hi-tech precision (Figure 14-6). In contrast, this work by Michael Todd is made by welding brass and bronze, except that some of the bronze was formed by pouring molten metal onto a floor to create natural shapes and textures (Figure 14-7). This particular

FIGURE 14-6 J. Pindyck Miller, Sung-God II. Machined aluminium.

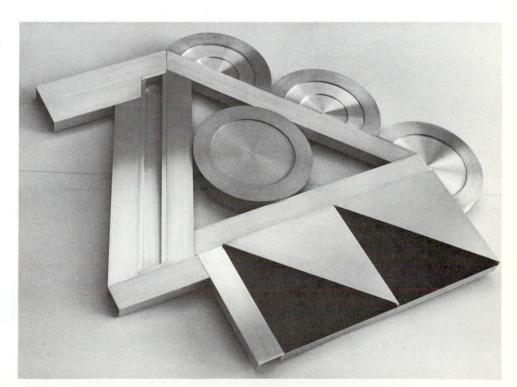

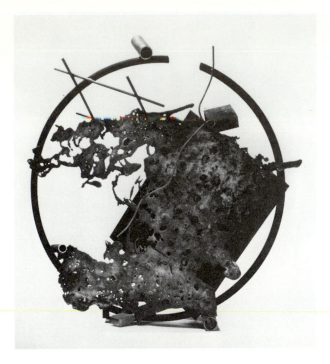

FIGURE 14-7 Michael Todd, Shiva's Dance XXXVI. 1985, patinated bronze and brass. Klein Gallery, Chicago; photo by Rob Mikus.

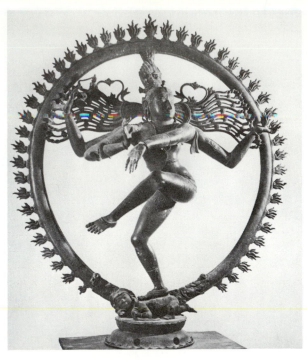

FIGURE 14-8 Shiva Nataraja. Chola Dynasty, c. 1250 A.D. Photo by Eliot Elisofon.

piece, entitled *Shiva's Dance XXXVI* refers to the Chola Dynasty sculptures from India depicting the god Shiva dancing the destruction of the universe (Figure 14-8).

CONCEPTS OF DIRECT-METAL SCULPTURE

With the technical processes available today, it is safe to say that virtually any metal can be controlled and joined to virtually any other metal, thus throwing the field of direct-metal sculpture more open before the artist than at any time in history. The field is so wide, in fact, that we must break it down to understand it at all. As a first division, let's consider three things: metal that is completely altered in shape and appearance; metal that retains its original form but is used to make new forms or shapes; and metal that has already been manufactured into an object, and that retains the feeling and identity of that object.

Completely transformed metal. If you buy sheet metal, then cut it, bend it, form it, and cover it with other metal, the original sheet is virtually unrecognizable. The English sculptor Trevor Faulkner makes birds out of sheet steel cut into small pieces, bent, and welded. He then coats these with different metals that can be oxidized or patinated to give the bird full color, but only with metal (Figure 14-9). Similarly, if you buy welding rod, and melt the rod drip by drip onto an armature, the

FIGURE 14-9 Trevor Faulkner, Fighting Cocks. Welded and blackened steel with fused brass and copper coloration. The upper bird is attached by two claws only. Courtesy of the artist.

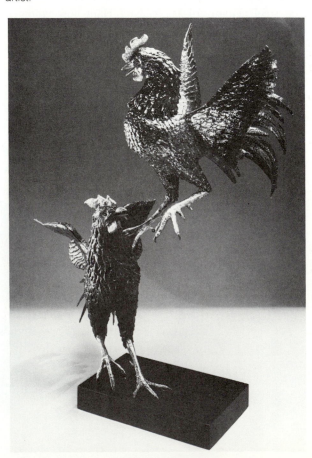

resulting form will no longer resemble the rod at all (see Figure 14-4).

Partially transformed metal. If you take metal that has been formed into the metal equivalent of lumber—that is sheets, bars, or tubes—and use it to build boxes, cages, or other constructions, the original shape of the metal is still apparent, but it assumes a completely new identity and feeling. This piece by David Smith is a good example of such a use of stainless steel stock (Figure 14-10). Although we usually think of metal as being manufactured in sheet form, wire is another form of metal. Richard Lippold is well known for elaborate constructions of very thin wire, which he attaches to the walls, ceiling and floor of a specially prepared space. These delicate sculptures have the transparency and shimmering lightness of spiderwebs (Figure 14-11).

Manufactured objects. The use of manufactured objects has been called *junk art.* It relies on the associations and character of objects previously manufactured in metal, yet cast aside by our affluent society. This sculpture by the foremost practitioner of junk art, the late Richard Stankiewitz, shows the use of preformed parts to create art (Figure 14-12).

A piece that falls somewhere between junk art and the use of metal "lumber" described above is *Keepers of the Fire* by Mark di Suvero, where heavy industrial I-beams, intended as metal with which to build things, become the main visual element, gaining meaning through the contrast of their ponderous weight with apparent weightlessness, and of their industrial seriousness with the quality of fun built into the work (see Figure 1-9).

We can conceive of a continuum like those we used to understand wood and stone along which these concepts can be located, with metal left entirely as found at one end, and metal entirely transformed at the other.

TECHNIQUES OF DIRECT-METAL SCULPTURE

By now we have discussed the concepts of sculpture thoroughly enough so that all that remains is to begin making some direct-metal sculpture. For this, however, you need to learn some techniques. Some sculptors learned technique first, then turned to sculpture later. David Smith, for example, like many sculptors, learned metalworking

FIGURE 14-10 David Smith, Cubi XXIII. Stainless steel. The Smithsonian Institution; photo by David Smith.

FIGURE 14-11 Richard Lippold, Aerial Act. Wire. Courtesy Wadsworth Atheneum, Hartford, Connecticut.

FIGURE 14-12 Richard Stankiewicz, Figure. 1955, steel. Hirshhorn Museum and Sculpture Garden, Smithsonian Institution.

in factory jobs, then applied his industrial knowledge to art. However, the opposite approach also works—that of conceiving of sculptures you want to make, then acquiring the techniques necessary to make them. In fact, the philosophy behind this book is that the desire to make art is the motivating factor behind all related learning.

Metalworking can be a lifetime study, since it involves welding, machining, repoussé, all the mechanical fasteners, sheet metal work, and finishing. But you needn't know all that to begin making metal sculpture. You can begin working, and add techniques as necessary. David Smith was fond of playing down technique (though his mastery of it was prodigious) by saying that technique was something the other guy did. What he did was make sculpture.

Techniques Needed for Sculpture

The techniques needed to make most sculptures are simple compared to the sophisticated industrial tech-

niques. They involve cutting, grinding, welding, mechanical fasteners, and sometimes forging. Knowing how to machine can be handy but it is not essential, and you can often have it done by commercial machine shops. You can also job out fancy finishes such as plating or anodizing to professionals. Thus, with a good knowledge of gas and arc welding, plus some simple forging, grinding, and fastening techniques, an artist can make direct-metal sculptures almost without limit.

OXY-ACETYLENE WELDING

Since the most usual material for direct-metal sculpture is steel, welding is your most important tool. *Gas welding* and *electric welding* are the two major forms of welding, and you must understand each, since together they form a powerful team that can accomplish almost any job. The more versatile of the two is gas or *oxy-acetylene* welding.

To learn welding thoroughly, you must read welding books, or even better, take a welding course at your local trade school.

Oxy-acetylene units are very handy to have in a sculpture studio, since they can cut steel, weld and braze metal, and heat metal for forging or patina application. They are not difficult to understand and use, but like any welding equipment, they can be dangerous, and should be treated with intelligence and care.

The Principle

Acetylene is a powerful gas that burns with a bright smokey flame in a normal atmosphere. When pure oxygen is added, the flame becomes smaller, cleaner, and much hotter. A bottle of compressed acetylene delivers gas through a hose to a torch, and a bottle of compressed oxygen delivers gas to the same torch, where the two combine and burn. Modern equipment allows burning only at the torch tip, and not back up through the hoses.

Acetylene is unstable at more than 15 PSI, so it is dissolved in acetone, which in turn is absorbed into a large porous mass, such as fiberglas or even balsawood, inside the tank. This way acetylene can be stored in the tank at 150 PSI or even more without danger. However, you must never allow the pressure of the acetylene at the regulator to go above 15 pounds.

Oxygen is stable at all pressures, and is stored in the tank at about 2800 pounds pressure, which is very high indeed. There is a serious danger of knocking the tank over, hitting the valve and breaking it off, in which case the tank will take off like a rocket and go through walls, ceiling, you, whatever, and sail off into the wild blue yonder. Always keep caps on the tanks when you move them, and always keep them well chained to the wall when in use.

Method of isolating the gases. To assure that the oxygen and the acetylene are never mixed up, two precautions have been taken by the manufacturer. First, every fitting on the oxygen side is normal, right-hand thread, and every fitting on the acetylene side is reverse, or left-hand thread. A groove is cut around every left-hand nut to indicate this (Figure 14-13). Second, everything connected with oxygen is colored green—gauges, hose, etc.—and everything connected with acetylene is colored red.

Regulators. The normal regulator is a two-stage regulator (Figure 14-14). To use a two-stage regulator, first, be sure the T-handle is backed out and loose before opening the tank valve. When the tank valve is opened, the pressure gauge nearest the tank will register the gas pressure in the tank. Turn the T-handle *clockwise* to screw it *in* to the regulator. Soon the second gauge will

FIGURE 14-13 Right- and left-hand threads on a gas welder. The cut around the nut indicates a left-hand thread.

FIGURE 14-14 A two-stage regulator for gas welding. The gauge on the right indicates the contents of the tank; the gauge on the left indicates the line pressure.

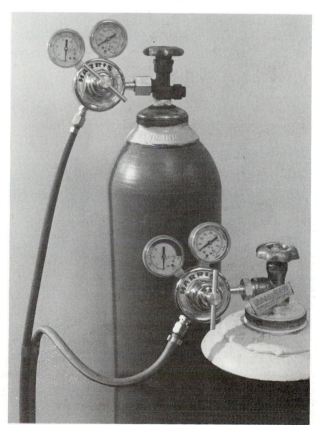

begin registering, and you can set its pressure where you want it for welding.

Some welding setups have *gang regulators*. There is a normal two-stage regulator on the gas bottles that feed a pipe running along a welding table. Along this pipe are single-stage regulators to feed each torch. To use, set the tank regulators to yield the highest pressure needed by any torch in the system; then set each single-stage regulator for the correct pressure for that torch.

When you open the tank valves to begin welding, open the oxygen valve all the way, so it bears against the *back seat* inside. Only open the acetylene valve a quarter turn, so it can be turned off quickly in case of emergency. The acetylene valve is the more dangerous one.

Welding and cutting torches. Torches are usually of two types: welding or cutting torches. The welding torch has removable tips that come in a variety of sizes. The crucial element is the size of the hole in the end, and thus the size of the flame. The larger the hole, the bigger the flame, though the temperature remains the same. It is like the difference between a birthday cake with one candle and one with fifty candles. Each candle burns at the same temperature, but fifty candles give more heat.

Setting gas pressures. The pressures you set on the regulator relate to the tip size. Naturally, you use more pressure for larger tips. For a very small tip, you need only about 3 pounds of acetylene and 5 pounds of oxygen. A medium-size tip runs at about 5 pounds and 8 pounds, and a large tip might need 8 pounds and 10 pounds. If the flame goes out with a pop, you need more acetylene pressure.

Preparing to Weld with a Torch

Supplies needed. To weld with a gas torch, you need, in addition to the tanks and torch, a flint striker to light the torch, gas welding goggles, and some good gloves. You also need some scrap steel, say ⅛ inch thick, and some steel welding rod, which comes in various sizes, with 1/16 inch being small, for light work, 3/32 inch medium, and ⅛ inch heavy. You don't need gas welding rod heavier than that, since the arc welder takes over at that point.

Lighting the torch. (Before doing this, be sure to read *Turning off the torch*, below.) To light the torch, be sure that the pressure is adjusted correctly, and that you can hear some gas escaping when you crack the torch valves open slightly, one at a time. Note again that the acetylene hose is red, and the oxygen green, and get the feel of the valves so you know which way you must turn them. Also, practice a little with the striker so you

can make a spark easily. Now open only the acetylene valve *just a little*, not even a quarter turn, cup the striker over the torch tip, and make a spark. You should get a bright yellow flame that gives off a good deal of black smoke.

Slip your goggles down over your eyes, and adjust the flame as follows: *Increase* the acetylene until the flame is large and bushy. If a gap appears between the tip and the flame, reduce the flame until the gap disappears, then bring it up again until just before that point. Now *add* oxygen. First you will see a lengthening of the flame, as it turns blue. You will see three flames—a long outer one, a middle cone, and a small inner cone. Notice, as you *increase* the oxygen, that the middle cone grows smaller. Continue adding oxygen until the middle cone merges with the smaller inner cone. Now you have a balanced, or *neutral*, flame (Figure 14-15).

If you have too little oxygen (middle cone still showing) you have a *reducing* flame, with reduced oxygen. If you increase oxygen past the neutral point, so the flame gets still smaller and begins to hiss, you have an *oxidizing* flame. You will use a neutral flame for most of your welding, but occasionally you must shade the flame to one or the other extreme to assure even combustion. For brazing you should use a slightly reducing flame, to avoid oxidizing the brass. Welding in a confined area usually requires a slightly oxidizing flame, to make up for less atmospheric oxygen.

Turning off the torch. You must also learn to turn the torch off. Notice that when you turned the torch on, you made all adjustments with the acetylene first, then the oxygen. Turn the torch off the same way. Turn off the acetylene first, completely, and then the oxygen.

FIGURE 14-15 Partially adjusted flame (*top*) and neutral flame (*bottom*).

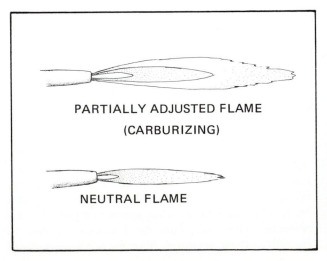

PARTIALLY ADJUSTED FLAME
(CARBURIZING)

NEUTRAL FLAME

Readjusting the flame. To adjust the size of the flame after the torch is lit, use this procedure: To *increase* the size of the flame, add acetylene first, then balance the oxygen. To *decrease* the size of the flame, reduce the oxygen first (adding that middle cone), then balance with the acetylene.

Some welders recommend another method to adjust the torch. In this method you begin with the T-handles of both regulators backed out and loose. Then you turn on both the acetylene and oxygen cylinders as before. Taking a striker, you open the acetylene valve on the torch about one full turn, then turn in the T-handle on the acetylene regulator until gas begins to hiss slightly from the torch tip. Light the acetylene and adjust the flame size with the regulator. Do the same with the oxygen.

Either method works, though in practice more sculptors and welders use the first method since it is faster. Because more pressure is usually set at the regulator than is actually needed, the first method allows you to increase the flame size if necessary without going back to the tanks.

Shutting the System Off

As you work, you will be continually lighting and extinguishing the torch. At the end of the working session, however, when you plan to leave the system overnight or longer, you must bleed it and shut it all down.

1. Turn off both tanks at the tank valve.
2. First, open the acetylene at the torch, and allow the gas to flow until it stops; then close the torch valve. Next, open the oxygen at the torch, bleed that line, and close that valve. All gauge dials should read zero after this procedure.
3. At the regulators, *back out* the T-handles by turning them *counterclockwise*. In other words, imagine the T-handle is a car steering wheel, and turn it as though you are making a left turn. The T-handles should be loose and wobbly. *Do not* screw them in tight, thinking you are turning everything off. Remember, the system is *off* when the handles are back out and loose.

To shut off a gang system, follow these steps:

1. Shut off both tank valves.
2. Open the acetylene torch valve and bleed the line; then close the valve. Do this for every torch that has been used that day.
3. Open the oxygen torch valve and bleed the line for each torch used. Be sure all torch valves are closed after the line is empty.
4. Back out the T-handles on the tank regulators.
5. Back out the T-handles on each line (single stage) regulator used.

Welding with the Torch

There are three ways to learn how to weld. First, you can read a book devoted solely to that complex subject. Second, and better, you can take a welding course, either in your sculpture department or at a technical school. And third, you can practice, practice, practice. (That's the only real way to learn anything.)

A simple weld. You can get started with a little instruction, right here. Take a couple of pieces of scrap steel—⅛ inch thick is ideal—and place them on a steel table or a table covered with fire brick. (Never weld on a wooden table, for obvious reasons.) Place the pieces of steel so they are lying side by side, their edges almost touching, with only a tiny gap between them (Figure 14-16). The gap should run side to side, not pointing away from you. Take a ³⁄₃₂ inch welding rod. Most right-handed people hold the torch in the right hand, the rod in their left; if you're lefthanded you may reverse this. Weld from right to left if you're righthanded, holding the torch in your right hand. Do the reverse if you're lefthanded.

Making a puddle. Light the torch, slip on the goggles, and barely touch the tip of the inner cone of the flame to the end of the joint between the two plates. Melt the steel plates until there is a small puddle of molten steel, and then feed the rod into that puddle so the puddle gets bigger. Do not try to drip the rod off onto the joint. Here's the rule: *no puddle, no rod.*

Control the heat on the work by moving the torch closer or farther away. Be sensitive to what's happening, and try to create a small puddle of roughly even size on both pieces of metal. When you have a puddle of melted steel, touch just the tip of the welding rod into the puddle and let it melt off, increasing the size of the puddle.

FIGURE 14-16 Metal pieces ready to weld.

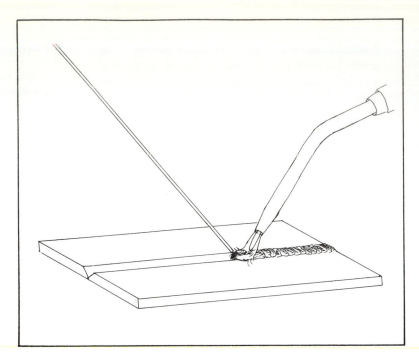

FIGURE 14-17 A torch creating a puddle, with rod to form weld.

Move the torch just a bit along the joint, so the puddle becomes longer, and add more rod to the puddle (Figure 14-17). Keep doing this, moving slowly along the joint.

This procedure gives you a nice bead of weld metal all along the joint, not globs and mounds of metal here and there. The main thing, of course, is to practice, so flop the metal over, using pliers, and weld the other side. This basic operation, running a bead down a slightly gapped joint, is the heart of gas welding, and if you master it, you are well on your way to being able to weld most anything.

Practice. While it's a good idea to practice on small scraps, if you're anything like me you'll want to begin making something soon. One way to practice and make sculpture at the same time is to cut or find a supply of pieces of ⅛ inch thick steel, roughly the size of playing cards, but in a random assortment of shapes, and begin sticking them edge to edge. You can angle the shapes to make a large, solid form, and you can cut their shape, with either a shear or a hacksaw, in order to begin adding at angles. If one piece goes on wrong, you can cut it off and add another. Whole areas can be bashed with a hammer to alter the shapes, and the surface can be ground with a body grinder to refine it. This piece, *Torso of a Juggler* by the American sculptor Don Schule is a work made with this technique (Figure 14-18).

The drip technique. Heat a small scrap of metal, and pile up the melted rod in one place, creating a mound of metal. Think of the new metal as though it were a modeling material, and try to build shapes with it. This is the method used by such sculptors as Bertoia and Roszak, who build onto welding rod armatures, coating all surfaces with globs of melted metal.

FIGURE 14-18 Don Schule, Torso of a Juggler. 1962, welded steel. Walker Art Center, Minneapolis.

The Cutting Torch

This torch is indispensable for direct-steel sculpture, and it is a good idea to become familiar with it so it works well for you.

The principle. Steel will burn if it is very hot and is in the presence of more or less pure oxygen. Notice that the cutting torch has a ring of little holes in the tip, with a bigger hole in the center (Figure 14-19). The outside holes each have a small flame, called the *preheat* flame, while the center hole shoots pure oxygen, the *cutting oxygen*, which is controlled by the big lever at the base of the torch.

Pressures for cutting. Cutting steel requires much higher oxygen pressures than welding does. You can leave the acetylene pressure set at 5 to 8 pounds, but you need 25 to 40 pounds of oxygen for most cutting jobs.

Kinds of cutting torches. There are two kinds of cutting torches in common use (Figure 14-20). One is a cutting torch only, which attaches to the hoses themselves. The other is an attachment that screws onto a welding torch body.

To use the first kind, turn on a tiny bit of acetylene and light, increase to bushy flames, then add and adjust the oxygen to get small neutral flames. To use the kind of torch that attaches to a torch body, first open the torch body oxygen valve all the way. Next, open the torch body acetylene valve a crack and light; then add oxygen using the small valve on the cutting attachment itself (see Figure 14-20).

When you squeeze the cutting oxygen handle, you should get a powerful hiss of oxygen coming out of the center hole. It should not blow out or change the balance of the preheat flames. Be sure the torch is operating properly before trying to cut.

Setting up the cut. To cut steel, you must first set it up correctly. There will be a shower of molten steel coming out of the bottom of the cut. The best way to cut is over a steel table, with the metal to be cut lifted three or four inches off the table on bricks. A bed of sand on the table prevents the steel from splattering. If you hang the steel over the edge of the table, the hot metal can shoot straight onto your foot, unless you stand clear and wear good boots. Use your head, and arrange a way to contain the cut metal.

Making a cut. With the torch lit properly, slip down your welding goggles, be sure your gloves are on, and use the preheat flames to begin heating one edge of the steel. Hold the torch so the tips of the inner flames are just touching the steel—about 3/16 inch away—and hold the torch tip vertically (Figure 14-21). When the steel has reached red heat, squeeze the cutting oxygen lever all the way. This should give you a stream of bright metal right through the steel. If the steel doesn't go instantly bright, it isn't hot enough. Release the lever and continue heating.

The instant you have a cut going, move the torch steadily ahead, keeping the tip close to the steel, and watching the cut. Try to move as fast as you can without overrunning the cut. If you go too fast or jerk ahead a little, the cut will stop, and you must go back to the end of the cut and preheat again.

Some problems and solutions. You will probably encounter some problems. One is that the underside of your cut may be very globby and messy. This is usually due to two things: your preheat flame is too big, and the torch tip is too far away from the steel. Try to cut with as small a tip and as small a preheat flame as possible, but with high oxygen pressure. Then try to keep the end of the tip very close to the steel—almost touching, in fact.

FIGURE 14-19 A cutting torch tip, showing preheat holes (*outer ring of holes*) and cutting oxygen hole (*center*).

FIGURE 14-20 Two kinds of cutting torches: regular torch (*bottom*) and cutting attachment (*top*).

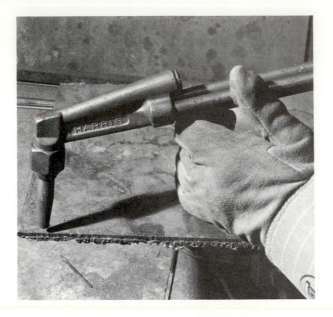

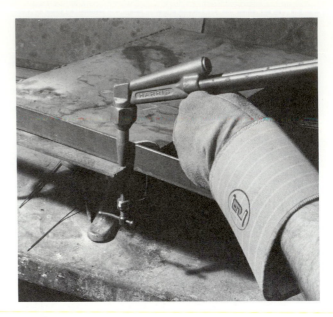

FIGURE 14-21 Cutting torch held properly for cutting.

FIGURE 14-22 Cutting against a straight edge. (Note the clamps holding the straight edge from slipping.)

FIGURE 14-23 Using a circle burner.

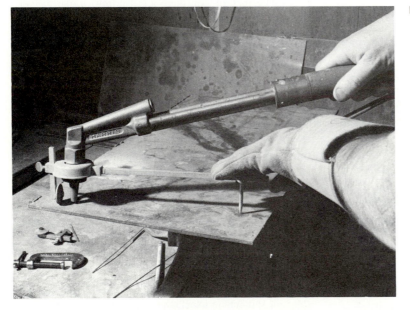

Another problem is wavy, wobbbly cuts. You can use a straight edge for straight cuts. A piece of angle iron clamped on the steel works well as a straight edge (Figure 14-22). You can also buy *circle burners*, which act like a compass to guide the torch in arcs (Figure 14-23). You can also use wooden guides, cut on the bandsaw and clamped with spacers about ½ inch above the steel. They char as you cut, but if you work outdoors, they are all right. If they catch fire, they are no more dangerous than a campfire, and they burn behind the cut, so you are always cutting against good wood.

Brazing and Soldering

Brazing and *soldering* are methods of joining two pieces of metal by flowing into the joint a metal with a lower melting point. This flowed-in metal actually dissolves the metals to be joined, like sticking sugar cubes together with water. When the joining metal melts below 850° F, the process is generally called *soldering*; when the joining metal melts above that point, it is called *brazing*. An exception to this is *silver solder*, which is a name given to a great number of alloys that have a wide range of melting points.

Kinds of solders. The tin/lead solders are low melting point solders best used with a paste *flux,* a substance to help the solder flow. Heat should be supplied by a propane torch, since an oxy-acetylene torch is too hot. The silver solders have melting points that range from near that of tin/lead (about 450° F), up in many increments to near 1500° F. These are best used with the appropriate silver solder fluxes. Finally come the true brazing materials, which are usually copper alloys such as brass and bronze, and are best used with powder brazing flux.

Requirements for a sound solder joint. There are four things that must be correct on a soldered or brazed joint, and if any one is wrong, the joint is no good.

1. *The joints must fit.* In welding, we leave a gap for the weld metal to fill, but in soldering and brazing the molten metal is drawn into the joint by capillary action, so the two pieces must fit well, touching cleanly but not clamped tightly together.

2. *The two surfaces to be joined must be absolutely clean.* Sandpaper is best, but wire brushing or sandblasting also works. Dirt, oxides, or grease kill the joint.

3. *The two surfaces must be fluxed.* Use the appropriate flux, and apply it evenly to both surfaces after they have been cleaned. Then press together and bind with wire, prop them carefully, or do something to make them stay in place.

4. *You must have the right heat.* Too little heat, and nothing happens. Too much heat, and the joint metal will bead up and run off. Heat slowly, trying the joint metal occasionally. When it just melts and flows, that is enough. You can coax the metal around the joint by gentle heating, but be wary of burning it up with too much heat.

Advantages of brazing. Brazing or soldering is particularly good for joining two different metals, such as steel and brass, for joining thick to thin, for making a joint where you don't want a weld bead, and for joining metals other than steel. You can also use the technique to "plate" steel, by flowing brass rod over the surface.

Cautions with brazing. Many silver solders contain elements such as cadmium which are very toxic in gas form. It is essential that all brazing operations, particularly those in which silver solders are used, be done with good ventilation. It is best to use a hood directly over the work which draws air up and out. You can also work before an open window with a fan at your back.

Galvanized steel is also potentially dangerous. This is steel that has been zinc plated. When it is heated the zinc burns off and is toxic. The same ventilation is needed.

ARC WELDING

Arc welding is the most common way to weld, particularly in industry, on the farm, and in the small shop.

There are two major kinds of arc welders in common use: the *stick welder* and the *wire,* or *MIG welder.*

Stick Welding

The principle in stick welding is that an electric current flows down the welding rod, passes to the metal being welded by jumping in an electric arc which generates intense heat, and flows back to the welder through a ground wire. The heat of the arc melts both the welding rod and the metal being joined, and they flow together to form the weld. It is essential to stabilize the arc, so a heavy coating of flux is placed on the welding rod, (which is called the *electrode*). This flux keeps oxygen out of the weld and creates a special atmosphere around the arc.

The machine. Most arc welders consist of a metal box with a few controls (Figure 14-24). There is an on/off switch, a big crank that changes the power as shown on a gauge of some kind, and places to plug in the various wires. There are only two wires, the one leading to the electrode and the ground wire (often labeled *work*). The electrode wire will usually have two or three holes that can be plugged into for a low, medium, or high range of power. (In Figure 14-24, these are the three white rings to the lower left of the machine. The upper left one is the high range; the lower left, the low range; and the lower right the work, or ground.) The power is rated in

FIGURE 14-24 AC/DC electric welder. Current control is the crank on top; AC outlets are on the lower left; DC outlets on the lower right; On/Off switch on the upper right. Courtesy of Miller Electric Company, Appleton, Wisconsin.

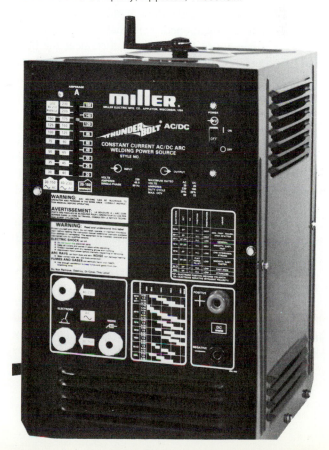

amps, with 80 amps being a good starting place for most work. If the rod burns up and welds too fast, turn the power down. If you can't get an arc or have trouble keeping one, turn the power up.

Arc welder safety.

The safety rules for arc welding are different from those for gas welding. First, and most important, is the welding mask. These large black head-covering masks with very dark lenses are absolutely essential. The light from an arc welder is many times brighter than that from an oxy-acetylene welder, and *will blind you fast* if you look at it. It will also damage the eyes of anyone working near you without protection. Always weld in a booth with curtains to shield the light from others. Also, this light acts like sunlight on the skin, only twenty times more powerful. You can get a good sunburn on any exposed skin if you weld for more than just a few minutes. So wear gloves, roll your sleeves down, and button your shirt to the top.

You can't get electrocuted with an arc welder unless you try really hard, so that is not a major worry. Obviously, don't weld with your feet in water, or anything stupid like that.

You must also concern yourself with ventilation. All welding produces gases that can be irritating or harmful. Welding stations or tables should all have exhaust fans drawing air through a hood placed over or along the edge of the work surface. Open windows and fans are also an important way to aid ventilation. Never allow fumes to build up without removing them.

Electrodes.

The electrode is the actual steel that fills the weld. As mentioned, it is coated with a flux to enable a stable arc to form. On the flux, near the bare end, is a number that gives you a lot of information about the rod. Though there are dozens of different numbers, you can quickly learn to read them to find out about the rod.

First, you should see the letter *E*, which means the rod is for arc welding. *G* is for gas welding. Then follow four digits. The first two are the tensile strength of the steel in thousands of pounds per square inch. Thus 70 means 70,000 pounds will break a one-square-inch rod of the electrode metal.

The third digit refers to the recommended position of welding with that rod, or, how much it drips. Number 1 means *all position*, 2 means *butt welds in flat position*, and 3 means *flat welds* only (that is, highly drippy). A number 1 is most common.

The last number is complicated and refers to power supply, type of covering, type of arc penetration, and presence of iron powder. This number is most commonly 0, 1, 2, or 3. All are good rods, although 2 is perhaps most commonly used. Thus a rod marked E-7012 means

70,000 pound tensile strength, all position, general purpose.

One other consideration is rod diameter. Arc rods are a little thicker than gas rods, with ⅛ inch being small, then ⁵⁄₃₂ inch, ³⁄₁₆ inch, and so on.

Getting set up.

Welding with a stick welder is not difficult once you get the hang of it, but like riding a bicycle it is tricky at the start. Begin by practicing making a bead on a piece of steel. Don't worry about making a joint; just lay beads across some old metal. Use metal about ¼ inch thick so you can use some power without burning things up. Place the metal on the welding table, and put an electrode in the electrode holder. To lay a bead on ¼ inch steel, select a ⅛ inch E-7012 or similar rod. Clamp the ground clamp to the metal, away from where you will weld. Set the machine for 80 amps, and turn it on. Position the tip of the electrode about three inches over the steel, and lower your mask. You can't see anything. Slowly lower the electrode tip and try to make a gentle stroke on the metal. As though you were striking a match, just lightly touch it and instantly draw it about ¼ inch away. It may take a few tries, and sometimes the electrode sticks to the metal. When it does, yank it off and start again. If nothing happens, jab the tip of the electrode sharply against the steel to break off a bit of flux so it makes contact.

If an arc just refuses to keep going, turn up the power. When you get an arc, begin moving the electrode along the metal slowly, looking at the puddle it is creating. Notice that the electrode is continually being eaten away and getting shorter. You must keep moving your hand toward the metal, or the arc will get too long. Keep the arc short and tight, the electrode almost touching the metal. Learn to maintain the arc, to control the puddle, and to move the electrode in small circles (Figure 14-25).

When you stop the arc, set the electrode down where it isn't in contact with the metal, lift your mask, and look at the bead. It will be all covered with flux or slag. Put on some clear goggles, take a chipping hammer (Figure 14-26), and chip off the slag. Now you can see your bead, which should look like the good one shown (Figure 14-27).

After you can make a reasonable bead, try joining two pieces, first with a flat butt weld as you did with gas, then with a T-joint. Whenever you finish a weld, put on clear goggles and chip the flux off the weld, both to see the weld and to remove the flux so later welds don't include it.

Figure 14-28 shows various joints prepared for welding, either with the stick welder, with gas, or the MIG welder. The general principle is to allow a gap so weld metal has someplace to go. When welding long pieces, you get warping as the metal gets hot. A simple

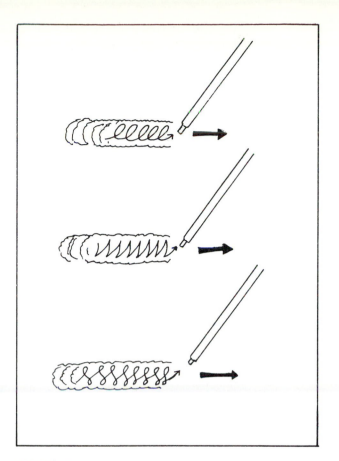

FIGURE 14-25 Some commonly used arc welding rod movements.

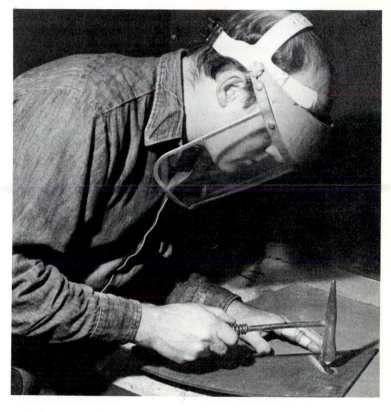

FIGURE 14-26 Using the chipping hammer to remove weld flux. (Note the face shield to protect against flying chips.)

FIGURE 14-27 Good weld bead (*top*) and poor weld beads (*center and bottom*).

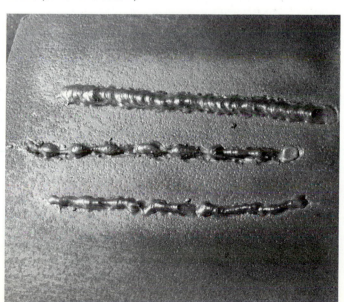

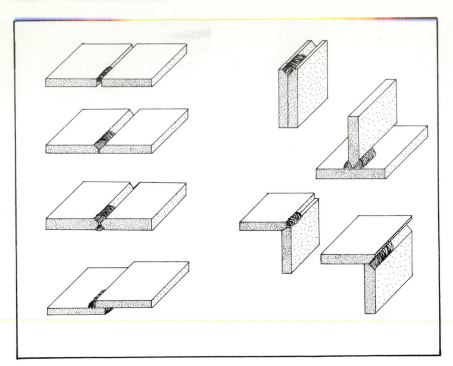

FIGURE 14-28 A variety of weld joints.

way to counteract this is to place small welds along the joint at intervals to clamp the pieces in position, and then to proceed with the weld.

MIG Welding

The principle. MIG means *Metal Inert Gas*, and is often called *wire welding* or *automatic welding*. The principle is similar to that of the stick welder, except that a thin wire is used instead of the electrode, and there is no flux. Instead, an inert gas, usually carbon dioxide, flows from a tank down the hose to the *torch*, or handpiece, and out around the wire tip over the weld area. Also, you don't feed the wire into the weld, but instead it is fed automatically by a little motor that pulls the wire from a large spool.

Adjusting the MIG welder. There are several adjustments on a MIG welder (Figure 14-29). You must adjust the current for the intensity of the weld. You do not change wire sizes often, but there are various weights suited to most of the welding a particular machine does. You must adjust the speed of the wire feed however, as well as the gas flow.

Assuming you have an average wire size, you first need to think about the current. This is similar to stick welding, in that you try it, and then adjust up or down as needed. The wire feed is similarly obvious; it either doesn't come out fast enough, or comes out too fast. The gas flow is usually set at the middle of the flow meter, then adjusted up or down as needed.

MIG welders are complex machines, and you should either read the instruction manual carefully, or receive instruction from a teacher before trying to use one.

Welding with the MIG welder. Wire welders have a trigger on the handpiece, which turns on the power (after the machine is on and the gas adjusted) and starts the wire feed. Before using, prepare everything. Have your metal in place, ground clamp secure, machine on, and gas flowing. Clip off the protruding wire with a wire cutter, leaving about $\frac{1}{2}$ inch showing. Place the wire so it just touches the metal, then lower the welding hood and hit the trigger. You should get an immediate arc, and you can begin moving the handpiece along to make a bead. Be ready to make adjustments to the machine as needed until the bead is smooth and automatic.

A MIG welder takes some time to adjust perfectly, but when adjusted, it is the fastest and easiest welder to use. It is best when you need to make a lot of similar welds. For the odd weld here and there, a regular stick welder is faster, since there is so little adjustment time.

TIG or Heliarc Welding

The principle. TIG stands for *Tungsten Inert Gas*. It is similar to MIG, except that TIG welders do not have a wire feed, but rather a tungsten electrode, which, because of its high melting point, does not melt off into the weld, but creates the arc. Weld metal is then fed into the puddle with a rod held in the other hand, very much like gas welding. Again, inert gas flows around the elec-

FIGURE 14-29 The MIG Welder. Since these machines differ from brand to brand, the manufacturer's instructions must be followed carefully. Courtesy of Miller Electric Company, Appleton, Wisconsin.

trode over the weld area, only argon is the preferred gas, not carbon dioxide.

Adjusting the TIG welder. There are many more controls on a TIG welder (Figure 14-30). First, you have a choice of how the current flows: AC, DC straight, or DC reverse. With AC you get equal heat between electrode and metal. With DC straight, you get ⅓ heat on the electrode, ⅔ on the metal. With DC reverse, you get ⅔ on the electrode, ⅓ on the metal.

Current selection. You will probably use the TIG welder for just three metals—stainless steel, bronze, or aluminum. Use DC straight for stainless steel and bronze, and AC for aluminum.

Other adjustments. The power adjustments on the TIG welder differ from machine to machine, but are easily figured out. A common form of power adjustment has one lever that gives general ranges of power, plus a finetuning knob to adjust more precisely. There is a *high frequency stabilization* switch that you turn to *On* for AC, and to *Start Only* for either kind of DC. Other switches and controls deal with such things as remote control units (foot switch) or water flow if water cooled. Read the instructions and figure out all the switches before beginning to weld.

You will use a bottle of either argon (recommended) or helium, with a flow gauge (Figure 14-31). Set the gauge to read about 8 to 12 cubic feet per hour;

usually this means getting the little ball to float about halfway up the gauge. Always be sure you have gas, and that it is flowing out the torch before beginning.

Many TIG units are air cooled, and for most sculpture studio purposes these are fine. Heavy production

FIGURE 14-30 The TIG or Heliarc Welder. Large-current control is on the left; fine current-control is the knob in the center. Again, these machines differ from brand to brand.

FIGURE 14-31 Argon flow gauge. The circular gauge shows the tank contents. The ball rises in the flow gauge to indicate the actual flow of gas.

units are water cooled, and you must make sure the water is flowing and has a good drain before beginning.

Electrodes come in different sizes, $^3/_{32}$ inch being medium and suitable for most welding. You can use either the red tip or green tip, as they both work well. But you must prepare the electrode tip for the kind of welding you are doing. For DC straight, which is correct for stainless steel and bronze, grind the tip to a point, like a pencil. Finish grinding with the grinding lines running lengthwise on the electrode, rather than around the tip (Figure 14-32).

FIGURE 14-32 Grinding a tip on the tungsten electrode. (Note the position relative to the wheel, to create grinding lines parallel to the electrode.)

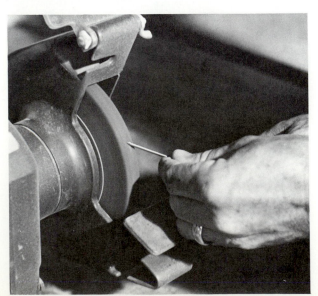

The torch has several parts, and you should become familiar with them. Figure 14-33 shows the parts laid out in a straight line in the order in which they should be assembled. On the right is the torch itself. To the left is the collet, which holds the tungsten electrode, which is sized according to the electrode size. Next, insert the electrode, and last, screw on the cap. Screwing the cap down tight locks everything in place. The ceramic cup on the torch tip is replaceable. These cups sometimes get full of spatter and should be replaced, since stray encrustations can cause the arc to wander. When mounted in the torch, the tip of the electrode should protrude about $^1/_8$ inch beyond the end of the gas cup (Figure 14-34).

For aluminum, or any AC welding, you need to *ball* the electrode. Start either by breaking the end off or grinding it perfectly flat. Then put the electrode in the torch with the tip protruding about $^1/_8$ inch. Set the machine to DC reverse, and quickly strike an arc, preferably against a heavy piece of copper, although aluminum will work. This should form a ball on the electrode (since two-thirds of the heat is going to the electrode). It happens quickly, so be alert. Stop the arc, let the electrode cool, change the machine to AC, and you are set to weld aluminum. If you corrode the ball by touching it to the aluminum, you must break it off and reball it.

Welding with the TIG Welder

You use the TIG welder very much like a gas welder. Be sure that the ground clamp is in place, that the gas is flowing, and that you have a welding rod in your other hand. Most TIG welders are foot operated. The pedal is operated like the gas pedal on a car; hit it a little and it starts the current. You can strike an arc (helmet down, remember!) by slowly bringing the torch nearer and nearer the work. When it's about $^1/_2$ inch away, the arc will form. Now bring the electrode still closer, and give it some power with your foot until you form a puddle. Feed the filler rod held in your other hand into the puddle as you did in gas welding, and practice making beads. You'll soon find you can glob on heavy beads of metal, then, using just the torch, make them flow down and into the parent metal, evening everything out. Again, it is a matter of practice.

The Electric Welding Station

Figure 14-35 shows an electric welding station with a straight arc welder and a TIG welder. Notice the fire extinguisher, which should be a part of every welding operation. The arc welder is on the floor with the argon bottle next to it, and the TIG welder is next to that. The welding table is metal with a fire-brick work surface. The shelf holds arc welding electrodes. On the table are bricks for supporting work, the ground clamp and torch

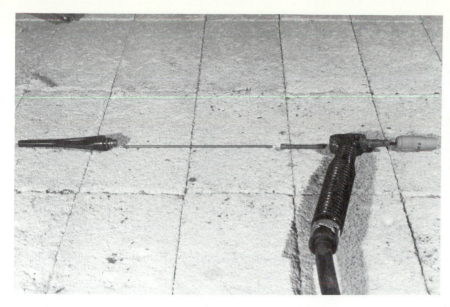

FIGURE 14-33 A TIG torch taken apart: (*from right to left*) torch, collet, electrode cap.

FIGURE 14-34 Correct amount of extension of the electrode.

FIGURE 14-35 An electric welding station: (*from left*) fire extinguisher, standard arc welder, argon bottle, TIG welder, welding table.

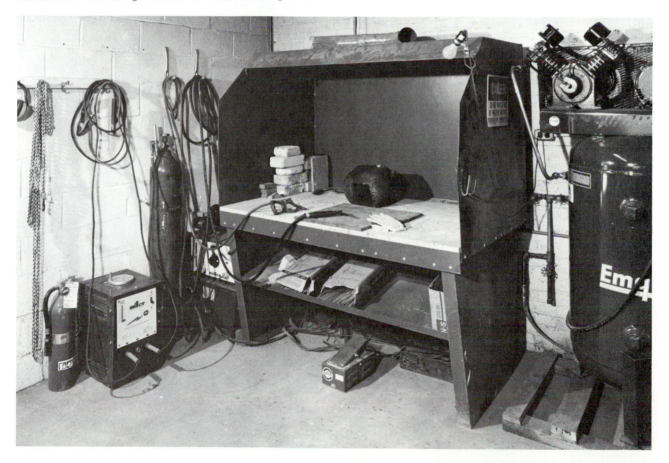

of the TIG welder, a welding helmet, and gloves. On the floor is the foot switch for the TIG welder. A clamp-on light (upper right) is helpful. Not shown in this view is the all-important curtain to shield others in the room from the light of the welder. It is also important to provide good ventilation.

OTHER KINDS OF WELDING

Industry uses a wide array of welding techniques that are suited to particular needs and involve specialized equipment. *Spot welding*, for example, does not mean just welding little spots, but is a process in which big pinchers reach around both sides of two sheets of sheet metal that are pressed together, and zap a current onto one spot, fusing the metal. A spot welder is perfect for joining thin sheet metal, but is limited to that function.

Another somewhat exotic process useful for the sculptor is the *powder torch*. This is an oxy-acetylene torch fitted with a little bottle of metal powder which can flow into the flame and coat a piece of metal. The powder is expensive, but it is a way to plate metal, either with the same kind of metal, to build it up, or with a different metal, for surface appearance.

Plasma torches have nothing to do with blood-banks, but involve an electric arc through which a stream of gas is shot, growing so hot it can melt steel or other metal like a laser. These torches are expensive but will cut any metal, unlike oxy-acetylene cutting torches, which cut only steel. They are particularly useful in a large and well-equipped studio where lots of work is handled.

Information on any advanced welding process can be obtained from your welding supplier or local trade school.

OTHER WAYS TO FASTEN METAL

Welding is only one way to fasten pieces of metal together. The other two ways are mechanical fasteners and adhesives.

Mechanical Fasteners

Sheet metal screws. *Mechanical fasteners* refers to nuts and bolts or rivets. Let's begin with the simplest screw fastenings, sheet metal screws. These are called *self-tapping*, since all you do is drill a properly sized hole, and screw them in. They will bend the thin sheet metal enough to create a once-around spiral into which the threads of the screw can bite. Sheet metal screws are good for thin sheet metal only.

Nuts and bolts. You can make a strong joint in thicker metal with nuts and bolts. (The bolt is the long thing; the nut is the doughnut that screws onto it.) Bolts come in a bewildering variety of names and sizes, but they can be explained very quickly. We're talking here about metal bolts, not tapered wood screws.

The *stove bolt* is a common hardware store item, and a very useful one for the sculptor. Stove bolts have different kinds of heads: flat, round, and hexagonal (Figure 14-36). The hex head bolts are often called *machine screws*. There are three measurements associated with them. First is the length of the screw itself, measured from the bottom of the head to the other end; second is the outside diameter of the screw shaft; and third is the number of threads per inch. Thus, a 2 inch ¼ by 20 means a 2-inch-long bolt, ¼ inch in diameter, with 20 threads per inch. Sizes from ³⁄₁₆ inch diameter up will be in fractions of an inch, but those below that will be in number size, followed by the number of threads per inch. Common sizes are 10, 8, and 6, getting smaller in that order.

Thread sizes. There are two basic kinds of threads in common American usage, the *N.C.* (National Coarse) and *N.F.* (National Fine). The N.C. is the more common. A ¼ inch by 20 thread is N.C.; the N.F. would be ¼ inch by 28. Go to a hardware store and look at both to sense the difference, and always be aware of the differ-

FIGURE 14-36 Different kinds of common bolts: (*from top*) flat-head stove bolt, round head-stove bolt, hex-head stove bolt.

ence when buying metal screws, as you can easily buy the bolt for one and the nut for another, or the wrong tap, and the things just won't go together. You use N.C. for most purposes, but use N.F. when you are threading into thin material and want more threads than the coarse would allow, or if for some reason you want a thin nut.

Metric screws. Don't be frightened of metric measurements. Metrics are actually a lot easier to use than our clumsy English or American units are. Problems only occur when you try to convert from one to the other; if you use one *or* the other, there is no problem. Many hardware stores now carry metric machine screws and tap and die sets, and you might consider changing to that standard, particularly if there is any international aspect to your work.

Metric screws are measured a little differently. First, the diameter is always indicated in millimeters, with common sizes being 2, 3, 3.5, 4, 5, 6, 8, 10, and 12. The thread pitch is shown differently, however. Rather than the number of threads per inch, the actual distance between two thread peaks is measured in tenths of a millimeter. Thus a typical metric screw might be 5mm dia., .8mm thread, or a 5 × .8. More about tap drill sizes later.

Materials for screws. Another consideration is the material from which the screw is made. Ordinary steel is most common, but there are three other materials that have special applications. Some screws or bolts are specially hardened. They have three small lines on the head (Figure 14-37), and can be used wherever special strength or wear resistance is needed. Stainless steel is best when the screw must go into bronze or other non-ferrous metal, particularly for exterior use. Brass or bronze screws are best where appearance will be improved by such a color, or when going into bronze for uses where high strength is not required. When steel goes into bronze outdoors, you must worry about electrolysis, where two different metals in contact will corrode in a damp atmosphere. Two ways to avoid this are electrical isolation of the two metals, or the use of stainless steel.

Threading Metal

Taps and dies are very useful for the sculptor, and you should practice with each on scrap material until you can confidently tap or thread metal.

Taps. Taps make screw threads inside holes. A set of taps includes many sizes, plus a tap handle or tap wrench. There are three kinds of taps, though you can usually find only the first kind in a hardware store. You can make the other kinds yourself. The three kinds are: taper, plug, and bottoming. The *taper tap* is tapered for easy starting, and is fine for threading through a piece of metal, but if you are going into a blind hole, it won't go all the way. When you reach bottom, change to a *plug tap*, which is somewhat tapered but blunt on the end. When that hits bottom, you change to the *bottoming tap*, which has no taper at all, and will cut those last few threads at the bottom of the hole. You can't easily find plug and bottoming taps in stores. If you are threading blind holes where you need threads all the way to the bottom, buy three taps of the correct size, and use a bench grinder to grind off about half the taper on the second one, and all the taper on the third. Keep a can of water handy, and dip the tap into the water constantly so it never becomes too hot to touch with your fingers.

Tap drills. Taps are marked with the same thread sizes as screws, but the trick is getting the proper size hole. Most drill bits are sized in fractions of an inch, which works fine, but there are also number drills, with sizes by number. These represent odd sizes, between some of the fractional sizes. For taps ¼ inch and smaller, they make correct sized holes. Instead of buying a whole set of number drills, just buy the ones you need. A ¼ inch by 20 thread is your workhorse thread in most cases, and that needs a number 7 drill, so buy a number 7 and keep it with your taps. Likewise, smaller taps work best in holes drilled with the correct number drill, so buy drills that fit the taps you have and keep them with the taps. For taps larger than ¼ inch, the fractional drills are

FIGURE 14-37 Heads of a hardened bolt and a regular bolt. The hardened bolt has the three raised ridges.

fine. The chart below shows all correct drill sizes for N.C. and N.F.

Metric tap drills. Finding the correct drill size for metric taps is easy. Metric drills are measured in millimeters and tenths of a millimeter. Simply subtract the pitch size of the screw from the screw diameter, and you have the drill size; for example, a 5 by .8 screw needs a 4.2 mm drill.

Tapping holes. You need a careful touch in tapping metal if you want to avoid stripping the threads out, or worse, breaking the tap off in the hole. Once you've drilled the proper sized hole, start with a taper tap securely tightened in the tap wrench. Place the end of the tap in the hole, hold the tap as near to perfectly aligned with the hole as possible, and press down hard, giving a little turn, about a quarter revolution. It should bite. If it doesn't, try again, and keep applying pressure as you turn so it bites into the metal. At that point apply a few drops of either light oil or thread-cutting fluid to the tap. Still pressing down hard, give it another smooth but steady quarter turn. At this point, back it up just a bit, and then go ahead again. Soon the tap will be in the thread, and you can proceed without the downward pressure, but remember to move forward about a quarter turn, then back up, then go forward a half turn (making up

the quarter you backed up, plus another quarter forward) and back up again. The backing up breaks off the chips that form. If you are doing a deep hole, back the tap out of the hole now and then and clean it off, then continue. Some metals cut cleanly without so much backing up, but others need it.

There is really only one way to find how much pressure you can put on a tap before it breaks, and that is to break a few. Big taps (½ inch or so) won't break, but a ¼ inch breaks without much trouble, and the small ones break easily if you're not careful. Don't put pressure way out on the ends of the tap wrench handles, but hold the wrench in close, and feel the tap beginning to bend. Use plenty of cutting fluid, and back the whole tap out now and then to clean off metal bits and dirt. If you do break a tap, it may have enough of a stub sticking out so that you can grab it with pliers and back out. You can buy tap removers, but they don't work well for small taps. All you can do is to grind it flush, then drill a new hole and go more carefully.

Threading with a die. A die cuts threads on a rod to make a screw. You'll use a die less often than a tap, but it is still handy. You must use the proper size die to fit your rod, which is the thread diameter matching the rod diameter. It is almost always necessary to grind a short taper on the end of the rod to start the die. Be

CHART OF TAP AND DRILL SIZES

Fractional Size	Wire Size	Number of Threads per Inch	Decimal Size	Drill Size	Alternate Drill Size
		National Coarse Drill Sizes (NC)			
1/8	5	40	.125	33	7/64 (s)
	6	32	.138	36	7/64
	8	32	.164	29	9/64
3/16	10	24	.190	25	5/32
	12	24	.216	16	11/64 (s)
1/4		20	.250	7	13/64
5/16		18	.3125	F	1/4 (s)
3/8		16	.375	5/16	
7/16		14	.4375	U	3/8
1/2		13	.5	27/64	
		National Fine Drill Sizes (NC)			
1/8	5	44	.125	37	7/64
	6	40	.138	33	1/8
	8	36	.164	29	9/64
3/16	10	32	.190	21	5/32 (s)
	12	28	.216	14	3/16
1/4		28	.250	3	7/32
5/16		24	.3125	I	9/32
3/8		24	.3750	Q	11/32
7/16		20	.4375	25/64	
1/2		20	.5	29/64	

Note: Alternate drill size will be either slightly small or slightly large, but is given in case no number or letter drill is available. If the alternate is slightly small, it is indicated (s), and should be enlarged with a reamer before tapping.

sure the die is in the wrench so you are starting from the tapered side. (The die usually says "start from this side" on the correct side.) Notice the little slit in the edge of the die. Die wrenches have a pointed screw that goes in that slit, that expands the die slightly. Turning that screw in tight expands the die, and the thread is really easy to make, but nuts won't fit on it. Leaving the screw out altogether makes it hard to thread, and nuts will be a little loose on the finished thread. So begin with the screw in tight, expanding the die, and make the thread. Then loosen the screw and cut the thread again, this time trying the nut for fit. Keep recutting with the adjusting screw ever looser until the nut goes on perfectly. Be very careful to start the die straight, because if it heads off at an angle, you won't get far before it refuses to cut any more.

Rivets

Most of the rivets used in sculpture are *pop rivets*. They are useful for holding thin pieces of sheet metal together. Pop riveters can be bought in any hardware store. All you do is drill a hole through the two pieces, insert the rivet, and squeeze the handles. They are fast, neat, tight, and permanent, so get things right before you rivet, because you can't get them apart without a serious hassle.

Adhesives

Amazingly, you can glue metal together quite effectively. This is handy when you want an invisible join, without a weld bead or bolt head showing. There are three major factors in making a good adhesive bond: the kind of adhesive, the joint design, and surface preparation.

Kinds of adhesives. New adhesives seem to appear on the market almost every day. Chief among those to consider for metal are the *epoxies*, and the *cyanoacrylates* (super glues). Epoxy glues have enough body to fill in gaps. They mix in two even proportions, and can be very strong, but they are very sensitive to correct surface preparation. Super glues seem to tolerate less perfectly prepared surfaces, but are more dependent on close joint design.

You can use five-minute epoxy, the kind that has two tubes fastened together so a common plunger pushes out equal amounts, to stick metal together with great success.

Joint design. The best joint is the one with the most area in contact. Joining two playing cards face to face is easy; joining those same cards edge to edge is almost impossible. Any time you can overlap pieces, bringing flat surfaces tightly together, you increase the strength of the joint.

Surface preparation. Surfaces must be thoroughly cleaned and slightly roughened to be joined. Cleaning is most important. When things look clean, they are not. When metal looks dry, it is not. To demonstrate this, take a dry piece of steel that has been lying around. Hold a welding torch flame on it and notice all the water retreating from the hot spot.

Cleaning grease and oil off metal is best done by sandpapering or sandblasting. Don't wash it with soap and water because you'll just add grease. You can also wash the metal with acetone, trichlorethelene, or another industrial degreaser. Don't smoke while you do this, have good ventilation, and keep the degreaser off your skin. The combination of roughing with sandpaper or sandblaster, plus degreasing with a good degreaser should give you a surface clean enough to accept glue well. Warming the metal and letting it cool drives off residual moisture. With super glue, however, a little moisture, even a smear of spit, sometimes aids the bond. Experiment. If you still have joint failures, try etching the metal in acid, or else weld or bolt it.

CUTTING METAL

The cutting torch is the basic metal cutting tool, though it works only on steel. There are other mechanical means for cutting metal that work on non-ferrous metals and are more precise.

The hacksaw. Don't underestimate hacksaws, because they do wonders in skilled hands, and quickly, too. Be sure you own a good hacksaw, and buy plenty of blades, preferably of different kinds. Materials for blades, range from the "home handyman cheapy," which is just hardened steel, up through the harder *molybdenum* (pronounced mol-EB-de-num), and on to even harder tungsten blades. The high-priced blade at the local hardware store is usually molybdenum, and best for your uses. Since you'll probably be cutting thin stock, get a blade with enough teeth per inch (24 is considered fine-tooth) so there are at least two teeth touching the material. If the material is thinner than two teeth, you strip teeth off. Use fewer teeth per inch for thicker material.

As with just about anything in life, practice helps. Use brass or soft steel, and practice cutting exactly on a scribed line, using steady but not frantic forward strokes and slightly lifted back strokes. Be sure the blade is in the saw with the teeth forward, and nice and tight. Slow steady work beats furious flailing every time.

The bandsaw. A metal-cutting bandsaw is very handy for cutting non-ferrous metals. Blades can be bought that cut steel as well. The metal-cutting bandsaw is a regular bandsaw geared down to about one-tenth the speed,

to something like 300 feet per minute or less, as compared to 3,000 for woodcutting (Figure 14-38). To use, select an appropriate blade, noting that the speed of the blade means you can get away with fewer teeth per inch than on a handsaw; then cut with steady but not excessive pressure. Use jigs and supports wherever possible.

Tablesaws. The woodshop tablesaw is also handy for cutting metal. Buy a metal-cutting blade for circular saws. Some look like cardboard but cut like mad. Don't confuse them with masonry blades, which look similar. A masonry blade won't cut metal well at all, so look at the label and use the right kind.

Always wear full face shield and good gloves when cutting metal with a tablesaw. Before cutting metal, particularly steel, clean the space beneath the saw of all sawdust so sparks don't start a fire. And be sure you plan each cut so you know exactly how to support the metal for the full cut. It is much more touchy than wood.

There are also non-ferrous metal-cutting blades (Figure 14-39) that look a lot like carbide-tipped wood-cutting blades, but have a different angle of attack. They cut plates of brass, bronze, and aluminum neatly and quickly.

Sabersaws with metal-cutting blades work well on

FIGURE 14-39 A non-ferrous metal cutting blade, carbide tipped. (Note the angle of the teeth, nearly straight out from the center.)

thin metals, and can cut even fairly heavy plate, given a strong enough saw.

Nibblers cut nice flat curves and free shapes in thin metal.

GRINDING

There are lots of ways to alter the shape of metal with grinding. You must remember that any time you grind metal with a power grinder, *put on good goggles or eye protection.* It only takes one fraction of a second for a sharp piece of metal to flash into your eye and blind you forever. No matter how big and tough you are, your eyes are no tougher than anyone else's, and you only have two of them. That's not so you have a spare. Your eyes work as a pair. Walk around for a few minutes with one eye closed and see how you'd like living the rest of your life like that. Now, go get some goggles!

The basic bench grinder is a useful tool, particularly for cleaning up the edges of cut pieces (Figure 14-40). Learn to use it as a part of making a cut, so the cuts end up clean and precise.

A combination disc and belt sander, normally made for wood, works well with metal for a little more precision. You can use either the disc or belt, though it will dull the sandpaper and make it less suitable for wood. Again, wear eye protection, and make sure that you don't grab hot metal with bare hands. As with the circular saw, clean out any sawdust before grinding steel, so sparks can't cause a fire.

Body grinders work well, too, but are only as good as the abrasive disc fitted to them. The standard hard grinding disc that usually comes in the box with a new mini-grinder (4 inches) is your workhorse, so buy a box or two of these discs. You can also get a pad to support heavy sandpaper discs in various grits, such as 36, 50,

FIGURE 14-38 A metal-cutting bandsaw.

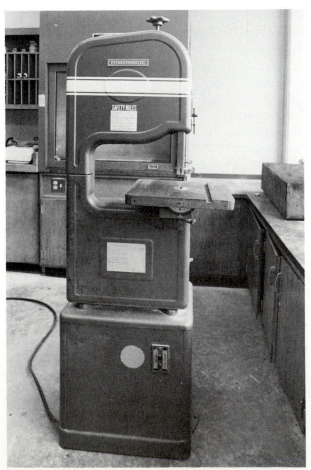

FIGURE 14-40 An 8-inch bench grinder, with wire wheel on the left.

or 80. These are very handy. Italian discs with small holes, called ZEC Abrasive Sanding Discs, are particularly effective for removing the tough dark film on hot rolled plate. You can also find variations on flap wheels that fit body grinders and work for smoothing surfaces.

Die grinders, though they are less useful for cleaning metal forms, can be used with stone points for reaching small areas and odd shapes.

FORGING

Forging means altering the shape of metal by hammering or bending. For steel, red heat is essential. You can heat steel most easily with a welding torch, but a proper forge is more efficient for serious forging. One way to heat steel with a torch is to clamp the torch in a padded vise, so you can easily reach the valves and the flame is in a handy position. This way you can hold the metal in one hand, the hammer in the other, then heat the metal and hammer it quickly without setting anything down or picking anything up (Figure 14-41).

Making a forge. A forge is nothing more than a bed of cinders on which you build a coke fire with air pumped in to make real heat. Cut eight inches off the bottom of a 55 gallon drum and mount it on legs. Then fit a blower hose to come right up through the middle of the bottom. Line the drum with sand, then cinders. Build a small wood fire on it, pile coal on the wood fire until it's going well, then pile coke on that, and get some air going. Soon you'll have a good coke fire. It produces a lot of heat and is best for serious forging, but, since it takes a while to get it going, you obviously don't use it

for a bit of banging here and there. Because the fire is extremely hot, you should have good ventilation, or work outdoors—such as under a spreading chestnut tree.

The anvil. The best thing to forge on is a good anvil, mounted securely on a stout section of tree trunk

FIGURE 14-41 A heating torch clamped in a padded vise for forging.

so the wood absorbs some vibration. An anvil is really a support for a set of blacksmith's tools that fit into it, to enable you to cut, punch, cup, groove, and so on. If you can find an old set of tools, you will be well-equipped. Otherwise, you must work with the nose and edges of the anvil. A stout section of log carved into a shallow hollow at the top also works for simple smithing. The wood chars under the hot steel (wetting it helps) but serves well.

You will learn to judge the correct heat of the metal as you work. Metal that is a dull, deep red will be hard to form, while brightly glowing yellow will be too soft.

You usually won't blacksmith a whole piece, but may forge pieces here and there, such as bending a rod or bar, flattening ends of bars, or beating the odd cup shape into plate. Two contemporary Spanish sculptors, Chillida and Martin Chirino, make works of forged steel. Chillida makes enormous things with massive equipment, but this piece by Chirino (Figure 14-42) could be made with studio-size equipment.

Remember that brass, bronze, and most non-ferrous metals cannot be forged with heat, since they do not grow pliable with heat, but rather, become breakable.

Instead, hammer them at room temperature. They soon "work harden" and become brittle, and at that point you *anneal* them by heating them to gentle red heat (red heat for brass and bronze—well under red heat for aluminum) and let them cool. This "resets" the molecules into the new shape, and allows them to be moved further before strain sets in and annealing is necessary again.

An example of magnificent work in cut, hammered, and welded bronze is *Still Life with Clarinet* by Kazuma Oshita (Figure 14-43). The entire sculpture was fabricated of sheet bronze—even the apples! It is an amazing *tour de force*.

MAKING METAL SCULPTURE

You now have all the tools you need to make metal sculpture. You can cut metal, grind it, forge it, and join it. With all the metal available in our society, from new stock to old junk, and the fact that any piece of metal can be left as found or changed profoundly, all that you need is imagination.

FIGURE 14-42 Martin Chirino, Landscape Mediterranea I. 1973, forged steel. Courtesy of the Grace Borgenicht Gallery, New York.

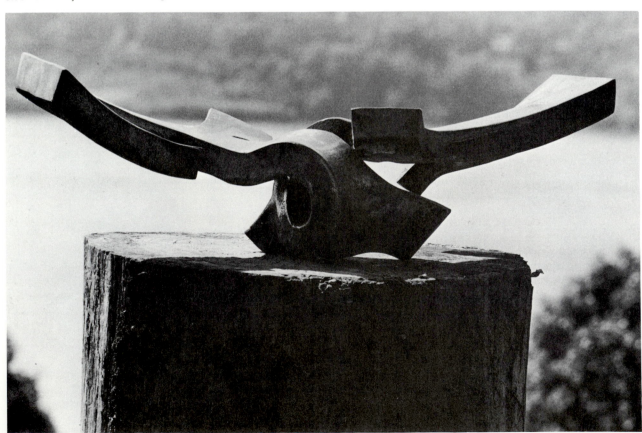

FIGURE 14-43 Kazuma Oshita, Still Life with Clarinet. 1984, hammered bronze. Alexander F. Milliken, Inc.; photo by Steven Sloman.

There is one more item that can be very useful for making metal sculpture, particularly large metal sculpture, and that is the professional metalworker. Many sculptors can get commissions on the basis of small models, then have the pieces fabricated in professional workshops. The cost of fabrication is included in the cost of the final piece.

Michigan sculptor Marcia Wood designed this piece (Figures 14-44 through 14-47) by starting with pencil sketches, then moving to small cardboard models. She went through the same sort of mental procedures described in the early chapters of this book. When she had a design that seemed right to her, she took the design to K & M Machine Fabricating Company in southern Michigan for fabrication. In their vast factory with modern equipment and skilled metalworkers, K & M fabricated the piece out of ¼ inch stainless steel, with the artist constantly present to supervise.

This is the way most large public sculptures, such as the Oldenburg *Bat Column* in Chicago, are made. Using professionals to fabricate your design is not cheating, nor is it unauthentic. After all, architects are responsible for their buildings, even though they don't lay the bricks themselves.

KINETIC SCULPTURE

Kinetic sculpture is sculpture that moves. Such sculpture is usually made of metal, though wood, bronze, glass, plastic, paper, and almost anything else can serve.

All motion depends on energy, and there are three common sources for kinetic works (though this listing of three is by no means all-inclusive). First, motors can turn, wobble, oscillate, or otherwise move the sculpture. Second, the wind outdoors or light currents indoors can move sculptures. And third, the viewer can be invited to prod, push, touch or otherwise set the piece in motion. Try to think of other ways to make sculptures move.

Although the variety of motion is limitless, it falls into a few categories. A piece can rotate around and around, oscillate back and forth, wiggle, sway, or move like a pendulum.

Some Examples

Surely the dean of kinetic sculptors today is George Rickey. His works use air for the energy source, either outdoor winds or gentle interior currents. While they can be helped by a friendly push, most move by themselves in air.

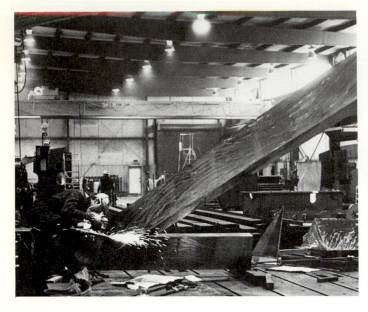

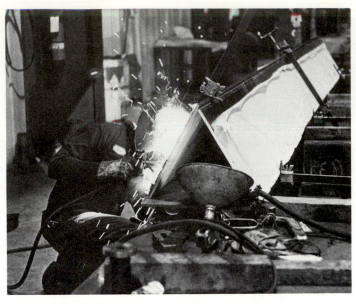

FIGURE 14-44 Marcia Wood, Avec Compassion.
1984, stainless steel. Under construction at the fabricator.
Courtesy of K & M Machine Fabricating, Inc., Cassopolis,
Michigan: photos by the artist.

FIGURE 14-45 Sculpture being welded.

FIGURE 14-46 Sculpture being hoisted at fabricators.

FIGURE 14-47 Marcia Wood, Avec Compassion,
compete and installed.

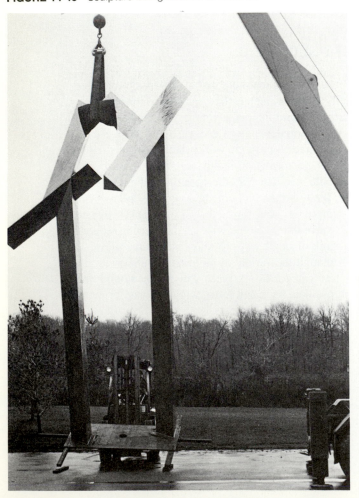

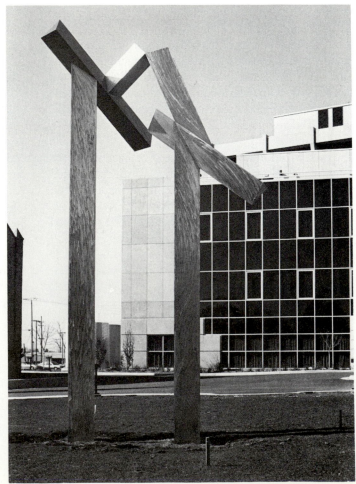

Rickey works in stainless steel, making hollow geometric forms of very thin metal. He adds interior weights to create balance points near the ends of long pieces. These long ends present a lot of surface to catch the wind. The nearer a piece is to being perfectly balanced, the slower its motion will be.

Most of his pieces involve oscillation or rotation. (Figure 14-48) is based on a section of a cone that rotates at the end of a long bar, which in turn rotates on the central shaft. All the points of rotation use smoothly operating ball bearings, so the piece is in constant motion.

Konstantin Milonadis also works with air-powered kinetic sculpture, but since his are intended to catch the wisps of interior breezes, they are made of extremely thin stainless wire, silver soldered together (Figure 14-49). They too have extremely free bearings, but can use simple bearings since the parts are so light. Their lightness is what allows them to move so easily.

This piece by Alan DeFrees (Figure 14-50) needs a gentle push from the viewer to set it in motion. But the motion is not as simple as it looks. Each upright is connected to the next by a piece of spring wire, so when the first goes, it starts the second moving after a delay, sending a wave of motion down and back.

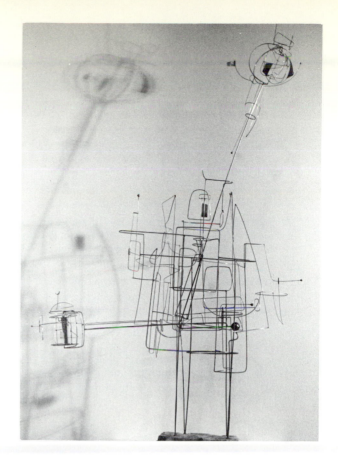

FIGURE 14-49 **Konstantin Milonadis, ARCA, NAVIS, AURA, PORTUS**. 1965, stainless steel. Snite Museum of Art, University of Notre Dame.

FIGURE 14-48 **George Rickey, Two Conical Segments, Gyratory II**. 1979, stainless steel. Snite Museum of Art, University of Notre Dame.

FIGURE 14-50 **Alan DeFrees, Picket Fence**. 1986, various woods, aluminum, bronze, steel. Photo by the artist.

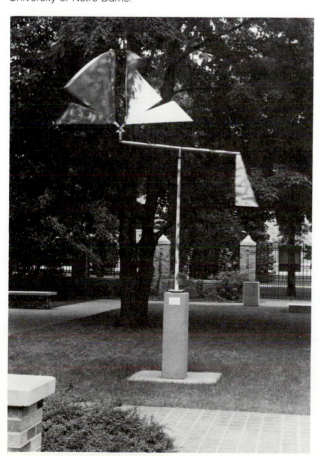

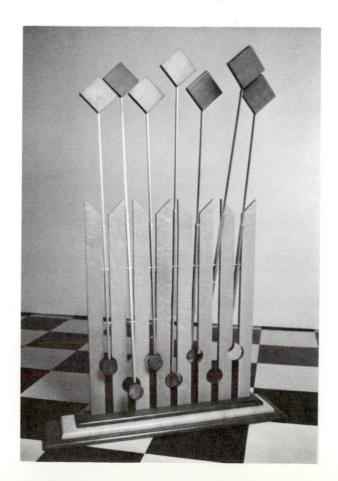

Other Possibilities

The possibilities are endless, of course, but here are a few ideas for kinetic works to jog your mind.

A piece could float and move across a pond with the wind.

A piece could contain a jet of water moving in different directions and setting other elements in motion.

A motor could drive wheels by means of a long rubber belt, each wheel having a slightly sticky bearing. This would cause the wheels to stick, the belt to stretch, and the wheels to turn fast for a moment, all at random.

Nonrigid elements like cloth could impart motion.

Elaborate machines could be created. You may have seen the "clock" in the Port Authority Bus Terminal in New York in which balls are sent endlessly along tracks and chutes.

Kinetic works can be funny, containing surprises, or can involve biting commentary with ominous or mind-lessly dull motion. But remember that kinetic sculpture is like a dancer. There is interest in the dancer, as there is interest in the sculpture, but the real interest is in the movement.

FINAL THOUGHTS ON METAL

Clay, stone, and wood have been here far longer than humans, but metal was useless until we learned to melt it, alloy it, and forge it. Thus metal is associated with humans, far more than other materials. Metal is hard, yet can be liquid; it is strong, yet can be foil; it is permanent, yet rusts away; it can be beautiful, yet can be junk; it can be cold and impersonal, yet can be lyric and expressive. It is perhaps the single most adaptable material the sculptor can use.

FIFTEEN

Other Materials

By now it should be clear that I believe sculpture is the expression of thought, made visible to others by making objects that embody our ideas. No material is beyond reach of the sculptor, whose only limits are those of the suitability of the material to the idea and the ability of the artist to convert material to expression.

However (there is always a lurking "however" in this sort of statement), there are some materials that usually work better for sculpture than others—the so-called traditional materials—and those have been covered in previous chapters. This leaves all the other material in the world, so we may need to consider some limits.

PERMANENCE

The ancient Egyptians felt that images of the pharoahs ensured their everlasting life, so the images were made in the most permanent materials known. The traditional materials of most of Western sculpture, marble and bronze, are almost permanent, but not completely so. Bronze, left outside untreated, corrodes in the atmosphere and may not last much beyond one thousand years. Likewise, marble erodes rather quickly in the open air, so most great marble sculptures have been taken inside, where they are indeed permanent.

How permanent do we want our sculptures to be? Some argue that in this uncertain age teetering on the brink of nuclear annihilation, permanence beyond just a few years is pointless. Others counter this by arguing that either we will survive this threat, or our works should be made permanent to provide a record of human thought. Some believe that there are too many sculptures around already, so perhaps slowly self-destructing works are not an altogether bad thing. Others point out that human thought has reached back into past centuries, so who knows what future minds may be touched deeply by today's works.

Think of the example of music in this regard. Music played before the age of recording was all lost; it lasted only as long as it took to play. Bach traveled many miles on foot to hear Buxtehude improvise on the organ. What did he play that so strongly affected Bach? Beethoven used to improvise for hours, losing himself in a sort of trance while he journeyed to distant musical lands. Gone . . . all gone. Yet all these musicians worked hard to record on paper some of their music, without which they would only be names.

It is worthwhile to spend some time thinking about these debates, and arriving at your own conclusions. Here is a suggestion regarding the permanence of your work. You might run through a lot of ideas with small models and sketches; these need not be permanent. However, when you clarify your thoughts and refine them into a more serious statement, it would be a shame to let all that effort evaporate quickly due to your choice of materials. If what you have to say has any merit, you might want to let future generations have a look at it.

AWARENESS OF MATERIALS

We live in a universe of matter. We ourselves are matter, and everything around us is matter. To become aware of the multiplicity of materials around you, try this: Sitting wherever you are as you read this, look around, making a mental list of the different materials you see—and don't forget the air! Like the old game of Twenty Questions,

with its categories of ''animal, vegetable, or mineral,'' you will see organic and inorganic materials. You will see leather and hair and skin; you will see plant fibers and wood; you will see metals of many varieties and stone, cement, plaster, clay (dishes, for example) and glass; as well as man-made materials such as plastic, paint, cardboard, paper, and rubber.

But you may also notice that you soon sense a pattern to materials, and that there are actually relatively few categories. You will see a lot of metal and wood. You will see a lot of cloth and paper. You will see a lot of plastic, glass, ceramic, cement, and plaster. And you will see air, water, and sand. These materials fall into the categories of hard materials, which are usually cut and joined (metal and wood); soft materials (cloth and paper); malleable materials, which are worked soft then hardened (ceramic, glass, plastic, plaster, and cement); and nonfixed materials, liquids and gases, or collections of particles such as sand.

New Uses for Old Materials

Many of the traditional sculpture materials already covered can be used in ways other than those described. For example, we looked at wax as a transitional material in metal casting, but Medardo Rosso used wax as a final material (Figure 15-1). He modeled in clay as usual, then

FIGURE 15-1 Medardo Rosso, The Concierge. 1893, wax over plaster. Collection, The Museum of Modern Art, New York; Mrs. Wendell T. Bush Fund.

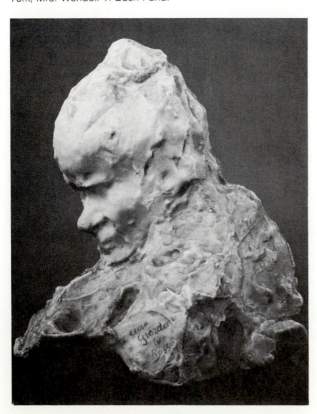

took a plaster mold and painted in a rather heavy (½ inch thick) layer of beeswax. Then he applied an inner shell of plaster to hold the form rigid. After he removed the plaster mold and retouched it, the sculpture was complete. He liked the translucent atmospheric look of the wax, which suited his impressionistic sculptural ideas.

The same technique has been used by other sculptors, the most famous being the extremely lifelike figures created by Madame Tussaud in the famous London Waxworks. Here, however, the wax is used as a base for the application of hair (each hair set in a tiny hole poked in the soft wax, then pressed closed) and for makeup— regular store-bought makeup for lifelike color.

Clay is usually treated as an intermediate material for later casting, as we have seen, or fired, as in ceramic sculpture. But clay can be left to air dry. The two bison in the cave at Tuc D'Audubert, some 15,000 years old, attest to the permanence of unfired clay, if left alone. I have also seen works in which dry powdered clay was used as a fluid material.

Our discussion of metal casting was concerned with careful control of the molten metal, feeding it into a carefully made mold so as to recreate a predetermined shape. But metal left uncontrolled takes a shape, though an unpredictable one. For example, years ago I melted small pieces of silver with a torch, then poured the molten metal into a pail of water. Fishing around, I pulled the bits out, looking for interesting ones. I remelted those globs which were not interesting, and poured again. In a half hour I had ''created'' dozens of small sculptures, from which I selected one to save (Figure 15-2). Molten bronze could be run out on a steel plate, forming shapes and patterns impossible to achieve any other way. The work by Michael Todd uses bronze ''cast'' this way (Figure 14-7).

We have already talked about using stone and wood in ways other than carving, so those materials should now present to you a much wider range of possibilities than before.

Nontraditional Materials

Some materials have been used for sculpture only rarely and in limited ways, yet are found in our daily lives. Glass, for example, is such a material. Blown, cast, or carved glass sculptures are usually difficult to produce, requiring specialized equipment and techniques. Yet every house, every building has lots of glass in the windows, and sheets of glass are available at every hardware store. And glass bottles are very common.

Using glass. Glass can be cut with a glasscutter. To make a straight cut in window glass, set the glass on a smooth hard surface and hold a straightedge tightly along the planned cut, with the straightedge covering the

circular scratch either with a circle cutter or around a pattern; then make radiating cuts like spokes to allow material to break away (Figure 15-5). Use pliers to snap off very small bits.

You can sand glass on a sander (**goggles! and gloves!**) to smooth edges, but polishing is beyond the capabilities of most shops. If there is a glass department in your school, they can help you learn.

Glass can be joined with epoxy glue, using the principles of thorough degreasing and cleaning before making the joint. Also, always try to have the maximum surface contact in a joint. Glass can usually be glued to other materials the same way.

This is only a brief introduction to glass as a sculptural material. Glass is gaining ground as a serious sculptural medium, and artists of significant stature are using it with great success. However, glass is a difficult me-

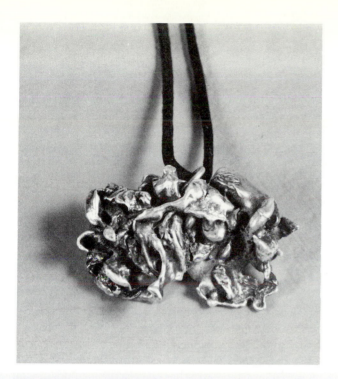

FIGURE 15-2 Tuck Langland, Necklace. 1962, poured silver.

piece you want to keep. Press harder on the straightedge than on the cutter, or the straightedge will slide. You can also get someone else to hold it, or you can clamp it, but you must be careful with clamps or you'll break the glass.

Run the glasscutter along the line of the cut (Figure 15-3). When it is working, it makes a characteristic hissing sound. If you don't hear that sound it isn't making the scratch, so be sure you get that sound all along the cut. It doesn't help to go over and over the cut. One tiny scratch is enough, but it must extend all along the cut, right out to each end. Remove the straightedge and be sure you made a scratch all the way.

Here's the tricky and fun part. Place the glass on the table, with the scratch on top and running right along the edge of the table, so the part you want to break off is hanging over the edge. Simply give it a sharp push and break it (Figure 15-4). There are a couple of tricks to doing this. Don't press gently, like a wimp, but give it a clean snap. And break it right away. Glass is actually a liquid which is so thick it moves very slowly. Windows in old buildings are measurably thicker at the bottom than at the top because the glass is sagging. The scratch you made breaks the surface tension of the glass, but that break will heal with time, so don't scratch it, then leave it a day or two. Break it right away.

You can make circular cuts or more complex cuts the same way, but always figure out a way to snap off the extra. To make a circular cut, for example, make the

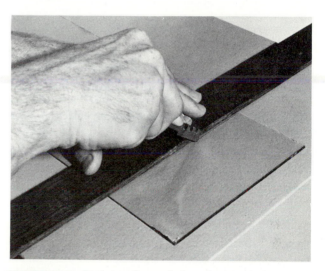

FIGURE 15-3 Cutting ordinary window glass against a straightedge.

FIGURE 15-4 Snapping off the cut.

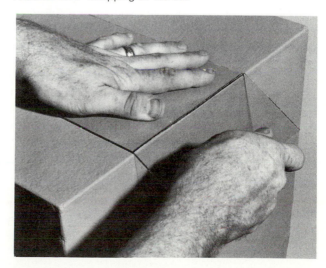

FIGURE 15-5 A plan of cuts for cutting circles or irregular shapes in glass. Always allow relatively simple pieces to snap off.

dium, to which a whole range of complex techniques can be applied—from blowing, to hot forming by other means, to engraving, carving, and even casting. Work with glass on a serious level will probably occur only in a school with a strong glass department.

Plastics

Not many years ago, this would have been a complete chapter, or even series of chapters. But plastics have lost some of their early luster as a sculpture material, and appear less often than they used to. I am reminded of the famous line in the film *The Graduate* in which a harried Dustin Hoffman, beset by grinning congratulators at his graduation party, is told by a leering uncle, ''I just want to say one word . . . Plastics.'' In the film—and in the minds of a whole generation—plastics were severely indicted as a tawdry, cheap material to be avoided.

But in keeping with the spirit of this book, we must approach plastics as we would any other material—that is, as having value as a vehicle for expressing thought. Therefore, as a sculptor, your concern should not be with the inherent value of a material, but with how it can serve your purposes.

Plastics are divided into two sorts—thermoplastic, and thermosetting. *Thermoplastic* gets soft when hot, and stiff when cool, like wax. *Thermosetting* is liquid, then gets hot and turns forever hard, like a boiled egg. Plexiglas is a thermoplastic. You can heat it to bend it, then cool it to make it rigid, and you can do that as many times as you want. Polyester and epoxy resins are thermosets; they harden just once and remain hard forever.

We talked a little about the thermosets as a casting material in chapter nine, but you can do other things with them besides casting. For example, you could dip a piece of cloth (your shirt?) into liquid resin, hang it in a predetermined position, and let it go hard. You now have a stiff shirt. Robert Mallary made several sculptures this way out of old tuxedos suspended by cords from hooks placed all over the walls, floor, and ceiling of a room (Figure 15-6). Wood and other materials were incorporated, and the cords cut off after final setting. The only trouble was that he used epoxy at a time when inadequate information was available about health hazards, and he became very ill. My recommendation is to stay away from epoxies, except for small amounts of glue, and to use polyesters with plenty of ventilation and good respirators.

Some thermosets are clear acrylic resins, which can encase things. I'm sure you've seen paperweights that are clear blocks with flowers or coins embedded inside. These resins, available at hobby stores, can be useful for encapsulating materials, either to give a frozen appearance or to preserve fragile or transitory materials.

With large sculptures of clear resins, we enter a complex field of technology, since the thicker the mass, the greater the heat produced, until it boils, leaving bubbles inside. Bruce Beasley solved this problem with a giant autoclave that increased the atmospheric pressure as the temperature rose, thus raising the boiling point and preventing the bubbles, but that is well beyond the scope of most readers of this book.

Thermoplastics are not terribly difficult to use. Plexiglas, Lexan, and similar plastics are available in sheet form and in blocks, in many colors, including fluo-

FIGURE 15-6 Robert Mallary, The Parachutist. 1962-63, tuxedo, umbrella, and resins. Walker Art Center, Minneapolis; gift of Albert A. List family.

rescents which seem pale in color, but glow at the edges.

Sheets of plastic come with protective paper glued to each side. Work the material with the paper in place until the very last; otherwise you scratch it. The paper is also handy for marking cuts.

Plexiglas can be cut with a standard tablesaw or bandsaw. Use a fine-toothed blade, and check the blade periodically to be sure there is no residue build up. When gum appears, use acetone to wipe it clean.

Plexiglas can be drilled best with tapered drill bits. These are specially made for plastics and cut very nicely, but I'll bet you haven't got any. So go ahead and use regular drill bits, and no one will ever know!

You can sand or use abrasives on Plexiglas to smooth sawcuts prior to polishing. Sandpaper also imparts a frosty or matte surface that can be very effective. Plastics can be polished using polishing compounds available from your plastics supplier. And they can be partially dissolved with acetone, yielding a wide range of interesting effects.

Plexiglas can be bent and formed with heat. There are two problems in doing this: how you heat it, and how you form it.

You can heat Plexiglas or Lexan for forming with heat lamps, hair-dryer-type heat guns, or a kitchen oven at about 280° F. You can also immerse the plastic in hot cooking oil (wash just like a dish later). Boiling water isn't hot enough. You will probably have to *anneal*, or cool the plastic very slowly after forming, to prevent stress cracks. If you heat it in an oven, for example, place the form in the oven with the plastic on it, then close the door, turn the oven off, and allow it to cool several hours.

As for forming, you can either freehand it or use a form. *Freehanding* means simple bending, using gloves. By heating a strip, grabbing it with gloves, and twisting it around, then propping it to cool slowly, you can easily create an endless variety of shapes. Or, you can make a form of wood, plaster, or just about anything that you can manipulate that will take moderate heat. You can press the heated sheet of plastic into it by hand, allowing it to drape naturally, or pull it onto the form with air pressure. For the latter, make a form that is covered with small holes drilled about 1 inch apart all over the surface. Place this form on a table, with an air-tight box built to fit over the top of the form, leaving a few inches of air space, and with holes in the table beneath the form to allow air to escape. Drape the heated sheet of plastic over the form; clamp the box down, covering the edges of the sheet, and apply compressed air to a fitting on the box. Conversely, the air can be drawn with a vacuum pump from beneath the form (Figure 15-7).

The most obvious way to join sheets of plastic is with glue. Usually a solvent glue is used. The two pieces are taped or clamped together, then a very thin fluid of solvent is allowed to be drawn by capillary action into the joint, slightly dissolving the plastics and letting them fuse. These solvent glues are available where you bought the plastics.

Another way to fasten sheets of plastic together is mechanically. They can be drilled and tapped, though the taps tend to gum up easily and require a little more working in and out than metal does. Still, there is something very ''space age'' about a neatly tapped hole with the screw visible inside the clear material. You can even buy nylon screws. Of course you can also bolt and nut right through the material.

There are other ways to fasten plastics, such as lacing and binding, and there is a way to weld plastic, but it requires special equipment and special practice. See your plastics dealer for supplies and information.

Other Plastics

There are many other kinds of plastics in our world which can be adapted for sculptural purposes. For example, plastic laminates (Formica) are very common. Often they have a wood grain surface, but they also come in imitation stone, leather, and cloth, and in smooth plain colors. Laminates can be used as decorative surfaces over wood or other forms.

Many plastics are in the form of thin sheets, such as plastic bags for bread, trash bags, tarpaulins, and Naugahyde made to look like blue jeans or lizard skin. These can be heat-sealed into balloons or sewed, as Oldenburg did with his *Soft Toilet* (see Figure 3-6). They can be crumpled inside a jar, anything. Think. How about a brick-texture plastic glued onto your Buick?

And then there are foams. There are two kinds of plastic foams, rigid and soft. Rigid foams are like styrofoam, which can be bought in sheets and blocks, cut easily with saws or knives and joined with the thick paste glues available for sticking it to walls for insulation. Styrofoam can be used as a base for building plaster (this is how Henry Moore's large pieces are made), covered with cloth or other soft material, tarred and feathered . . . anything. You can burn it with a propane torch for surface effect, but watch out. I did that once and nearly burned down a TV studio where I was working. If a fire gets going (do it outdoors, please), a hose puts it out fast.

Soft foams are like foam rubber. They are available in sheets, blocks, pillows, chair seats, and all sorts of shapes. A manufacturer might be able to supply you with a block 8 feet on a side. What you do with that is your problem! Sheets can be folded, tied, pierced, stuffed in slatted crates, or formed into people or animals.

The foam plastics are created by mixing two components which then foam and set, known technically as thermosetting plastics. These components can be bought, mixed, and either formed in a mold or turned loose. If a mold is used, either plaster or rubber is fine, but treat the mold the same as though you were casting polyester resin. It is best to have a fully closed mold; then calculate, according to the manufacturer's instructions, how much liquid material to pour in. Once the liquid is mixed and poured in, the mold is capped, allowing for air to escape. The foam swells, fills the cavity, and actually creates pressure inside. The more liquid you put into a given space, the greater the pressure created, and the higher the density of the final foam. When it is hard (you can either just leave it overnight, or look at the foam remaining in your mixing container), you remove it. Both rigid and flexible foams can be cast this way.

I once watched a demonstration in which some guys had a gun that shot premixed foam like shooting oatmeal out a hose. This stuff would glob onto things like chairs and ladders, then sit there and swell up, making grotesqueries before our wondering eyes. Such guns are expensive, and the results seemed more suitable for movie companies doing horror flicks than sculptors, but someone might find a use for it.

Soft Materials

This category includes materials like cloth, string, yarn, rope, and paper. As we move into discussing less traditional materials, we also move farther away from being able to describe how to use them. More invention is needed. Cloth, of course, has a long and complex tradition of techniques for using it, called sewing. It would certainly be beyond the scope of this book to try to cover that complex field, so if sewing answers your needs, find books or teachers and learn on your own.

FIGURE 15-7 Plastic forming a jig, using pressure (*top*), and vacuum (*bottom*).

Don't mentally reject sewing because it seems inappropriate to the guts and masculinity of sculpture. Remember, you are making ideas visible, and, as with speech or writing, you need as big a vocabulary as possible.

Paper. Paper is gaining popularity as a casting medium. The principle is to press liquid paper pulp into a mold. Plaster molds are easier to use, though many casters are having success with rubber molds. The pulp is compressed tightly against the mold and allowed to dry completely, forming a cast. Since it is necessary to press the pulp in, relief sculpture is about all that is being cast so far.

The process is tricky and demands an experienced teacher and some practice. The results can be very attractive, though, so it might be worthwhile pursuing if you want lightweight white or multicolored reliefs.

Another way to use paper is in semitraditional *paper sculpture* in which sheets of paper are cut, folded, and glued to form three-dimensional objects and images. Though such sculptures are often of the cute school, I

again insist that any material, any process, is only as good or as bad at the person using it.

Another way to use paper is seen in this provocative piece by the Chicago artist Sherry Healy (Figure 15-8). Beginning with large styrofoam shapes, she applied a thick mixture of paper pulp directly to the styrofoam, almost like cement, letting it harden before fans. This produced forms that were lightweight but visually heavy, with a dark, almost metallic look. Placing them on the wall and surrounding them with what appears to be discarded rope and other refuse, she evokes a sense of discovering the remains of a primitive civilization.

String and cord. There are limitless things that can be done with string and cord, but most have something linear about them, unless you wad the material up in clumps. It can be stretched, laced, braided, woven, or, alternatively, mixed with resin or glue and pressed in molds. This caged back by the Polish Sculptor Magdalena Abakanavowitz was made by mixing coarse yarn with a glue and pressing it into a rough mold (Figure

FIGURE 15-8 Sherry Healy, AGRUA. 1984, hand-formed paper over wood and styrofoam cores. Courtesy of the artist.

FIGURE 15-9 Magdalena Abakanavowitz, The Cage.

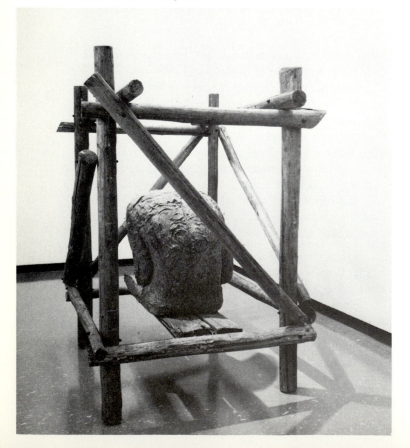

15-9). Strings can be glued over forms creating ridges, as Henry Moore did in Figure 15-10.

Rope can be purely formal, creating a linear element in a work, or it can have associations of bondage and restraint. Chain is another form of rope, as is wire or cable. Thin monofilament fishing line is almost invisible, and can act as tiny strands of light, or can hold objects suspended without obvious support.

Leather is clothlike, but with a special character. It can be sewed into forms like bags or tents, or it can be glued over forms—again, either for its visual color and texture or for its associative effect, as in this work by Nancy Grossman (Figure 15-11). We don't usually think of zippers as sculptural materials, but Grossman's work includes them as an integral part of her formal and narrative language. She uses the associations leather has (black jackets, etc.), then adds the zippers in particularly appropriate places, the eyes. The pulls of the zippers are forms like eyes, and the sense of closing, zipping shut, is highly expressive in this piece.

Found Materials

Dolls, washtubs, banisters, swords, baby bottles, gloves, telephones, trombones, dishes, books, orthopedic appliances, underwear, toothbrushes, computer key-

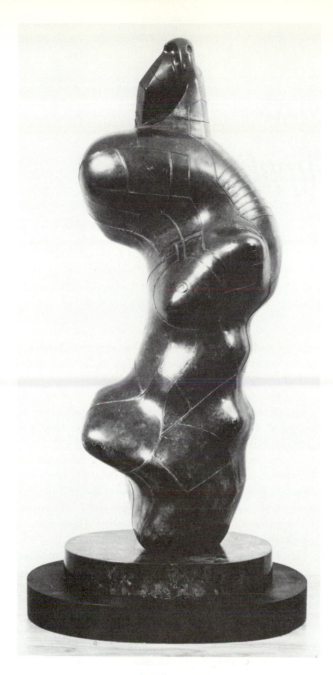

FIGURE 15-10 Henry Moore, 3/4 Figure: *Lines.* 1980, bronze. Courtesy of Kent Fine Arts, New York.

FIGURE 15-11 Nancy Grossman, Ghost. 1977-80, carved wooden head with pigskin, cast aluminium, and zippers. Collection of Bruce and Roxanne Bethany; photo: Geoffrey Clements, New York.

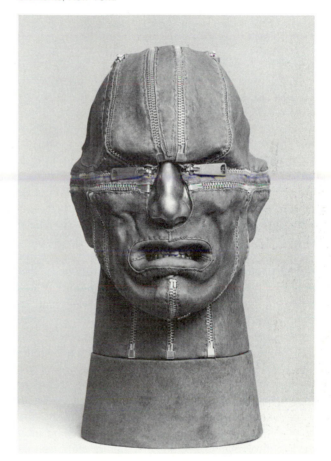

boards, car bumpers, horse harnesses, pencils—anything and everything is fair game if it conveys your ideas. Technique with found materials is all improvisation. What is needed is sensitivity and vision.

So here, at the end of the book, we return to the ideas discussed at the beginning. Think of form, of feelings, of your world, of the shapes you see as you fall asleep, of things that are special to you. Try not to lean on art magazines and the latest fashion in the galleries. Don't try to be like other artists. Try to be yourself. That's the hardest thing of all. If you can do that, then the whole world of forms and materials will become clear to you, and you'll know what to make, and what not to attempt. Your only job is to make your thoughts clear,

to tighten them, edit them, and strip off irrelevant parts, to focus ever more clearly on the essentials. Use any materials at all to let others know your sculptural thoughts, and use as much technical effort as you need to let those materials assume a new life as sculpture.

Derek Sellars, the English sculptor, once said, "If a sculptor goes to a junk yard and collects a bunch of junk, takes it to the studio and makes a sculpture out of it, and then goes back to the junk yard and throws it on the heap, it shouldn't blend in, but should look like someone threw a sculpture there." Let your intelligence and sense of order and arrangement transform materials into *your* work, something that only exists because you ordered it and gave it logic and form.

APPENDIX

List of Suppliers

Finding sources for the tools and materials you need is very important, because without them you can't get the proper things to do your best. And sculpture suppliers are not on every corner. Sometimes you have to search hard to find a certain item, and often you may have to write away for what you need. Here are a few tips to help you locate supplies in your area, or nationally.

First, you can buy many of the things you use from ordinary sources. You can find electric drills, saws, files, sandpaper, paint brushes, etc., in hardware stores or well-equipped lumberyards. Plaster, cement, glue, paint, and lumber also come from those suppliers. Auto parts stores are treasure troves of things like polyester resins, body putty, and sanding and smoothing tools and supplies. There are probably industrial suppliers in your area or town who have a complete range of more specialized tools such as die grinders, air tools, and bandsaw blades.

Don't forget art supply stores. While mostly filled with paint, canvas, paper, and drawing and commercial art supplies, many have some sculpture tools, and can often order supplies for you. Also ceramic shops can be useful sources for sculpture tools.

Another important source of supplies and materials is the Yellow Pages. When you need something and can't find it, get on the horn with the Yellow Pages and start calling around. Chances are you'll be told they don't have it, but ask if they can suggest somewhere else you might call. Often you get three or four leads, one leading to another, and before long you have located a source.

Another good source of suppliers is advertisements in art and sculpture magazines. There are two national magazines devoted solely to sculpture—one rather traditional and the other more contemporary. Both carry ads for tools and supplies, as well as services. Also, look at the regular art magazines, though the ads are mostly for drawing and painting supplies.

The two sculpture magazines are: *Sculpture Review*, published quarterly by the National Sculpture Society, 15 E. 26 St., New York, NY 10010. This is the publication of the traditional, figurative sculpture society.

International Sculpture, published bimonthly by International Sculpture Center, 1050 Potomac Street NW, Washington D.C. 20007. This covers the full range of sculpture, and has, in addition to many ads, frequent lists of suppliers of one category or another. These lists can be obtained from the ISC.

The complex field of suppliers has been broken down in the following list into six categories of suppliers, the larger ones listed alphabetically according to state. The six categories are:

1. *Sculpture tools and materials.* These are specialty stores, usually carrying a full range of modeling and plaster-working tools, wood and stone stools, abrasives, etc., including wood and stone carving blocks, mounting services, and the like.
2. *Mold-making materials.* This category includes manufacturers or suppliers of the various rubbers, resins, and fillers associated with molding and casting in materials other than metal.
3. *Foundry supplies.* This includes materials and equipment directly related to metal casting.
4. *Wood tools.* There are many woodworking suppliers in the country, and most carry carving as well as furniture-oriented tools.
5. *Stone and stone tools.*
6. *Metal tools and supplies*, and other supplies, including plastics, safety equipment, etc.

1. SCULPTURE TOOLS AND MATERIALS

California

A. D. Alpine, Inc., 3051 Fujita St., Torrence, CA 90910.
Ceramic supplies.

M. Flax Inc., 10852 Lindbrook Dr., Los Angeles, CA 90024.

Kemper Tools, P.O. Box 696, Chino, CA 91710.

Connecticut

Foredom Electric Co., Route 6, Bethel, CT 06801.
Flexible shaft grinders.

Florida

Montoya Art Studios, 4110 Georgia Ave., West Palm Beach, FL 33405.
A major supplier of everything for the sculptor.

Maryland

Eagle Ceramics, 12266 Wilkins Ave., Rockville, MD 20852.
General sculpture tools.

New Jersey

Micro Mark, P.O. Box 5112 TN, 24 East Main St., Clinton, NJ 08809.
Miniature tools for small work.

New York

Casting Supply House, 15 West 47th St., New York, NY 10036.

Craftools Inc., 36 Broadway, New York, NY 10013.

New York Center Art Supply, 62 Third Ave., New York, NY 10013.

Schneider Art Supplies Inc., 306 Columbus Ave., New York, NY 10023.

Sculptor's Supplies, Ltd., 99 East 19th St., New York, NY 10003. One of the major suppliers of tools for the sculptor.

Sculpture Associates, 40 East 19th St., New York, NY 10003.
A major nationwide supplier.

Sculpture House, Inc., 38 East 30th Street, New York, NY 10016.
In addition to many imported tools, they also make their own, including a good range of modeling stands.

2. MOLD-MAKING MATERIALS

Design Cast Corp., P.O. Box 134, Princeton, NJ 08540.
Design-Cast (described in the text) is an important casting material.

Perma-Flex Mold Co., 1919 East Livingston Ave., Columbus, OH 43209.
Makers of 21 different formulas of flexible molding compounds.

Polytek Development Corp., P.O. Box 384, Lebanon, NJ 08833.
Makers of urethane molding compounds.

Smooth-On, Inc., 1000 Valley Rd., Gillette, NJ 07933.
Makers of Smooth-On urethane molding compounds.

Synair Corp., P.O. Box 5269, 2003 Amnicola Highway, Chattanooga, TN 37406.
Makers of Pour-a-Mold urethane molding compounds.

Chemicals Division, United States Gypsum Co., 101 South Wacker Drive, Chicago, IL 60606.
This is the place to write to for any questions concerning plaster or plaster products.

Casting resins (polyester recommended) can usually be found locally. A first source is auto parts stores, which carry gallon cans of layup resin, plus various kinds of glass. Looking further in the Yellow Pages, you can find plastics suppliers with a more complete range of resins, and various fillers and release agents etc.

3. FOUNDRY SUPPLIES

Bryant Laboratory, Inc., 1101 Fifth St., Berkeley, CA 94710.
Suppliers of patina chemicals.

The Joseph Dixon Crucible Co., Wayne St., Jersey City, NJ 07303.

Kindt-Collins Co., 12651 Elmwood Ave., Cleveland, OH 44111.
Suppliers of wax products, such as preformed sprues, sticky wax, patching wax, etc. Very useful products.

McEnglevan, 700-708 Griggs St., P.O. Box 31, Danville, IL 61832.
Makers of Speedy Melt bronze furnaces.

Nalco Chemical, 9165 S. Harbor Ave., Chicago, IL 60617.
Makers of ceramic shell slurry.

Premier Wax Co., Inc., 3327 Hidden Valley Dr., Little Rock, AR 72212.
Suppliers of microcrystalline waxes for bronze casting.

Pyrometer Instrument Co., Inc., Bergenfield, NJ 07621.

Syscon International Inc., 1108 High St., South Bend, IN 46618.
Makers of pyrometers.

Shellspen Ceramic Slurry, P.O. Box 113, Sarasota, FL 33578.
Makers of ceramic shell slurry designed to remain suspended without constant stirring.

StanChem, Inc., 401 Berlin St., East Berlin, CT 06023.
Makers of Incra-Lac.

Norman A. Thomas Co., Inc., 742 Woodward Ave., Birmingham, MI 48011.
Suppliers of jewelry-making tools and supplies, including Kerr Jewelry investments.

Additional suggestions for foundry supplies: First, look under Foundry Equipment in your local Yellow Pages. Second, call a few local foundries, particularly those mentioning investment casting, to ask where they buy such materials as a slurry, bronze, and crucibles. In many cases, foundry people are willing to visit your setup and offer suggestions.

4. WOODWORKING SUPPLIES

California

Woodline, The Japan Woodworker, 1731 Clement Ave., Alameda, CA 94501.
Japanese woodworking tools.

Fair Price Tool Co., Box 627F, La Canada, CA 91011.

Connecticut

The Fine Tool Shops, Inc., 20 Backus Ave., Danbury, CT 06810.

Illinois

Craftsman Wood Service, 1735 Courtland Court, Addison, IL 60101.
Wood and tools.

Frog Tool Co. Ltd., 700 West Jackson, Chicago, IL 60606.

Greenlee Tool Corp., 2230 23rd Ave., Rockford, IL 61101.

Massachusetts

Buck Brothers, Riverlin Works, Milbury, MA 01527.

Woodcraft Supply Corp., 41 Atlantic Ave., P.O.Box 4000, Woburn, MA 01888.
One of the biggest and best.

New Mexico

Woodworkers Supply of New Mexico, 5604 Alameda NE, Albuquerque, NM 87113.

New York

Frank Mittermeier, Inc., 3537 E. Tremont Ave., New York, NY 10065.

Garrett Wade Co., 161 Avenue of the Americas, New York, NY 10013.
Ranks with Woodcraft Supply.

Wetzler Clamp Co., Inc., 43-13 11th St., Long Island City, NY 11101.
Makers of all sorts of woodworking clamps.

Ohio

Broadhead Garrett Co., E. 71st St., Cleveland, OH 44101.
A huge firm supplying just about everything for schools, including lots of woodworking and other tools.

Leichtung, 5187 Mayfield Rd., Cleveland, OH 44124.
Woodworking tools.

Woodworking is big business, both professionally and as a widely practiced hobby. Thus there are hundreds of shops selling woodworking tools, woods of all kinds (well beyond the local lumberyard in variety and quality), and everything else associated with wood. One good source for finding lots of suppliers is *Fine Woodworking* magazine from The Taunton Press, Inc., P.O. Box 355, Newtown, CT 06470. Browsing through an issue or two will yield lots of addresses from the many advertisers. They can also supply lists of suppliers.

5. STONE AND STONEWORKING TOOLS

Alabama

Moretti-Harrah Marble Co., P.O. Box 330, Quarry Road, Sylacauga, AL 35150.
Hard white marble.

California

American Pneumatic Tool Company, 14710 Maple Avenue, Gardena, CA 90249.
Pneumatic tools.

Baja-Onyx, P.O. Box 9021, San Diego, CA 92109.
Marble and Onyx bases cut to size and polished.

City Tool Works, 425 Stanford Street, Los Angeles, CA 90013.
Tools.

Fillmore and Garber Inc., 1742 Floradale Ave., South El Monte, CA 91733.
Abrasives, diamond wheels, air tools, etc.

Marble Unlimited, 14554 Keswick St., Van Nuys, CA 91405.

Western Marble Co., 321 West Pico Blvd., Los Angeles, CA 90058.

Colorado

Colorado Alabaster Supply, 1507 North College Avenue, Fort Collins, CO 80524.
Nationwide distributor of alabaster.

Western Sculpture Supply, 2855 West 8th Ave., Denver, CO 80204.

Connecticut

Union Carbide Corp., Old Ridgebury Road, Danbury, CT 06810.

Delaware

Stone Age, RD #1, Box 514, Smyra, DE 19977.

District of Columbia

Cathedral Stone Company, 2505 Reed St. NE, Washington, DC 20018.
A big shop with everything.

Florida

Montoya Art Studios, 4405 Georgia Ave., W. Palm Beach, FL 33405.
A major supplier of everything for the sculptor, including a full range of carving stones and tools.

Sculpture Studios, 1150 Clare Ave., West Palm Beach, FL 33401.

Georgia

Georgia Marble Co., 2575 Cumberland Pkwy. NW, Atlanta, GA 30339.

Illinois

Arrow Equipment Co., 4646 S. Kedzie, Chicago, IL 60623.
Pneumatic tools.

Brunner and Lay Inc., 9300 King Franklin Rd., Chicago, IL 60607.
Tools.

Granite & Marble World Trade, 2434 W. Fulton Ave., Chicago, IL 60612.
Large supplier of all sorts of stone.

Indiana

(Indiana produces the best all-around carving limestone in the country, all of it in the region around Bloomington and Bedford.)

B. G. Headley Quarries, P. O. Box 1224, Bloomington, IN 47402.

Fluck Cut Stone, Inc., P. O. Box 637, Bloomington, IN 47402.

Indiana Limestone Co., Inc., P. O. Box 72, Bedford, IN 47421.

Maine

Bicnel Manufacturing, P. O. Box 627, Rockland, ME 04841.
National distributors of carbide tip tools.

Massachusetts

Bates Brothers Quarries, 611 Pleasant St., East Weymouth, MA 02189.

H. E. Fletcher, Groton Road, West Chelmsford, MA 01863.
Granite.

Maryland

Hilgartner Natural Stone Co., 101 West Cross St., Baltimore, MD 21230.
A large outfit with a wide variety of stones.

Michigan

Marble Institute of America, 33505 State St., Farmington, MI 48024.

US Industrial Tool and Supply Co., 13541 Auburn St., Detroit, MI 48233.
Pneumatic tools.

Minnesota

Mankato Stone Center, P.O. Box 3088, Mankato, MN 56001.
Minnesota limestone.

Vetter Stone Co., P. O. Box 38, Kasota, MN 56050.
Kasota limestone is a dense, hard limestone of great beauty, in a variety of colors. Bases and carving blocks available.

Missouri

The Stone Center, 3200 Brannon Ave., St. Louis, MO 63139.

Nevada

Sierra Marble Ltd., 2150-3100 Mill St., Reno, NV 89502.
Marble.

New Hampshire

Granitech Research, P.O. Box 226, Brookline, NH 03033.
A center for information on granite.

New York

Ameristone, 405 Lexington Ave., New York, NY 10174.
Marble and granite.

New York Marble Works, 1399 Park Ave., New York, NY 10039.

(See Sculpture Associates, Sculpture House, and Sculpture Supply. These three all supply a full range of carving stones, and tools.)

Tapa Stone Studios, Hewitt St., Lake Peekskill, NY 10537.
A sculptor's studio with a full range of supplies and services.

Ohio

Waller Brothers Stone Co., P.O. Box 157, McDermott, OH 45652.

Pennsylvania

Dan Lepere & Sons Co., 57 Armat St. Philadelphia, PA 19144.

Rhode Island

New England Stone Industries, Inc., Providence Pike, Smithfield, RI 02917.
Full-range stone shop.

Tennessee

Christie Cut Stone, 2082 Elzey Ave., Memphis, TN 38104.
Limestone.

The Marble Shop, P. O. Box 10127, 6000 Walden Ave., Knoxville, TN 37919.

Texas

Capital Marble and Granite Co., 5526 Highway 290 West, P.O. Box 3171, Austin, TX 78735.

Virginia

Soapstone for Sculpture, P.O. Box 3241, University Station, Charlottesville, VA 22903.
Good soapstone, perfect for beginners.

Wood and Stone Inc., 7567 Gary Rd., Manassas, VA 22110.
Lots of stones. They also make Akemi, a fine stone adhesive to join stones or fill holes (in other words, to salvage disaster).

Vermont

Granite City Tool Co., 11 Blackwell, Barre, VT 05641.
Tools

Gravet Marble and Granite Co., Route 4, Rutland, VT 05736.

Rock of Ages, P.O. Box 842, Barre, VT 05641.
Lots of marble and granite, plus services. National distribution.

Vermont Marble Co., 61 Main St., Proctor, VT 05765.

The best source of quality stones for carving can be sculpture suppliers, such as the three in New York (Sculpture Supply, Associates, and House), and Montoya in Florida. Many cities have shops that cut and install stone, such as marble fireplace fronts. These shops often have scraps and cut-off pieces, and can advise on further sources. Again, use the Yellow Pages, and ask questions.

6. METAL AND OTHER SUPPLIES

Alcan Metal Powders, P. O. Box 290, Elizabeth, NJ 07207.
Fillers for resin casting.

American Metalcraft, Inc., 4545 Homer St., Chicago, Il 60639.
Lots of sheet metal in brass, copper, aluminum, stainless, etc.

Brookstone Co., Hard to Find Tools, Brookstone Bldg., 127 Vosefarm Rd., Peterborough, NH 03458.
All sorts of handy and unusual tools.

Dynabrade Inc., 72 E. Niagara St., Tonawanda, NY 14150.
The Dynabrade file is a power belt/file which is very handy.

Hobart Brothers Co., Box EW-330, Troy, OH 45373.
The leading supporter of welded sculpture among welding equipment manufacturers. They hold summer classes and workshops, and take a strong interest in the problems of sculptors working in welded metals.

Industrial Arts Supply Co., 5724 W. 36th St., Minneapolis, MN 55416.

Tools for plastic working, plastic welding, etc.

Industrial Products Co., 21 Cabot Blvd., Langhorne, PA 19047.
Safety equipment.

Rohm Haas, 5750 Jarvis, Niles, IL 60648.
Manufacturers of Plexiglas and other sheet plastics.

Again, your best friend is the Yellow Pages. Look up ''steel,'' ''brass and bronze,'' ''aluminum,'' ''welding equipment and supplies,'' ''plastics,'' ''safety equipment,'' etc. Call local welding shops, local contractors, anyone who might use what you need, to find where they get it.

Bibliography

ANDREWS, OLIVER. *Living Materials, A Sculptor's Handbook.* Berkeley, CA: University of California Press, 1983.

ANGRAVE, BRUCE. *Sculpture in Paper.* London: Studio Publications, 1957. (This book deals with cut paper sculpture, not cast.)

AUERBACH, ARNOLD. *Modelled Sculpture and Plaster Casting.* New York: Thomas Yoseloff Publishers, 1961.

BALDWIN, JOHN. *Contemporary Sculpture Techniques—Welded Metal and Fiberglass.* New York: Reinhold Publishing Co., 1967.

BATTEN, MARK, *Direct Carving in Stone.* London: Alec Tiranti, 1966.

BEECROFT, GLYNIS. *Casting Techniques for Sculpture.* New York: Charles Scribners Sons, 1979.

CARSTENSON, CECIL C. *The Craft and Creation of Wood Sculpture.* New York: Charles Scribners Sons, 1971.

CHOATE, SHARR. *Creative Casting.* New York: Crown Publishers, 1966.

CLARKE, GEOFFREY, and CORNOCK, STROUD. *a sculptor's manual,* London: Studio Vista (Reinhold), 1968.

COLEMAN, RONALD J. *Sculpture: A Basic Handbook for Students.* Dubuque, IA: William C. Brown, 1968.

DAWSON, ROBERT. *Practical Carving in Wood, Stone, and Other Materials.* New York: Watson-Guptill, 1972.

DIVALENTIN, MARIA and LOUIS. *Sculpture for Beginners.* New York: Sterling Publishing Co., 1969.

ELISCU, FRANK. *Sculpture Techniques in Clay, Wax, and Slate.* Philadelphia and New York: Chilton Co. Book Division, 1959.

FAULKNER, TREVOR. *Direct Metal Sculpture.* London: Thames and Hudson, 1978.

FISHLOCK, D. *Metal Colouring.* Teddington, England: Robert Draper, 1962.

FLINN, RICHARD A. *Fundamentals of Metal Casting.* Reading, MA: Addison-Wesley, 1963.

GROSS, CHAIM. *The Technique of Wood Sculpture.* New York: Arco Publishing, Inc., 1957.

GRUBBS, DAISY. *Modeling a Likeness in Clay.* New York: Watson-Guptill, 1982.

HOFFMAN, MALVINA. *Sculpture Inside and Out.* New York: W. W. Norton, 1939. (Out of print, but a classic if you can find a copy.)

JACKSON, HARRY. *Lost Wax Bronze Casting.* New York: Van Nostrand Reinhold, 1979.

LANTERI, EDUARD. *Modelling and Sculpture.* New York: Dover, 1965. (This is a reprint of a fine old classic.)

LUCCHESI, BRUNO, and MALMSTROM, MARGIT. *Modeling the Figure in Clay.* New York: Watson-Guptill, 1980.

LUCCHESI, BRUNO, and MALMSTROM, MARGIT. *Terra Cotta,* New York: Watson-Guptill, 1977. (Both Lucchesi books are highly recommended.)

MEILACH, DONA Z. *Contemporary Art with Wood.* New York: Crown, 1968.

MEILACH, DONA Z. *Contemporary Stone Sculpture.* New York: Crown, 1970.

MEILACH, DONA Z., and KOWAL, DENNIS. *Sculpture Casting.* New York: Crown, 1972.

MEILACH, DONA Z., and SEIDEN, DONALD. *Direct Metal Sculpture.* New York: Crown, 1966.

MILLER, RICHARD MCDERMOTT. *Figure Sculpture in Wax and Plaster.* New York: Watson-Guptill, 1971.

MILLS, JOHN W. *The Technique of Sculpture.* New York: Reinhold, 1965.

MORRIS, JOHN D. *Creative Metal Sculpture.* New York: Bruce Publishing, 1971.

NORMAN, THELMA. *Wax Modeling.* South Brunswick, NJ: Yoseloff, 1966.

OLSON, LYNN. *Sculpting with Cement.* Valparaiso, IN: Steelstone Press, 1981.

PADOVANO, ANTHONY. *The Process of Sculpture*. New York: Doubleday & Co., 1981.

PANTING, JOHN. *Sculpture In Fiberglass*. New York: Watson-Guptill, 1972. (Very good—highly recommended.)

RHODES, DANIEL. *Kilns: Design, Construction and Operation*. Radnor, PA: Chilton Press, 1968. (Other books by Rhodes on ceramics are excellent.)

RICH, JACK C. *The Materials and Methods of Sculpture*. New York: Oxford University Press, 1973.

ROUKES, NICHOLAS. *Sculpture in Plastics*. New York: Watson-Guptill, 1968.

SLOBODKIN, LOUIS. *Sculpture—Principles and Practice*. New York: Dover, 1978.

STRUPPECK, JULES. *The Creation of Sculpture*. New York: Holt, Rinehart and Winston, 1952.

VERHELST, WILBERT. *Sculpture—Tools, Materials, Techniques*. Englewood Cliffs, NJ: Prentice-Hall, 1973.

WILLS, FERELYTH and BILL. *Sculpture in Wood*. New York: Arco Publishing, 1975.

YOUNG, RONALD D., and FENNELL, ROBERT A. *Methods for Modern Sculptors*. San Raphael, CA: Sculpt-Nouveau, 1980. (*The* book for ceramic shell casting.)

Index